Advance Praise for
PRISON BORN

"*Prison Born* provides a compelling and penetrating account of the injustices of the Canadian legal system, which dehumanizes incarcerated pregnant persons and the children born to them while serving their sentences." —**DAVID MILWARD**, University of Victoria, author of *Aboriginal Justice and the Charter* and *Reconciliation and Indigenous Justice*

"*Prison Born* takes on the harmful state practice of infant separation in the Canadian criminal legal system, with attention to its gendered, racialized, and colonial impacts. Following the story of one woman and her child, born while she was serving her sentence, Robin F. Hansen exposes the brutality and injustice of punishment practices and asks important questions about why and how these practices are normalized." —**DEBRA PARKES**, Chair in Feminist Legal Studies, Peter A. Allard School of Law, University of British Columbia

"Insightful and urgently necessary, *Prison Born* sheds light on harms resulting from the routine practice in Canadian Corrections of separating infants from incarcerated mothers at birth. It explores how these harms are not felt equally and are damaging in particular, gendered, and racialized ways that perpetuate the living legacy of colonialism in the present. It is a highly insightful text worth reading." —**REBECCA JAREMKO BROMWICH**, Department of Law and Legal Studies, Carleton University

"This book tells the story of 'Jacquie' and her newborn son 'Yuri' and how the author was able to help keep the Canadian criminal justice system from brutally separating them. Necessary reading both as a compelling

story and as a critique of how the Canadian criminal justice system continues to fail and violate the rights of Indigenous people, women, and their children." —**KENT ROACH**, CM, FRSC, author of *Canadian Justice, Indigenous Injustice*

"This is an essential and gripping book about the most extraordinary collateral consequence that our sentencing courts impose: the separation of mother and infant through incarceration. It is unconscionable that our legal system has not been pressed into finding a better way. This book will help." —**LISA KERR**, Director of the Criminal Law Group at Faculty of Law, Queen's University

PRISON

INCARCERATION AND MOTHERHOOD IN THE COLONIAL SHADOW

BORN

ROBIN F. HANSEN

University of Regina Press

Copyright © 2024 Robin F. Hansen

All rights reserved. No part of this work covered by the copyrights hereon may be reproduced or used in any form or by any means—graphic, electronic, or mechanical—without the prior written permission of the publisher. Any request for photocopying, recording, taping, or placement in information storage and retrieval systems of any sort shall be directed in writing to Access Copyright.

Printed and bound in Canada. The text of this book is printed on 100% post-consumer recycled paper with earth-friendly vegetable-based inks.

Cover art: "Baby blue blanket newborn isolated on white background, Top view" (modified) By Dzha / Adobe Stock and "Simple Hand Drawn Irregular Dots Vector Pattern" by Magdalena / Adobe Stock
Cover design: Duncan Campbell, University of Regina Press
Interior layout design: John van der Woude, JVDW Designs
Copyeditor: Rachel Taylor
Proofreader: Rachel Ironstone
Indexer: Patricia Furdek

Library and Archives Canada Cataloguing in Publication

Title: Prison born : incarceration and motherhood in the colonial shadow / Robin F. Hansen.
Names: Hansen, Robin F., author.
Description: Includes bibliographical references and index.
Identifiers: Canadiana (print) 20240362527 | Canadiana (ebook) 20240362608 | ISBN 9781779400086 (hardcover) | ISBN 9781779400079 (softcover) | ISBN 9781779400109 (EPUB) | ISBN 9781779400093 (PDF)
Subjects: LCSH: Women prisoners—Legal status, laws, etc.—Canada. | LCSH: Pregnant women—Legal status, laws, etc.—Canada. | LCSH: Indigenous women—Legal status, laws, etc.—Canada. | LCSH: Mothers—Legal status, laws, etc.—Canada. | LCSH: Maternal deprivation—Canada. | LCSH: Children of prisoners—Canada. | LCSH: Children's rights—Canada. | LCSH: Motherhood—Canada. | LCSH: Sex discrimination in criminal justice administration—Canada.
Classification: LCC KE9416 .H36 2024 | DDC 344.7103/56—dc23

10 9 8 7 6 5 4 3 2 1

University of Regina Press, University of Regina
Regina, Saskatchewan, Canada, S4S 0A2
TEL: (306) 585-4758 FAX: (306) 585-4699
WEB: www.uofrpress.ca

We acknowledge the support of the Canada Council for the Arts for our publishing program. We acknowledge the financial support of the Government of Canada. / Nous reconnaissons l'appui financier du gouvernement du Canada. This publication was made possible with support from Creative Saskatchewan's Book Publishing Production Grant Program.

For the people who change this.

CONTENTS

List of Tables ix
Introduction xi

PART I. OBSERVATIONS
Chapter 1. Sentencing the Newborn 3
Chapter 2. Automatic Separation in Canada 19

PART II. THEORY
Chapter 3. A Systems View of the Legal System 35
Chapter 4. The Colonial Lens: Seeing the "Savage" and the "Dying" 51
Chapter 5. Case Study: The Stanley Acquittal 63

PART III. ANALYSIS: SPATIAL DEFINITIONS IN COLONIAL IDEOLOGY
Chapter 6. The Instrumentalized Stereotype of the Unfit Indigenous Mother 83
Chapter 7. Courts as the Gateway to Indigenous Over-Incarceration 95
Chapter 8. Prison Wastelands and the Removal of Children 131

PART IV. ANALYSIS: OTHER ASPECTS OF THE SYSTEM

Chapter 9. Law through the Androcentric Lens **147**

Chapter 10. Factors that Buffer the Legal System from Change **163**

PART V. SOLUTIONS

Chapter 11. The Illegality of Shackling a Pregnant Person in Labour **175**

Chapter 12. How the Law Protects a Newborn from Automatic Separation from Their Mother **195**

Conclusion **209**

Acknowledgements **219**

Appendix Canadian Federal/Provincial/Territorial Ministers of Justice (2023) **221**

Bibliography **223**

Notes **265**

Index **303**

LIST OF TABLES

Table 2.1. Number of Infants Born in Custody, 2011–2015 & 2016–2019 **25**

Table 11.1. Colonial Lens Norms **176**

Table 11.2. Androcentric Lens Norms **178**

LIST OF TABLES

INTRODUCTION

One spring afternoon in 2016, I received a call at my university office from a woman who has chosen here to be called Jacquie.[1] She knew that I was a law professor, and she was seeking help in a deeply troubling situation. Jacquie, an Indigenous woman from a Treaty 6 First Nation with close family ties to a Métis community, was in her third trimester of pregnancy and very concerned about the welfare of her child. He was due to be born in several weeks and was to be automatically separated from her at birth by the prison system, against her strong wishes and against contemporary medical and developmental knowledge. Jacquie was incarcerated at the Pine Grove Correctional Centre in Prince Albert, Saskatchewan, Canada, and she could not afford a lawyer and had no legal representation. When she called me, Jacquie was weeks away from being forced to abandon her newborn.

The Saskatchewan Ministry of Justice, according to its website description, "provides a fair justice system that upholds the law and protects the rights of all individuals in Saskatchewan."[2] What was about to happen to Jacquie's unborn son, however, was neither just nor fair. Not one state actor (such as a judge or social worker) had directly considered his interests during Jacquie's sentencing;[3] he was at that time not yet

born and by Canadian law was not yet a legal person.[4] However, there would be no consideration of his interests after his birth, either. Instead, he would be automatically removed from his mother's care according to Pine Grove Correctional Centre's policy. This was the same policy that had been applied for decades in Saskatchewan, and in most of Canada: after birth, each baby born to an incarcerated woman was automatically, immediately removed from their mother's care. Once born, Jacquie's son would have no right to due process in state decisions that affected him, as someone inexplicably denied access to the rule of law.

The "rule of law" is a constitutional principle which posits that law must trump bare political power. It means that no one is above the law, and that no one is below the law, either: All persons are entitled to rule by law, not by arbitrary state conduct operating with disregard to a person's status as a rights holder. In *Reference re Secession of Quebec*, the Supreme Court of Canada (SCC) described the rule of law as one of the unwritten principles underlying the Canadian Constitution, a principle "invested with a powerful normative force...binding upon both courts and governments."[5] Relevant here, the SCC also opined that this principle "provides a shield for individuals from arbitrary state action."[6]

The seminal case on the rule of law principle, *Roncarelli v. Duplessis*, dates from 1959.[7] In 1940s Montreal, Mr. Roncarelli was a wealthy restaurateur who sparked Quebec Premier Duplessis's ire by providing bail money, on several hundred occasions, to detained Jehovah's Witnesses. The SCC found that Premier Duplessis was not entitled by his political office to arbitrarily cancel Mr. Roncarelli's restaurant liquor license in retribution for funding the release of arrested Jehovah's Witnesses. The Premier was not above the rule of law.

The state, by not affording Jacquie's son due process even as it committed an act with lifelong effects, was about to treat him as less than a full

• INTRODUCTION •

legal person, as someone below the rule of law. His constitutional right to fair process under section 7 of the Canadian Charter of Rights and Freedoms was being ignored, as was his right to due process under the Bill of Rights, as well as his common law right to administrative fairness.[8]

Jacquie's son was also poised to be treated in a way that was patently incompatible with Canada's obligations under the United Nations Convention on the Rights of the Child (UNCRC).[9] Canada ratified this treaty more than three decades ago and is required to, at a minimum, *consider* the best interests of the child in all state decisions that affect children. According to treaty Article 3(1), "In all actions concerning children, whether undertaken by public or private social welfare institutions, courts of law, administrative authorities or legislative bodies, *the best interests of the child shall be a primary consideration.*"[10] This is a core obligation of this treaty, the most widely ratified international human rights treaty on the planet—and one that was being ignored for Jacquie's son.[11]

When I spoke with Jacquie that day in 2016, she was firmly focused on safeguarding her son's future. Her sentence was in relation to an event that had occurred the year before: while impaired, she had sought more alcohol from a bar by showing scissors to the bartender, leading to a charge of armed robbery. She had no criminal record at the time and was remorseful and cooperative after the incident, seeking to live positively from then on. In the interval between the offence and the sentencing, she developed a good therapeutic rapport with a counsellor, completed a treatment series, and resolved not to consume alcohol in the future (which she has upheld).

Following her arrest, Jacquie was initially in custody for about a month before being released on house arrest pursuant to a recognizance order (in other words, she promised to return to court when scheduled to appear). She was under house arrest for six months leading up to

her sentencing and became pregnant near the beginning of this period. During the sentencing hearing, her counsel told the judge that Jacquie would be separated from her infant immediately after birth if she was sent to regular provincial custody. Her lawyer tried to argue for a sentence served on weekends, or by lengthy house arrest. However, the judge was unpersuaded and sentenced Jacquie to thirteen months of provincial custody, which was one month less time than the prosecution had sought. Jacquie would have to give birth while incarcerated. Not only was she sentenced to time in prison, Jacquie was also sentenced to lose her child at birth.[12]

Jacquie was looking for a lawyer for her appeal, and I tried to find her free criminal legal representation. Legal Aid Saskatchewan had not chosen to represent her on appeal, for reasons I do not know. I contacted the Community Legal Assistance Services for Saskatoon Inner City (CLASSIC) clinic but was told the clinic had a policy against providing representation in sentencing appeals (due to resource limitations). I next contacted representatives of the local Elizabeth Fry Society; they fielded my questions but did not offer legal representation. I then heard about one criminal lawyer who had expressed mild interest in the case; his view was that a successful appeal was unlikely but that the case could be drawn out long enough procedurally for some bonding between mother and child to occur. After my initial inquiry, however, he did not respond to my email. I tracked down another criminal lawyer who appeared initially keen, but she was ultimately unavailable. I lastly filed an application for Pro Bono Law Saskatchewan's Criminal Appeals Panel program, home to distinguished senior members of the criminal bar, but no one volunteered.

There was evidently no free legal help for Jacquie. I realized that if people in her situation commonly had access to lawyers, they would be

• INTRODUCTION •

in a very different situation. Since I could find no free criminal lawyer, I decided to act for her. As I went through the process, many showed me patience and kindness, including persons at the Court of Appeal, Ministry of Justice, Corrections, the office of the Sheriff, and several police departments, as well as lawyers and colleagues. I remain very grateful to those who helped me provide the representation that I could.

This book places one episode of the legal system—Jacquie's sentencing and appeal—under a microscope to reveal that the Canadian legal system has rules and assumptions in operation that are problematic and, most importantly, unacknowledged. At present the legal system denies Charter rights to newborns, removes them from their parents without due process, and fails to consider the child's best interests. It furthermore fails to uphold the UNCRC, to which Canada is a party. All of this is being done disproportionately to Indigenous women and children.

After all of the fact-finding concerning the Canadian state's oppression by law of Indigenous peoples—including the Royal Commission on Aboriginal Peoples, the Truth and Reconciliation Commission, and the Commission on Murdered and Missing Indigenous Women and Girls—we cannot in good faith continue to operate the Canadian legal system in the same manner as we have always done. Yet we are doing just this in many quarters. Indicators such as the present-day worsening of over-incarceration of Indigenous persons show the perniciousness of wrong-headed norms in Canada's system. Statistics Canada reporting on provincial incarceration shows that in 2020–21, Indigenous persons were imprisoned at 8.9 times the rate of non-Indigenous persons in Canada.[13]

This book explains how Canadian law arrived at a place where a judicial sentence against a pregnant person leads to the suspension of newborn children's rights at birth, without due process and with no regard to the child's well-being or best interests, or to the lifelong health

impacts this may have on the child. It examines why implicit judgment, before the birth of a child, is apparently sufficient in Canadian law for some newborn children to be denied their mothers, notwithstanding the fact that this can represent a significant health deprivation with lifelong repercussions.

In order to understand how and why the Canadian legal system treated Jacquie and her son Yuri in this manner, I turn to three theoretical approaches: systems theory, spatialized justice, and critical Indigenous legal scholarship. This book in particular employs the work of systems theorist Niklas Luhmann, critical race scholar Sherene Razack's work on spatialized justice, and critical Indigenous legal scholars, including Patricia Monture, to describe how anti-Indigenous systemic discrimination operates in Canadian law.[14]

My essential argument is that systemic discrimination in law here takes the form of racist understandings of people and places that circulate with potence in the legal system. These understandings are ideological extensions of the Doctrine of Discovery and *terra nullius* ("empty land").[15] They are communicated as defined meanings of *spaces*, particularly of places and persons. Categorical meanings of spaces (or "spatial categories") form part of law's communications and effectively voice and perpetuate racist norms. The relevant spatial categories have several versions, and can be communicated as combinations, but commonly they define Indigenous persons as: (1) innately hostile, uncivilized, or threatening ("savages" meriting violence), and/or (2) naturally "dying" or disappearing (not meriting medical assistance or the necessities of life).[16] The focus of this work is on the separation of newborns from mothers in the Prairie Provinces, but the model of Canadian law that I present is relevant across Canada and is reflected in many facets of the legal system's treatment of Indigenous peoples.

INTRODUCTION

I use Luhmann's systems theory to dissect legal system operations, discussed below, and Sherene Razack's spatialized justice analytic to understand racism and law.[17] Spatialized justice postulates that some spaces are understood in law as having universal justice rules in effect, while other spaces are understood as having such rules suspended. As raised above, just as words create meaning, spatial categories of places and persons signify meaning too. Some spatial categories are defined to contain unjust norms or biased assumptions that direct whether universal justice principles are suspended within a given instance of the legal system: bluntly, meanings embedded in spatial categories can signal the dehumanization of others. Dehumanization does not need to be absolute in order to be oppressive.[18]

Settler colonialism, including its gendered anti-Indigenous racism, is the ideology that sources the main biases seen operating against Jacquie and her son in the legal system. This is consistent with an intersectional understanding of discrimination.[19] In the background, however, is the influence of more generalized patriarchal male-centricity in law, politics, and public policy, which undermines appropriate consideration of pregnancy and childcare in sentencing and prisons across the board, for all pregnant persons. Also, although not discussed in as much detail as settler colonialism and patriarchal androcentrism in this book, a third ideology, related to the presumed inhumanity of prisons, also comes to bear in this discussion, raised in chapter 8.

Put otherwise, the spatial categories that direct automatic newborn-mother separation, as done by sentencing courts and corrections agencies, express biased norms from two ideologies: (1) settler colonialism, namely its gendered anti-Indigenous racism, and (2) androcentrism, or what can be referred to as heteropatriarchal male-centricity. These ideologies overlap and each in its own way rationalizes automatically removing a child such as Yuri from his mother at birth. I call the norms that fit within

settler colonialism "colonial lens norms." I call the norms that reflect the ideology of heteropatriarchal male-centricity "androcentric norms."

This book primarily discusses anti-Indigenous racism, since this relates to Jacquie and Yuri's treatment by the legal system. This focus is not intended to minimize other forms of systemic discrimination;[20] while every form of discrimination requires examination in its own right, that is beyond the scope of this book. That said, it bears stating that anti-Black racism, anti-Indigenous racism, and racism against other racialized persons all have connections to socially constructed whiteness and presumed entitlement to domination and privilege.[21] Furthermore, while I focus here on cisgender women as mothers, given Jacquie's experiences, it must be clearly acknowledged at the outset that not only cis women become pregnant and give birth; trans men, nonbinary persons, and gender diverse individuals also experience pregnancy and childbirth and must be included in societal understandings of birthing parents.[22]

This book is organized into five parts. Part I contains observations of Jacquie's treatment by the legal system (in chapter 1) and of automatic separation done by sentencing judges and prisons across Canada (in chapter 2). Part II next explains the theoretical scholarship applied (chapters 3–5). It introduces systems theory and spatialized justice, and shows how these two approaches, when combined, provide a tool for analyzing operations of the legal system, in order to uncover where and how spatially embedded norms enter into legal process. Included in part II is a systems theory analysis of the acquittal of Gerald Stanley for the shooting death of Colten Boushie, an example of anti-Indigenous bias that simply cannot be overlooked.

Part III (chapters 6–8) analyzes Jacquie and her son Yuri's treatment by the legal system. It unpacks four spatial categories that expressed anti-Indigenous norms in the legal system's communications, namely: the

• INTRODUCTION •

Indigenous mother, the courtroom, the prison, and the Indigenous child. Part IV next turns to other aspects of the legal system that also played a role in Jacquie and Yuri's treatment, namely androcentric norms (chapter 9) and structural buffers that insulate the legal system from change (chapter 10). The three structural buffers identified are: a glaring lack of access to lawyers; a lack of representation and diversity on the bench and in positions of political leadership; and a lack of cumulative public scrutiny concerning prison admission decisions, since these are overwhelmingly unwritten. Each of these factors contributes to stasis in the law.

Part V concludes with a way forward, without colonial lens norms' perversion of the law. It explains the patent unconstitutionality of shackling a woman in labour and of removing a newborn from their mother's care without fair process. International human rights law is instructive on these points as well.

While chapter 3 describes Luhmann's systems theory in more detail, a few comments are warranted here. The Canadian legal system is understood here as being just that—a system. Like other systems, it operates in feedback loop cycles, namely positive and negative feedback loops. This terminology does not refer to whether or not a loop is beneficial but instead refers to the role of the feedback loop in the system. Simply put, negative loops maintain stasis and positive loops effect change. To provide an example, a negative feedback loop is like a thermostat that keeps a house at a given temperature. In contrast, a positive feedback loop is like aspects of climate change: melting snow and ice in turn lead to increased temperatures because less heat is reflected back to space once the snow and ice is gone, since water for instance absorbs more heat than does ice. Positive loops amplify change within the system.

In a legal context, this means an innovative SCC ruling will ripple through the law applied in courts and initiate a positive feedback loop of

change. In contrast, court decisions that replicate existing caselaw fulfill a negative feedback loop and favour inertia. Each act of the legal system is a circular reference to the rest of the legal system as it is perceived as existing from time to time.[23]

In Jacquie's case, and in cases like hers, the feedback loop of legal communications runs as follows: At Stage One, a judge makes one direct determination, as well as a second *implied* determination; at Stage Two, sometime later, administrative agents take action, having been triggered by *both* of the judge's determinations at Stage One. These administrative agents' actions impact a vulnerable third person, who was not directly considered by the judge at Stage One. State agents act to affect this vulnerable person, but this person's interests, let alone his or her constitutional rights, are not transparently considered at any point in the process. In this feedback loop, this third person is rendered a bystander to the legal system's flow: he or she is a person disentitled from due process and from the rule of law, without the capacity in the system to have his or her rights enforced or interests considered.[24]

More specifically, when a pregnant woman is sentenced, the judge makes a determination communicating that a given custodial sentence is warranted. Importantly, a second, implicit determination is also made at that time: the judge looks at the pregnant woman, is informed that there is no place for that woman's child in jail, and yet sends her to prison with a sentence that extends well past her due date. The only way that this sentence can be rendered is if the judge not only considers the crime, but also determines, without actually declaring, that the woman's worth as a mother is such that—and the status of the coming child is such that—*it is acceptable under the law for her child to be taken away from her care at birth*—that it is acceptable for said child to be deprived of their mother. The judge sentences the newborn.

• INTRODUCTION •

When the child is born, the child is separated from his or her mother by administrative actors, namely corrections authorities usually in cooperation with social services agencies. This administrative act is made as a matter of course since the child is not permitted to remain with the mother due to corrections policies. During sentencing, the judge does not assess the woman's capacity to mother, nor the effects of separation on the well-being of the child—at that stage the child is not yet born.[25] It is logically impossible to adequately consider the legal rights of someone who is not yet born during the sentencing of the mother, since her child only becomes a legal person at birth—and yet this paradox means the child's future rights are pre-emptively denied to them.

Pre-judgment—the root in Latin of "prejudice"—is literally what is occurring in the feedback loop outlined above.[26] There is a prejudice against the child. In the sentencing court, the newborn and mother are judged before the birth regarding whether they can or should stay together to bond, and a judgment of "no" is rendered. Later in the feedback loop, this pre-judgment is activated and realized by subsequent state authorities in their actions to automatically separate mother and child.

This is done notwithstanding a significant body of research that has demonstrated the importance of bonding during the "fourth trimester" (the three months immediately after birth) on the physiological, psychological, and emotional development of a child.[27] The separation of a child from their mother or primary caregiver can have lifelong effects on the child's health and development.[28] Indeed, psychiatric illnesses, including Reactive Attachment Disorder and Disinhibited Attachment Disorder, are related to a young child's lack of sustained bonding.[29]

It is beyond contention in pediatric research that focused care and attachment to a caregiver as a newborn is key to development and indeed has lifelong effects on an individual.[30] This practice by judges

and corrections ministries of causing newborn children to be denied access to their mothers is thus an example of the well-documented lag which can exist between policy-making and science.[31] To recklessly and systematically interfere with the availability of a birthing parent as a caregiver shows, at minimum, a wilful disregard of the ample scientific evidence. Given the medical and psychological consensus on the importance of devoted care and bonding for a newborn's development, I have difficulty seeing how an unexamined interference with an infant's access to their available caregiver would not show an imputed intent to harm the newborn.

In this legal system feedback loop, newborn children can be removed from their mothers without any accountable decision-maker taking responsibility for this, making the act effectively non-reviewable. All are responsible and yet no one is responsible, a segmentation of bureaucratic responsibility.[32] The judge points to corrections policy as the cause of the action. Corrections administrators point to judicial sentencing as tying their hands. Child welfare authorities act according to their role, which can include immediate placement of the newborn in foster care. At no stage is the newborn given the space in the process to have his or her interests considered, even as the Canadian state operates the legal system in ways that severely impact the child's most basic interests. In the words of Rufus Prince (1920–1989), former vice president of the Manitoba Indian Brotherhood, the child is a "legitimate victim"[33] of the Canadian legal system.

POSITIONALITY AND ACCOUNTABILITY

Before examining this systems process in the chapters that follow, I present below my own positionality as an author in the interests of transparency. Sherene Razack offers comments on participant accountability

during discussion of social hierarchies. She observes that we cannot hope to talk our way out of being personally positioned in systems of social oppression, notwithstanding any good intentions. Accountability in the context of understanding social hierarchies requires that "we invest our energies in exploring the histories, social relations, and conditions that structure groups unequally in relation to one another and that shape what can be known, thought, and said."[34]

Considering accountability in this work means two things for me. First, I am directing my focus on exploring the unequal structuring of groups, and specifically the actions of colonizing actors.[35] Second, I see the merit in sharing the position I am writing from, alerting the reader to my perspective. I am a white cisgender settler woman four-plus generations removed from Europe.[36]

My mother and father grew up on farms in what is now called Southern Alberta, although on both sides their families were not the initial homesteaders on the land. My parents' parents and grandparents had bought the land a decade or two after the first homesteaders, who had themselves obtained the land directly from the Dominion government. Canada might assert that its Dominion title to land, and the extensive settler ownership that followed, was enabled by Treaty 7; but this would not acknowledge ample evidence that government negotiators did not in fact disclose the land "cease and surrender" clauses contained in the numbered treaties.[37] Instead, treaties like Treaty 7 were negotiated and entered into by the parties as pacts with the represented intention that the land was to be shared respectfully.[38]

Prior to the farming in Southern Alberta which began in my family in the 1910s and 1920s, one of my great-great-grandfathers had worked as an Indian Agent in Northern Manitoba in the early 1880s, in Selkirk and Norway House. When he later moved west, his son, my

great-grandfather, was born in 1885, becoming according to family lore the first settler baby born south of the Bow River, just west of High River, Alberta.

Most of my ascendants came from England, Denmark, Germany, and Austria, although my ancestry is partially unknown, since my grandmother's mother died young from Spanish flu, leaving details on her origins sparse. Some of my English ancestors fled their debts for Canada in the dead of night. The Danes left for a less rigid society, in part after family drama related to my great-grandfather marrying below his class. The Germans were "peasant stock" agriculturalists emigrating in the 1840s, first farming in Ontario; my grandfather on this side quit elementary school to work on the family farm, before moving west.

At bottom my Anglo-European ancestors immigrated because it was an option. They were white, the racial group preferred by Canadian colonial authorities;[39] when they arrived, they freely participated in the economy. By the mid-1900s, their children were bussed to and from school. They were able to travel around the country. They could hire lawyers, drink alcohol, and vote, although the voting rights initially only extended to males. They could practice their religion, hold gatherings, and rely on the police to protect their security. Colonial Canada welcomed my ascendants in a bid to build the British Empire.

A barrier to open discussion amongst white Canadians about colonialism is that people are loath to disrespect or criticize their ancestors or extended family. In thinking through this myself, I believe that it is possible to separate the question of whether my ancestors worked hard, loved their families, and contributed to their communities from the question of whether they participated in and benefited from a racist economic and social system. The answer to both sets of questions for my family is yes.

INTRODUCTION

Questions regarding the past are important, but the present is the space within which we have to act. Colonial invasion is "a structure rather than an event,"[40] as comparative historian Patrick Wolfe observed. This structure lives on in the present, not least in the legal system. Shifting how this system works will take changes imposed from the top down; it will also require that the individual people whose communications make up the legal system do two things: (1) end denial of the fact that racist norms operate in the legal system, and (2) actively reject such racist norms as they circulate in the system.

On the first point, individuals must reject the non-acknowledgement and denial that the Canadian state is based on racist assumptions, such as *terra nullius* as well as the civilized vs. uncivilized binary as between Anglo-European settlers and Indigenous peoples; addressing denial will require individuals to reflect on and reckon with the past. On the second point, the system will shift as persons communicate expectations that directly reject the racism embedded in past practices and legal precedent. This will require normalizing non-confrontational discussions about colonial biases.

PART I

OBSERVATIONS

ered
SENTENCING
the NEWBORN

FOLLOWING MY UNSUCCESSFUL ATTEMPT TO FIND JACQUIE A free criminal lawyer, I began to act for her myself. As a first step of providing legal representation to Jacquie, I listened to the audio recording of her sentencing. The transcript arrived some days later. There was no written judgment available, as is the case for 96 percent of all adult admissions to sentenced custody in the province in a given year.[1] The audio recording left a deep impression on me. Jacquie's counsel was seeking a sentence served on weekends, or another alternative to regular incarceration, in order for Jacquie and her child to stay together:

[DEFENCE COUNSEL]:...[T]here's been a real and tangible impact on her [Jacquie], the intergenerational effects of the residential schools,

social conditions, addictions, and the like. They're all very prevalent, the stark pattern that my friend had commented on. Three generations of mothers leaving their children to be raised by others. And, in turn, I'd suggest, after some significant life event then becoming responsible for their children's children, that we keep seeing repeating itself. Patterns of abusive relationships, patterns of abandonment and generational addiction issues, that in and of themselves is a factor, but also feeding back into the negative relationships and the abandonment issues. It's all very circular....

[Jacquie] is the newest maternal link in this chain, I think. There's a real evident pattern there. And now that it's identified, I think, obviously, it would be important to address it. Putting an end to that pattern within their family, not only would assist her and her family, but, I would submit, Your Honour, it assists society in general. It reduces risk; not only risk that she might present, but perpetuation of the cycle that it might present, so we don't have the same—same thing repeating itself down the road.

THE COURT: Well, in her culture, is this a negative thing to be raised by a grandparent?

[DEFENCE COUNSEL]: No, but there's, of course, issues of not having the parent present, and abandonment issues... So—I—I think, obviously, having family involved raising the children is a good thing. It's not the optimal thing, obviously. Having the parent involved, you wouldn't have these situations like that.

It was not made clear what sources the judge was relying upon in his depiction of Jacquie's "culture," nor why he had brought up a "grandparent."[2]

The Judge evidently thought it appropriate to suggest that maternal presence was of reduced consequence for an Indigenous child.

In the Canadian legal system, sentencing is meant to be an individualized process that takes into account the situation of the person being sentenced. The most relevant aspect of Jacquie's situation in the courtroom on the day of her sentencing was the fact she was six months pregnant. But her pregnancy was given almost no regard. All the judge said was, "And a further factor is that she is presently pregnant," without elaboration. Even though the defence had outlined that there was going to be no place for the child in the prison, the judge listed her pregnancy as a neutral factor, rather than a mitigating or aggravating one. This was apparently not the time or the place for any reflection on whether Jacquie would now contribute positively to society as a mother.

After being incarcerated without legal representation for an appeal, Jacquie was in a very difficult situation without the effective means to change this situation herself. Representing herself from the correctional centre was a far worse option than having me represent her. Not only was it a problem that she lacked legal training and access to the internet, but she did not always receive faxes or messages promptly. This became especially obvious when the prison staff did not pass on an important message to her from the Saskatchewan Court of Appeal (SKCA), in what turned out to be a pivotal oversight.

Shortly after she was incarcerated in spring 2016, Jacquie had requested that the SKCA grant her Court-Appointed Counsel for her sentencing appeal. The idea was that court-ordered funds would enable her to find an experienced criminal lawyer to represent her. Such motion hearings for Court-Appointed Counsel were generally heard at 10:00 a.m. on Wednesdays, and Jacquie was to attend the hearing virtually with conferencing technology from the correctional centre.

At 2:45 p.m. on a Tuesday afternoon in spring 2016, I called the Court Registrar to make sure that everything was fine for Jacquie's motion hearing for what I thought was the next day. I had just spoken with Jacquie and she had strangely not yet received her notice of the motion hearing which we presumed to be set for next day, considering that the appropriate documents had been filed. When I called the Court Registrar, however, a staff person informed me that Jacquie's motion was rescheduled to be argued at 3:00 p.m. that same day (i.e., in fifteen minutes' time), and that Court staff had called and informed persons at the prison of this the day before, on Monday. I reported that no one had told Jacquie. While I was on the phone with the Court staff person, Jacquie, back at the prison, went to the guards to put in a request to receive a fax that I had sent in that morning, which she had also not received. It was when Jacquie was putting in this request to receive my fax that a guard told her that she had a "professional call" (i.e., the motion hearing) at 3:00 p.m., giving her a mere ten minutes' notice.[3]

The motion hearing must have been brief because Jacquie called my office, uncharacteristically in tears, at 3:18 p.m. She told me that the Crown lawyer had opposed the motion, stating that "the sentencing was fair," and that the Court of Appeal Justice had commented to Jacquie that she seemed "to know what she was doing" in managing her appeal. Jacquie, with her lack of legal training, had no understanding of the legal language used during the course of the hearing. "They might as well have been speaking Chinese," she said to me. She wondered who qualified as being eligible for Court-Appointed Counsel: "Do you have to have a learning disability?" she asked. She had been judged according to an opaque legal test that she had neither training to understand nor technology to research and create an argument for. Recall also that she had ten minutes' notice of the hearing. The SKCA Justice had little

SENTENCING THE NEWBORN

appreciation for her imminent delivery date in six weeks (or for the fact that babies can arrive at any time), stating that there could be a sentencing hearing for her to present her case scheduled on a day that was only three weeks before her due date. This Justice also said that Jacquie would get a list of Pro Bono and CLASSIC clinic lawyers, seemingly unaware of CLASSIC's policy against representing people in sentencing appeals.

The stress caused by the motion hearing, including the lack of warning, may have in part precipitated the early labour and delivery of Jacquie's son just days later. The labour might have also been related to her untreated gestational diabetes, which had been diagnosed and documented by an outside obstetrician just before her incarceration, only to be flatly dismissed as an impossibility by prison health care staff. Gestational diabetes, if untreated, presents a risk of preterm labour as well as other significant health risks to mother and child, including pre-eclampsia and higher risks of maternal mortality.[4]

On Wednesday, the day after the failed Court-Appointed Counsel hearing, I spoke with Jacquie and she had regained her composure. "I was having a moment," she explained. "I think I might be having Braxton Hicks contractions," she continued. "I've felt them now and then today." She was feeling more than Braxton Hicks,[5] however. By Thursday, Jacquie was in full labour. It is worth sharing in full how Jacquie recounts her experience of labour and delivery within the legal system:

> On Thursday morning, I woke up to another day at Pine Grove Correctional Centre. Upon waking up I was told to pack my stuff for I would be moving to Sharber today, a privileged unit at Pine Grove. I had started feeling slight cramps, but they weren't extremely intense. I just tried to ignore them and continue on with my day for I had been

awaiting this move since being in Pine Grove for there is nothing but great words about Sharber and it's the place to be in the jail.

A staff member came to get me to relocate. On the way I noted to her how I felt, but quickly said it was probably Braxton Hicks for I was only seven months and the pain was very tolerable at the time. She said to take it easy and offered to help transfer my belongings.

Upon arriving at Sharber I was shown my cell and given the ground rules. I tried to get settled and began unpacking, avoiding my cramps. I then lay down to read, waiting for the girls to get back from programming. I also noted to them when they returned how I felt and told them I thought I was in labour. They said it was probably just stress, and to try to relax. I recall giving Robin Hansen a call to tell her how I felt. My cramping was getting a wee bit more intense and I was terrified by what was going to happen to my baby and who was going to look after him. I didn't know exactly what was going to happen. I began to feel panicky for I knew I received a thirteen-month sentence, and I was currently working on an appeal but was denied legal counsel. I was over-the-top stressed out about everything. Everything was building up. I felt like I had no more hope. I was feeling extremely depressed.

Later that day after supper I met with my case worker. I informed her how I felt but told her it was mild. She quickly said to let her know if I needed to go down to medical to see nursing staff. She seemed to be concerned. I returned to my cell and started working on the booklets she had given me. I was trying to relax. One of the girls came to get me and told me to come hang out. I knew my cramps were slowly growing and I hadn't felt my baby move all day. He was always a very active baby. I was beginning to feel overwhelmed. So I went. I wanted to get my mind off things. We sat around a table and began to colour.

I told them the pains were getting worse and I knew something wasn't right. I started to cry, I was scared, worried, and terrified of what was going to come. It was way too early. My baby wasn't fully developed and we could run into tons of problems.

So I got up and proceeded to see my case worker. I told her I was ready. She already knew what was going on. She took me almost immediately. When I arrived at medical to see nursing staff, they took my blood pressure and told me it was too early and I wasn't in labour. They also said to return to my cell and be on bed rest. When I got back I told the girls. They weren't impressed. Neither was I. They knew I was in pain and could see it in my face. So I had a shower in hopes to relax my body so that I could try to sleep. It was about 10:00 p.m. by this time, almost time for lock-up. The pain was becoming more agonizing. I told staff that I needed to go to the hospital, for I knew that it wasn't normal the way I felt. They returned me back to medical to see nursing staff.

This time they didn't check me but told me that I wasn't in labour. They told me I wasn't bleeding, my water didn't break, I didn't lose my mucous plug, and to return to my unit. I was crying and I had very severe pain in my lower back and in my abdomen. At this point I thought there was no hope. I was either going to have my baby in my cell or something terrible was going to happen to me or my baby.

It was time to lock up. I went back to my cell and couldn't get comfortable. I was beyond emotional. I started pacing back and forth in my cell. I felt I needed to have a bowel movement but couldn't. I laid on the floor, I did everything to ease the pain; nothing was working. It was only getting more and more irritable. I told my cellmate jokingly that she would have to deliver my baby. I was so angry at this point. I felt I was being treated so poorly and that it wasn't right for anyone to

be treated that way, pregnant or not. I questioned the health of other people. I felt sick to my stomach. Did you have to be literally almost dying to get proper medical attention? Even then I'm not sure it would be possible. I felt completely hopeless. What was going to be the outcome? I could not sleep. I began to sweat and get extremely dizzy. I began to strip. I felt I was going to pass out. I just wanted the unbearable pain and discomfort to end. I wanted to know my baby was okay.

Finally I *could not* handle it any longer. I rang for staff at this point. They came and said that the nursing staff were gone and they would call the ambulance to take me to the hospital. One staff helped me to the wheelchair and took me to the front door. Upon the ambulance arriving, they told me they had to shackle my feet. And then told me to get up and walk to the stretcher. They told the medics I could walk.

Two guards were sent to come with me. The medics asked me tons of questions and gave me laughing gas, which didn't make me laugh but feel drunk. Upon arriving at the hospital I needed to pee, and the guards told me to walk to the bathroom, and I did with my shackles on. The doctors and nurses came to check me and put the contraction machine on me. Only to find out I wasn't having any. They checked my cervix with the shackles on. They gave me a steroid shot and admitted me into the hospital for they thought I was having something wrong with my bowel. I had to walk a couple times in the shackles moving from bed to bed. They moved me to a room. Here I became settled because the medicine was easing the pain, but it was still there. By this time it must have been past twelve midnight. I had dozed off. I woke around 2:00 a.m. The guards were sitting at my doorway. I said I needed to use the bathroom. I still had the shackles on. One guard followed behind me. I couldn't pee. I sat for about five minutes. I got up and walked back to my bed. Shortly after I felt a

warm burst of fluid come from me. I lifted the blanket too see that I was lying in a pool of blood. I began to panic. The guard ran for the nurse and doctor.

They then moved me to a labouring room and called an on-call specialist. They gave me an ultrasound and saw that my placenta had ruptured. A life-threating condition for both mother and baby. The doctors said I would be rushed to Saskatoon by ambulance. I was scared and terrified. I didn't want a C-section. I wanted my family. They wouldn't let me call or talk to them. I was alone and felt terrible. During this time I still was in shackles, but I remember for a period of time they took one side off when the doctor checked my cervix. The ambulance came and I had to get up and change beds again. I had the shackles on my ankles.

On the way to Saskatoon one guard rode with me and one followed in the vehicle. When we got there around 6:30 a.m. the doctors came to check me. They checked my cervix and I had the shackles on. The guards then traded, from Pine Grove staff to Saskatoon staff. I remember they removed the shackles. I was then checked again and told that I would be having a baby and was three centimetres dilated. They moved me to a labour and delivery room, where I stayed until my baby was born at 12:53 in the afternoon.

For many hours, prison health staff had dismissed Jacquie's obvious alarm for the health of herself and her child. Jacquie eventually left for the hospital in an ambulance late in the evening, *after* the prison health staff had left for the night. Guards put shackles on Jacquie's legs when she was brought out of the facility in labour to the ambulance, presumably according to what was then standard—horrendous—practice.[6] Jacquie laboured for hours still in leg restraints *as noted on her hospital*

chart at Victoria Hospital in Prince Albert before an emergency transfer to Saskatoon, due to a ruptured placenta. This entailed a 140-kilometre ambulance ride, *still in leg shackles*. These shackles were at last removed in Saskatoon, and she delivered her baby at noon the next day, six weeks before her due date in July.

Even on her Saskatoon hospital chart it was indicated that Jacquie was to be returned to Pine Grove prison in Prince Albert, without her baby, upon discharge. She was to be unable even to avail herself of the "five days" rule, described in the next chapter, since the appropriate birth plan paperwork had not been filed with social services.

However, in what seemed like a miracle, a way was opened. Corrections staff, showing admirable human decency, in some last-minute scrambling identified space in a small Saskatoon secure residential facility where Jacquie could stay. She was permitted escorted absences to visit Yuri, her newborn son, who would be hospitalized for several weeks. This continued the contact between mother and infant at the key time when bonding and nursing could become established, and also enabled the delivery of pumped breastmilk.

Late on the afternoon of Yuri's birth, I called the Crown and explained that Jacquie's baby had arrived ahead of schedule. I requested a Consent to Release, under largely the same conditions she had had prior to her sentencing while under house arrest, which would enable mother and son to be together once he was released from hospital. Thankfully, this request was accepted in the light of the circumstances. Ultimately the appeal resulted in a Consent Judgment which allowed mother and infant son to continue to be together under a lengthened sentence served under house arrest. Yuri was thankfully not denied his mother's care. Today, I can tell by the pictures Jacquie sends me that her family is doing very well, and that their bond is strongly established.

• SENTENCING THE NEWBORN •

Jacquie and Yuri's specific story is in the end positive; they were not separated at Yuri's birth and are living well now. Their story reflects what most people I believe understand: that only in rare and *individually identified* circumstances would be it wise to interfere with a newborn's bonding with his or her mother. It was readily apparent that Jacquie's case was not one of those circumstances, both in my opinion and those of others familiar with her. The system had to be given pause in its operational assumptions, however, by Jacquie's appeal process in order for this understanding to be acted upon and in order to dislodge the colonial lens norms in the legal system that had previously worked against Yuri.

Although Jacquie and her son were able to stay together, I would estimate that every year a minimum of about forty-five other newborns across Canada are unjustly removed from their mothers and denied the chance to bond with them, with profound effects on these children's health and lives. This estimate is based on my access to information requests, presented in the next chapter.

Changing this legal system feedback loop will require addressing courtroom attitudes and corrections policies. Strong prejudices exist against mothers who have interactions with the criminal law. I realized the depth of these prejudices after a revealing exchange I had with a professional from whom I had requested documentation in my role as Jacquie's lawyer. He was initially hesitant to provide documentation to me, stating that this was out of concern that it could "be used as leverage to keep her out of jail." I responded that Jacquie was very keen to mother her newborn and that she would be unable to do this if in jail.

What was telling was how this individual, unprompted, continued: he maintained his position and stated that "foster care is preferable in some cases." I countered by saying that this was, in my view, surely not one of those cases. I provided details of the offence, the timing, and of Jacquie's

strong commitment to her son's well-being. Ultimately the person did provide the information I had requested. But I remained struck by this person's immediate and sustained insistence that if a jail sentence had been decreed, the consequent denial of bonding and motherly care was automatically of no importance. I realized that this was the key type of thinking that had led to my client and her son's predicament. This person, like so many others, expressed the assumption that a woman sentenced for a crime had no value as a mother. This person also knew Jacquie's race. This professional was set to enact the implied determination that Jacquie's sentencing judge had communicated earlier: the determination that she was a worthless mother.

At the request of the Crown, the sentencing Judge had sent Jacquie to jail in her third trimester of pregnancy, with all involved knowing that this would mean that her baby would be removed from her care. This was an unspoken (and non-transparent) collective judgment determining that Jacquie was a worthless mother, and that it was acceptable for her child to be removed, including for placement into foster care. This implicit judgment regarding her fitness as a mother was made at the sentencing stage, and this was the initial legal communication in the feedback loop in action. This implicit judgment sentenced her newborn to be taken from his mother and not to have his mother's care or bond with her.

It is this initial courtroom communication that must be interrupted in the legal system. It cannot be made to be acceptable in this system that a woman's value as a mother is non-transparently declared to be nil. The stereotypes at play, discussed in the coming chapters, must be challenged head-on. The science on newborn health and attachment must be put before the court. Fit sentences should not be premised on assumed worthless motherhood and should include non-custodial options to suit the demonstrated circumstances; indeed, this is the case

for all persons before a court who will leave their children without a caregiver if they are incarcerated.

Counsel should put before the court the clear treaty obligation Canada has to *directly* consider the best interests of the child in *all* state decisions affecting such children—including state sentencing of children's mothers.[7] This international law obligation is part of Canadian domestic law, since Canada is presumed to legislate in compliance with its international law obligations.[8] The sentencing provisions of the Criminal Code must therefore be interpreted as including a consideration of the best interests of the child in the sentencing of their caregivers.

Automatic separation here relates to race and history. Like 85 percent—that is, nearly all—of the women sent to jail in Saskatchewan,[9] Jacquie is Indigenous. I have already mentioned the Judge's reference to Jacquie's "culture" (suggesting that the presence of a mother was of little importance in the raising of an Indigenous child, and that a grandparent's presence was sufficient). As I examine in chapter 7, in Jacquie's sentencing the Judge also made reference to the resources that Jacquie had (supposedly) put towards her college education, which he suggested erased the impact of residential schools from her personal background. One cannot help but notice the similarity of this reasoning to the widely held racist stereotype which holds that Indigenous people in Canada are spoiled by free education and a "free ride" in general.[10]

Members of Jacquie's family were forced as young children into Indian Residential Schools. This information was before the Court in Jacquie's sentencing. As is now extensively chronicled—including in the 1996 Report of the Royal Commission on Aboriginal Peoples (RCAP) and the 2015 Final Report of the Truth and Reconciliation Commission (TRC)—through forced residential schooling, Canada vastly maltreated Indigenous children by dislocating them from their families, denigrating

their identity, depriving them of food and medical care resulting in horrendous death rates, subjecting them to predation by sexual abusers, and causing them to endure physical and emotional violence and torture.[11]

As was exhaustively documented during the process of the TRC and in its reports, the legacy of these schools is multi-generational. The assault on Indigenous peoples included that which was committed against the parents and families who had their children taken and who were left behind bereft of them. These schools affected the children forced to attend them during their time there and also severely impacted their adult lives, with enormous repercussions for their own children's negative experiences in childhood, and indeed those of their children's children. Insufficiently treated trauma and psychological injury (including post-traumatic stress disorder) are connected to issues that include interpersonal violence, self-intoxication as self-medication, and risk of addiction—both substance-related and behavioural.[12] A further health issue connected to the legacy of residential school trauma is Fetal Alcohol Spectrum Disorder (FASD), one which the criminal justice system has not yet adequately or appropriately responded to.[13]

Many Indigenous people in Canada have shared their experiences of the Indian Residential School system, as both direct and indirect survivors. Patricia Monture writes about the intergenerational legacy of residential schools: "This terror of residential schools is not a terror of the past alone; it constantly recreates itself and continues to transform Aboriginal communities. The loss of parenting skills in one generation, for example, impacts on generation after generation until the loss is fully addressed. However it is not just the loss of skills that is the legacy of residential schools. The loss of the human ability to trust is a paramount concern. The real consequence of this imposition is the creation of peoples who do not remember how to live in peace and with peace."[14]

Jacquie's family members were taken from their families as young children and brought to residential schools. The legacy of these schools very negatively affected Jacquie and her family, in all the ways discussed above. Jacquie is an intergenerational survivor of residential schools; this fact remains obvious regardless of her educational level.

When a judge, such as the one who sentenced Jacquie, so summarily disregards the impact of residential schools, the legal system is revealed here to be a vehicle for continued colonial state domination. SCC judgments recognize the injustices meted out by Canada to Indigenous peoples, and the need to end over-incarceration,[15] but many judges have not actually heard the SCC's messages on these points, nor have the counsel who are presenting in the courtroom. This tension in the legal system is examined in chapter 7 in my discussion of the courtroom as a spatial category with embedded colonial assumptions. Local and appellate judges continue to ignore Indigenous experiences and treat Canada as a virtuous actor, absolved from past culpability: an actor which (still) does not have to change its conduct or attitude towards Indigenous peoples.

While I listened to the recorded sentencing, I heard no actual consideration by the judge of a non-custodial sentence for Jacquie. It was never a question of *if* she was going to jail; it was a question of *for how long*. Alternatives to traditional custody were available and put before the Court, including secure health centres that accommodated women with infants. Anything but prison was ignored, however. The Judge took pains to emphasize Jacquie's moral culpability, ignoring her successful completion of a treatment series with a counsellor and her identification as low risk to the community. He also used sentences of non-pregnant people exclusively as reference points. Such was the operation of the Canadian legal system towards Jacquie and Yuri.

AUTOMATIC SEPARATION in CANADA

MY RESEARCH ON THE TOPIC OF CHILDBIRTH AND INCARCERated mothers had begun before I met Jacquie. In 2014, I happened across a court decision called *Inglis v. British Columbia*.[1] This Charter case arose after a Provincial Director for BC Corrections instituted automatic separation by unceremoniously terminating the mother-baby program at the Alouette Correctional Centre, a provincial program that had been successfully in place in various forms for more than three decades.[2] The Provincial Director, who was later promoted by his superiors to Assistant Deputy Minister, did not evaluate the program before ending its operation. Rather, the Court found that the Assistant Deputy Minister had cancelled the program because he decided that "the custody of infants was not within the mandate of Corrections."[3] This application of an androcentric lens to determine the

scope and character of the public sphere of prison in a manner that is inappropriate for women is discussed in chapter 9.

Five years after the program's closure, after extensive litigation, in *Inglis* the BC Supreme Court reinstated the mother-baby program. The Court found that the program closure violated section 7 of the Charter for both mothers and babies (the right to security of the person),[4] as well as violated section 15 equality rights with regard to how "[t]he cancellation of the Program had a disproportionately negative impact on the claimant babies, depriving them of attachment and bonding with their mothers and the benefits of breastfeeding, notwithstanding that their mothers were able and willing to care for them."[5] The Court furthermore noted that "[p]rior to the cancellation of the Program, the determination of whether babies born to women imprisoned at [the centre] could remain with their mothers was based solely on an assessment of the best interests of the child."[6] The case also discussed in the context of its section 15 analysis "the history of overrepresentation of Aboriginal women in the incarcerated population and the history of dislocation of Aboriginal families caused by state action."[7]

When I first encountered *Inglis*, I was in the late stages of pregnancy myself, with my second child. I was appalled by the Assistant Deputy Minister's decision and the leaders above him who had supported him. These decisions showed a chilling disregard for children's welfare, deep disrespect for women, and bald ignorance of what it is to care for someone during early infancy.

The importance of bonding in infancy cannot be ignored or simply dismissed. As noted in this book's introduction, medical literature is clear: bonding and the lack thereof has lifelong health effects on a child.[8] Newborn infants need attention and care around the clock, and most mothers, through an intensive cascade of hormones, are primed

and ready to focus on their infants' well-being.[9] Human brains undergo changes during pregnancy that last for up to two years, conditioning instincts and reflexes involved with child care.[10] The arrival of a newborn child is the culmination of a months-long process of psychological preparation accompanied by the increasing awareness of the presence of a growing fetus. Infants accustomed to the warmth of their mothers are often instinctively drawn to nuzzle, and to root for nourishment.

If this essential bonding is to be interrupted, it must be for a just and defensible reason, and by a society fully aware of the implications of such a separation. But throughout Canada, newborns are routinely taken from their mothers without consideration of how this will impact these infants' mental and physical health, and without consideration of the fact that if initial bonding is disrupted it cannot be simply "jump-started" later in the child's infancy. Contrary to the provincial policy that precipitated the *Inglis* decision, and contrary to policies prevalent across this country, disruption of infant bonding should simply not be done without reason.

This chapter (and this book) focuses on the Canadian context and legal landscape, but the issues surrounding maternal incarceration and related rights violations are phenomena that extend beyond borders. Automatic separation is an especially grave problem in the United States where each year hundreds, if not thousands, of newborns are automatically taken from their mothers' care due to prison policies; U.S. incarceration rates are extremely high, and only a few states allow newborns the possibility of remaining with their mothers.[11] That said, there are initiatives underway to change this, as seen in Minnesota's *Healthy Start Act* that became law in 2021, which facilitates mothers and infants staying together during the first year of life, such as in community alternatives to prison. This initiative directly responds to the fact that many

pregnant women affected by automatic separation are indeed only facing brief sentences.[12]

I looked first to Saskatchewan, where I learned that automatic separation is practiced; if an accepted Birth Plan is set in place with the Ministry of Social Services prior to delivery, an incarcerated mother and her newborn child can remain together following birth for *five days*, after which time the infant is removed.[13] The policy I reviewed allowed the mother and child to be housed together in a family visiting unit in the correctional centre. This period could even involve "parent skill enhancement" for the mother, which seemed pointless if the child was going to be taken from the mother at five days old.

Either the infant is then taken by someone the mother can identify who is acceptable and available to care for the newborn, or the baby is placed in foster care, meaning either with a foster care provider or in a group home with revolving caregivers. At the time Jacquie contacted me in 2016, foster care providers in Saskatchewan were paid a mere $675 maintenance rate each month to care for a child aged zero to five; the foster care provider might have a maximum of four foster children at a time (with no more than three children under thirty months), unless special permission is granted.[14] Ironically, the child might have his or her best interests considered for the first time by the Ministry of Social Services when the mother seeks to have the child returned to her, at which point the child's established bonding relationships with foster care providers may be considered.[15]

Manitoba is similar to Saskatchewan in its approach. Of the eight infants born to incarcerated mothers in Manitoba in 2015, seven were immediately placed in provincial foster care, while one was placed with a designate of the mother.[16] Some may wonder why more newborns are not taken by a mother's designate, such as a family member. I submit

that most people, myself included, would have difficulty identifying anyone they know and trust who has the surplus time, energy, and resources available to devote to the intensive effort that caring for a newborn requires. There is a reason why maternity leave is mandated by law: to give time and financial stability for the demanding requirements of early childcare. To be frank, those with the health and capacity for such a task tend to be already fully occupied. For instance, caring for a newborn is an undertaking that requires leave from one's work, presenting professional, legal, and financial complications.

In most jurisdictions in Canada, the provincial and territorial practice is similar to that in Saskatchewan and Manitoba. Sentencing decisions and prison policies interlock to violate women's and children's rights, especially the child's right to fair process. Judges sentence pregnant women to incarceration knowing full well that these women will not be able to keep their babies in jail; this fact is simply not acknowledged as significant.

Provincial and territorial prisons, presumably according to facility-level policies, automatically separate women from their newborns. The federal system is unique here because of the formal Mother-Child Program, described shortly. Decisions regarding newborn-mother separation occur in a haphazard fashion. Depending on the timing and duration of the sentence (e.g., whether incarceration begins early or late in the pregnancy), a prison administrator may be able to use his or her discretion to release the mother in time for the delivery (e.g., via parole eligibility), avoiding the removal of the newborn from his or her mother.

Since the majority of sentencing decisions are done in open court via oral judgment, there are few sentencing records in relation to pregnancy. One study from 2014 found that an estimated 5 percent of incarcerated women in Ontario were pregnant at the time of the study.[17] In order to address this lack, I gathered data concerning the number of women who

gave birth in custody, submitting two rounds of access to information requests. The results are discussed in detail in Table 2.1.

The responses received suggest that automatic separation has been avoided in recent years in the Northwest Territories and Nova Scotia, sporadically in BC, and occasionally in Saskatchewan. It would also be avoided if the mother was accepted into the Federal Mother-Child Program, a rare occurrence. (A person is incarcerated in provincial or territorial facilities when their sentence is less than two years. Federal facilities are for those sentenced to two years or more.)

For the first set of requests, I have data for only one year for Manitoba, and I lack data for BC, Quebec, and the federal system. I received confirmation that in the five-year period of 2011–15, in Canada at least 69 women gave birth while in custody and in 67 cases the newborn was removed from his or her mother, without a review of the child's interests. Regarding the other two cases, in one the child was kept with his or her mother (NWT), and in the other the mother was given a temporary absence from prison of five weeks (Nova Scotia).

News reports referenced in Table 2.1 for BC during this time suggest a minimum average of 3 births in custody per year, for a possible five-year total of 15. Quebec is a populous province and one would estimate the number would be between BC and Ontario (26), perhaps around 20 in a five-year period. If Manitoba had 8 births in 2015 alone, presumably a five-year period would see at least 20. Adding these speculations to the access to information request total, and still excluding the Federal Corrections system, this would put the number of children born to incarcerated mothers in a five-year period at about 124, with all children separated from their mothers at birth, except for 4: 2 in BC as reported by the media,[18] 1 in the Northwest Territories, and 1 in Nova Scotia who stayed with his or her mother for five weeks on a temporary absence.

Table 2.1. Number of Infants Born in Custody, 2011–2015 & 2016–2019

Jurisdiction	# of infants born, 2011–15 inclusive	# of infants born, 2016–19 inclusive	Notes for 2011–2015	Notes for 2016–2019
Ontario	26	Not disclosed	No Mother-Baby Program; automatic separation practiced.[19]	No records found[20]
Alberta	15	Not disclosed	"All babies are removed; none are kept in the facility with the mother."[21]	No records found[22]
Manitoba	8 in 2015 (no earlier records available)	• 2016: 2 • 2017: 4 • 2018: 6 • 2019: 4 • Total: 16	"Unfortunately no records were kept prior to 2015... From January 1, 2015, to December 31, 2015, 8 female offenders delivered babies while in custody of the Women's Correctional Centre (WCC). Seven out of the eight babies were apprehended by Child and Family Services and one baby was placed with family."[23]	• 2016: 2 infants removed from mother after birth; 2 infants taken by social services; 2 infants Indigenous • 2017: 4 infants removed from mother after birth; 2 infants taken by social services; 4 infants Indigenous • 2018: 6 infants removed from mother after birth; 4 infants taken by social services; 6 infants Indigenous • 2019: 4 infants removed from mother after birth; 0 infants taken by social services; 4 infants Indigenous

Jurisdiction	# of infants born, 2011–15 inclusive	# of infants born, 2016–19 inclusive	Notes for 2011–2015	Notes for 2016–2019
Manitoba (continued)				• Total: All 16 infants removed from mothers; 8 taken by social services; 8 presumed cared for by mother designate; all mothers Indigenous[24]
Saskatchewan	7	15	No Mother-Baby Program; automatic separation practiced.[25]	At least 10 infants removed from mothers (8 taken by social services, 2 cared for by family); 1 baby in unclear care situation; 4 babies cared for by mothers (presumably release was possible given sentence timing)[26]
Nova Scotia	5	0	One woman was granted a 5-week temporary absence for childbirth before returning to the facility (without the child). No Mother-Baby Program; automatic separation practiced.[27]	No births in custody[28]
New Brunswick	5	4	No Mother-Baby Program; automatic separation practiced.[29]	4 infants removed; 3 taken by social services[30]

Jurisdiction				
Prince Edward Island	2	1	No Mother-Baby Program; automatic separation practiced.³¹	Removal or accommodation not disclosed³²
Newfoundland and Labrador	0	Reported as less than 5 (used estimate of 3 for total)	No Mother-Child Program; automatic separation practiced.³³	All infants removed; whether taken by social services was not disclosed³⁴
Northwest Territories	1	2018: 1	Newborn was permitted to stay with mother according to facility-level policy.³⁵	Prison-level accommodation policy³⁶
Yukon	0	Not disclosed	"To date, no women have given birth in Yukon while incarcerated."³⁷	"[D]isclosure would be an unreasonable invasion of third party personal privacy."³⁸
Nunavut	0	Not disclosed	Policy unknown.³⁹	Third party privacy cited⁴⁰
Quebec	Not disclosed	Did not submit request	No records available⁴¹; no Mother-Baby Program; automatic separation practiced: "[L]orsqu'une femme donne naissance durant sa détention, la famille ou les Service sociaux prennent l'enfant en charge" (When a woman gives birth during detention, the family or Social Services takes the child).⁴²	Did not submit request considering earlier lack of records

Jurisdiction	# of infants born, 2011–15 inclusive	# of infants born, 2016–19 inclusive	Notes for 2011–2015	Notes for 2016–2019
British Columbia	Unknown; unsuccessful in submitting request[43]		According to one media report,[44] from 2008 to 2015, 26 babies were born to women in BC provincial custody, and three of those were born after the Mother-Baby was brought back in June 2014. Fourteen of these 26 babies were placed in foster care, and all were separated from their mothers. According to another media report,[45] between June 2014 and July 2016, two babies had used the BC Mother-Baby program, while four other babies born to inmates during that time had not.	5 infants removed and taken by social services; 3 cared for by mothers[46]
Federal[47] (sentences of more than two years)	Not disclosed	Not disclosed	"We have carefully searched our records... and did not identify any records regarding your request." As of January 2017 there were currently ten mother participants in the Federal Mother-Child program.[48]	No records found[49]

Minimum Total*	69	48	*This number excludes Quebec and BC data, 4 years of Manitoba data, and Federal data • Total infants cared for by mother 2011–15: 2 (NWT & NS (for 5 weeks)) • Total newborn-mother separations for 2011–15: 67	*This number excludes Quebec, Alberta, Yukon, Nunavut, Ontario and Federal data • Total infants cared for by mother, 2016–19: 8 (BC, SK, & NWT) • Total reported newborn-mother separations for 2016–19: 38; of these: 24 were reported taken by social services; 11 were cared for by family or mother designate; and 3 were separated from mother with care status otherwise unclear (NL) • Total infants whose care status is unknown: 2 (PEI & SK)

With a five-year total of 120, this gives a rough estimate from the 2011–15 data that every year in Canada a minimum of about 24 newborns are automatically removed from their mothers through provincial and territorial systems. As noted the federal numbers were not made available, and I have not included immigration detention births, although this is an area where further research is merited.[50]

Looking at the 2016–19 results, it is interesting that Alberta and Ontario suddenly did not have records for this later round of requests, despite having had records available for the earlier round of requests. On the plus side, this time I was successful in receiving reports from BC and for every year from Manitoba. Nunavut and Yukon declined to disclose, citing privacy. Working with this later round, which covers a four-year period, I have confirmation that there were 48 births in custody (excluding Ontario, Quebec, Alberta, and federal corrections). Of these 48 births, 38 were reported as leading to automatic separations: 24 taken by social services, 11 to a designate of the mother, and 3 whose care status is unknown, beyond the fact they were separated. Two of the 48 births had unconfirmed outcomes (Prince Edward Island and Saskatchewan). Of the 48 confirmed births in custody during this four-year period, in only 8 cases was automatic separation avoided such that the newborns were cared for by their mothers (Northwest Territories, British Columbia, and Saskatchewan).

For the provinces and territories whose data was not available, I estimated data based on the reported and estimated 2011–15 data. For Ontario I estimate 5 births per year for a total of 20; Quebec, 4 births per year for a total of 16; Alberta, 3 births per year for a total of 12; and for Nunavut and Yukon, 0 births per year. Presuming that all of these resulted in automatic separation, given reported policy practices, I would thus estimate the undisclosed automatic separations for provincial and

territorial corrections for these jurisdictions in 2015–19 at 48. Adding this to the four-year total of automatic separations (38) provided via access to information requests yields a combined total of 86. Dividing this by four (years) yields a rounded conservative estimate of 22 separations by provinces and territories per year. This is very close to the estimate of 24 per year based on the earlier round of access requests, and gives a rough estimated average of 23 newborns per year automatically separated from their mothers by provincial and territorial corrections.

Prisoners in the federal system have a minimum sentence of two years, making the likelihood of giving birth while imprisoned very high if a woman enters custody pregnant. It is possible to estimate federal birth numbers given admissions and pregnancy data. Public Safety Canada reported 530 female federal admissions in the 2019–20 fiscal year.[51] A review of published sources by Sufrin et al. suggests that between 4 and 10 percent of women entering prison are pregnant.[52] This is comparable to the aforementioned Ontario study finding that 5 percent of the imprisoned women in the study were pregnant at the time of the study.[53] If 5 percent of the 530 women entering federal custody in 2019–20 were pregnant, then 27 (rounded from 26.5) women likely gave birth while in federal custody in that year.

My access request did not yield any information on the number of infants who might have remained with their mothers as participants in the federal Mother-Child Program. It is notable that the *Office of the Correctional Investigator Annual Report 2021–2022* reported on the problematically low participation seen in the Mother-Child Program to date and recommended taking measures to increase participation.[54]

Researchers Paynter et al. reported that as of January 27, 2019, there were five participants in the program who were federally incarcerated, although this number does not distinguish between full-time, part-time,

or even infrequent contact with children.[55] Similarly, between 2012 and 2019 these researchers reported an average of 9.6 new maternal participants per year entered into the program, but this information could not be disaggregated as to what level of participation this entailed. Even a single visit from a child would make the mother count as a participant. The authors also note that a pregnant woman could become enrolled in the program, and become recorded as a participant, even if ultimately her newborn was separated from her at birth and did not have a chance to participate.[56] Despite these limitations, this information is useful to suggest that only a handful of women are accepted into the Mother-Child Program, and that the majority of children born to federally incarcerated mothers are automatically separated from them. If 9.6 women entered into the Mother-Child Program annually, and if perhaps half of the program participants (5) might be caring for their young children full time in a year, we can estimate that about 22 children born (or 27–5) would not be in the program and would be separated from their mothers at birth.

I thus approximate that each year in Canada a minimum of about 22 infants are automatically taken from their mothers at birth due to federal corrections policies, and that about 23 infants are taken from their mothers due to provincial and territorial corrections policies. This gives a conservative total of about 45 newborns each year who are removed automatically from their mothers without a due process inquiry by the state, as a product of sentencing. The fact that there is so little record-keeping of this practice underscores how devalued mothers and their newborns are in this situation. No one is keeping track of this problem because it is not cared about. It is sobering to think about the hundreds of children who have had their mothers denied to them in this way over the years.

PART II

THEORY

A SYSTEMS VIEW of the LEGAL SYSTEM

FROM HER SENTENCING HEARING THROUGH TO YURI'S BIRTH, Jacquie experienced the realities of newborn separation in Canada: mother and newborn each sentenced to separation with no regard to the coming newborn's best interests. In order to understand why this is such a common occurrence, we need to understand how Canada's legal system functions, both in theory and practice. Here, I turn to Niklas Luhmann's systems theory and Sherene Razack's concept of spatialized justice.

Luhmann's systems theory, which he termed *autopoiesis* (building on the biological concept of self-replicating systems), conceptualizes human society as a system of communications; within this, the legal system is a functionally differentiated sub-system of society. In Luhmann's view, the legal system consists of its acts of communication; the system is

in fact a network of communicated expectations of others' expectations.[1] Legal norms' delimitation lies in "congruent generalisation, and more precisely: in the use of conflicts and the implied chance of victory for the construction of a network of congruently generalised expectations."[2] In other words, the legal system is a self-replicating network of communicated expectations of what it is expected to be.

Importantly, the legal system is understood as essentially amoral, meaning that it is not inherently connected to a moral order.[3] Instead, system content is coded along a binary of what is expected to be "legal" vs. "illegal."[4] The legal system furthermore changes according to the rules that it sets for its own change, such as by new legislation.[5] Law is understood as distinct from other systems such as the political system.[6] While there are many interactions between political and legal systems, each has its own existence according to its own rules.[7] The legal system is closely associated with political power and political systems, but it is distinct from the political system because it has its own rules for reproducing itself.[8] Even judicial appointment, while essentially an exercise in politics, still occurs within the bounds of the legal system since judges must be selected from a *legally* acceptable pool of candidates.

Luhmann's theory has been criticized as too rigidly constructing the boundaries between the legal system and other systems of communication within society, and for minimizing the role of individuals within the system, considering that they are the ones emitting the communications.[9] Despite this, it remains useful here for isolating a specific legal communications cycle, namely the marking of a newborn for separation from his or her mother. Systems theory assists in tracing and understanding the dynamics of this legal process.[10]

In contrast, Sherene Razack's concept of spatialized justice is productive in helping understanding the role of race within Canada's legal

system, especially her analysis of colonial Canada and its treatment of Indigenous persons. Here I am understanding Razack's concept of spatialized justice as both a theory and a methodology.[11] Methodologically, Razack "unmaps" constructions of spaces in order to reveal assumptions concerning the bounds of legal personhood and entitlement to justice.

Razack examines the 1995 killing of Pamela George, a Saulteaux woman and mother, in Regina, and the subsequent trial of her killers, two young white men, who were convicted of manslaughter rather than murder. Razack writes: "I propose to unmap these journeys...to denaturalize the spaces and bodies described in the trial in an effort to uncover the hierarchies that are protected and the violence that is hidden when we believe such spatial relations and subjects to be naturally occurring. To unmap one must historicize, a process that begins by asking about the relationship between identity and space. What is being imagined or projected on to specific spaces, and I would add, bodies? Further, what is being *enacted* in those spaces and on those bodies?"[12] Razack understands the power of defining spaces, especially when those spatial definitions are understood by others in a way that creates a shared understanding: a common policy.

This approach bears some parallels to discourse analysis in socio-legal scholarship[13] and its recognition of competing truth narratives in power relations[14] but has an added dimension: it interrogates how spaces themselves are defined, either implicitly or expressly.[15] Not only is language analyzed for its content, but the constructed meanings of spaces themselves are dissected for their significance in narrating and legitimating entrenched power in society.

Razack situates Canada as a settler society built on racial hierarchy; spatialized justice explains that central imperatives of the colonial project, including the dispossession of Indigenous persons of their lands and the spatial containment of Indigenous persons away from "white" areas,

are connected to spatialized categories of meaning.[16] Regarding dispossession, there are the key spatialized constructs of the "empty" land, and the "savage" populations.

Razack describes the rationales for colonialism contained in these categories: "Colonizers at first claim the land of the colonized as their own through a process of violent evictions, justified by notions that the land was empty or populated by peoples who had to be saved and civilized."[17] This has further implications for Indigenous containment, in that there is the spatialized concept of the "white" settled space from which Indigenous persons must be excluded. Razack observes, "There are perhaps no better indicators of continuing colonization and its accompanying spatial strategies of containment than the policing and incarceration of urban Aboriginal peoples, a direct continuation of the policing relationship of the 19th century."[18]

Spatialized justice analysis queries how social constructions of space communicate colonial norms to establish boundaries between spaces where universal justice norms are in effect, and spaces where such justice norms are suspended. Razack writes, "I explore how various legal and social constructs naturalize these spatial relations of domination, highlighting in the process white respectability and entitlement and Aboriginal criminality."[19] For example, Razack observes: "Ultimately, it was Pamela George's status as a prostitute, hence not as a human being, and her belonging to *spaces beyond universal justice*, that limited the extent to which the violence done to her body could be recognized and the accused made accountable for it. Although it was central to the defence to spatialize accountability in this way, neither the Crown attorney nor the judge contested these relations between space and justice."[20]

In addition to geographical space becoming marked according to colonial hierarchy, the bodies of Indigenous persons themselves become

socially constructed as violable spaces. In examining the death of an Indigenous man named Paul Alphonse in police custody in BC, Razack observes: "The resolute spatialized hierarchy of the colonial world, the policing required to maintain its boundaries, and the habit of domination visible in the everyday treatment of the conquered population are all evidenced in police/Indigenous relations in Williams Lake. As Slotkin reminds us, the settler colonial world is one in which frontier men confront wilderness. The bodies of Indians become the site at which civilization must win over savagery....Violence is not visible when it is meted out to bodies whose difference means that they can and, in fact, must be violated (if order is to be preserved)."[21]

In addition to a "savage" which must be dominated and contained, another important way that the Indigenous body is constructed according to colonial imperatives is as a "dying" Indigenous person. This construction facilitates taking of the "empty" land. Razack explains, "Viewed as abject bodies always on the brink of death, Indigenous people can be imagined as less than human, a dehumanization that gives birth to the settler as fully human and as having emerged from the state of nature in which Indigenous people are thought to be trapped."[22] Concerning the murder of five-year-old Phoenix Sinclair, Stewart and Laberge write: "We argue that no one took action to intervene and help save Phoenix's life because no one cared about yet another Indigenous child who was experiencing neglect. Phoenix becomes Razack's remnant: a remainder of a citizen-subject who is understood to always be in a state of decay because of being out of place in a contemporary settler state."[23]

That someone may be spatially defined as "dying" is a crucial insight in spatialized justice analysis. The spatial category of the "dying Indian" masks others who may in fact be responsible for an Indigenous person's death, and also absolves people from their duty to help persons

in distress, since such "dying" persons are purportedly already beyond help. Razack furthermore highlights a common variation of the "dying Indian," namely the "drunken Indian."

Razack's analysis of the Frank Paul inquiry is topical here. Frank Paul was a Mi'kmaw man who died from hypothermia in Vancouver in December 1998. He was arrested for being drunk in public and then abandoned by police in a back alley where he died; his sister was told that he had been killed in a hit-and-run car accident, and she did not find out the truth until three years later.[24] Razack writes that the inquiry report "indicates a dehumanization of Indigenous peoples, practices born of the belief that there is no moral or legal duty to care for such abject beings. The historical and contemporary construction of Indigenous peoples as 'drunken Indians' organizes the dehumanization discussed here."[25]

Razack's theory of spatialized justice shows where and how Indigenous legal personhood is unrecognized by the system. Colonialism's dispossession, spatial containment, and violence are facilitated by "naturalized" or expected conceptions of space that deny or subvert Indigenous humanity. In dispossession, areas are seen as empty of humans when they are not. In spatial containment, Indigenous bodies are to be ejected from areas marked as "white,"[26] and are policed and imprisoned. Accountability for violence is minimized by dehumanizing the person violated as a "savage." Furthermore, Indigenous bodies are constructed as being nearly dead by definition, absolving others of responsibility.[27] Each of these categorical spatial presumptions further the colonial project: they corrupt the legal system's ability to provide the rule of law to Indigenous persons.

The coded definitions relevant to spatialized justice analysis also have a ubiquitous presence in broader North American colonial culture. For instance, Thomas King identifies how in twentieth-century Hollywood Native Americans were portrayed nearly always in one of three main

ways: savage, noble, or dying.[28] Indeed, this categorization of Indigenous persons is clear in many artifacts of North American settler culture, particularly those depicting pioneer life. A classic example is Laura Ingalls Wilder's *Little House on the Prairie*, first published in 1935, and televised in the 1970s.[29] The "savage Indian" appears several times including when two Indigenous men enter the family's cabin.[30] The "noble" Indigenous type takes the form of a leader who convinces other Indigenous persons not to attack European settlers.[31] Wilder's treatment of Indigenous persons according to the "dying" stereotype appears with a description of a line of Indigenous persons disappearing over the horizon: "More and more and more Indians came riding by... Indian ponies were still going by.... Then the very last pony went by. But Pa and Ma and Laura and Mary still stayed in the doorway, looking, till that long line of Indians slowly pulled itself over the western edge of the world. And nothing was left but silence and emptiness."[32]

Laura reacts to the disappearing Indigenous persons by pleading with her parents to let her take an Indigenous baby. "Laura looked straight into the bright eyes of the little baby nearer her. Only its small head showed above the basket's rim... she wanted that one little baby... The little baby was going by. Its head turned and its eyes kept looking into Laura's eyes... 'It wants to stay with me,' Laura begged, 'please, Pa, please!'"[33] Laura's eerie compulsion, as a settler, to acquire the "disappearing" Indigenous child is chilling considering colonial policies aimed at taking Indigenous children and pursuing genocide.[34] These are discussed further in chapter 8.

"Savage" or "dying" Indigenous persons are thus common tropes in colonial culture. They are short-hands of meaning employed to play principal roles in explaining North America's allegedly benign political creation. These concepts of the "savage" and the "dying" (or "disappearing")

Indigenous person are fit directly within the pervasive colonial construct of *terra nullius*, which "relies on the myth of Indigenous inhumanity (and invisibility) in order that title can be found to belong to colonizers."[35] Razack's scholarship isolates the continued weight and power of labels such as these within the Canadian legal system.

EXPECTED VIOLENCE TOWARDS INDIGENOUS PERSONS IN CANADIAN LAW

Bringing Luhmann and Razack together yields a penetrating account of the Canadian legal system. Recall that Canadian law is a legal system imposed upon lands claimed by the Canadian colonial government (land that makes up part of what some Indigenous Peoples name Turtle Island). With the legal system understood here as a network of communicated expectations,[36] it is worthwhile to ask: Whose expectations was the Canadian legal system founded on? In Anglo-Canada, it was primarily the expectations of British colonizers communicating with other British colonizers. The Canadian legal system here extends from English law, including the common law, the Law of Nations, and *terra nullius*. As Patricia Monture observed: "A preliminary examination of legal structure and theory clearly identifies that certain groups have not had an equal opportunity to participate in the process of defining social and state relations (including the law). Women, Aboriginal people and other so-called minorities have not shared in the power to define the relationship of the institutions of this country (including the university, the law courts, criminal justice institutions, and social services)."[37]

The Canadian legal system is built on the expectations of the British and Canadian authorities and was expected to realize the colonialization of Canada. The legal system was expected to facilitate the dispossession

and spatial containment of Indigenous persons as part of the development of Canada as a colony. This should not be a controversial statement given the bare reality that Canada is a state made by a foreign power in an area where there were clearly people living here first. As Monture wrote:

> Think about everything that First Nations people have survived in this country, the taking of our land, the taking of our children, residential schools, the criminal justice system, the outlawing of our potlatches, sundances, and other ceremonies, and the stripping of Indian women (and other Indian people) of their status. Everything we survived as individuals or as Indian peoples. How was all of this delivered? The answer is simple: through law. For almost every single one of the oppressions I have named, I can take you to the law library and I can show you where they wrote it down in the statutes and in the regulations. Sometimes the colonialism is expressed on the face of the statute books, and other times it is hidden in the power of bureaucrats who take their authority from those some books.[38]

The United Kingdom formed its colonies here by acting through both its political and legal systems. The Anglo-Canadian state committed violence against Indigenous peoples through political acts as well as "legal" acts that were manifestations of the Anglo-Canadian legal system. Applying Luhmann's theory, one can categorize the state's violence as being political, legal, or both.[39] Many of the acts were both, such as application of the *Indian Act*, passed in 1876, as well as its predecessors.[40] Canada's withholding of food rations on the prairies in order that starving Indigenous peoples could be more easily coerced was a tolerated administrative act under the law as well as a political act.

Indigenous persons on the prairies faced extreme food insecurity in the 1870s and 1880s. European newcomers had almost entirely exterminated the plains bison in North America, which prior to this had numbered in the millions, shot mainly for sport, leather, and political purposes. The fur trade economy was also finished. James Daschuk describes how Canadian authorities, by Department policy, withheld food aid from malnourished Indigenous persons in order to dispossess them of their lands:

> A key aspect of preparing the land was the subjugation and forced removal of indigenous communities from their traditional territories, essentially clearing the plains of aboriginal people to make way for railway construction and settlement. Despite guarantees of food aid in times of famine in Treaty No. 6, Canadian officials used food, or rather denied food, as a means to ethnically cleanse a vast region from Regina to the Alberta border as the Canadian Pacific Railway took shape.
>
> For years, government officials withheld food from aboriginal people until they moved to their appointed reserves, forcing them to trade freedom for rations. Once on reserves, food placed in ration houses was withheld for so long that much of it rotted while the people it was intended to feed fell into a decades-long cycle of malnutrition, suppressed immunity and sickness from tuberculosis and other diseases. Thousands died.[41]

In addition to being a political act, withholding food was also carried out through the legal system since the Department of Indian Affairs was purportedly acting within its legal sphere of action. As Daschuk describes: "Instead of supplying rations to famine-stricken populations

'in a national famine,' as Morris had promised, rations were used as a means of coercing First Nations into submitting to treaty. Malcolm D. Cameron, a Liberal MP, accused the Indian department of being driven by 'a policy of submission shaped by a policy of starvation.' In 1879, a number of bands traded their independence for food. In the Battleford Agency, Mosquito, Moosomin, Thunderchild, and Little Pine all accepted treaty in exchange for rations."[42]

During the expansion of the Anglo-Canadian legal system across what became Canada, the law overtly discriminated against Indigenous persons (who could not vote),[43] and sometimes state actors caused scandal by acting in excess of their legal authority.[44] However, a further problem vis-à-vis the rule of law and Indigenous persons stemmed from something more insidious: legal authority was interpreted such that state conduct violating Indigenous persons' rights that was consistent with the colonial mission was regarded as legal behaviour within the system. Violation of Indigenous individuals' legal personhood was tolerated and expected. Rufus Prince, former vice president of the Manitoba Indian Brotherhood observed: "We can trace an unbroken record of injustice back through generations, to our grandfathers and our grandmothers, our great-grandfathers and to those before them. We can trace them back to the time when a label was put on our people, legitimate victim. *Other people learned that they could victimize us and nothing would happen* because the laws, your laws, did not protect us."[45] There was violation of Indigenous rights to such a systematic extent that the Canadian rule of law included the denial of Indigenous persons' right to the rule of law.

The Canadian legal system was thus established as containing pervasive expectations, some written, some unwritten, that Indigenous persons were not full persons under the law.[46] A special "non-personhood" was applicable to them, creating for instance the functional foundation for

the Pass System whereby Indian Agents purported to have full control over whether persons could leave the reserve.[47] While not entrenched in written law, the Agent had the de facto power in law to issue or deny "passes." If caught off reserve without one, a person could be imprisoned through the North-West Mounted Police's application of vagrancy laws, an expected feature of the legal system.[48]

These events and dynamics from the 1800s show how long there have been dehumanizing expectations in the Canadian legal system vis-à-vis Indigenous peoples. A colonial lens framed the system's interactions with Indigenous persons then and continues to do so now. This lens employed the spatialized justice categories that Razack identifies, which are still potent today. It has often applied the devaluing labels of "savage" and "dying." For example, in order to stop Indigenous women from having the right to control their bodies, law's colonial lens has applied the rationale that these Indigenous women were not really women, but were "savage" prostitutes, entitling men to their bodies. In order to force children away from their families, such as for residential schools, adoption, or foster care, the reasoning has been applied that these were not real families with real children; they were uncivilized "savages" or were a "dying" race, and the children had to be "saved." In order to stop state agents including police from having to answer for brutality that killed Indigenous persons, the rationale has been applied that the given Indigenous person was "dying" anyway, such as by being a "drunk" prone to dying regardless of police action.[49]

The "dying" stereotype—which one recalls supposedly justifies withholding assistance or humane treatment of Indigenous persons since they are "dying" anyway, making help pointless—is long-standing in Western Canada. This stereotype crystallized in Western Canada during the aforementioned high death rates by disease at the end of the nineteenth

century. Ignoring that Indigenous persons were terribly malnourished and thus susceptible to illness due to the Department of Indian Affairs' withholding of rations, a popular understanding was perpetuated that Indigenous persons were just prone to dying. James Daschuk's *Clearing the Plains* enumerates the ways the Department of Indian Affairs weaponized rations, with the predictable effects of increasing susceptibility to disease. Daschuk also notes: "Women were especially vulnerable to sexual abuse by those who controlled the flow of food."[50] The longer term effects of these policies included "the construction of the belief in the inherent vulnerability of Indigenous people to disease... Canadians could accept TB rates on reserves as high as twenty times those in neighbouring settler communities because it was believed that First Nations people were *just prone to sickness*."[51]

The "dying" Indian stereotype is thus central to past and present Canadian policy towards Indigenous peoples, on a broader level than simply the legal system. It is a reason for exclusion and neglect of Indigenous communities within Canada. In my view the effects of this lens continue to be seen in significant health disparities and unsafe drinking water in Indigenous communities.[52] The rule of law that applied to settler Canadians was not applied to state dealings with Indigenous persons because of a purposeful blind spot which accepted the violation, domination, and assimilation of First Nations, Métis, and Inuit peoples.

Territorially speaking, it is worthwhile to note that the entire legal basis for Canada's sovereignty over the Prairie Provinces is dubiously based on either: (1) a 1670 Charter by a king far away from Canada who had never been here and who effectively wrote "I'm giving this area to the Hudson's Bay Company" (and whose descendent monarch then bought the land "back" in 1869–70)[53] or (2) Agreements between the Crown and Indigenous Nations that were promptly violated by Canada[54] and never

later referred to by Canada as international treaties.[55] However one looks at it, Canadian law's main explanations for the establishment of much of Canada (i.e., the Crown's underlying title)[56] shows little to no respect for Indigenous peoples as persons entitled to the rule of law.

In the first case, Indigenous peoples were blatantly ignored and treated as non-persons by the Crown in the Hudson's Bay Company Charter. In the second case, it is very doubtful that colonial negotiators actually disclosed key "terms" of the treaties to their Indigenous counterparts, namely the territorial surrender clauses.[57] Non-disclosure of treaty contents would be fraud, which is illegal under international treaty law, even with its Eurocentric underpinnings.[58] Thus, as regards treaty-making as a legal source of Canada's claim to territory, the record suggests that the Anglo-Canadian state (and its representatives) did not consider that it had a legal obligation to treat Indigenous peoples equally as fellow legal persons, worthy of good faith legal treatment. Instead, it was acceptable to them to conduct treaty-making which involved fraud and coercion through selective access to rations.[59]

Once the treaties were completed, the British sovereign then fundamentally breached the spirit of the treaties (e.g., by passage and implementation of the *Indian Act, 1876*), in addition to breaking specific treaty promises with impunity such as those related to agricultural assistance, on-reserve schooling, and even land allocation, fostering Indigenous destitution.[60]

After this "legal" sleight of hand was used to acquire the territory, the Anglo-Canadian state then hammered Indigenous peoples with its own criminal law and laws concerning "Indians" to contain them and force them on British terms into the new country, namely into Canada. This was similar to the approach that had been used earlier in Ireland, whereby Britain employed racialized penal law to subjugate the Irish.[61]

The legal system's degradation of Indigenous persons from "persons" to "Indians" also bears similarities to the "civil death" concept in English and American law that Colin Dayan traces in detail in *The Law is a White Dog*.[62] Reviewing the treatment of incarcerated and enslaved persons, among others, Dayan details how it is long-standing in such law that the state can render some persons to be simultaneously alive physically and for the purposes of criminal culpability, but also to be dead civilly such that they are incapacitated with respect to their civil status as persons, restricting, for example, their ability to vote or hold civil rights.

There are many discriminatory provisions in the *Indian Act* and other written Canadian laws. But besides what is contained in the formal statute provisions, there is the accepted coercion through law's unwritten colonial lens; this relieves state actors of their obligations towards Indigenous persons to treat them as persons entitled to the rule of law and universal justice principles. This colonial lens is an insidious extra layer of norms which governs Canadian-to-Indigenous relations. It provides a special default treatment level for Indigenous peoples in the legal system which is much worse than treatment for non-Indigenous settler Canadians who are not seen as hostile to the Canadian societal system. The colonial lens was and is part of Canadian law; in order to remove it from the law, it must first be acknowledged to exist.

The insights of systems theory and spatialized justice together shed new light on the operation of Canada's legal system. Not only is the legal system a network of communicated norms expressed literally in words, but it is also a network of norms expressed by common reference (implicit or explicit) to meanings embedded in spatial categories. When communicated among system actors, these embedded norms are part of the legal system and its rules; these norms are then part of the law that actors replicate in their legal actions.

When spatial categories are defined to include norms that reflect colonial racism, and when people perpetuate these norms by not rejecting them in their communications, the ideology of colonial racism lives on in the legal system. It is as if legal system actors have a common lens for viewing Indigenous people as "dying" or "savage"; this colonial lens persists and skews the legal system unless contrary anti-racist norms are inserted into the spatial categories' meaning during legal system communications. Particularly since silence can perpetuate a racist norm in the legal system, there is nothing to say that continuation of racist norms in the system must necessarily be done consciously. Implicit bias can thus perpetuate racist ideology similarly to conscious adherence to racist norms. What matters is whether a racist norm expressed by one actor is met with a matching expectation (including acquiescence) by another actor to the effect that that norm is classified as "legal" within the system.

To answer the question raised at the outset of this chapter, automatic separation of mothers from their newborns is occurring because there are spatialized justice norms in effect through communicated expectations in the legal system which command this practice. In the chapters that follow I examine the specific norms that directed the initial decision to deprive Yuri of his mother without review of his needs or interests. The first set of norms are those which are part of the colonial lens, examined in the next chapter. A second set of norms is evident as well, connected to law's androcentric lens, which assumes that the public sphere is an appropriately male domain. The androcentric lens is outlined in chapter 9.

THE COLONIAL LENS:
SEEING the "SAVAGE" and the "DYING"

ONE STARTING POINT FOR UNDERSTANDING THE COLONIAL lens is a basic acknowledgement of the premise of the foregoing chapter that Canadian law, particularly in English Canada, is at root British colonial law. Its colonial objectives make a law that is prone to seeing Indigenous persons as exterior to the realm of civilized justice, entitling authorities to commit violence against Indigenous peoples even under the guise of legality. As Ojibwe scholar Heidi Kiiwetinepinesiik Stark summarizes: "The imposition of colonial law, facilitated by casting Indigenous men and women as savage peoples in need of civilization and composing Indigenous lands as lawless spaces absent legal order, made it possible for the United States and Canada

to shift and expand the boundaries of both settler law and the nation itself by judicially proclaiming their own criminal behaviors as lawful. Indigenous nations and their attending sovereignty became contained in this liminal space, cast as foreign and then violently remade as domestic in order to subsume Indigenous sovereignty with the bounds of the state."[1]

Recall how this expectation of the lawless space is rendered explicit in Razack's analysis: "If Pamela George was a victim of violence, it was simply because she was of the Stroll/reserve, Aboriginal, and engaging in prostitution. No one could then be really held accountable for her death, at least not to the extent that there would have been accountability had she been of spaces within the domain of justice."[2] This suspension of civilized law exists in spaces understood as outside of civilized colonial society; Indigenous persons can thus be construed as being outside of the body politic, as evident in Duncan Campbell Scott's statement that "our object is to continue until there is not a single Indian in Canada that has not been absorbed into the body politic."[3]

There was a central contradiction in how Canada saw Indigenous persons during the establishment of this country. Indigenous persons were not Canadians, entitled to the rule of Canadian law. They were foreign persons, part of foreign societies. Their foreignness was important to Canada because it enabled Canada to make treaties with Indigenous persons ostensibly in order to secure land. But rather than let Indigenous persons remain entitled as foreign persons to their own foreign societies, including their foreign internal jurisdiction, Canada instead embarked on a campaign to construe Indigenous persons as Canadian law criminals, in order to process Indigenous persons within Canadian law and render them as being not foreign persons but Canadian offenders.

Assimilation of the foreign Indigenous person happened through the criminal law and through the offences found in laws concerning

"Indians." Gavigan observes: "If one collapses the *Indian Act* into criminal law, one also renders less visible two important developments; first, the increasingly coercive nature of the *Indian Act*, and second, the correspondingly greater power and authority of Indian Agents."[4] Offence provisions worked here as a mechanism of legal rebranding: from foreign actor to domestic criminal and non-conforming "Indian."

In addition to shielding state agents from accountability for violence against Indigenous persons, the colonial mission was available as a lens which would minimize civilian legal responsibility for violence against Indigenous persons. Witness the sixteen-year delay in bringing the criminal case to trial for the 1971 murder of Cree teenager Helen Betty Osborne in Manitoba. Witness the impunity of those responsible for each of the thousands of Indigenous women, girls, and Two Spirit persons who have been murdered or have gone missing since 1950.[5] Civilian violence was also prone to be sanitized by the media through this same colonial lens. Describing the death in 1953 of Alvina Brass, an Indigenous girl from the Keeseekoose First Nation in Saskatchewan, a newspaper used this headline: "Orgy ends in death for Indian girl, 12."[6]

Racist perceptions made by everyday people in society, and reflected in media, directly impact the legal system's operation. One only has to think of how in 2020 a bank employee perceived an Indigenous grandfather and granddaughter, visiting the bank to open an account, as criminal "threats," such that the employee called the police on these clients and led them to be handcuffed outside the bank.[7]

When the Canadian legal system is understood as a key instrument of the Anglo-Canadian colonial mission, it is unsurprising that this legal system would contain expectations that it operate consistently with the colonial objectives of dispossession, containment, and assimilation of Indigenous persons. Luhmann's theory analyzes each operation

of the legal system as an individualized event that cannot be isolated from its historical context.[8] This colonial lens in the legal system operates in feedback loops, continually seeking to force a colony over the Indigenous peoples present here. The forced changes include "legal" theft of Indigenous peoples' children, in order to remake them into colonial children. This relates to the Indian Residential Schools, as well as to forced sterilization, the Sixties Scoop, and the Millennium Scoop. As chapter 6 discusses, Indigenous women under this colonial shadow are construed as supposedly lesser humans, including as objectified "savage" prostitutes, certainly not respected mothers.

This lens continues to operate in the Canadian legal system today every time assumptions are applied to establish a false normalcy of depriving Indigenous persons of their legal rights and full humanity and granting those who violate their rights impunity for so doing. When viewed through this colonial lens, Indigenous people lose their basic right to even claim rights in the legal system.[9]

Due to the colonial lens, there was no police investigation ordered by the coroner for sixty hours after an Indigenous woman named Nadine Machiskinic was discovered fatally injured at the bottom of a hotel laundry chute in Regina in 2014, after falling ten stories.[10] Whoever found her likely did not request the police, but only the ambulance, and for two and a half days no one else rejected this communicated expectation that the police were unnecessary. Through the colonial lens, it was somehow understandable that this Indigenous woman had died (as a "dying" Indigenous person); or, alternatively, through this lens she was not a really a person (but a "savage"), and no one could be culpable for killing her, since her death was not a killing.

This same colonial lens provided the rationale in 2015 for the shackling and jailing of an Indigenous sexual assault *complainant* in Edmonton

during the criminal trial of her attacker, as well as provided the rationale for why she was transported multiple times in the same police van as her attacker.[11] She was also forced to stay in a cell adjacent to her attacker during breaks in the proceedings, compelled to walk by her attacker when leaving the courtroom, and testified for many hours in the courtroom while in shackles.[12] The judge, lawyers, and police all refused to see this woman as a person, with innate dignity. They used the colonial lens to see her as a "savage" whom they were entitled to contain. Her name was not released.

The colonial lens disregarded the humanity of Cindy Gladue, following her murder in 2011, when lawyers' dehumanizing expectations permitted the placing of her actual reproductive body parts on display in an Edmonton courtroom, before her killer was acquitted.[13] The SCC ordered a new trial on the charge of manslaughter in 2019, and Barton was found guilty by jury verdict in 2021.[14]

In addition to actors in the courts, expectations of the colonial lens can create a problematic role for the police, as Alison Hargreaves notes:

> We might consider the "literal translation of the word for police" in the Carrier language, spoken by Dakelh communities along the Highway of Tears: *Nilhchuk-un*, or "those who take us away." A reference to the RCMP's role in removing Indigenous children from their homes and enforcing their compulsory attendance at residential schools, this word captures a long history of state-sponsored displacement in which the police have been instrumental.[15]

Another example of the dehumanization of Indigenous women is seen in how the Winnipeg Police in 2022 did not try to pursue searching for Morgan Beatrice Harris, Marcedes Myran, Rebecca Contois, and Buffalo

Woman, even after determining with considerable certainty where their remains were likely located, in a landfill.[16]

In all of these circumstances, implicit bias, alongside express bias, has a significant role in maintaining the potency of the colonial lens within the legal system. It is because such bias can be effective regardless of the level of awareness of the biased person that I use the term colonial "lens" to explain how the legal system operates in a biased fashion against Indigenous peoples. It is a common *perception* among actors (i.e., as if seeing through a lens) that operates here to dehumanize. Even if this perception is not understood consciously in all cases, if it is acted upon within the legal system the system continues to oppress according to the lens's norms. In other words, the colonial lens "reads" certain specific persons and spaces (as per spatialized justice theory) as having dehumanizing assumptions associated with them; and since silence is acquiescence, unless an actor rejects this "reading" once it is communicated, it will be this biased understanding that will direct the legal system.[17]

To provide an example of the implicit bias of the colonial lens, Cree author and lawyer Harold R. Johnson recounts in a 2017 article an experience in which he initially perceived an Indigenous woman in a biased fashion, thinking she was drunk and asking him for money at a McDonald's. Upon closer examination, however, his perception radically shifted and he realized that she was only seeking to talk with him in a friendly manner; in the article he urges all Canadians to look twice at an Indigenous person in order to avoid falling immediately into colonial assumptions.[18]

Implicit (or unconscious) bias and conscious bias are difficult to distinguish in practice and both perpetuate systemic discrimination.[19] Socialization leads to shortcuts in thinking that can include unconscious

biases that are racist, sexist, homophobic, transphobic, and ableist, among other forms of discrimination. Unconscious and conscious bias can operate within relational discrimination (directly amongst persons in their interactions) and within structures or institutions.[20]

Following Dr. Samir Shaheen-Hussain's *Fighting for a Hand to Hold*, in which he describes changing the racist rule prohibiting caregivers from accompanying their children during medical evacuations from Northern Quebec, I understand systemic discrimination as a broad concept.[21] It can encapsulate both the system itself and the instances of interpersonal or relational discrimination that can make up the system. Also relevant is how legal scholar Colleen Sheppard describes systemic discrimination:

> The problem does not stem from an isolated act of an aberrant individual or from a single policy or rule. It is a broader, dynamic, and institutionalized phenomenon perpetrated, sometimes unwittingly, by individuals who may even endorse the ideals of equality... The dynamics of systemic discrimination operate to entrench and perpetuate inequality. Exclusion reproduces itself as inequitable norms and standards become the unquestioned backdrop upon which anti-discrimination laws are required to function.[22]

The colonial lens is a way to describe systemic racism against Indigenous peoples executed by the law and legal processes. The lens is a way of seeing that skews the individual and cumulative operations of the legal system such that it is far from providing justice to all. Long-standing racist spatial definitions circulate in the legal system when they are communicated by system actors, even by silent acquiescence.

SEEING AND REJECTING COLONIAL LENS NORMS

When a colonial lens is shared among actors in the legal system (including passively), these normative expectations form the legal system and create systemic discrimination. This conceptualization of the system is important for understanding how the system works and how the system can change.

The Saskatoon freezing deaths are an important example of the process of change. For decades, colonial lens expectations in effect within the police force tacitly and/or actively supported the police practice of "unarrests," whereby police would take an Indigenous person out of town, in winter, and abandon the person alone to freeze. This was a tolerated de facto "legal" part of the legal system, due to its consistency with the colonial mandate including spatial containment and elimination of Indigenous peoples. Neil Stonechild's freezing death merited only a two-day internal investigation in 1990.

During a chance seatbelt check, Indigenous Saskatoon resident Darrel Night in February 2000 told police Sergeant Bruce Ehalt that just days before, other police officers had abandoned him outside of town in the bitter cold, in an area where the bodies of Indigenous men Lawrence Kim Wegner and Rodney Naistus had been recently discovered. Wearing only a jean jacket, with the temperature colder than twenty degrees below zero, Darrel Night had miraculously survived after walking kilometres to a power station, where thankfully the security guard had heard his knocking on the door and let him in, calling him a taxi.[23] In sharing this information with Sergeant Ehalt, Mr. Night offered a break in the expectation congruency that made up the legal system; he was suggesting in his communication to Sergeant Ehalt that this police conduct was not acceptable within the system.

SEEING THE "SAVAGE" AND THE "DYING"

When the police officer he told believed him, and mirrored Night's expectation that this horrendous conduct was not an expected "legal" part of the legal system, the expectation congruency which had supported the practice was broken, at least in the immediate vicinity of the force where the believing officer operated. The sergeant mirrored Night's expectation that he was a human being who did not deserve to be treated in a dehumanizing fashion. A colonial lens spatial definition was not communicated by Night, and the sergeant matched this communicated expectation that justice required an investigation of the officers' conduct. The sergeant initiated an investigation that ultimately led to the firing of the police officers who had abandoned Night outside of town in the bitter cold that evening.[24] The officers were eventually criminally charged with unlawful confinement and sentenced to eight months in custody.[25]

Chains of expectations must be broken and remade differently for the law to change its operation. The expectations which validate colonial dehumanization, even passively, impede change. The automatic separation of Indigenous newborns from their incarcerated mothers is an act of violence perpetuated by the legal system which has yet to have its legitimating chains of congruent expectations sufficiently broken, although in Yuri's case it thankfully was, showing a way forward.

The violence of separation in the form of child apprehension is explained by the Commissioners of the Inquiry into Murdered and Missing Indigenous Women and Girls (MMIWG): "The apprehension of a child from their mother is a form of violence against the child. It also represents the worst form of violence against the mother. Apprehension disrupts the familial and cultural connections that are present in Indigenous communities, and, as such, it denies the child the safety and security of both."[26] This is an act of violence which is achieved

where there are mirrored expectations that deny and ignore the legal personhood of the newborn and his or her mother. The newborn is a legal person, however, who should be at a minimum considered in a legal decision which will dramatically affect him or her. As I explain in chapter 12, automatic separation of newborns from their mothers is indeed contrary to doctrinal Canadian law, notably because the state is obviously violating the newborn's security of the person without even a modicum of due process.

The coming chapters of this book examine four spatial categories of meaning, each a vessel for embedded colonial lens norms, which are evident in Jacquie and Yuri's interactions with the Canadian legal system. First, Jacquie is subject to spatial categorization as an *Indigenous woman*. Indigenous women are viewed through the colonial lens to be highly questionable, immoral mothers, and if sentenced to custody they are confirmed to be worthless non-mothers.[27]

Second, the *criminal court* as a site of interaction between the legal system and an Indigenous individual communicates two colonial lens norms: deviant Indigenous persons require custody, to be dealt out by the court; and Canada is perpetually innocent, is not a cause of over-incarceration of Indigenous persons, and has no moral culpability or legal liability as regards its carceral treatment of Indigenous persons. By these norms the court is effectively a conveyor belt with the expected purpose of funnelling deviant "savages" to prison.

Third, *prison* is coded as a wasteland for the discarded and/or "dying," as well as those who must be contained, perpetually labelled as security threats, entitling the use of violence against them. The problematic norm in effect here is that in prison, any suffering is expected and accepted, since prisoners merit violent containment and/or they are "dying" and beyond help anyway. This norm, which validates boundless

suffering in prison, explains how prisoners are maltreated by, for example, the denial of appropriate medical attention.

Fourth, the spatial category of the *Indigenous child* signifies this colonial norm: Indigenous children generally belong in and are better off in Canadian state care rather than with their families. Yuri is regarded by the system as a hapless, non-person afterthought, whom Canada is of course entitled to "save" and to absorb and mould; he is certainly not a person entitled to due process.

These spatial categories, and the norms they contain, form part of the legal system to the extent that legal actors, even passively, expect that they do. These communicated categories imbue the legal system with colonial norms that rationalize the treatment faced by Yuri and Jacquie. Until these embedded norms are acknowledged and ousted from the legal system's expectations, this system will continue to employ in places a colonial lens that erases the legal personhood of Indigenous newborns like Yuri, denying children the opportunity to have their rights and interests considered before state acts are taken that affect them. These norms are examined below, beginning with examining (in chapter 6) how the colonial lens sees an Indigenous woman as a mother.

While my focus is on the impact of these colonial lens norms in the context of newborn-mother separation, it is clear that they have an impact more broadly in the legal system. For this reason I include in the next chapter a case study of Gerald Stanley's acquittal for the killing of Colten Boushie. Furthermore, it should also be noted that the spatialized assumptions examined here are also often barriers to the legal system seeing Indigenous women's value as mothers to their children in a wide range of court decisions, not only those involving current pregnancy. Colonial lens norms, such as the presumed unfit mother, must be rejected by courtroom actors in such circumstances. As discussed in chapter 12,

in order for Canada to adhere to its obligations under article 3 of the UN Convention on the Rights of the Child, unbiased reflection on the impact of sentencing on the interests of a parent's children must be put before the court as a necessary consideration in sentencing in all cases.

CASE STUDY:
The STANLEY ACQUITTAL

I INCLUDE A DETAILED EXAMINATION OF STANLEY'S ACQUITTAL because, despite the national and international outcry it caused, it was in many ways a routine event within the Canadian legal system. The decision was not appealed by the Crown. Stanley's acquittal is an important example of the legal system operating according to prejudicial assumptions, connected to spatial categories, that signal the suspension of universal justice rules, which would otherwise apply to Indigenous persons. This chapter is dedicated to Colten Boushie's family and supporters. They have worked tirelessly to denounce anti-Indigenous racism operating in Canadian law and society.

In 2018, colonial lens spatial definitions, including the intruding "savage," were employed in the acquittal of white rancher Gerald Stanley in the shooting death of Colten Boushie, a young Cree man. There was

not even minimal legal responsibility placed on Gerald Stanley for the death.[1] Gerald Stanley avoided murder and manslaughter charges; this was even though Stanley admitted to bringing his gun into the SUV where Colten Boushie was sitting, through an open window, as Boushie was seeking to leave the situation, with Colten Boushie dying from a gunshot to the head.[2]

The manslaughter charge was avoided even though Stanley never argued self-defence or defence of property. He succeeded by invoking unexamined assumptions that *suggested* he was acting in self-defence, or in defence of a third party (his wife), but he never directly argued that he was legally justified in his actions. More technically, he never raised a defence, such as self-defence, that the prosecutor would have had to have shown, beyond a reasonable doubt, did not apply.

Scholarship regarding Gerald Stanley's acquittal has focused on topics including jury selection, the right to defend property, the hang-fire argument, and the silencing of Indigenous perspectives.[3] Particularly of note here is the monograph *Storying Violence*, by Cree/Saulteaux scholar Gina Starblanket and Cree scholar Dallas Hunt. In this work, Starblanket and Hunt isolate the colonial myths that were at play in Stanley's trial and connect these to Canada's origin story of settlement, writing with regard to the latter:

> Here we see multiple narratives operating in tandem: the myth of the vanishing Indian, the narrative of the irrelevant/incidental Indian as part of the myth of elimination (some Indians might remain, but settlers need not worry about them or their counter-claims), and if they become a problem, then the 'murderable Indian,' whereby violence is justified in the name of progress and prosperity.[4]

These mythologies have parallels to the spatial categories identified earlier, drawn from the work of Razack and others. "Vanishing" is similar to "dying" and "murderable" is similar to "savage." Of critical importance, Starblanket and Hunt, along with other scholars, have observed how imagery related to the invasion of one's "castle" was central to Stanley's defence.[5]

The prairie version of the castle doctrine is deeply ingrained in some settler communities and dates back to how homesteaders embodied outposts of "civilization." It was their efforts that changed how the land was used and formed Western Canada as a political and physical white space. Furthermore, since some settlers started out with very little in terms of material wealth, developing their operations through years of labour with high stakes and uncertain results, they believed that they had earned the right to protect their homestead by any means they deemed necessary. Of critical importance, Indigenous occupiers of land on the Canadian prairies were conversely *not* permitted to claim protection from liability by the castle doctrine.

There remains clear support today among some prairie constituencies for a version of the castle doctrine that justifies *any* actions taken in self-help by rural dwellers on their land, framed as applying when RCMP response is expected to be delayed.[6] Stanley's lawyer during the trial emphasized that "the Stanleys were on their own"[7] in order to couch Stanley's actions as being within the privilege afforded by this prairie version of the castle doctrine. Those that espouse this idea, however, fail to explain why the regular rules that allow reasonable force for self-defence and defence of property are regarded as insufficient. Nor do they address the fact that even the police, when they do arrive, are not unbounded in their authority to use force, but are also obliged to justify their conduct according to proportionality and reasonableness.[8]

The castle doctrine is a colonial construct that was communicated via three spatial categories prominent in the Stanley trial: (1) the inviolability of settled property; (2) the "savage" intruding criminal; and (3) the vulnerable, innocent, and hard-working settler. The castle doctrine is anchored especially in the first category (the property) and is communicated as follows: If the (2) "savage" intruder violates (1) settled property, then, necessarily, the (3) innocent settler is entitled to use any force against the intruder.

Time and time again in the trial and surrounding events, Colten Boushie was referred to as fitting into category (2), facts to the contrary not withstanding. Gerald Stanley, along with his family, was continually suggested as fitting category (3), the blameless and hard-working settler, despite any conduct that contravened this labelling. The symbolic violation of the Stanley property (1), both the land and the Stanley quad (explained in the facts below), was turned to again and again as justification for the killing, despite the fact that defence of property was never directly argued by Stanley's counsel.

The above three spatial categories, and the castle doctrine rule they communicated, operated effectively within the legal system right from the beginning. The castle doctrine circulated, without successful challenge, in the communicated expectations of the legal system from the moment that Gerald Stanley's son implied its application in his initial call to the police after the shooting. [9] Repeatedly these categories and their embedded meanings were met with support and acquiescence amongst legal system actors until they ultimately resulted in the acquittal. In the remainder of this chapter I explain how this occurred in two sections. First, I examine the trial transcripts, noting how the castle doctrine was likely inserted into the criminal law applied. Second, I outline how a systems-theory understanding of law explains the acquittal.

R V. STANLEY: COLONIAL LENS DEFINITIONS WITHIN THE PROCEEDINGS

The events as presented in the courtroom were as follows. Five Indigenous persons in their late teens and early twenties were in a Ford Escape with a flat tire, after a day's outing to the river with drinking and swimming. They had been riding on the rim for some time when the driver (C.C., a minor) decided to seek help at Gerald Stanley's ranch.[10] This was also the story according to witness and family statements to the media.[11]

When they arrived at the ranch, C.C. and another person, E.M., left the Ford and one of them got on Gerald Stanley's quad and tried to ride it. Gerald Stanley and his son, Sheldon, shouted at C.C. and E.M. Sheldon Stanley smashed the Ford Escape's windshield with a hammer, and Gerald Stanley broke a taillight. C.C. and E.M. got back in the Ford Escape and tried to exit the area. The Ford Escape, still riding on the tire rim, drove down the lane for a short distance but then collided with a parked vehicle and stopped. C.C. and E.M. left the Ford and ran away. Gerald Stanley fired what he described as warning shots as they ran away; the persons running away did not believe they were warning shots, and C.C. described a shot as flying close to him.[12]

Colten Boushie had been sleeping in the Ford and at no time left the vehicle while it was on the Stanley property. The two other persons, including witness B.J., also had remained in the vehicle. Around the time the Ford collided with the parked vehicle, Colten Boushie awoke. When C.C. and E.M. fled, Boushie moved between the seats to sit in the driver's seat to try to keep driving away. Gerald Stanley said that he went to the Ford and reached in through the driver's side window with his left hand (which was holding the gun clip) to take the keys from the ignition. Stanley stated during the trial "I don't know what the right hand was doing,"[13] yet his right hand (which was holding the gun) also went into

the cabin of the vehicle, and the gun went off. Colten Boushie was fatally shot behind his left ear.[14]

After Colten Boushie's death, the Ford Escape was left with the doors open in the rain and wind for more than twenty-four hours. Mr. Boushie's body was also left beside the vehicle for twenty-four hours. Blood and other evidence was washed away, and the RCMP forensic specialist was not sent to inspect the vehicle directly, relying on the initial photos that had been taken in the dark, and on the later photos which were taken after the vehicle had been exposed to the rain and wind.[15] Meanwhile, that evening the RCMP visited Colten Boushie's mother and told her that her son had been killed. One or more RCMP officers told Colten Boushie's mother to "get it together" when she became emotional, asked if "she had been drinking," smelled her breath, and checked in her microwave to see if there was indeed food there ready for her son when he returned home.[16]

From the first RCMP news release the following day, which framed the shooting as being related to theft, support for the castle doctrine was an obvious block to the legal system finding Mr. Stanley criminally liable for killing Colten Boushie.[17] Colten Boushie was repeatedly framed as being in the category of a criminal hostile invader, such that the castle doctrine rule could be applicable. The RCMP officer who, following the verdict, posted in a Facebook group "Too bad the kid died but he got what he deserved,"[18] expressed a view consistent with this doctrine. Reported during testimony at the preliminary inquiry was the statement by Gerald Stanley's wife, Leesa Stanley, made directly following the young man's death, that that was what you got for trespassing.[19]

There was an outpouring of support for the validity of the settler castle doctrine after the shooting. Saskatchewan Premier Brad Wall took the unprecedented step of posting a statement denouncing the racist vitriol.[20] The deluge of racist comments on social media after the

shooting were victim-blaming and equated Indigeneity with criminality. The racism was ostensibly in support of Gerald Stanley, and focused on a farmer's supposedly unfettered entitlement to protect his property.

The problem with the castle doctrine, however, was its inconsistency with formal Canadian law. Rules on self-defence and defence of property do not extend to cover what Mr. Stanley did. Self-defence requires an objective threat to person (Mr. Boushie had taken no such action), and force used in defence of property must be reasonable and employed to secure the property.[21] Stanley's reaching into the cabin of the vehicle with a gun in his hand was not an act that lent itself logically to the reasonable protection of his property.

Instead of applying these defences, then, the legal system contorted itself to apply the castle doctrine in a different manner and to excuse Mr. Stanley's conduct by other means. Jury deliberations in Canada are secret, but from reviewing the trial transcript, including the judge's directions to the jury, one can trace the pathways of reasoning that were available to the jury in order to arrive at Stanley's acquittal, assuming they followed their instructions.

The charge of manslaughter against Stanley was made by way of two possible avenues: (1) assault or (2) careless use of a firearm. Each of these are examined below. (The Crown might also have grounded the manslaughter charge on the straightforwardly illegal act of pointing a firearm at someone, but that was not the theory of the case adopted by the Crown.)[22]

ASSAULT

The charge of manslaughter by assault would have failed if the jury accepted the improbable "hang-fire" explanation and saw the gun discharge as pure accident.[23] The claim here was that the gun malfunctioned

and fired unexpectedly. By this argument, one of Stanley's "warning" shots did not discharge immediately, but instead was fired after a delay, once the gun was inside the SUV. A jury's acceptance of this explanation would have had them focus on a bulging bullet casing retrieved at the scene. It would have also have had them disregard Crown expert testimony describing the maximum delay between trigger pull and bullet discharge as being less than half a second.[24] The court's allowance of layperson testimony (without objection by the Crown) concerning hang-fires of longer duration, including an example from forty years ago using a different firearm, was a move that was conducive to the jury's ignoring of expert evidence on this point.[25] Indeed, the failure to properly frame the value of this civilian testimony was arguably a legal error that might have formed the basis of an appeal.[26]

But the jury's seeming acceptance of the hang-fire explanation hinged most upon the marginalization of witnesses whose testimony was hostile to Mr. Stanley's case. Particularly due to the RCMP's negligence in the handling of the physical evidence, witness testimony was of great importance. Beginning even at the preliminary inquiry, B.J.'s description of events was treated as being without weight. She had been sitting in the back seat of the Ford at the time of the shooting. The judge at the preliminary inquiry did not mention her evidence in his decision to commit Stanley to face trial, and instead only mentioned the evidence provided by Sheldon Stanley.[27] This undermining of her value as a witness continued through the trial process, and the Crown, in his closing address, ultimately declared that he did not intend to rely on B.J.'s testimony.[28]

B.J. described Mr. Stanley as shooting her friend twice (rather than once, which would have been consistent with his injuries), and instead of seeking to explain the inconsistency of her testimony with other evidence, such as by a discussion of echo or the acknowledgement of

trauma she had experienced in relation to the case, the Crown essentially cut ties with her and said that he would not be relying on her—an "extraordinary concession by the prosecutor," in Ken Roach's words.[29]

After witnessing her friend's death, B.J. was handcuffed and detained on theft charges after the shooting, taken on a high-speed chase in an RCMP cruiser (since officers claimed to have forgotten she was there), and was incarcerated for nineteen hours without sleep or food.[30] Considering the circumstances of her initial statement to the police after this ordeal, it should have come as no surprise that she was not forthcoming towards them. Yet the Crown made little attempt to contextualize her initial statement (in which she did not report Stanley as shooting Boushie) or to salvage the overall credibility of her testimony.

The jury's acceptance of the hang-fire explanation therefore appears on one level to be a tantamount preference for a white farmer's recollection of a hang-fire event forty years prior, down to the seconds of duration of the supposed hang-fire, over an Indigenous woman's version of events from a year and a half before. B.J.'s failure to report the shooting by Stanley to police when she was first detained was regarded as problematic in court proceedings, yet the aforementioned circumstances of her statement to police were treated in the courtroom as unremarkable; it was apparently expected that she be forthcoming towards the police even after her extremely hostile experiences with them following the violent death of her friend.

The hang-fire defence was also treated problematically by the judge in the instructions to the jury. He left it open to the jury to conflate the precautionary waiting period following discharge of a firearm (up to sixty seconds), outlined in safety manuals, with the actual durations of hang-fires (less than half a second), according to expert testimony.[31] The judge seemed to leave it up to the jury to accept a longer hang-fire than

was conceivable according to expert evidence. The hang-fire explanation, then, became an inflated possibility.

The hang-fire explanation effectively treated the firing of the gun as an act of God, beyond Stanley's control, centring on Stanley's spatial definition as an innocent player.[32] This stripped him of agency or culpability regarding what his gun did. It was an unlikely explanation, and that the jury seemed to accept it was likely due to the dearth of physical evidence (due to RCMP conduct), the disparagement of Indigenous witnesses, and the flexibility afforded by the court to the defence in its framing of the phenomenon of hang-fire, especially with regard to the treatment of dated layperson testimony.

CARELESS USE OF A FIREARM

Even if the hang-fire argument was accepted, there remained another possible route to conviction of manslaughter, namely by careless use of a firearm. This would have failed if the jury found that Stanley did not commit the unlawful act of careless use of a firearm, by determining that Stanley's conduct was not established to be a "marked departure from the standard of care that a *reasonably prudent person would exercise in the same circumstances.*"[33] It was apparently the all-non-Indigenous jury's view of what was reasonable in the circumstances that would have settled this question of reasonableness in the careless use of a firearm.

This "reasonableness in the circumstances" analysis is the chief entry point for the castle doctrine's application in the legal reasoning likely employed by the jury. This is because the castle doctrine is a supposed privilege to use force, one that is dependant on the establishment of *certain circumstances*, namely infringement upon one's domain (the key spatial category of inviolable property, introduced above).

THE STANLEY ACQUITTAL

Stanley's lawyer's closing address to the jury directly connected the prairie version of the castle doctrine to an assessment of reasonableness, presumably with regard to the charge of manslaughter by way of careless use of a firearm, stating: "The Stanleys were on their own. And you're going to end up assessing the reasonableness of their actions, whether it was a marked departure or not from what you can reasonably expect of somebody in those circumstances. You've got to measure it within that context."[34] The Stanleys were communicated as fitting the spatial category of innocent, vulnerable settlers. It is notable that their claim to innocence in this category bears similarity to the broad claim to Canada's perpetual innocence that is discussed in chapter 7, in the context of colonial lens norms that direct Indigenous over-incarceration.

The castle doctrine's application would ensure that anything Stanley did in *the circumstances* of the "invasion of his castle" would be free from liability. Most critically, it was available to influence the jury's determination of what constituted "reasonable conduct" in the handling of a firearm in the circumstances, relevant to the charge of manslaughter. Without this doctrine's (unacknowledged) application, in what world would it be reasonable to bring a gun through an open window into the cabin of a vehicle, placing it extremely close to the head of someone who is sitting there? To find that this behaviour, of bringing a gun into the vehicle close to Mr. Boushie's head, did not meet the minimum threshold of careless use of a firearm, is in my view the core travesty in the legal outcome of this case. Or, more correctly, it is deeply problematic that the jury appeared to find that there was insufficient evidence to show beyond a reasonable doubt that Stanley's conduct departed from that of a reasonable person in the circumstances.

I should not neglect to mention the main counterargument to the view that I submit here. Some contend that it might not have been

reliance on the castle doctrine that led the jury to find that Stanley was not careless under the circumstances; instead, the jury might simply have believed that Stanley honestly and reasonably believed that the gun was unloaded, and that it was not, in those circumstances of honest and reasonable belief, careless to bring the gun close to Mr. Boushie's head. To which I must reiterate: is it is *ever* reasonable to bring a weapon to someone's head even if you honestly and reasonably believe it to be unloaded, recalling of course that self-defence is itself a separate line of analysis?

We cannot know definitively what drove the jury's verdict. A jury's reasoning that Stanley was not careless because he honestly and reasonably thought the gun was harmless, or a jury's reasoning that Stanley was not careless in the circumstances because his home was "under attack" and thus anything he did in those circumstances was reasonable, were each potential lines of reasoning for the jury to find lack of carelessness.

In my view, however, when the case is read in the light of the social outcry in support of the castle doctrine that it caused, when it is taken in historical and geopolitical context, and when references by Stanley's counsel to the Stanleys "being on their own" in their "castle" are understood as references to the prairie castle doctrine, it is extremely likely that the castle doctrine's persistence within the legal system was the main reason behind Stanley's acquittal. The continued references in the trial and elsewhere to (1) the violation of the sacred property, (2) the criminal "intruders," and (3) Stanley's hard-working, vulnerable and innocent settlerhood were all the conceptual ingredients needed to frame Stanley's circumstances as being covered by the castle doctrine.

The castle doctrine theory of the case was also clear right from the opening statements. Mr. Stanley's lawyer framed Colten Boushie's death as a result of Mr. Boushie and his companions' creation of the situation.

They were the hostile actors. He stated: "This is really not a murder case at all. This is a case about what can go terribly wrong when you *create a situation which is really in the nature of a home invasion*. For farm people, your yard is your castle. That's part of the story here."[35] Bear in mind that Colten Boushie was asleep during initial events before the shooting.

In addition to this reference to the Stanleys' "castle," Stanley's counsel also went so far as to use words like "intruders" and "being terrorized" to frame his arguments, casting Colten Boushie as falling into the relevant category (a hostile criminal) needed to communicate the applicability of the castle doctrine.[36] It is notable that this labelling as a criminal is similar to the blanket assumptions of Indigenous deviance discussed in chapter 7, in the discussion of colonial lens norms that cause Indigenous over-incarceration.

The Judge also seemed amenable to this defence narrative insofar as he twice described "warning" shots as being justifiable in defence of property, related to a concession by the Crown.[37] The Court allowed Mr. Stanley's subjective fear for himself and his family to be stressed repeatedly, without consistent correction regarding how the law of self-defence and even defence of third parties requires an objective threat (i.e., a reasonable apprehension, not just a risk that is subjectively felt).[38] Thus, even though self-defence and defence of property were of no use to Mr. Stanley as direct defences, they were employed as "phantom" defences, in Ken Roach's words,[39] invoked at various points, albeit in incorrect formulation, to frame Mr. Stanley's conduct as being justified in the circumstances.

The expectations against finding Stanley in the wrong, regardless of the scope or details of his actions, were thus connected to assumptions in effect for many decades. To conform to the long-standing terms of this rule which protected Mr. Stanley, he was presented as a hard-working family man who worked the land: a model settler. Mr. Stanley's lawyer

stated in his opening statement: "But that's what we have here is we have a family. And Gerry—Gerry didn't go looking for trouble on August 9th, 2016. He was doing what he does every day. He was working on his ranch. And that's what they were all doing. They were working on the ranch, cutting the grass. The son comes home, he gets put to work. I don't even think he got put to work, just naturally went to work. That's what the day started like for Gerry and the Stanleys."[40]

The Stanley family was shown as being respectable and industrious, with the latter attribute deeply connected to white entitlement to land. Mr. Stanley's rights had been interfered with by the Indigenous persons who had violated the rule that they were to stay out of his dominion. For this it was acceptable that they were exposed to violence as he reinstated the proper order and punished them for their transgression of it. In this colonial lens understanding of the circumstances, the Indigenous occupants of the Ford had invited violence upon themselves by straying from the boundaries set for them and violating colonial property. Mr. Stanley was protected from criminal liability in the Canadian system by deep-set assumptions regarding who is civilized and who is not, and when the legal system will punish and when it will not.[41]

A SYSTEMS THEORY UNDERSTANDING OF *R V. STANLEY*

How Stanley's acquittal happened, when using systems theory and spatialized justice principles, is as follows. Through chains of matching communicated expectations regarding what is "legal" and "illegal" in the system, norms were applied that are not formally part of Canadian law, but which are in fact accepted and expected to be "legal" within the legal system. Review of the events suggests that expectation chains regarding how the legal system should operate were also communicated nearly

exclusively, if not entirely exclusively, by legal system actors who were not Indigenous.

The racial makeup of the actors raises the usual paradox, of course: that we are all the same fundamentally as people regardless of skin (race is only socially constructed, and anyone can subscribe to racist ideology),[42] and yet we are *not* all the same because the social construction of status, including race, clearly matters in society. Canada is a settler colonial country with a specific history involving unequal access to resources and power, and those inequities have related in a significant way to race.

Someone of any race can express and support racist ideology; but those who benefit from societal adherence to racist ideology face social and economic loss if they actively reject this ideology, as compared with letting it perpetuate around them, to their benefit. This means that while being a white settler is clearly not what determines whether or not you subscribe to an ideology of colonial racism, it does mean that logically you are more likely to be passively or actively open to it, since it is to your benefit, as compared with if it did not benefit you. There will be costs to rejecting colonial biases that favour you, and this is also only possible if you take the time to become aware of such biases rather than letting them remain implicit. Furthermore, even if you are not in a position to necessarily benefit from colonial ideology, there will likely be a basic transaction cost for anyone in engaging in a challenge of the status quo, along the thinking of Ronald Coase's seminal article "The Problem of Social Cost."[43] It usually takes additional effort to challenge something rather than to simply acquiesce and navigate the system as it stands.

The cost involved in acknowledging and challenging racist norms is one reason why racism continues in our society. This cost is ratcheted up by the impact of the prominent societal narrative positing that socio-economic hierarchy is organized primarily according to a colour-blind

meritocracy.[44] Colour-blind (or colour-evasive) meritocracy is an ideological smokescreen; it provides a pretence that race has no import whatsoever and people only get what they earn, allowing racial distortions and structural barriers to socio-economic mobility to be denied and ignored.[45] This common narrative increases the effort involved in challenging racist norms since one must first continually brush away at the omnipresent rhetorical cobwebs of colour-evasiveness and presumed meritocracy before addressing racist ideas themselves.

In the Stanley proceedings, the judges (both with regard to the preliminary hearing and the trial), lead counsel, and jury members all appear to have been non-Indigenous.[46] While Stanley's lawyer issued a statement early on that the case was "not a referendum on race,"[47] suggesting that race was irrelevant, he did take the step of rejecting five visibly Indigenous persons from serving as jurors, sending a contrary message to the effect that perhaps race was significant after all.[48]

As noted above, the castle doctrine's expected application in the legal system was communicated via express and implicit references to the spatialized categories of an innocent settler, with inviolable property, which had been breached by hostile invaders. With the above comments on the differential costs to rejecting racism in mind, it must be acknowledged that the racial makeup of the jury significantly undermined the appearance of justice being served in Stanley's trial, as has been an issue with other cases involving lack of representation in jury composition.[49]

I contend that ultimately the jurors selected did not reject the application of the prairie version of the castle doctrine, which had been circulating in the system's expectations since Sheldon Stanley's 911 call, and which was explicit in the defence's theory of the case. The initial communication to the police made by Stanley's son set in motion the expectations of the system regarding this death. Recall next the initial RCMP

press release suggesting that theft was at play, the police officers' egregious treatment of Boushie's family during the next-of-kin notification, and the poor police preservation and recording of evidence.[50] The treatment of the evidence in turn made the court proceedings more reliant on witness testimony, with all the castle doctrine invocation that this entailed.

Once the castle doctrine is seen to be operating as an expected rule in the legal system, everything else that happened in the case makes sense. If any action on Stanley's part was expected to be privileged as legally excusable in the circumstances, the RCMP's treatment of the evidence in the case (allowing nature to destroy it) is unsurprising. Why bother to safeguard evidence if there is no real case expected against Stanley? It also makes sense why Indigenous witnesses and family members were treated as wrongdoers, including during witness testimony, since they were being labelled as the actual violators of the proper order.[51] Furthermore, it becomes unsurprising that the Crown was ineffectual in securing a conviction on even a minimal criminal charge in relation to the death.[52] There was no culpability expected in the circumstances.

In order to disrupt this rule granting landowners carte blanche, new expectations regarding their conduct must be put into place. The sanctity of human life demands it; values must be established that support rural dwellers' sense of security without providing blanket immunity for bloodshed.[53] The law of self-defence and defence of property does not have an implicit extension anywhere that grants a free privilege to use unfettered force, and this ought to have been made crystal clear to the jurors, such that one or more of them might have rejected the expectation that the castle doctrine would apply.

PART III

ANALYSIS

SPATIAL DEFINITIONS in COLONIAL IDEOLOGY

The INSTRUMENTALIZED STEREOTYPE of the UNFIT INDIGENOUS MOTHER

WHEN THEY ARE VIEWED THROUGH A COLONIAL LENS, IT IS acceptable according to the assumptions of that lens to dehumanize Indigenous women and to commit violence against them. There is a presence here of both the "savage" label, which invites violation, and the "dying" label, which presents Indigenous women as always already on the verge of disappearance or death due to their own deficiency. The phenomenon of murdered and missing Indigenous women, girls, and Two Spirit people in Canada is a manifestation of their devaluing on a systemic level. The Interim Report of the National Inquiry into Missing and Murdered Indigenous Women and Girls stated that "we need to understand how social structures and

laws have so devalued the lives of Indigenous women and girls."[1] A normative message provided by the colonial lens is that universal justice norms do not apply to Indigenous women.

Where the legal system communicates and replicates this embedded norm, it subjects Indigenous women to a range of degrading treatment. This includes the denigration of Indigenous women as mothers. This chapter presents scholarship on the origins and scope of colonial dehumanization of Indigenous women and examines its role in Jacquie and Yuri's interactions with the legal system.

The objectification of Indigenous women has long-standing roots in European colonial consciousness.[2] On the Canadian prairies, the Anglo-Canadian state's proliferation of a dehumanized definition of Indigenous women dates back to at least when authorities were imposing Dominion law over the area. This was at a seminal time in the colonial project. Historian Sarah Carter identifies how colonial authorities used derogatory images of Indigenous women in their Western development policies:

> There was a sharpening of racial boundaries and categories in the 1880s and an intensification of discrimination in the Canadian West... The Canadian state adopted increasingly segregationist policies toward the Aboriginal people of the West, and central to these policies were images of Aboriginal women as dissolute, dangerous, and sinister. From the earliest years that people were settled on reserves in western Canada, Canadian government administrators and statesmen, as well as the national press, promoted a cluster of negative images of Aboriginal women. *Those in power used these images to explain conditions of poverty and ill-health on reserves.*... Responsibility for a host of other problems, including the deplorable state of housing on reserves, the lack of clothing and footwear, and the high mortality rate, was placed

THE INSTRUMENTALIZED STEREOTYPE

upon the supposed cultural traits and temperament of Aboriginal women. The depiction of these women as lewd and licentious, particularly after 1885, was used to deflect criticism from the behaviour of government officials and the [North-West Mounted Police] and to legitimize the constraints placed on the activities and movements of Aboriginal women in the world off the reserve. *These negative images became deeply embedded in the consciousness of the most powerful socio-economic groups on the Prairies and have resisted revision.*[3]

The image employed was a colonial incarnation of the Madonna-Whore dichotomy well known in Judeo-Christian heteropatriarchal thought. But there was a twist: in order to become virtuous, Indigenous women had to lose their very identity. Cree/Assiniboine/Saulteaux historian Winona Stevenson presents this process: "Aboriginal women were understood and represented in ambiguous and contradictory terms—the 'noble savages' (Princess) and or 'ignoble savages'... This binary classification has its roots in the patriarchal Victorian virgin-whore dichotomy. However, colonialist imperatives, supported by racist ideology, intensified the binary imaging of Aboriginal women... unlike European women, their burden was even more severe—to be 'good' they had to defy their own people, exile themselves from them, and transform into the European ideal."[4]

The figure of the "Indigenous woman" is thus conceptualized as "squalid and immoral... liv[ing] in a shack at the edge of town, and her 'physical removal or destruction... understood as necessary to the progress of civilization.'"[5] This denigration of Indigenous women was engineered simultaneously with the pedestalization of Anglo-European women, as Stevenson details: "The European ideal of womanhood was projected on Aboriginal societies throughout the colonized world where

it functioned as the 'single most important criterion for contrasting savagism with civility'... Victorian morality was the severe standard against which Aboriginal women were judged. They were ultimately found wanting because almost everything about their being—their appearance, their social, economic, political, and spiritual positions, activities, and authority—was a violent affront to the European ideal."[6]

This veneration of white women and vilification of Indigenous women is traceable to an Anglo-European patriarchal understanding of colonialism's religious righteousness.[7] White women were regarded as virtuous because they were subservient to Anglo-European men and were within the realm of "Man's" civilization (and they furthered colonial expansion through their childbearing). Indigenous women, to the extent that they remained outside of Anglo-European "Man's" rightful domination, were hostile to the colonial vision and denounced it.

The juxtaposition of white feminine virtue against Indigenous women's moral deficiency is deeply ingrained in colonial consciousness and remains today; Métis anthropologist Marlene McKay elucidates this construct:

> This dichotomized positioning of White and Aboriginal women entrenched Aboriginal women in a state of degeneracy; given the identity formation of Aboriginal women, becoming a proper wife and mother would continuously be monitored. By becoming good wives and mothers, Aboriginal women would supposedly be redeemable by following European social customs and submitting to the perpetual process of scrutiny of their lives that is still applicable. The ill treatment of and interference in the lives of Aboriginal women could be justified only on the grounds that they were inherently morally flawed and in need of fixing, ostensibly through Christianity

as the handmaiden of colonization. These processes of colonization through Christianity were meted out through European men who served as missionaries and through assumptions of the proper Christian woman, which is to say, European. However, it would seem that the transition was always only partially achievable if judging by the continuous need to monitor Aboriginal women, a surveillance which continues to exist today.[8]

The derogatory image of the immoral Indigenous woman served the colonial project very well. Indigenous peoples were deprived of adequate land and resources for living spaces and livelihoods due to the Anglo-Canadian state's breach of treaty obligations.[9] But the responsibility for Indigenous persons' poor quality of life was deflected onto Indigenous women. Indigenous women who were forced into poverty through these economic and legal restrictions were cast as slovenly housekeepers who did not know how to use what resources they were given. Furthermore, the description of Indigenous women as being "whores" fostered abuse and violence by Anglo-European authorities and by the general population.[10]

This negative stereotype also labelled Indigenous women as unfit mothers. Their maternal degradation fed into government programs of cultural erasure and assimilation, including the residential schools. As supposedly bad mothers, Indigenous women could also be blamed themselves for violations of their reproductive rights, including coerced sterilization.[11]

The figure of an immoral, "savage" Indigenous mother in a deficient family and home is thus key to the spatialized injustice of colonial ideology. This stereotype supported land dispossession: Anglo-Europeans purportedly were entitled to the land since they would put it to civilized and moral use. The stereotype also supposedly explained a cause

of destitution and ill-health on reserves, in other words, why Indigenous persons were "dying." It also rationalized violence against women, who were dehumanized as "savages." It even justified the taking of Indigenous children, who were understood to be living with bad mothers in "savage" and "dying" families, and who needed to be "saved" and civilized.

According to this pervasive colonial lens, Indigenous mothers were and are by their nature "suspect mothers"; combine this image of general unfitness with that of a woman who is declared a criminal in court, and the woman may be branded immediately as fully worthless to her child, with no need for actual examination of the facts to see if this is true.[12] This pre-judgment is bullying by stereotype.[13] Those who espouse the view that implicit judgment of motherhood before childbirth is sufficient for removal of a newborn from his or her mother rely on prejudice against her to validate their reasoning.

Having been found to have committed a crime does not on its own justify the oppressive act of having one's baby taken away, let alone justify infringement of the child's rights. That someone commits a crime does not mean that they are also without value as a mother. Stereotypes are being used in the court, through communicated spatial categories, to declare the woman to be a bad mother and thus justify what is not otherwise a justifiable act. If she was not implicitly deemed a bad mother, then why would it be legally permissible to remove the baby from her care considering that, medically, emotionally, and psychologically speaking, sustained bonding is extremely valuable to a newborn's health and development?

In his essay "The Bully's Pulpit: On the Elementary Structure of Domination," anthropologist David Graeber identifies that the bully "creates a moral drama in which the manner of the victim's reaction to an act of aggression can be used as retrospective justification for the original act of

THE INSTRUMENTALIZED STEREOTYPE

aggression itself."[14] Graeber notes how victim-blaming is a form of bullying.[15] The victim is "asking" for the treatment they receive by reason of the victim's actions or characteristics.

On a societal level, victim-blaming attitudes are mass bullying—in other words, oppression—whereby we all internalize and accept norms that cast people as being destined to be bullied by reason of their role in a morality drama. For instance, we espouse statements to the effect that a raped person was asking for it because of where he or she was, or what he or she was wearing.

Graeber's modelling of bullying fits strikingly well with Luhmann's theory of law as a social system. The bystanders, in accepting and sanctioning the oppression they are witnessing, are communicating their expectations of the system through their silence. Graeber himself notes the triangular relationship between bully, the bullied, and audience members who witness the bullying and who acquiesce by silence. These audience members are primarily kept quiet by their desire not to be targeted themselves. Graeber's analysis is consistent with theory on the structure of power, which describes that power may be exercised by coercion, reward, or conditioning.[16] Oppressors establish conditioned power which subjugates the person who is bullied into a role in which it is *expected* that the person will be dominated. Silent or egging-on onlookers validate this cruel arrangement.

Graeber also explains *why* we as bystanders validate oppression through silent acquiescence, or through supporting victim-blaming rationales.[17] In his view, we do this primarily because we do not want to be next. We do this out of fear. We do this out of insecurity. As people we seem to have a need to feel our place in a pecking order, whereby we can point to others as being inferior to ourselves, such that we can feel that we ourselves are valid. We have difficulty attaching intrinsic value to

ourselves, and others, as people. And this should not be surprising considering that we have organized ourselves in a fashion that treats much of human life on the planet as practically worthless. In this world, we are letting people starve around us. Humans use others for slave labour. We are cruel in how we exercise power. And those who witness bullying and oppression know this, or are in the process of learning this. Empathy is in short supply.[18]

Oppression begins to be defeated when people deny the premises that have been accepted to justify it at its source. A call to principle can suffice, such as a statement that the oppressor does not deserve to dominate. In the present scenario, the oppressive decision to pre-emptively deny a newborn caregiving by the person giving birth to them, the statement of principle could identify that in most cases, it is not necessary to remove an infant from its convicted mother. Alternatively, the statement could identify that separating newborn from mother is a gravely consequential action that should not be done without individualized reflection. Importantly, the communicated spatialized categories that use a colonial lens seeking to justify such conduct in the legal system must be rejected and disrupted. The spatially implied "worthlessness" of the mother to her coming child must be directly confronted and rejected in the courtroom. Automatic removal of incarcerated mothers' newborns is oppression by the state, done in courtrooms and corrections ministries. By watching in silence we are condoning this targeted violence against mother and infant, as we see in many of Jacquie and Yuri's experiences.

For a pregnant Indigenous woman in the courtroom who is sentenced to lose her child, the oppression happens in the following fashion. Elements of imperfection (e.g., criminal conduct) are amplified by others such that the mother is labelled a bad mother. In addition, characteristics that are not imperfections in themselves (e.g., Indigenous identity),

but which are made to be associated with a particular type of bad mother stereotype (e.g., the racist colonial stereotype of a questionable Indigenous mother), become a lever for bullying, such that the mother is labelled according to an oppressive stereotype. As in Graeber's piece, bullying by stereotype is an invocation of purported morality, so that the mother supposedly deserves to be belittled and disrespected and to have her agency reduced. It is an exercise in power and domination that takes the form of a refusal to see a woman as a whole person and reduces her to a dehumanized caricature.

Stereotypes which force women to fit exclusive and controlling categories, such as those related to Madonna and Whore, are still prominent in legal reasoning, both as actually expressed and as a subtext in the form of spatialized categories. For instance, rape shield laws in Canada are designed to thwart this classification; these rules manage the admissibility of evidence in order to stop the courtroom application of the label of "whore" to a sexual assault complainant, which could unjustly dispense with the issue of her consent. This was the category into which Alberta Court of Appeal Justice John McClung tried to force a sexual assault complainant in 1998 when he expressed that she hardly presented herself in a "bonnet and crinolines."[19] The label of "whore" can unfairly serve as a designation of ongoing consent; a complainant thus labelled either has no right to withhold consent, or is deemed to have likely consented and to be not worth believing to the contrary.

In sentencing a pregnant woman to custody, and knowing the child will be removed upon birth, both the oppressors and spectators in court are participating in this oppression by stereotype. Judgment by the "bad mother" stereotype removes the woman's claim to her identity as a mother, removes her right to her maternity, and facilitates dehumanizing treatment. Just as there is no acknowledgement that the judge is

sentencing the newborn at the same time as the pregnant woman, there is no acknowledgement of the additional trauma the woman is being forced to endure when she is sentenced to lose her child.

This type of double-punishment is not acknowledged in sentencing reasons, an indication of how the sentence is operating through conditioned power. Carrying a child for nine months, experiencing the rush of hormones and brain changes involved in childbirth to prepare for caring for that child, seeing that child, and then having the child taken away without knowledge of their future welfare is an intensely traumatic proposition for the vast majority of persons. But the trauma this separation poses to the mother is not a consideration of the judge or the corrections ministries; we are, after all, dealing with someone who has been marked as a fallen woman, a criminal, a worthless mother, and ultimately a sub-person in this legal system who supposedly deserves her fate of losing her right to maternity.

It furthermore appears that some Canadian corrections personnel apply restraints (such as handcuffs and leg shackles) to pregnant persons, *including while in labour*, as was Jacquie's experience. There is a dearth of policy direction against the shackling of pregnant prisoners in Canada, and there are reports of shackling during labour from other jurisdictions.[20] Courtroom actors must have some inkling of the health risks to mother and child they are creating when they sentence someone to give birth while incarcerated. Not only are shackles in labour an affront to the person's human dignity, but they also make labour and delivery more difficult and painful, imperilling the parent and impeding the child's safe delivery. The anticipated treatment of pregnant women in sentencing them to custody, including the demonstrable risk of being shackled in pregnancy and in labour, further shows how the court bullies and dehumanizes women; any suggestion that rehabilitation is a goal

served by sentencing a pregnant woman to give birth in custody is disingenuous. How is one to heal and re-enter society after having a newborn baby removed following a traumatic labour in shackles?

In Jacquie's case, the sentencing judge placed absolutely no value on her role as a mother to her coming child. He barely acknowledged her pregnancy, considering it to be a neutral factor. When viewed through the colonial lens, her maternal value was a non-issue in sentencing. She was viewed and judged through the colonial lens, employed by all involved (especially by the judge and the Crown prosecutor), as a non-mother, and tacitly as a "bad mother." Thus, her child's care did not have to be considered beyond the usual automatic separation at birth. The judge also made reference in court to how in Jacquie's "culture" it was not a bad thing for a child to be raised by a grandparent, placing on Indigenous mothers a role of dubious importance, and ignoring well-documented legacies of intergenerational trauma due to the Indian Residential Schools and other dimensions of colonialism. The judge wrote Jacquie off as a mother and painted her as an immoral woman that even resources for education could not save.

This prejudice against Jacquie as a mother also reverberated in the words of the professional I approached shortly after Yuri's birth. As described in chapter 1, I requested documentation from him in my capacity as Jacquie's lawyer. Knowing almost nothing about Jacquie except for her race and her incarceration status—he knew nothing of the crime for which she had been convicted, her counselling and treatment, etc.—this man assumed that it was just and acceptable for her to be returned to jail without her child, stating: "Foster care is preferable in some cases." I shared relevant information, and he did eventually provide a basic level of assistance, but the value he placed on mothers who deliver while in custody was crystal clear in our conversation. The policies that

prevail across Canada suggest his views towards incarcerated mothers are representative of many who have contact with the legal system.

Several corrections staff members, including health care staff, treated Jacquie horrendously during her labour, especially by denying and delaying appropriate medical attention and by restraining her legs together in metal shackles for many hours, during her acute medical distress. They treated Jacquie in a dehumanized fashion. Fitting with Razack's spatialized justice categories, Jacquie was treated as someone who was "dying" (and was not entitled to or "needing" care) and/or who was "savage" (and was deserving of pain and violation of her body and dignity, requiring containment at all costs).[21] Also troubling was the fact that hospital and ambulance personnel did not themselves prompt the removal of the leg shackles, but instead acquiesced to corrections' communicated expectation that they were appropriate.

The spatial category of the immoral Indigenous woman, especially the dimension of this construct which casts her as an unfit mother worthless to her child (and that it is in the child's best interests to be separated from her), contains biases that must be challenged and removed from the legal system's expectations. Fortunately, the eventual resolution of Jacquie and Yuri's case shows that there are many in the system who do not expect that the norm of the unfit Indigenous mother belongs in Canada's legal system. There needs to be space made in courtrooms and corrections administrations for the amplification of such contrary norms that are also present in the system, especially those that value due process and the consideration of the best interests of the child.

COURTS as the GATEWAY to INDIGENOUS OVER-INCARCERATION

A S A SITE OF INTERACTION WITH INDIGENOUS PEOPLES, THE Canadian criminal court is a spatial category laden with meaning. As discussed in chapters 3 and 4, the Canadian legal system was a key tool in establishing Canada by enacting violence towards Indigenous peoples. It is no accident that the Canadian court is entrenched in the legal system as a pathway to Indigenous incarceration. Legal system actors (particularly lawyers, judges, and police) disproportionately communicate expectations which favour imprisonment of Indigenous peoples over non-custodial treatment, as compared with expectations in relation to non-Indigenous persons.[1] This is an example of a path dependency; the legal system continues to behave in largely the same way as it always has.[2]

Certain embedded colonial lens norms relating to Indigenous persons and the criminal law are extremely well entrenched in Canada's legal system, practiced over many decades; it is as if these norms have achieved the consistency of layered sedimentary rock. They are the habitual basis for sentencing jurisprudence and for police surveillance and investigation strategies.

Two colonial norms, embedded in the spatial category of the criminal court, are discussed in this chapter. These are each based on the civilized/uncivilized binary in Canadian law, a result of colonial mythology. The first norm is this: the Indigenous person in court is a "savage" who has transgressed "civilized" law, requiring additional containment and coercion (through incarceration) in order to be neutralized as a threat and to be placed appropriately within civilized society. The second norm is this: wrongs committed by Canada against an Indigenous person appearing in court are unmentionable and without legal weight; they are to be denied or rationalized away since it is impossible that Canada could be uncivilized or less than benevolent.[3] By this norm it is legally inconceivable that Canada would owe legal accountability to Indigenous persons for how the legal system treats them as it pursues colonialism. Canada is perpetually innocent.

The pervasiveness of these two norms in the legal system helps explain Indigenous over-incarceration due to Canadian legal system actors' sentencing bias and over-policing.[4] It is empirically demonstrated that Indigenous peoples receive harsher sentences than non-Indigenous persons,[5] and that Indigenous peoples are more highly scrutinized for criminal behaviour than non-Indigenous peoples.[6]

As this chapter argues, these two embedded norms help to explain why courts are the sites of disproportionate transfer of Indigenous persons to prison. The chapter contains three sections. The first section

outlines the history of Indigenous over-incarceration, and its role in the colonial project. The second section of this chapter next turns to the thus far unsuccessful statutory and SCC attempts to address over-incarceration. The third section reviews how these embedded norms directed Jacquie and Yuri's initial sentencing.

HISTORY: INCARCERATION AS INDIGENOUS CONTAINMENT AND ERASURE

The over-incarceration of Indigenous peoples in Canada has been a publicly recognized phenomenon for more than forty years, since at least the late 1970s or early 1980s.[7] As discussed in this book's introduction, contemporary statistics reveal that Indigenous over-incarceration is still worsening. Statistics Canada reports that in 2006–07, Indigenous peoples' proportion of correctional admissions in Canada was 21 percent for provincial and territorial correctional services and 19 percent for federal correctional services. In 2016–17 those figures had increased to 28 percent and 27 percent, with only 4.1 percent of the adult population of Canada being Indigenous.[8] For 2020–21, Statistics Canada reported a continued increase, to 31 percent and 33 percent, with 5 percent of the adult population being Indigenous.[9] In addition, the agency reported that of youth admitted to custody in 2020–21, 50 percent were Indigenous, despite Indigenous youth representing only 8 percent of the youth population.[10]

Provincial imprisonment statistics for 2020–21 identify that in contemporary Canada Indigenous adults and youth are 8.9 times more likely to experience incarceration than non-Indigenous adults and youth.[11] Indigenous women in 2022 made up half of all federally incarcerated women for the first time, while comprising less than 5 percent of

the Canadian population.[12] Recalling that positive feedback loops are those that amplify changes, there is evidently a system-level positive feedback loop in operation that promotes ever-increasing incarceration of Indigenous persons by the Canadian legal system.

This continuing and extreme disproportionality is clear notwithstanding that nearly thirty years ago Parliament responded to Indigenous over-incarceration by passing changes to the Criminal Code which urge judges to consider non-custodial options in sentencing Indigenous offenders.[13] The perverse acceleration of this social phenomenon, despite Parliamentary attempts to address it many years ago and the fact it has been obvious for so long, leads me to believe that the embedded norms that perpetuate over-incarceration are akin to sedimentary rock, nearly foundational to the legal system's process.

Canada has long used criminal law and incarceration to pursue colonialism, and to assault Indigenous peoples on two fronts: suppression of Indigenous political will and suppression of Indigenous culture (i.e., forced assimilation).[14] Regarding political will, the colonial lens has sanctioned the political use of criminal law in strategic instances to secure Canada's political domination, as in the decision to showcase the might of the Canadian state through the mass public hanging in Battleford, Saskatchewan, in 1885, in which eight Indigenous men were hanged for their participation in the North-West Resistance.[15] Criminal law has also been used as a political tool for removing Indigenous leadership: in 1885, pīhtikwahānapiwiyin (Chief Poundmaker), a Cree leader who was a signatory to Treaty 6, was targeted by the Canadian government.[16] In a move designed to intimidate Indigenous Nations and remove an important leader, pīhtikwahānapiwiyin was falsely accused and convicted of treason for alleged collaboration with Louis Riel in the North-West Resistance. pīhtikwahānapiwiyin was imprisoned in the Stoney

Mountain penitentiary where he later died. Today, Canada's engagement of criminal law, policing, and incarceration as means to supress Indigenous political will and assert Canadian state power remain a manifestation of the role of the colonial lens in the legal system.[17]

Canada also used criminal law, including its courts and police, to force cultural assimilation upon Indigenous persons, including through the *Indian Act* and the Indian Residential Schools. Since Canada's colonial displacement of Indigenous peoples is based on the precept that Indigenous peoples are "savage" compared to "civilized" Anglo-Europeans who are entitled to use the land "properly," the enforcement of criminal law against Indigenous peoples was preoccupied with punishing Indigenous peoples for their very status as Indigenous peoples, with cultures that were different from Anglo-Europeans. The starting place for criminal law process, and indeed broader Canadian legal process, was that Indigenous peoples were inherently savage threats to Canada. As geographer Madelaine Jacobs describes:

> The disproportionate incarceration of indigenous peoples in Canada is far more than a socioeconomic legacy of colonialism. The Department of Indian Affairs (DIA) espoused incarceration as a strategic instrument of assimilation. Colonial consciousness could not reconcile evolving indigenous identities with projects of state formation founded on the epistemological invention of populating idle land with productive European settlements. The 1876 *Indian Act* instilled a stubborn, albeit false, categorization deep within the structures of the Canadian state: "Indian," ward of the state. From "Indian" classification conferred at birth, the legal guardianship of the state was so far-reaching as to make it akin to the control of incarcerated inmates. As early iterations of the DIA sought to enforce the

legal dominion of the state, "Indians" were quarantined on reserves until they could be purged of indigenous identities that challenged colonial hegemony.... Adults and children deemed noncompliant to state laws were coerced through incarceration.[18]

In addition to the abilities of regular courts and police, as well as the distinctly colonial role of the North-West Mounted Police and RCMP to enforce Indigenous civilization and containment,[19] Canada also granted Indian Agents the power to incarcerate Indigenous persons with little reporting or oversight and to impose control, under the Pass System, over their basic ability to leave the reserve. Beginning in 1881, Indian Agents were empowered by statute to serve as justices of the peace with wide-ranging powers to enforce the *Indian Act*, including use of imprisonment.[20] Canadian law cloaked Indian Agents with judicial powers to conduct trials related to enforcement of the *Indian Act* (including alcohol rules), as well as jurisdiction over criminal offences specific to "Indians," including "Indian prostitution," vagrancy, or riotous conduct in groups of three or more.[21] Jails or lock-ups were built on reserve, and Indian Agents at times had a pecuniary interest in fines received.[22] The Indian Agent's judicial rulings were not reported or commonly reviewed.[23] As summarized in the 1991 report of the Aboriginal Justice Inquiry of Manitoba:

> All Indian agents automatically were granted judicial authority to buttress their other powers, with the result that they *not only could lodge a complaint with the police, but they could direct that a prosecution be conducted and then sit in judgment of it.* Except as accused, Aboriginal people were excluded totally from the process.
>
> The clear result of all this development was that Indian agents were armed with broad power over almost every aspect of Indian life.

• COURTS AS THE GATEWAY TO INDIGENOUS OVER-INCARCERATION •

They presided at all Indian council meetings and virtually directed local decisions. As agents and as justices of the peace, they presided over the enforcement of laws in relation to: trespass to reserve lands; removal of renewable and non-renewable resources; sale or purchase of farm produce; logging; non-payment of rent; seizure of goods; band council by-laws; actions in debt, tort or contract; private purchase of Crown presents to Indians; *intoxication offences*; *common bawdy houses*; *celebrating a Potlatch or Tamanawas*; inciting Indians to make riotous demands or breach the peace; pursuing land claims or raising funds for that purpose; sale of ammunition to Indians when prohibited by the superintendent general; and regulating Indians in obtaining homesteads in Manitoba, the North-West Territories and the Keewatin District.[24]

It is, however, beyond the scope of this chapter or even this book to examine the full invasiveness of Canadian statute and practice in controlling Indigenous peoples' freedoms. Extensive statutory law[25] and recorded state practices show Canada monitoring everything from Indigenous persons' family relations, property and succession, economic freedoms, mobility rights, and political structures to their spirituality.[26]

A hallmark of this control, perhaps unsurprisingly, was broad statutory basis and expansive discretionary powers for Indigenous incarceration. For instance, Anglo-European settlers did not have to worry that consuming or possessing alcohol would lead to immediate imprisonment, whereas Indigenous persons did.[27] Settlers did not have their basic mobility restricted by the power of Indian Agents to issue or deny "passes," with vagrancy laws and incarceration used to contain persons found without a pass, whereas Indigenous persons did.[28] Indigenous people faced jail even for the practice of their own cultural ceremonies.[29]

It was also illegal for an Indigenous parent to resist the abduction of one's child to residential school, with a fine and/or imprisonment resulting.[30] Providing an extra level of subjugation by the Canadian legal system, it was also illegal for an Indigenous person to hire a lawyer to make a claim against the state.[31] There was even differential targeting of Indigenous vs. settler women through the criminal law since, as Carter summarizes: "Separate legislation under the Indian Act and, after 1892, under the Criminal Code governed Aboriginal prostitution, making it easier to convict Aboriginal women than other women."[32] This legislation supported equating Indigenous women with prostitutes in law and practice, consistent with the stereotyping discussed in the previous chapter.

As Harold R. Johnson underscores in *Firewater*, many Indigenous leaders, including those who negotiated Treaty 6 in what is now Saskatchewan and Alberta, did not want the destabilizing force of alcohol in their communities and had insisted on a ban of alcohol sale therein in their treaty relations with the Crown.[33] But the Crown quickly twisted its legal obligation not to allow the selling of alcohol into a rationale for incarcerating Indigenous persons, placing criminality on any Indigenous person with proximity to alcohol possession or consumption.

Similarly, instead of negatively sanctioning those who abused Indigenous women sexually, criminality was pinned on Indigenous women themselves. This included the low-threshold prostitution legislation mentioned above, which was still present in the Criminal Code as of 1944 and likely until the major revision of the Code in 1953–54;[34] law and practice permitted mass policing and jailing of Indigenous women as "prostitutes." This label then justified these women's dehumanization both within the legal system and without.

The colonial legal system thus creates oppressive but easily applied criminal categories for Indigenous persons (like "whore," vagrant, or

"drunken Indian"), and then punishes Indigenous persons according to the criminal categories that it has created for them. Criminal law is a trap set for Indigenous persons; it contains denigrating definitions for them that they are unwillingly forced into, resulting in incarceration, coercion, and degradation.

In sum, since Canadian authorities were intent on establishing that Indigenous persons were not only "savages," but generally criminals too, Canadian law included expectations that labels of criminality could be put on Indigenous persons with ease, lack of accountability, and lack of challenge by the Indigenous persons affected, who were generally disempowered by this legal system, without lawyers or indeed much money.

This selective criminalization of Indigenous persons in law and in practice, as compared with non-Indigenous persons, was combined with excessive attention to Indigenous conduct by the police,[35] courts, and Indian Agents, resulting in the over-imprisonment of Indigenous persons. Tim Quigley's research describing the cyclical connection between policing and criminalization was cited in *R v. Gladue*:

> When more police are assigned to detachments where there is high Aboriginal population, their added presence will most assuredly detect more criminal activity. For crime is everywhere and all of us, at some time in our lives, commit it, whether it is "borrowing" our employer's pen for use at home, driving while impaired, use of soft drugs, etc. *What differs is the detection rate and that is largely a function of policing.*[36]

The surveillance of Indigenous persons by the police and the courts, and associated over-incarceration, is observable in the Saskatchewan context. Pre-1945 incarceration statistics put the Indigenous prison population at about 5 percent for males and 20 percent for females in

Saskatchewan.[37] However, by 1968–69, jail admissions statistics were 52.2 percent Indigenous prisoners for males and 92 percent Indigenous for females.[38]

Writing in 1981, Skinner et al. state that "This marked increase in incarceration of Indian and Metis people may be due to a number of factors such as: their changed lifestyle—increased access to alcohol, the rural-urban migration; increased police surveillance and efficiency; and changes in legislation."[39] Razack has noted how crowded conditions on reserves led to increased inward migration to Western Canadian cities in the 1960s, with friction between the police and Indigenous persons occurring in the context of attempts to exclude Indigenous persons from the "white" space of the city.[40] (Prior to World War II, the Pass System also kept most Indigenous persons in the region confined to their reserves.)

Perhaps the most compelling explanation for post–World War II Indigenous over-incarceration is given by Madeline Jacobs, who notes that over-incarceration coincides with the diminishing role of the Indian Agent in scrutinizing criminality and controlling Indigenous life: "The burgeoning proportion of Aboriginal inmates in federal and provincial prisons in the second half of the twentieth century and in recent years is not, in a strict sense, a new phenomenon. The overrepresentation of Aboriginal persons in provincial and federal correctional systems is, to a certain extent, *a relocation of incarceration from the purviews of individual Indian Agents into more centralized institutions.*"[41]

Indigenous over-incarceration in jails today is more accurately a relocation of previously less visible over-incarceration on reserves and in reserve lockups. It originates the control of Indigenous persons through criminal law today in the control of Indigenous persons through the criminal/colonial law enforcement jurisdiction of the Canadian state exercised by Indian Agents, courts, and police, in their suppression of

Indigeneity and their vigilance against Indigenous persons as purported threats to the settler state. The stereotypes of Indigenous criminality that Canada created for colonial purposes in its legal system, which drove over-incarceration on reserves and in reserve lockups, continue their reiteration in the legal system, driving Indigenous over-incarceration in jails presently.

Statutory changes regarding offences specific to Indians began to occur after World War II. For instance, the "Indian Prostitution" offence discussed above was not included in the Criminal Code after the major revision in the early 1950s. Also, provisions which made possession of alcohol an offence for Indigenous persons were struck down by the SCC in 1970 in *Drybones*.[42] Ten years earlier in 1960, the province of Saskatchewan under Tommy Douglas had elected to legalize Indigenous possession and consumption of alcohol—the only province to do so, and with public controversy resulting.[43] The need for reform was made obvious by the discrimination faced by Indigenous veterans of World War II. These persons had put their lives on the line for Canada, but they were barred from Legion Halls due to alcohol laws.[44]

While most discriminatory provisions on alcohol were no longer on the books after these changes, discriminatory attitudes and expectations continued within the legal system. Instead of enforcing Indigenous-specific alcohol provisions, police and courts applied generally applicable statutory law disproportionately against Indigenous persons, such as the offence of public drunkenness. Inertia meant that category of the "drunken Indian" (requiring containment) remained an effective norm in the legal system's expectations, even though the written law had changed. The colonial lens, which expects that an Indigenous person is readily seen as a criminal in law, lived on in the discriminatory application of generally applicable law.

Once we understand the legal system's acts as expressions of expectations, it becomes easy to see instances of inertia in the system where expectations do not change as quickly as one might expect. Once entrenched, it can be difficult or comparatively costly to break from shared expectations that are operating in a particular part of the legal system. This is path dependency in action. Wrongful conviction cases, for instance, display examples of "tunnel vision" on the part of police and other actors; where once a person is conceptualized as guilty, authorities cling to this expectation and act according to it even in the face of exonerating evidence.[45] It can become easier to maintain the guilt of someone who is innocent, rather than to incur the costs to yourself (including time and reputation) that exoneration, a diversion from the established path, would entail.

System inertia remains today for Indigenous persons encountering the Canadian legal system. Path dependencies long established are costly to disrupt, requiring openness and intention to change, and investment of resources such as in education programs and/or adopting shifts in operating methods and protocol.

Due to system inertia, even though Indigenous persons are legally allowed to drink, the triggering label of the "drunken Indian" remains in the legal system. Expectations remain in the system today that it is unacceptable for Indigenous persons to consume alcohol and not face containment by the legal system, while there is not the same expectation for Anglo-European persons, who are perceived as inherently less of a societal threat.[46] The inertia's continuance is not just a question of whether individual officials in the system remain racist; it is a question of whether or not a critical mass of decision-makers in the system become overtly *not* racist (i.e., anti-racist) so as to change the shared expectations of what the law is vis-à-vis race away from its earlier form.[47] Silence is

acquiescence to racist norms continuing in the system; the old norms remain in effect in the areas of the legal system where the norms continue to be commonly expected among actors.

I return now to observe Indigenous criminalization and incarceration in the Saskatchewan context, where the impact of historical criminalization of Indigenous alcohol consumption is clear. Recall that by 1968–69, Saskatchewan admissions statistics to jail were 52.2 percent Indigenous for male prisoners and 92 percent Indigenous for female prisoners.[48] Skinner and et al. present a breakdown of the offences which most commonly led to incarceration in Saskatchewan between 1969 and 1974: "The most common offences for males appear to be theft, offences against the Liquor Act, the Vehicles Act, and driving offences. Similarly, for females the most common offences are the offences against the Liquor Act, the Vehicles Act, and driving offences. A large proportion of offences against the Vehicles Act and driving offences are liquor-related. *Thus liquor-related offences constitute a high proportion of offences for which individuals are incarcerated.*"[49] Skinner et al. also note that a huge proportion of people—in 1972–73, 50 percent of male admissions and 70.3 percent of female admissions— were jailed simply because of fines owed.[50]

Writing in 1994, Tim Quigley observes the evident pattern of alcohol provision enforcement leading to disproportionate Indigenous incarceration: "Consider, for instance, the provincial offence of being intoxicated in a public place. The police rarely arrest whites for being intoxicated in public. No wonder there is resentment on the part of Aboriginal people arrested simply for being intoxicated. This situation very often results in an Aboriginal person being charged with obstruction, resisting arrest or assaulting a peace officer. An almost inevitable consequence is incarceration, either as the immediate sentence upon conviction or upon default of payment of a fine. *Yet the whole sequence of events is, at least to some extent,*

a product of policing criteria that include race as a factor and selective enforcement of the law."[51]

The data presented here is Saskatchewan-based, but the long-standing phenomenon of discriminatory policing and jailing of Indigenous persons, including in the context of alcohol consumption, is Canada-wide. It is a key part of the cycle of over-incarceration and relates to the colonial system's construction of Indigenous persons as being threatening "savages" requiring ready containment, as compared with whites who are for instance able to drink more freely, without ready targeting according to legal system norms.

Based initially in statute that discriminated according to race, practice has continued in the legal system such that an Indigenous person is readily interpreted by system expectations including the "drunken Indian" as being due for entry into the justice system.[52] In addition to the "drunken Indian" stereotype in the law is the stereotype of Indigenous women discussed above which readily casts them as criminalized "prostitutes" often with implied substance abuse problems. Rather than perceiving the role of the court as being the source of an individualized assessment of the accused or a course of action that could rehabilitate, the automatic reflex of the court operating according to colonial lens expectations is to incarcerate Indigenous persons, since these persons are seen primarily as uncivilized transgressors (e.g., "drunks" and "whores") due for containment in jail as a matter of course.

In the light of this continual surveillance of Indigenous persons, it is unsurprising that an RCMP officer asked Colten Boushie's mother in her own home if she had been drinking when he informed her of her son's death.[53] In contrast, it is unfathomable that a police officer would interrogate a white mother in this fashion while informing her as next of kin that her son had just died. In this case, the RCMP also showed its

criminalizing expectations towards Indigenous persons when personnel issued a press release immediately after the shooting which framed it as having happened in the context of a "related theft investigation."[54]

To summarize, when seen through a colonial lens Indigenous persons are "savages" who, if they stray from the bounds of colonial legality constructed for them, are also criminals due for additional containment. The role created for "Indians" by law in Canada was one of containment on reserves and relegation to economic marginalization. If Indigenous persons transgressed these rules, then the full force of coercive Canadian law was upon them to put them back in their place within civilized society. Jail's role was supposedly to further the "civilizing" of Indigenous persons; however, this was not the immediately anticipated result of incarceration. The way for Indigenous persons to become "civilized" through the *Indian Act* was rather by marrying out (for women) or by "enfranchisement" (a renunciation of Indian status that required meeting certain thresholds of conduct, such as education, and included a probation period in some circumstances).[55] Jail's "civilizing" goal was thus only indirectly pursued in practice as compared with the more obvious goals of punishment, containment, and erasure. The purported ultimately beneficial effect of jail in "civilizing" Indigenous persons is still echoed today, however, when jail is problematically presented as a place of Indigenous healing and of access to rehabilitative programs;[56] research suggests rather that jail is a stressful and damaging environment, more consistent with punishment objectives than healing.[57]

A historical review suggests that in order to establish grounds for coercion and containment of Indigenous peoples, the Canadian legal system created through legislation and practice easily applied and race-specific labels of criminality for Indigenous peoples. These included such crimes as practicing their culture, or trying to stop the abduction of their

children by the Canadian state. The system also ensured that many different types of Canadian authorities had coercive power and were enabled to apply these labels and ensure incarceration as needed.

As the foregoing discussion suggests, the first colonial lens norm attached to the spatial category of the Canadian court when it encounters an Indigenous accused is: "savages" appearing in court are to be sent to jail for infractions of civilized law because they are threats to civilized Canadian society and require additional containment. Custody is a given. They go to jail to be contained as "uncivilized"; importantly, they also go to jail subject to potential erasure, perceived as "dying Indians" not entitled to assistance and even unfit for the modern world.

FAILURE TO ADDRESS OVER-INCARCERATION: COLONIALISM IS NEVER (LEGALLY) WRONG

The second colonial lens norm embedded in the spatial category of the criminal courtroom is the court's necessary denial of Canada's guilt towards Indigenous persons. This blocks courts from perceiving an Indigenous accused as being someone who has been gravely wronged by Canada. Courts are blinkered from recognizing that an Indigenous accused may well have been less likely to act in an illegal way had Canada not enacted severe violence towards him or her as a child (and/or towards his or her parents as children, and towards his or her grandparents and great-grandparents, and so on). The courtroom is understood to be defined as a place where Canada gets a free pass in criminal law for its conduct towards Indigenous peoples. Canada is never on trial for crimes against Indigenous peoples.

In order for Canada's culpability in its treatment of Indigenous persons to be recognized in Canadian courtrooms, colonialism's injustice

itself would have to be recognized by courtrooms. The basic fact that Canada is a settler colonial state that has treated Indigenous peoples appallingly is still not broadly acknowledged in the Canadian legal system; furthermore, to the extent that it is acknowledged, colonialism's injustices are only moral failings with associated emotionality but without system-level norms that denounce colonial conduct as actually "illegal" within the system.

To allow Canada's culpability to be acknowledged in the courtroom would require system-level determination that the residential schools (and other acts) were legally wrong, even extending to a level of criminal immorality, worthy of consideration alongside the criminal law rules faced by persons who are accused in the courtroom. However, such a system-level recognition would imply that Canada is not "superior" to Indigenous Nations, and that savagery is myth. Without the notion of savagery and Canada's supposed inherent superiority, seizing Indigenous peoples' lands would no longer be justified by the colonizers' "civilized" ways. This would then require that non-Indigenous persons face the responsibility of benefiting from the theft of land and resources. Thus deep colonial rationalizations continue to be at play which rely on and support the implicit use of the "savage" stereotype in court, give the wrongfulness of Canada's actions no legal weight, and entrench the path dependency of routine recourse to incarceration for Indigenous persons.

Canada's use of criminal law as a tool to oppress Indigenous peoples is described by Heidi Kiiwetinepinesiik Stark, who identifies how this criminalization of Indigenous agency is a purposeful distraction from the obvious illegality of Canada's conduct.[58] She notes that the manufacturing and projection of the "criminality" of Indigenous peoples, by Canada and its state organs like the courts and the police, happens simultaneous with the illegality of Canada's conduct vis-à-vis its treaties with

Indigenous nations.[59] Canada, or the British Crown, negotiated treaties with First Nations leaders, on the supposed understanding of mutual respect. Simultaneously with this treaty-making, however, Canadian officials were drafting the *Indian Act, 1876* which deeply subjugated Indigenous peoples and forced internal changes to Indigenous leadership structure, including installation of the heteropatriarchal systems of domination in effect in Victorian England, which had hitherto not been part of Indigenous social systems.[60]

Canada sought to obtain the land through treaty and recognition of Indigenous nationhood, since one cannot make treaties without reciprocity. But when Canada then breached the treaties, it asserted that the Indigenous nations were the criminals, at fault in (Canadian) law. It also denied the nationhood of the Indigenous peoples with whom it had made treaties. First Nations were recognized as nations for the purposes of negotiation, but then they were not nations who could have internal power and jurisdiction. Instead, Canada constructed them as masses of criminals (applying the *Indian Act* and then the Criminal Code) with incarceration the main means of processing and containing them.

The legal system's reluctance to acknowledge Canada's wrongdoing vis-à-vis Indigenous peoples is thus closely connected to the colonial narrative of a justly created Canada. Increasing over-incarceration of Indigenous persons is strongly related to this reticence to acknowledge wrongdoing. The expectation that the criminal Indigenous "savage" requires jail is not changing because it is buttressed by the second embedded norm which maintains that Canada is perpetually innocent. This norm ensures that Canada's illegality towards Indigenous persons is never to be acknowledged or given legal weight.

The inability of the legal system to stop (and indeed its acceleration of) the over-incarceration of Indigenous persons is all the more striking

considering it was over twenty years ago in 1999 in *Gladue* that the scc termed this phenomenon a "crisis":

> The figures are stark and reflect what may fairly be termed a crisis in the Canadian criminal justice system. The drastic overrepresentation of aboriginal peoples within both the Canadian prison population and the criminal justice system reveals a sad and pressing social problem. It is reasonable to assume that Parliament, in singling out aboriginal offenders for distinct sentencing treatment in s. 718.2(e), intended to attempt to redress this social problem to some degree. The provision may properly be seen as Parliament's direction to members of the judiciary to inquire into the causes of the problem and to endeavour to remedy it, to the extent that a remedy is possible through the sentencing process.[61]

In 1995, four years earlier, Parliament had amended the Criminal Code in response to the systemic over-incarceration of Indigenous persons.[62] The new Code provision, section 718.2(e), was authoritatively interpreted by the scc in *Gladue* above and in *R v. Ipeelee* in 2012. In the latter case the Court explained:

> The Court [in *Gladue*] held, therefore, that s. 718.2(e) of the Code is a remedial provision designed to ameliorate the serious problem of overrepresentation of Aboriginal people in Canadian prisons, and to encourage sentencing judges to have recourse to a restorative approach to sentencing (*Gladue*, at para. 93). *It does more than affirm existing principles of sentencing; it calls upon judges to use a different method of analysis in determining a fit sentence for Aboriginal offenders* [emphasis added]. Section 718.2(e) directs sentencing judges to pay particular

attention to the circumstances of Aboriginal offenders because those circumstances are unique and different from those of non-Aboriginal offenders (*Gladue*, at para. 37). When sentencing an Aboriginal offender, *a judge must consider* [emphasis in original]: (a) the unique systemic or background factors which may have played a part in bringing the particular Aboriginal offender before the courts; and (b) the types of sentencing procedures and sanctions which may be appropriate in the circumstances for the offender because of his or her particular Aboriginal heritage or connection (*Gladue*, at para. 66).[63]

This is strong language from the SCC: it places an obligation on sentencing judges to consider systemic or background factors and appropriate sanctions for an offender. This approach is justified because Indigenous persons are in a different position when sentenced as compared with a non-Indigenous person, as the SCC stated in *Gladue*: "It must be recognized that the circumstances of aboriginal offenders differ from those of the majority because many aboriginal people are victims of systemic and direct discrimination, many suffer the legacy of dislocation, and many are substantially affected by poor social and economic conditions."[64]

The urgent need to reduce Indigenous over-incarceration can be stated from on high in fine language from the SCC, but the legal system's unresponsiveness is writ large and sentencing judges are still sending Indigenous persons to jail in disproportionate numbers, indeed at increasing rates.[65] The foundational expectations of the legal system, expressed by judges, lawyers, and others, have not changed, regardless of Ipeelee and *Gladue*.

The strong language of the SCC becomes watered down as it trickles through the court hierarchy. Colonial lens norms still in effect in courts influence the flow of judicial decision-making. Compare the SCC

assertion in 2011 that section 718.2(e) "*does more than affirm existing principles of sentencing; it calls upon judges to use a different method of analysis* in determining a fit sentence for Aboriginal offenders"[66] with the words of the SKCA in 2015: "Thus, while s. 718.2(e), as interpreted by *Gladue* and *Ipeelee*, mandates a particular kind of analysis when sentencing an Aboriginal offender, *it does not create a wholly new sentencing paradigm*. Sentencing judges must attempt to give meaningful effect to the remedial purpose of s. 718.2(e) and must be highly alert to the *ongoing problem* represented by the troubling incarceration rates of Aboriginal people."[67]

The SKCA here frames over-incarceration as a mere "ongoing problem," not a "crisis," and communicates expectations to other Saskatchewan courts that the status quo approach to sentencing remains. In the same decision, the SKCA also emphasizes Indigenous maltreatment of Indigenous individuals, without acknowledging any culpability of the Crown in its treatment of Indigenous persons: "note that this means a sentencing judge must attempt to understand not just the situation and background of the offender and the particulars of the crime in issue. He or she must also, to the extent reasonably possible, attempt to understand the relevant dynamics of the community and the circumstances of the victim. After all, *the victims of crimes committed by Aboriginal offenders are all too frequently other Aboriginals*, often ones with precisely the same *Gladue* backgrounds as the offenders."[68]

The legal system's steadfast support of Canada's beneficence undermines its ability to actually complete the reasoning mandated in *Ipeelee*. This case explains that "systemic and background factors *may bear on the culpability of the offender*, to the extent that they shed light on his or her level of moral blameworthiness."[69] Yet in order to accept that an Indigenous person's moral culpability is possibly reduced by systemic and background factors related to colonialism, judges would have to

acknowledge and accept the implication that the accused's culpability is *lessened* because some of it actually belongs elsewhere: with the Canadian state. For *Gladue* and section 718.2(e) to actually affect a judge's ascertainment of moral culpability, there has to be a possibility of seeing that part of what the accused person did is not their fault.

For systemic or background factors to mitigate moral culpability, the legal system thus has to provide for the conceptual possibility that some of the Indigenous person's moral blameworthiness does not belong to him or her, notwithstanding that the Crown is then implicated in the blame, for what the Crown did to Indigenous persons. Instead of facing this, the blameworthiness of Canada is denied in courts all across Canada, including the one in which Jacquie was sentenced.

JACQUIE AND YURI'S SENTENCING: DENYING RESIDENTIAL SCHOOL TRAUMA AND IGNORING NON-CUSTODIAL OPTIONS

Jacquie's initial sentence is instructive in showing how judges and lawyers are still deeply hostile to the basic premises of *Gladue* sentencing nearly thirty years after this landmark case. There is resistance to acknowledging the mere existence of Indigenous systemic and background factors, let alone these factors' bearing on moral culpability or their direction towards appropriate non-custodial sentencing options.

The Judge rejected that Jacquie's *Gladue* factors were relevant to her moral culpability or to a non-custodial sentence because he neatly erased the entire existence of these systemic and background factors in his reasoning. These factors were negated by the fact that Jacquie had taken some college classes. The Judge held, "[A]lthough there is intergenerational issues, and those continued with her, she—those resources allowed her to obtain her post-secondary education."

This is quite a jump in logic, but what is happening here is twofold. First, the Judge is exonerating Canada for the violence it committed against Jacquie and her family because Canada is assumed to have somehow provided her with resources for education. Canada has thus *removed the trauma* by paying for education. There is no blame remaining on Canada because Jacquie was able to take college classes, likely (according to stereotype) on Canada's dime. Canada has already done enough for Jacquie, there is thus no blame on Canada, and Jacquie must hold all the blame for what she did. *Gladue* sentencing provisions are thus rendered irrelevant to addressing over-incarceration, because obvious factors including residential school impact are seen as not affecting moral culpability because they are neutralized or absolved by Canada's subsequent conduct. In fact, these *Gladue* factors, by his reasoning, do not even exist after Canada's presumed education payments, and are not relevant as grounds for considering alternative sentencing.

The second aspect of the Judge's rationale is as follows: an Indigenous woman who takes college classes is as whole as she can be, proving that she actually *has no trauma today* from Canada's conduct. This racist construction of an Indigenous woman is unfair and paints her as a "savage." It assumes that the achievement of taking college classes represents the full realization of an Indigenous woman's personhood. Would it be the same to assume that a non-Indigenous person had not suffered trauma simply because they took college classes? Should no college- or university-educated Indigenous person be entitled to redress from Canada simply because they have already received enough and are presumably whole? By the reasoning of this Judge, university- or college-educated persons would not have any demonstrable trauma worthy of remedy or consideration. Since the judge views the trauma as nonexistent, the background and systemic factors are therefore also not seen

to exist, and there is no need to consider the effects of such factors on moral culpability or on appropriate sentencing.

In Jacquie's case, the Judge utterly failed to complete the full analysis mandated by Criminal Code section 718.2(e), as interpreted in *Ipeelee*, in which the SCC obliges the following: "When sentencing an Aboriginal offender, a judge must consider: (a) the unique systemic or background factors which may have played a part in bringing the particular Aboriginal offender before the courts; and (b) the types of sentencing procedures and sanctions which may be appropriate in the circumstances for the offender because of his or her particular Aboriginal heritage or connection."[70]

I think it's vital here to reproduce in full the relevant portion of the transcript of the reasons for Jacquie's sentence to see how this was done:

> THE COURT: ... There's been intergenerational abuse, starting with the residential schools. And that's resulted in intergenerational abuse of alcohol and inability to raise their children. This resulted in her leaving her home at 15 and having difficult relationships of her own, and abuse of alcohol and drugs.
>
> However, she did have sufficient resources to get back on track and obtain her grade 12 and some post-secondary education; and, further, employment with that education before she lapsed back into alcohol and drugs. The counsel for the accused has brought to the court's attention the decision of *Ipeelee* and the—and the aspects of *Ipeelee* that apply. And the Supreme Court in *Ipeelee* affirmed and expanded on their decision in *Gladue* and held that:
>
>> When sentencing an Aboriginal offender, courts must take judicial notice of such matters as the history of colonialism, displacement,

residential schools and how that history continues to translate into lower educational attainment, lower incomes, higher unemployment, higher rates of substance abuse and suicide, and higher levels of incarceration for Aboriginal peoples.

In this case, I—I don't need to take—well, in this case, in addition to taking judicial notice of that, I have, in fact, information that I've just pointed to regarding the Gladue effect on her [emphasis added]. The court goes on to indicate that:

These matters provide necessary context for understanding and evaluating the case-specific information presented by counsel. These matters on their own speak to sentence; however, they do not necessarily justify a different sentence for Aboriginal offenders.

Saskatchewan Court of Appeal in *Slippery*, in 2015, made comments about the sentencing after *Ipeelee* and indicate that:

...a judge's sentence inquiry into "the degree of responsibility" of an Aboriginal offender, under 718 of the Criminal Code, must not end with a consideration of the systemic and background factors noted in *Gladue*. Those factors may be relevant to the question of an offender's responsibility but they are not determinative of it. Rather, a sentencing judge must consider and weigh all factors that might bear on an offender's degree or level of responsibility before reaching a conclusion on that point.

They indicate that:

Systemic and background factors are—are not the only considerations which are relevant in determining an offender's blameworthiness. The sorts of factors that normally come into play on this front remain relevant to the assessment of the culpability of a—of an Aboriginal offender. The circumstances of such an offender "which could reasonably and justifiably impact on the sentence imposed" may speak to his or her moral culpability to an extent which would lead to a different sort of sentence than what might normally be imposed for the same offence. There is no invariable rule on this front (as indicated in *Ipeelee* at paragraph 171). Sentences have to be determined on a case-by-case basis taking into account all relevant considerations.

Courts are not simply to:

> ...stack up all of the *Gladue*-type considerations... and, if the list is long or severe, automatically proceed on the assumption that some—those factors have had a substantial limiting effect on the offender's culpability.

And, as I pointed out the—she—although there is intergenerational issues, and those continued with her, she—those resources allowed her to obtain her post secondary education. I must also look at the law in relation to sentencing. The law is through Section 718, and also through the cases.

The Judge in Jacquie's sentencing then concludes: "In this particular case I find, given all the circumstances that I've mentioned, including the aggravating factors, the mitigating factors, the factors I will call neutral

factors and the *Gladue* factors, that the moral culpability of this accused is still high." To reiterate: the fact that Jacquie had finished high school, attended some post-secondary classes, and been employed was evidence that *no other factor in her life related to her experiences as an intergenerational survivor of residential schools had relevance.*

Investigating the SKCA decisions the Judge relied upon yields some interesting results. First, the language in the quote beginning "Systemic and background factors are—are not the only considerations which are relevant in determining an offender's blameworthiness" is actually from the SKCA in *R v. Chanalquay*, cited in *R v. Slippery*, as is the subsequent quote about not stacking up considerations. What is striking about the sentencing Judge's reference to the "stacking" quote is how condensed it is. In addition to the omissions indicated by ellipses, the sentencing Judge quoted part of one sentence from *Chanalquay*, but omitted five sentences that followed:

> [52] A sentencing judge should not simply stack up all of the *Gladue*-type considerations at play in a case and, if the list is long or severe, automatically proceed on the assumption such factors have had a substantial limiting effect on the offender's culpability. The required analysis is more demanding than that. To determine the extent to which *Gladue* factors impact on an offender's moral culpability, a sentencing judge must examine both the nature of the relevant factors and the particulars of the crime in issue. He or she should then consider the extent to which the unique circumstances of the offender "bear on his or her culpability" (*Ipeelee* at para. 83) in the specific context of the case at hand. As mandated by the Supreme Court, the search here is not for a cause-and-effect relationship but for circumstances that cast light on the degree of the offender's blameworthiness for the specific

offence in issue. It might be that the *Gladue* considerations impact the offender's culpability a great deal, not at all, or only to some intermediate extent.[71]

The sentencing Judge at no point considered the *Gladue* factors "at play in" Jacquie's case, nor did he consider "both the nature of the relevant factors and the particulars of the crime at issue." He made no connection between the *Gladue* factors (including residential school impact and childhood dislocation) and the crime at issue (stealing alcohol while impaired). He entirely side-stepped the required analysis by immediately pointing to her college classes as somehow erasing the very existence of Jacquie's *Gladue* background and systemic factors. As noted above, the factors were no longer a live issue because, for one thing, Canada had already "compensated" Jacquie by providing resources for her education, and for another, Jacquie obviously had no trauma, since she had taken college classes. By straightaway erasing the factors, he also erased their potential relevance to Jacquie's moral culpability and erased his own obligation to consider a sentence appropriate given her heritage, including the secure treatment centre, intermittent custody, or non-custodial options before him.

Until courts and all actors in the legal system are able to recognize the ignobility and guilt of Canada, for violence and intergenerational injury committed through the residential schools and other acts of discrimination, rather than reflectively erase Canada's culpability by reliance on colonial lens rationales (such as the one which holds that college classes cancel-out *Gladue* factors), *Gladue* sentencing as mandated by the SCC cannot occur and over-incarceration will continue.

Courts cannot adequately engage in *Gladue* analysis, including its imperative to consider "the unique systemic or background factors which

may have played a part in bringing the particular Aboriginal offender before the courts" when there is a pervasive contrary norm that is widely circulating in the legal system and society at large that is blocking courts from even perceiving these systemic or background factors from existing. This "blocking" norm is the stubborn insistence that Canada's colonialism is not wrong. Simply put, it is denial. This norm negates the conceptual possibility of ever acknowledging Canada's blame in a substantial way in the courtroom.

As long as it is assumed that Canada is at root legally blameless for everything it has done to Indigenous peoples, Indigenous persons' injuries will be habitually ignored in Canadian courts. They will be sentenced according to the "normal" offender profile of a non-Indigenous person, or more accurately where colonial lens norms are in effect, according to the profile of a "savage" Indigenous person who requires jail and to whom Canada owes nothing. Without a meaningful *Gladue* process, sentencing factors will continue to reflect only what makes the Indigenous person a criminal, not what Canada does and did to Indigenous persons.

The criminal court paradigm treats the accused as a rational, conscious, and deliberate actor in the crime at issue. It is awkward in this setting to consider that the Crown has any responsibility for Indigenous criminality. A practical approach, therefore, is the use of the victim–criminal continuum for judges to assess the moral culpability of the accused, an approach outlined by Elspeth Kaiser-Derrick in *Implicating the System*.[72] This approach leaves the accused's victimhood in substantial vagueness (i.e., does not point the finger directly at Canada) and so does not directly implicate Canada's guilt. It is therefore less likely to hit the wall of colonial denial in legal reasoning that is endemic in the legal system, allowing the "systemic and background factors" to be abstracted from their specific colonial authority perpetrators. Another approach

that may sidestep the norm of denial is reliance on the principle of proportionality as a means to acknowledge and consider state misconduct in the context of sentencing.[73]

Indigenous over-incarceration is increasing because of denial that Canada has used and continues to use criminal law improperly and unfairly against Indigenous peoples, and because of the minimization of the fact that Canada has mistreated Indigenous peoples through forced residential schools and other horrendous policies. Courts are approaching *Gladue* as if it is a way to give Indigenous persons "special treatment" rather than acknowledging that this is rather a remedy towards fixing how Indigenous persons' treatment is below the "level playing field" of the law experienced by many non-Indigenous persons, in terms of intergenerational trauma, and in terms of discrimination, including in over-policing and sentencing bias.[74]

A central problem of the legacy of the residential schools and its consideration in sentencing (and over-incarceration) is that *Gladue* factors are framed as only mitigation of Indigenous criminality and not as connected to any legal wrong on the part of the Canadian state or its legal system. There has never been a criminal finding against the Canadian state, acknowledged within the Canadian legal system, for residential schools or for other wrongs against Indigenous persons. (The structure of the Canadian legal system would apparently not even permit a criminal determination to be made within the domestic legal system, considering that the style of cause would be *R v. R*; there has not been any international law court determination of Canada's criminal wrongfulness in this regard either.) The character of the Independent Assessment Process of the Indian Residential School Settlement Agreement is civil settlement only.[75] Canada has furthermore fought tooth and nail against having to pay compensation as ordered by the Canadian Human Rights Tribunal.[76]

For their part, publicly funded commissions like the TRC chronicle events, but their allocation of blame is empty of legal repercussions.

Indeed, a key criticism of commissions is that they appear to process Canada's actions without mandating or realizing actual change within the legal system. Regarding the Royal Commission on Aboriginal Peoples, Mohawk anthropologist Audra Simpson observes, "Numbering five volumes and over 4,000 pages, this national exercise to document the 'problem' created a multitude of recommendations, but none of those recommendations in this state-sponsored and state-driven research needed to be heeded."[77] While expressing sympathy for its victims, the TRC also seems to subtly grant absolution to the perpetrators. Simpson writes:

> When power takes a certain form and demands and requires that we line up in certain ways and presents then an impossibility of concordance, I wish to argue that it then requires instead a volley of spectacles and in this, the inducement to move public sentiment forward, now....the Truth and Reconciliation commission, a state-sponsored listening exercise that archives these narratives of deep suffering and pain, takes into its auditory arena all of these wounds. Oka, of course will never be forgotten (in that territorial context). However, that land remains improperly rendered and Indigenous bodies remain themselves, and simultaneously outside of themselves, in this new market for their pain. And in this, the exteriority of their lives, from the West, from the points of reason, opened up a further space for settler instantiation and now, I want to note, with the cunning, and masking language of *reconciliation*—a settler absolution.[78]

Judges can thus ignore residential school effects in sentencing because the Indigenous persons are still the only ones being cast in the legal

system's reasoning as criminals. The state is never framed as having also performed immoral and liability-incurring conduct which should be weighed up against what the Indigenous accused has done, to see if Canada contributed to or was effectively the cause of the Indigenous person's criminality. The statement that Canada has committed the international crime of genocide against Indigenous peoples is a contrary message to this, made by the MMIWG Commission in 2019, but this is not technically a law-making determination within Canada's legal system considering that it was made by a commission of inquiry.[79] Whether this declaration will nonetheless affect the communicated expectations within the legal system of Canada's guilt vis-à-vis Indigenous peoples is an open question.

It is true that there are serious questions overall regarding whether sentencing people to custodial punishment is actually useful in addressing crime and recidivism.[80] My point is not about the ultimate outcomes of the legal system, however, so much as it is about spotlighting the norms that are being applied in current legal process. Recall that Luhmann conceives of the legal system as being primarily closed to direct outside input, albeit with specific rules for taking in external material (e.g,. according to changes in statute). The substance of the law that holds that colonial domination never incurs guilt, or that such domination is not fundamentally "illegal" to use Luhmann's terminology, has not yet been changed within the practice of criminal law vis-à-vis Indigenous persons. This means that *even if* the Criminal Code changes (which it has), and *even if* the SCC mandates special sentencing analysis (which it has), the contrary legal norm in wide circulation can erase even the existence of *Gladue* factors, let alone their impact, because it holds that Canada's colonial conduct must be continually stamped as innocent (or "legal") in law and as being without substantial impact on the criminality of others;

this very real norm, that is hidden in plain sight, renders the legislative and jurisprudential steps to address over-incarceration entirely impotent in their effects within the practice of the legal system.

One substantive legal determination of note, however, that has been made within the legal system is the Canadian Human Rights Tribunal's ruling that Canada has discriminated against First Nations children on reserve by under-funding child welfare services.[81] Canada sought multiple appeals and reviews of this decision, with a settlement agreement reached in January 2022. The Human Rights Tribunal in its 2016 decision wrote: "The Panel Members... believe it important to acknowledge the suffering of all residential school survivors, their families and communities. We recognize the courage of those who have spoken about their experiences over the years and before this Tribunal. We also wish to honour the memory and lives of the many children who died, and all who were harmed, while attending these schools, along with their families and communities. We wish healing and *recognition for all Aboriginal peoples across Canada for the individual and collective trauma endured* as a result of the Indian Residential Schools system."[82] The tribunal decision included extensive quotation of the 2008 Residential Schools Apology by then Prime Minister Stephen Harper, and furthermore declared: "In the spirit of reconciliation, the Panel *also acknowledges the suffering caused by Residential Schools. Rooted in racist and neocolonialist attitudes, the individual and collective trauma imposed on Aboriginal people by the Residential Schools system is one of the darkest aspects of Canadian history.... The effects of Residential Schools continue to impact First Nations children, families and communities to this day*."[83]

Language such as this, which squarely addresses that Canada has wronged Indigenous peoples, including through residential schools, with contemporary, intergenerational effects, is currently sorely lacking in

criminal sentencing decisions concerning Indigenous survivors. Indeed, it is not uncommon for judges to mistake *Gladue* factors as being primarily about the accused's personal experience with residential schools, rather than as being about the intergenerational impacts of settler colonialism and systemic discrimination in the administration of justice more broadly. If language such as that seen in the human rights tribunal decision above was a widespread part of sentencing jurisprudence, then at last *Gladue* factors would not be reflexively erased by judges in the fashion seen in Jacquie's sentencing. This type of language sweeps away the denial norm discussed above, allowing judges to at last see Canada's guilt in creating Indigenous "criminality"; with the denial norm rejected, *Gladue* factors will not be continually ignored and may actually be seen by individual judges in their perception of the moral culpability of the Indigenous person being sentenced.

If Canada is serious about reconciliation or addressing over-incarceration, in my view, it should introduce within the legal system a judicial determination (such as a reference case) or legislative statement connoting at least quasi-criminal state culpability for the residential schools and other violations of Indigenous families and communities; this would bring in language similar to that seen in the Canadian Human Rights Tribunal decision above and change the narrative in criminal courtrooms. It would break the hypocritical façade which suggests that Indigenous persons are the only "uncivilized" criminals here.[84] It would frame access to healing treatment and alternatives to custody as legal obligations that Canada *owes* to Indigenous peoples, in order to begin to make right the crimes Canada committed against them. The federal UNDRIP Act is a start at changing expectations, but the legal effects of its perambulatory language denouncing systemic racism, colonialism, and *terra nullius* are still unknown at this time.[85]

In contrast, through the colonial lens the criminal courtroom is still coded as a site of containment and domination of criminalized Indigenous persons who are, by the definitions ascribed to them by the colonial lens, inherently hostile to the Anglo-Canadian state. The congruent expectations which support the continued practice of over-incarceration appear still in effect in the bulk of the Canadian legal system. Many Canadian courts (and police) continue shuttling Indigenous people into jail, despite direction from the SCC that frames over-incarceration as a crisis and obliges judges to consider systemic and background factors that may mitigate moral culpability and may direct sentencing towards alternatives to custodial sentences.

Recall that in 2016, Indigenous persons in Saskatchewan made up 16 percent of the province's population, but Indigenous women made up 85 percent of the population of incarcerated women.[86] These figures suggest that Indigenous women are jailed at more than five times the rate of non-Indigenous women in Saskatchewan. In Jacquie's case, the courtroom was a space where, as an Indigenous woman, her moral culpability was strongly emphasized while her moves towards rehabilitation were wholly ignored. Incarceration was the only option seriously considered for her by the court, despite her pregnancy and low-risk status. The judge went with the practiced momentum of the legal system vis-à-vis Indigenous peoples and gave her a heavy sentence.[87] Path dependency prevailed, and the courtroom here was unequivocally coded as the entry to Indigenous containment in jail.

Canada's culpability was presumed non-existent in this spatialized courtroom site of the legal system. Information on how colonial policies including the residential school system had inflicted trauma and affected Jacquie and her family was arbitrarily deemed unimportant. Her resources for education absolved the Canadian state for any wrongdoing.

Or alternatively, she was regarded as a "savage" without any trauma, considering that her college classes showed her to be supposedly unscathed, and due for incarceration.

As a final note, the insidiousness of judging an Indigenous woman to be an unfit mother due to her being sentenced to custody deserves highlighting. This is because the determination that custody is appropriate for this woman is itself a product of colonial patterning, namely the over-incarceration of Indigenous persons discussed in this chapter. An emphasis on incarceration alone as the appropriate sentencing option is evident in Jacquie's sentencing.

This is a cunning and vicious circle. Not only is an Indigenous woman a "bad mother" because she is purportedly immoral given her race (discussed in chapter 6), but an Indigenous woman is also a "bad mother" because she is sentenced to custody, notwithstanding that she is deemed deserving of custody because she is an Indigenous "savage" and subject to over-incarceration as threat to the state. The courtroom setting thus reflexively amplifies the already deviant subjecthood of the Indigenous woman, unfairly rendering her as a bad mother, and providing the colonial lens rationale needed to justify the sentence of separation that her newborn receives.

8

PRISON WASTELANDS and the REMOVAL of CHILDREN

TWO REMAINING SPATIAL CATEGORIES WITH EMBEDDED COLOnial lens norms are evident in the legal system's interactions with Jacquie and Yuri: the prison and the Indigenous child. I turn first to prison. Dehumanization in prison can happen at a level that is individualized to the particular incarcerated person, such as in terms of their race and gender.[1] Yet dehumanization also happens at a less individualized level that is roles-based within the carceral context, notably according to the status ascribed to prisoners as compared to guards.[2] Persons living and working in prisons navigate a system that has a propensity, exacerbated by hierarchized power and a lack of outside oversight, for dehumanized treatment and for the retreat of the formal rule of law.[3]

It is beyond the scope of this work to comment in detail on the history and practice of imprisonment in Canada, but a few observations are useful here. In 2020, Canada had an incarceration rate of 104 per 100,000 people; this is much lower than the U.S. (629) and is comparable to countries such as the UK (134); Canada's rate is much higher than Scandinavian countries such as Finland (50).[4] Canadian prison policy has been described as punitive in orientation, with a liberal veil of therapeutic programming, as compared with the strong focus on rehabilitation seen in Scandinavian policies.[5] To the extent that prison workers see themselves as working in a strictly punitive system rather than one aimed at rehabilitation, there is a likelihood that incarcerated persons will be dehumanized in prison, since they will be seen as criminals who are meant to be continually suppressed and who have little value to society.[6]

Two modes of carceral dehumanization, connected to an ethos which places punishment above other objectives, involve defining the prisoner as (1) a perpetual threat[7] who is also (2) ignorable (non-person) debris.[8] These assumptions can interact to create a cycle where persons, like Ashley Smith, are destroyed by these operationalized norms of the prison system.[9] Ashley Smith entered youth detention at age fifteen, on a one-month sentence related to throwing crab apples at a mail carrier, and she remained almost continually in custody for the next four years, transferred between institutions across the Maritimes, Quebec, Saskatchewan, and Ontario and spending extensive time in isolation, before she died alone a federal cell with guards looking on in 2007—three days after requesting to be transferred to a psychiatric facility.[10] If viewed predominantly as perpetual security threats to be suppressed, incarcerated persons can have expansive force used against them, with their mental health and physical distress then alternatively

either ignored as it declines or interpreted as violence that merits further force and/or additional incarceration.

How does the colonial lens see prison in a way that is consistent with colonial objectives? As noted in the preceding chapter, jails have a use in the colonial mission in containing Indigenous persons, triggered particularly when "savages" transgress the civilized law created to contain them.[11] In addition to this "savage" label, Razack identifies prisons as spaces populated by "dying" Indigenous persons.[12] Razack applies Zygmunt Bauman's analysis in noting that the "waste" of society is disposed in prisons and left to decay.[13] Since persons in prison are "dying" on their own, this means that they supposedly do not require medical assistance from prison staff, nor can others be responsible for injuring these people, since they are the source of their own injuries.[14]

There are thus overlaps between the prison dehumanization that is connected to strongly punitive carceral roles, and that which is achieved when prisoners are seen through the colonial lens. First, a carceral understanding of a prisoner as being inevitably a security threat, who deserves any force used against them, is similar to the definition of an Indigenous person as a "savage" towards whom violence is purportedly acceptable. Second, a carceral understanding of a prisoner as being a non-person who is to be locked away and forgotten, as being tantamount to trash, is similar to the construction of the "dying" Indigenous person, a person whom it is pointless to help since they are to be written off as effectively dead or disappearing anyway.

According to both the colonial lens and an exclusively punitive understanding of carceral roles, prison can be spatially defined as a place where personhood and entitlement to universal justice norms is suspended. Prison can be coded tacitly as a place where boundless force is acceptable against ever-savage prisoners, as well as simultaneously

a wasteland populated by the "dying" with no obligation for humane treatment. Indeed, this spatial definition of prison appears prominent in society since there is a real ambivalence expressed on the part of the public, judges, policy-makers, and politicians as to whether jails should actually be humane places.[15]

While rehabilitation is a goal of incarceration, ample evidence shows that prisons in Canada can be inhumane: violent and lawless places for prisoners and at times for the guards.[16] This extends to a systemic lack of legal accountability for state mistreatment of incarcerated persons.[17] In another case, an Indigenous man named Adam Capay was subjected to four years of solitary confinement in a windowless plexiglass cell, lit by artificial light twenty-four hours a day, in a provincial prison in Thunder Bay, Ontario; it is clear that a decision was made to leave Capay to decay.[18]

A commonly expressed view is that a prison in fact is not a place for humans who are entitled to humane treatment while being prepared for reintegration into society. "A prison is no place for a baby" is a familiar refrain. The obvious retort is, who is it a place for? This view is held in a spirit of superiority and vengeance: i.e., prisoners get what they deserve. For example, responding to complaints of unsafe, undercooked food following the privatization of prison food services, the Premier of Saskatchewan at the time stated that if prisoners did not like their food, they should not be in jail.[19]

To entertain the thought that a mother and infant could remain together even in custody, one would have to reject the definition of prison as a place that is simply expected to be inhumane. If jails are defined as places for waste or the permanently threatening, then this makes them unfit for babies. If the rule of law and the right to legal personhood is assumed to be suspended in jail, then it is of no consequence that separation is traumatic and punitive for the mother and unfair to

the baby since the mother is not viewed as fully human in this context and apparently neither is her child.

The account of Jacquie's experience in chapter 1 shows how prison is defined as a space of unregulated pain and dehumanizing treatment in several ways. First, the judge ignored the fact that Jacquie's baby would be taken from her in jail, shrugging off the cruelty of this. "Anything goes in prison" is the thinking; it is supposed to be punishment (a "savage" merits violence), and it does not matter how people are treated once they are there because they are discarded as "dying." Next, the prison doctors and nurses did not treat Jacquie's gestational diabetes, notwithstanding that the condition had already been diagnosed and documented by a specialist prior to incarceration. This constructs Jacquie as not "needing" or being entitled to assistance, as being someone it is pointless to help. Furthermore, for many hours prison health care staff did not provide Jacquie with health care when her labour started. Only *after* the health care staff went home for the night was Jacquie finally allowed to leave the prison in an ambulance for the hospital. This is serious neglect, suggesting that, perceived as a "dying" Indigenous woman, she could be left uncared for with expected impunity. Her child's health was similarly disregarded.

When Jacquie finally received the medical attention that her labour required, it was conditional on her being put into leg shackles, in which she laboured for many hours. This is torturous treatment of a fellow human being, and yet in an imprisonment setting, it was somehow excused and accepted. Once Jacquie entered prison, she was coded as a dehumanized "savage" who deserved pain, and/or a "dying" Indigenous person whom it was pointless to try to help, in other words as being "trash" unentitled to legal rights.

It must be stated clearly, however, that the dire conception of prison presented above does not capture the fullness of Jacquie and Yuri's

experience. Their story also reveals positive and contrary expectations present in the legal system, which is why their bonding was miraculously not interrupted after Yuri's birth, despite this being contrary to the dominant pattern of expectations in the system. Responding to outsider concern for Jacquie and Yuri, corrections employees found an alternative to separating Yuri from his mother's care. A space for Jacquie was found closer to the hospital, and escorted visits with her son were permitted; this was in effect until he was strong enough to leave the hospital to stay with his mother. It would have been best if a solution such as this could have been crafted during her initial sentencing.

Importantly, Jacquie and Yuri's experience shows that there are persons working in the legal system who do *not* subscribe to (i.e., communicate) the expectation that dehumanized treatment without bounds is accepted in custody, and who do not see inmates as "savage," "dying," or as waste. Actors in the legal system, from corrections, prosecutions, and the Court of Appeal, communicated expectations after Yuri's birth which contrasted with those evident in Jacquie's initial sentencing. Namely, these expectations did not label Jacquie as a non-mother by virtue of her sentence and did include space in the legal system for consideration of Yuri's interests. This space for considering Yuri as a person with rights and interests allowed the legal system to craft a sentence that did not deny him the opportunity to bond with his mother. Expanding and building upon those communicated expectations that express support for norms like our common human personhood and newborn entitlement to health is key to dismantling the impact of the colonial lens in the legal system.

Expectations that a mother and her newborn child can and should remain together, save in specifically identified and exceptional cases, thus already exist in pockets of the legal system, as Jacquie and Yuri's case

ultimately shows. These expectations must be encouraged and kindled to ensure that no child is unfairly denied access to his or her mother.

I turn now to how the colonial lens defines the spatial category of the Indigenous child. I ask: What embedded norms relate to the categorical construction of Yuri as an Indigenous child? How was Yuri seen through the colonial lens such that it was purportedly acceptable for him to lose access to his mother immediately after his birth, based on implicit judgment weeks before? How does the legal system, when it operates according to colonial objectives, see an Indigenous child?[20] Just as is the case with the Indigenous woman, the courtroom, and prison as spatialized categories, the typologies of the "savage" and "dying" come into play.

When the colonial lens is operating in the legal system it interprets the Indigenous child as signifying an embedded norm that runs as follows: Canada can generally take an Indigenous child legally and do with "it" what it will because the child's family is "savage" and/or "dying" and the child is better off in the care of the state. As discussed below, Canada's presumed legal entitlement to take Indigenous children is the sine qua non of the massive colonial violence perpetuated against Indigenous peoples through the residential schools, the Sixties Scoop, and today's Millennium Scoop.

The colonial attitude towards Indigenous children is steeped in ideas of racial superiority and assimilationist goals. This colonial view holds that the Canadian state is entitled to take Indigenous children away from their families at will, meaning that even today in Yuri's case, apparently no officials balked before his birth at the prospect of separating a newborn from his mother even without an inquiry regarding risk of harm. The colonial lens dehumanizes Indigenous children as chattel for the taking.

The Canadian legal system enforced the residential school system by forcibly removing children from their families at very young ages. As

noted in chapter 7, it was a carceral offence not to send one's child to the residential schools.[21] Anglo-European settler children were not removed from their families by Canadian policy at tender ages to have their support attachments severed, to face the detrimental effects of an institutionalized environment, or to face racism, abuse, torture, deprivation, and death. One hundred and fifty thousand Indigenous children were forced from their families in this way, the Canadian state seeking to break down families and communities, and stop "Indians" from existing.[22] This continued even after Canada ratified the Convention on the Prevention and Punishment of the Crime of Genocide in 1952, which obliges states not to commit the crime of genocide, the definition of which includes "forcibly transferring children of the group to another group."[23]

The Canadian legal system also realized the forced apprehensions of thousands of Indigenous children from their families into permanent adoptions, including many to the United States and Europe, where some families paid thousands of dollars for a child.[24] The Sixties Scoop spanned the latter part of the twentieth century and saw more than twenty thousand children taken from their families for adoption by non-Indigenous families.[25] Today, funding incentives exist which favour apprehensions over supports to Indigenous families, perpetuating the Millennium Scoop crisis in apprehensions, with Indigenous children twelve times more likely to be taken from their families by Social Services than non-Indigenous children.[26] According to Census 2021 data, 53.8 percent of children in foster care under fourteen are Indigenous, yet Indigenous children make up only 7.7 percent of the child population under fourteen in Canada.[27] The sheer disproportionality of child apprehensions as regards Indigenous vs. non-Indigenous persons calls out for disruption of system expectations in place. As Cree/Assinniboine/Saulteaux social work scholar Raven Sinclair (Ótiskewápíwskew) describes:

When these statistics are juxtaposed with the reality that Indigenous people comprise between 4 and 17% of provincial populations and yet up to 85% of all the children in care, our concern should increase exponentially because these numbers are statistically improbable. It may well be true that generations of residential school trauma created the conditions for increased child apprehensions, *but it is also likely that systemic and institutionalized structures have emerged that are enabling and encouraging overrepresentation.* Critics are arguing that provinces are fostering Indigenous overrepresentation because the financial benefits contribute to income security for those involved in the child welfare system.... Provincial Ministries benefit through per capita transfer payments for Indigenous children in care and also receive the per capita child tax benefits for any child who is in the care of the system. An economy, once built, will perpetuate itself. If the Indigenous child welfare system has become an economy and is operating to the benefit of foster parents and mainstream social work infrastructures, the will to disassemble that system will be limited and, indeed, actively resisted.[28]

Institutional practices that normalize disproportionate apprehension are resistant to being disrupted, with Saskatchewan initially proclaiming in 2019 that it would not abandon "birth alerts" (labelling of pregnant women before childbirth for apprehension of their children) even though the MMIWG Commissioners had expressly enjoined all provinces from using "birth alerts," as one of the Commissioners' "Legal Imperatives."[29] The province eventually announced an end to the practice in January 2021, joining nearly every other Canadian jurisdiction in doing so, with Quebec still continuing the practice as of July 2022.[30] One way of reading this resistance to change is seeing an embedded norm in force in the Canadian legal system (including child welfare law) which

creates the expectation of acceptability that Indigenous children will be taken from their mothers and families by the state.

The colonial lens thus constructs a disturbing fallacy regarding Indigenous children whereby Indigenous children are seen as belonging to the Canadian state. Canadian "care" is presumed to be a better environment for these children than that provided by an Indigenous child's family. By this lens, Canada is legally entitled to take Indigenous children away from their parents, families, and communities and absorb them into the colonial state. Indigenous children are not persons in this view; they are only "potential" persons, should they survive becoming "civilized" and assimilated.

Much has been said of the "good intentions" of those taking Indigenous children from their families. But it is difficult to ignore that meddling in other peoples' lives can be closely related to feelings of entitled power.[31] If state actors wanted to help Indigenous children in families who were destitute, these actors could have sought to help by doing what was needed on those families' own terms, rather than via force. It is also worth recalling that on the prairies some of this destitution followed treaties with Canada which were supposedly to help Indigenous communities prosper.[32] But Canada then doomed many Indigenous communities' agricultural prospects by giving them poor land,[33] no equipment,[34] and rules against selling their products freely, as well as by giving Indian Agents too much power over their mobility.[35] Helping Indigenous people on their own terms was not within the expectations of these state actors. Instead, there were expectations that involved feeling superior (by knowing what was best) and exerting state domination.

A "good" motive does not change the inherent character of a particular act. The character of the act here is removing children from their homes through exerting power over those children and their families. Those

taking Indigenous children away from their families, when employing the colonial lens, would not take Anglo-European settler children away from their families in the same systemic way. The colonial lens sees Indigenous children differently from Anglo-European children, justifying removal against their families' will.

The colonial lens sees Indigenous children as born guilty of being "savages" and this supposedly excuses all those who participate in a system designed to take them from their families, and also means that whatever negative experiences arise from being removed is just those children's lot in life. This again bears similarity to the "dying" Indigenous person stereotype. Those Indigenous children who suffer by dislocation in residential schools, in foster care, or as a result of adoption, do so because they were "dying" anyway. This makes all suffering inconsequential and absolves those who are actually the cause of such suffering.[36] The notion that children were "dying" anyway provided the excuse for nonconsensual medical experimentation on Indigenous children in residential schools, forced experiments that involved purposeful denial of adequate nutrition.[37] The idea that Indigenous children are doomed also underlies the rationale for the forced sterilization of Indigenous women.

From 2007 to 2013, Indigenous survivors of residential schools and their family members presented their stories to the TRC, as part of the Indian Residential School Settlement Agreement. The TRC, led by Justice Murray Sinclair, released Calls for Action aimed at addressing the legacy of the residential schools and mitigating their negative impacts. Twenty-two of the ninety-four Calls to Action are focused on Indigenous children and youth, and another twenty-five are focused on justice in the legal system. Of particular relevance here, Call to Action #1 calls upon "the federal, provincial, territorial, and Aboriginal governments to commit to reducing the number of Aboriginal children in

care," while Call to Action #30 calls upon "federal, provincial, and territorial governments to commit to eliminating the overrepresentation of Aboriginal people in custody over the next decade, and to issue detailed annual reports that monitor and evaluate progress in doing so."[38]

But there is an elephant in the room. How can the Canadian state, its legal system, its institutions and personnel, now address the injustices visited upon Indigenous peoples if its agents were responsible for these very injustices? Is reconciliation possible or is the Canadian legal system inherently discriminatory and colonial? Can Canada, including its provinces and its agents, actually shift the colonial lens's value expectations that underpin and are manifested in the legal system? The TRC Report notes lingering and well-placed skepticism towards this possibility:

> Many Aboriginal people have a deep and abiding distrust of Canada's political and legal systems because of the damage these systems have caused. They often see Canada's legal system as being an arm of a Canadian governing structure that has been diametrically opposed to their interests. Not only has Canadian law generally not protected Aboriginal land rights, resources, and governmental authority, despite court judgments, but it has also allowed and continues to allow, the removal of Aboriginal children through a child-welfare system that cuts them off from their culture. As a result, law has been, and continues to be, a significant obstacle to reconciliation.... Given these circumstances, it should come as no surprise that formal Canadian law and Canadian's legal institutions are still viewed with suspicion within many Aboriginal communities.[39]

How can the Call to Action regarding foster care and child apprehensions be feasible at a time when there are more Indigenous children in

care than were in residential schools during the height of their operation?[40] Relatedly, if the federal government insists on less funding for child welfare and health for Indigenous children than for non-Indigenous children (and wastes money in litigation), how are families to be supported, rather than divided?[41]

For expectations to change regarding Indigenous children, the colonial belief in Anglo-European superiority must be overcome. Rather than actually validating, supporting, and assisting a mother in overcoming the challenges she faces, many people operating within the legal system currently express communications that self-righteously denounce the mother as worthless, tut-tut at the fate of her children, and move along. A case in point is the treatment of incarcerated mothers like Jacquie. Some may state that a correctional facility is no place for a child, and thus send a woman there alone, regardless of the grave impacts this decision may pose to her child(ren), including potential placement in the state child welfare system.

If the child is what is most important, however, it makes sense to not demonize his or her mother but to keep her available to her infant for love and nurturing and to support her with access to extended family and social services. Judges sentence children to lives of upheaval when they assume a woman to be a worthless mother based on racist and sexist stereotypes that are magnified through the colonial lens.

Those in the courtroom and in corrections ministries who participate in these decisions are free to go home and wring their hands at the human misery inherent in criminal law. *It is the baby that bears the burden of the decision.* The baby is the one who has been dehumanized and dislocated from his or her family at a critical time in life. Only when legal and political actors relinquish their sense of superiority will they be able to see the baby as a human being and assess what action is actually in his or her best interests.

Once the mother is released from custody, she has the onus of convincing social services that she is fit to have her baby returned. This will be after the baby has had time to adjust to his or her surroundings, and it may well be that social services will as a result of this adjustment deem it in the best interests of the child to not be with his mother.[42] The irony here is that there was no consideration of the child's best interests when the child was placed in foster care, yet suddenly there is consideration of the best interests of the child in order to get him or her out of social services' care. The bias towards assimilation is clear.

PART IV

ANALYSIS
OTHER ASPECTS of the SYSTEM

LAW THROUGH the ANDROCENTRIC LENS

COLONIAL LENS ASSUMPTIONS, WHILE EXTREMELY INFLUENtial, do not tell the full story of why prisons are recklessly separating newborns from their mothers across Canada. There is an additional overlay of norms, grounded in male-centricity, which is also driving this practice. These are the norms of the androcentric lens. This lens projects key tenets of heteropatriarchy, an ideology that protects male societal dominance,[1] conflates sex with gender identity, and privileges heterosexuality.[2] These norms have influence upon the overall policy climate in corrections and in criminal sentencing.

An androcentric lens is given effect here through spatial categories which are communicated and contain normative assumptions concerning what is appropriate in the public sphere vs. what is appropriate in the

private sphere.[3] By this lens, gender is an exclusive male-female binary and gender diverse persons' experiences and identities are denied.

Through this androcentric lens, "female issues" are seen as properly contained in the private sphere, whereas the public sphere, including court, is male domain. As Razack describes:

> The issues that women take into the courtroom typically concern matters of the private sphere and, as such, fit awkwardly into public discourse. Even today, when such issues are normally served up as political fare, in some circles, the *personal* travails of childbirth and breastfeeding, sexually explicit intimidation by the boss, sexual assault and abortion, and to a lesser extent, discrimination in the workplace, are still not appropriate topics for conversation. Their appearance in the courtroom, a very public forum, is often in full scientific dress: women's needs in childbirth become a medical matter; our experience of harassment and discrimination, a psychological issue; rape, a sociological phenomenon; and reproductive choice, an intellectual problem of balancing the rights of someone who has no independent existence against the rights of someone who does. Women's daily personal experiences as beings who give birth, work for pay, take care of children, and are raped, battered, and harassed, enter the courtroom as though by stealth.[4]

The androcentric lens[5] supports the feedback loop of automatic newborn-mother separation. It defines the public sphere as being primarily suited to males not females, ignores and thus legitimates the punishment of the child alongside the pregnant person sentenced, and relegates acceptable femininity, including motherhood, to the private sphere.

This androcentric lens is in a sense operating in reverse to the colonial lens; the colonial lens projects stereotypes of the "other" to dehumanize, while the lens of androcentrism projects images of the (male) self in order to exclude the humanity of others. The colonial lens views Jacquie as an Indigenous woman and she is treated in a fashion specific to how her intersectional identity is read according to that lens.[6] The androcentric lens oppresses differently because in addition to permitting persons to be attacked according to their specific identities, this lens also oppresses by proliferating a particular patriarchal worldview that centres cis men as the default person in the public sphere to the exclusion of others.

Race has an important place within the ideology of Western heteropatriarchy, since white heterosexual cis women are privileged in this worldview above other women, although they must conform to heteronormative ideals relating to who is pure and acceptable as a wife and mother;[7] the heteropatriarchal worldview can thus have broad and detrimental effects on many different types of people, yet each person will experience its biases according to their specific intersectional identity.

As regards the feedback loop of automatic newborn-mother separation, three spatialized categories are communicated within the system, each of which contains androcentric norms. First, when in the public space of prison, an incarcerated person is spatially categorized by default as conforming to a male standard, even if they are a pregnant person. Second, when someone is sentenced in the public sphere of court, they are also spatially categorized by default as a man, even if they are a pregnant person. Third, within heteropatriarchal ideology a valid mother does not exist outside of the private sphere; therefore, a pregnant person in the public sphere of court or prison is categorized spatially as a non-mother or "bad" mother without rights related to childbearing or parenting.

Each of these spatial definitions creates an opening for an androcentric norm to enter the legal system in the form of congruent communicated expectations. Three embedded norms corresponding to the spatial categories above are evident in Jacquie and Yuri's treatment by the legal system: (1) the accommodation of pregnancy, childbirth, and newborn care in prison is "special" treatment; (2) the accommodation of pregnancy and childbirth in sentencing is "special" treatment such that it is acceptable to sentence and punish children alongside the people who bear them; and (3) a primary caregiver outside of the private sphere (of patriarchal male authority) is categorically a bad mother, without rights associated with childbearing, and is automatically devalued as a caregiver regardless of the value that the person has to their child. These three norms are examined below, after further discussion of the private and public spheres.

Until the social disruptions of the twentieth century, in Western patriarchal thinking women were relegated to the private domain as wives and mothers. In this division of heteronormative gender roles, a woman's appropriate place was in the home. Men were the head of the family with control over their private domain, having full authority over their wives and children. Wife-rape was not a crime: a man owned his wife's body.[8] Men were the persons entitled to power and presence in politics and in business. Women could not vote, hold office, or own property separately from their husbands. Most women were permanently the wards of men. Until 1929, women in Canada were not given legal status as persons in their own right.[9]

Scholars have connected cultural understandings of this "appropriate" placement of Anglo-European women in Western society to particular variation of Christianity. In her 1974 work, feminist theologian Rosemary Radford Ruether identified that church fathers' "depersonalized view of sexual relations gives three basic images of the possibility

of woman... woman as whore, woman as wife, and woman as virgin."[10] As Orit Kamir, Professor of Law and Gender at Hebrew University in Jerusalem, wrote in 2006: "The archetypal woman as virgin is Mary, the nonsexual, mothering Madonna; The archetypal woman as wife is the ideal image of domesticated, subservient post-Eden Eve. Eve, destined by God's punishment to serve her husband and bear his sons, is the appropriate role model for all women, 'Eve's daughters.' The archetypal woman as whore is Lilith... Although desired by men, Lilith is feared and hated, an outcast from normative society."[11]

An influential version of Christianity thus gave Anglo-European women two main models for moral behaviour: the gracious mother (Mary) or the dutiful wife (Eve). Perceived deviation from these morality archetypes could be used to render women subject to denigration and labelling as whores, or witches, a characterization closer to Lilith than to Mary or Eve. Even the pain of childbirth was said to be related to women's sinfulness. As chapter 6 explores, Anglo-European men created a unique version of the Madonna-Whore dichotomy for application to Indigenous women, juxtaposing a helpful, civilizable princess archetype with an ignoble "savage" archetype and further contrasting the civilized virtue of white domesticated women with the purported immorality of Indigenous women.[12]

In patriarchal Anglo-European society, women entered the public sphere only on men's terms. To be acceptable as a good and moral mother in the public sphere one had to be attached to the authority of a man through marriage. Because men controlled women's "honour," unwed motherhood was shameful and women were denigrated for it.[13] Women are still denigrated for unwed motherhood around the world.[14]

The use of the public-private divide to control women's status and agency gave men the benefit of women's unpaid labour in the home.

As Susan C. Boyd summarizes, "The ideology of mothering in Western nations portrays women as selfless, giving and pure."[15] The inequality continues today with Statistics Canada reporting that women in Canada as of 2015 do on average 50 percent more unpaid labour in the home than men.[16] By androcentric bias, work in the public sphere is defined as "real" work while work in the private sphere is not;[17] private sphere labour such as parenting is moreover construed as something that a "good mother" is naturally called to do, neatly erasing the labour and effort involved.

When women entered the public sphere of employment in great numbers in the twentieth century, it was an enormous and continuing battle to change the expectations of their presence in the public sphere from those dictated by androcentrism to instead those appropriate to them, according to their perspectives and needs. When such women entered the paid workforce en masse, a pronounced political and economic power struggle began to determine the terms of this presence in the public sphere. Equal pay is still not a reality in Canada.[18] Regarding their right to be mothers, notwithstanding their existence also as paid workers in the public sphere, such women had to fight for maternity leave. (This struggle is far from over, particularly given the appalling state of maternity leave today in the United States where just twelve weeks of unpaid leave are granted.)[19]

Humane treatment of persons in the public sphere at times requires that they are treated in a manner specific to their gender identity and pregnancy status. However, in order to reject responsibility towards pregnant persons, people who use an androcentric lens tend to inaccurately pathologize pregnancy as a solitary strategic act. For example, when maquiladora workers in Mexico are systematically subject to pregnancy tests, and those who are pregnant are excluded from employment;[20]

this is done with the rationale that pregnant women want to be hired in order to gain maternity benefits. Intent is imputed to their pregnancy. This misogynistic reasoning places women at fault for their pregnancy. Such a construction is contrary to basic biology.

Impregnation may be consensual or not. It may be accidental or not. An unfair assumption regarding the conditions of impregnation can be used to deny women treatment in the public sphere that is appropriate to their status as women (and even to impugn their motives for motherhood and future worth as a mother). For example, the faulty reasoning in the employment context goes that employers do not owe women anything as mothers because women become pregnant on purpose in order to be entitled to "special" treatment. Persons by this rationale may enter the public sphere of employment only on terms which treat them as being effectively cis male, namely by being unpregnant so "special" treatment will not be necessary. Accommodating pregnancy is, however, not "special" treatment; it is *fair* treatment that is appropriate to pregnant persons and treats them as full citizens, rather than subjecting them to a standard that they are inherently precluded from ever meeting, namely the standard of never being pregnant.[21]

The public-private divide in Western Judeo-Christian heteropatriarchal culture has thus often set the default conditions for humane treatment in the public space on androcentric terms, requiring political action to establish parameters for women's and gender diverse persons' presence that are not hostile to them. In other words, the prisoner in a jail, and the accused in a court, are each spatialized categories that can contain the androcentric norm which holds that normal treatment is set at the treatment of cis male persons. There has thus far been insufficient political action to change the expectations of acceptable practices in prison (and sentencing) away from this default male setting to a setting

which is humane towards pregnant persons and newborns, including their specific health needs (e.g., there is still traumatic automatic separation which denies bonding, and there is still the use of barbaric leg shackles in labour).

Androcentric norms, communicated in spatialized justice categories, can thus direct automatic newborn-mother separation realized by the legal system, along with colonial lens norms. As noted at the outset of this chapter, these androcentric lens norms are: (1) accommodation of childbirth and newborn care in prison is "special treatment"; (2) consideration of the effects of sentencing on a newborn child is "special treatment," meaning that pregnant person and child must be punished together; and (3) worthy mothers are not found in public courts of law nor in the public sphere of prison. Each of these three is discussed below.

ACCOMMODATION OF CHILDBIRTH AND NEWBORN CARE IN PRISON IS "SPECIAL TREATMENT"

As presented in chapter 2, in some jurisdictions the accommodation of a birthing parent's newborn has been the result of on-the-ground initiatives pursued in order to establish programs and practices at the facility level. This model is a cause for hope in that it shows that facility-level accommodation policies can be established administratively, assuming there is no interference from decision-makers up the hierarchy who are intent on maintaining androcentric assumptions in the legal system.

There is no such accommodation for pregnant persons at the provincial or territorial level presently in most of Canada. Pregnant persons are kept in prisons designed around a default male prisoner ideal, and their pregnancies are considered abnormal conditions.[22] (To some male politicians, access to adequate menstrual products in prison is seen as a luxury

rather than a human right.)[23] Also, just like in the maquiladora example above, intent is often imputed to pregnancy. I have heard from people who truly should know better that if a woman knew that she could remain with her baby in prison, she would get pregnant deliberately to ensure "light" incarceration; this suggests a gross misrepresentation of what it means to care for a newborn. This is another example of women's work as unpaid caregivers not being seen as laborious or as real work.[24]

This "they just want special treatment" view regarding the accommodation of childbearing in correctional environments and in sentencing is contradicted by a basic fact: the vast majority of women in Canada become pregnant and give birth at some point.[25] Half of these pregnancies are unexpected, and half of these in turn involve failed birth control.[26] Babies happen. Rather than imputing motive or placing blame on pregnant persons for this, why not structure the key areas of the public sphere so they are not inherently hostile to persons who are childbearing beings? Accommodation of pregnancy is simply not special treatment. Being pregnant is what many women and gender diverse persons do. It is part of their valid humanity.

The concept of humane birth can also lack prevalence in prisons, a testament to androcentric assumptions in operation. Health care is denied, and reports of labour and impending birth ignored. Births have happened with women alone in their cells.[27] One incarcerated woman in Alberta was forced to carry a dead fetus in utero for weeks, despite repeatedly seeking help from prison staff.[28]

Thus, a key ideological rationale for the feedback loop of automatic separation is that prisons, as public spaces, are coded by default as places that persons must enter on male terms. Any accommodation of pregnancy or childbirth, a basic aspect of human beings, is construed to be "special" treatment.[29] Any deviation from or accommodation within this

male model is a hard-fought political victory. As Patricia Monture writes, "Law is a particularly good example of the way in which the male construction of reality is implemented in such a way that the gender specificity of legal relations is vanished."[30]

A prison is inaccurately portrayed to be no place that could possibly appropriately accommodate a primary caregiver with a newborn. Yet it is entirely feasible to have a mother care for her infant in a secure setting, as many examples show.[31] As of writing, Canadian jurisdictions, save for a few, have not yet shifted assumptions sufficiently to discard this heteropatriarchal construction of the public sphere, in order to create a space that accommodates persons who are childbearers. Perhaps if there were more representation and diversity regarding gender in positions such as premiers and justice ministers,[32] change towards equality would occur more quickly and the chosen laws and policies which shape the public sphere, including prisons, would be made less hostile to pregnant persons.

The public-private divide, a concept long employed as a tool of heteropatriarchal domination, works perniciously here.[33] Recall how childbearing persons fought to enter the public sphere (as wage earners), leaving their reproductive lives largely in the private sphere. In the current context, however, incarcerated pregnant persons have been forced into the public sphere of prison, and are fighting to bring their reproductive lives with them. It is in the public sphere of their temporary residence of prison where pregnant persons must fight for space for their reproductive lives. The results of this unfinished conflict are present-day discrimination against pregnant persons on the basis of their temporary residence and grave injustice to their children.

This battle for accommodation of pregnancy and childbirth is an unfinished project even as the scientific understanding of newborn

health, and of a newborn's experiences' impact on lifelong health, has moved forward dramatically over the past fifty years.[34] This scientific understanding has not permeated corrections policies or sentencing law, as both remain unchanged from their form taken in the decades past, remaining seemingly impassive to the fact that their treatment of pregnancy and childbirth seriously affects newborn children. This filtering out of scientific knowledge from the legal system is consistent with Luhmann's theory of *autopoiesis*, described in chapter 3, since law self-replicates according to its own code and excludes foreign material that is inappropriately "introduced" to the legal system, such as through scientific consensus that is "external" to the legal system. By clinging to the definition of persons in the public space as fundamentally male, those in power refuse to see that these policies have real and negative impacts on newborn children.

Jacquie did not have an appropriate or even humane birth experience in the androcentric public sphere of the correctional environment. She was not regarded with humanity in the treatment she received—not by those who ignored her diganosis of gestational diabetes, nor by those who ignored her repeated requests for help for hours once her labour started, nor by the guards who put her in leg shackles during labour. The nurses and doctors at the Victoria Hospital in Prince Albert did not insist that the shackles be removed, nor did ambulance staff. Only (with a change of guards) after arrival in Saskatoon were the shackles eventually removed. This is simply no way to treat a woman in labour. Jacquie had a ruptured placenta; both she and her son were at risk of dying.

On one level, the shackling of persons in labour happens because people are still treated in the public space of prison as if they were male prisoners who could not be in labour. There is no cis male equivalent to the experience of being pregnant or in labour. Restraint regulations

specific to pregnant persons have simply not yet been set in place in most jurisdictions, as this has not yet been made a priority. The practice of shackling a person in labour is a health risk to the mother and child and is a profound affront to the labouring person's dignity as they are already in a very compromised and exceptional physical and emotional state.[35] Obviously, labour can be painful and stressful, and placing shackles or handcuffs on someone only exacerbates their distress and discomfort. The illegality of shackling a person in labour is examined in chapter 11.

MOTHER AND CHILD MUST BE PUNISHED TOGETHER

Under the heteropatriarchal androcentric lens, an accused person before the public sphere of court is by default male. This means that when sentencing a pregnant person, the court judges the person as if they were a singular man, and the legal expectations employed include a refusal to acknowledge the coming child as a pertinent issue. Since the child's future existence as separate from his or her pregnant parent is ignored, the court acts as if it is acceptable in law for the child to be punished as if he or she was and will forever be the same person as his or her parent.

Sentencing a pregnant person is not the same as sentencing a cis man, but the androcentric lens insists that it is. This androcentric lens leads to a conflation of the state's interest in punishing crime with a supposed state interest in imposing maltreatment on a newborn child. This maltreatment of the newborn is pursued though automatic denial of the newborn's otherwise available primary carer, notwithstanding that in all but rare cases a newborn child who is denied connection to his or her birthing parent is at a clear and medically demonstrated health disadvantage to a newborn child does have access to a primary carer from birth onwards. This includes the lifelong effects of physical and emotional

bonding and, in cases where nursing is able to become established, the positive immunity effects of breast milk.[36]

In Jacquie's sentencing, the judge did not review sentencing cases of pregnant offenders, likely because counsel did not bring them before him. The sentencing of pregnant persons, and of those who are primary caregivers for small children, is profoundly affected by an androcentric lens in Canadian law. Canada lags behind many countries in developing sentencing policy that addresses the rights of the child, as well as the sentencing and caregiving effects.[37]

A MOTHER WHO DEVIATES FROM THE PRIVATE SPHERE IS A BAD MOTHER

Reluctance to incorporate or value newborn or reproductive health in correctional processes, and indeed in sentencing itself, relates to the following ideological rationale for the status quo: criminals are to be treated as if they were male since they are in the public sphere which is, by default, male domain. As a corollary of this, any woman leaving the feminine domain of domesticity as wife and mother does so at her own peril. According to still influential Judeo-Christian cultural categories, she becomes exposed to being construed as an immoral whore in the mode of Lilith (Adam's first wife who would not submit), not entitled to humane treatment, with dire potential effects on her child.

The public-private divide in Western patriarchy, complete with its reliance on archetypes used to model appropriate types of women (Mary the Virgin and Eve the dutiful wife vs. Lilith the Whore), is relevant to the feedback loop of automatic separation because it makes it very difficult for people who are steeped in this ideology to see a woman who has dealings with the law as someone who could also be a mother of value.

The categories of female archetypes are mutually exclusive within this version of Judeo-Christian Western thought. One simply cannot be a Whore and a Madonna at the same time. Feministic theologian Dorothee Sölle describes this mechanism of denigration: "So the image of a sublime and elevated Mary was integral to the oppression of women. She is enthroned above us. She is pure; we are filthy. She is desexualized; we have sexual needs and problems. We can never measure up to her and should therefore feel guilty and shamed.... Raising someone up on a pedestal is a strategy of domination. Women are glorified, elevated, and praised so that they can be humiliated, restricted, and blocked at every turn. The inevitable reverse image of the Madonna is the whore. *Finalmente siamo donne, non piu putane, non piu madonne!* (We are women, not whores or madonnas!) This is one of the slogans of the women's movement in Italy."[38]

A deviant of the law is immediately rendered outside the bounds of acceptable motherhood (she is neither pure nor dutiful), creating the easy grounds for implicit judgment by all involved that she is a worthless mother, and that the child can be acceptably taken from her once born. In this cultural tradition, valid childbirth and childcare are narrowly construed as occurring in the private sphere, by cis women who are under the sanction of a male head of household. As soon as a pregnant person is a deviant from this model, they are unclassifiable as an acceptable caregiver according to this variation of long-standing archetypes in this Judaeo-Christian Western cultural tradition. Furthermore, by this rationale what "good mothers" do is not real, laborious, valuable work, but rather it is the fulfillment of a semi-angelic calling, suggesting that being a mother is not really a demanding job, since it just comes with natural ease to the "good" ones. If a mother's work is not seen as actually laborious or effort-intensive, per se, then the erasure of a mother's availability to do this job can be glossed over in court proceedings.

The androcentric lens casts a wide net for "bad" mothers, as anyone who has been determined to be a criminal deviant in the public forum of court, and sentenced to containment in the public sphere of prison, is likely exposed in their own way to be seen through this lens as so distant from the realm of good motherhood and domesticity that they are a deemed a non-mother or bad mother. This androcentric lens thus contributes to law's systemic hostility towards sentencing persons in light of their child care obligations, and to the systemic hostility towards accommodating infants in women's custody facilities outlined in chapter 2.

As discussed in chapter 6, the specific prejudice operating in Jacquie's case relates to her identity as an Indigenous woman. The branding of a woman as an unfit mother happens in ways that are unique to each person, relating to their intersectional identity. Elena Windsong reflects on the importance of intersectionality in conducting accurate qualitative research: "A key insight of intersectionality is the call for research to move away from additive analysis, meaning analysis based on ranked, dichotomous thinking in which an individual is classified as more or less oppressed/privileged.... Another critique of additive analysis is that it does not account for the lived experiences of individuals such that race, gender, and class are not necessarily experienced separately but instead intersect in everyday life.... Further, it is not just individual identity that does not map out clearly within additive analysis, but interactions and social structures also do not solely exist along the lines of race or gender or social class alone."[39]

Persons of many backgrounds, races, and gender identities are discriminated against in matters involving pregnancy and reproduction.[40] Interference with family bonding and the targeting of children and parents for separation is not a new or rare form of violence, despite its obvious prominence today.[41] Considering that state and civilian denigration

of Indigenous women has been in operation in Western Canada since at least the 1880s,[42] the fact that a woman is Indigenous makes her exposed to being judged as an immoral, unfit mother. When this prejudiced view is part of congruent expectations in the legal system, it corrupts the legal system with racism.

10

FACTORS that BUFFER the LEGAL SYSTEM from CHANGE

AW IS UNDERSTOOD HERE AS A LARGELY CLOSED SYSTEM WITH specific rules for how new information may be brought into the "legal" vs. "illegal" code that the law follows. Considering the main mechanisms for how law changes, via the judiciary, the legislative, and the executive branches of government, it is clear from Jacquie's case that at least three key factors are buffering the legal system from change. These factors, in addition to general transaction costs[1] involved in challenging status quo relations, help keep the colonial lens and the androcentric lens very much alive in the legal system's expectations, protecting embedded norms and perpetuating the feedback loop of

automatic separation, notwithstanding that it constitutes a disregard of personhood and a lack of due process.

The first insulating factor is a glaring lack of access to legal representation. The people subject to the act of newborn-mother separation are not empowered in the system to challenge the judge's or the administrative agents' conduct by using the legal system's tools: they are not lawyers, they cannot afford lawyers, and our country does not provide them with lawyers. Secondly, there is a lack of diversity of life experiences and perspectives among judges and law-making politicians; this contributes to repetitious patterns of thought and practice over time. Third, the sentencing judge's determinations are not subject to wide societal scrutiny. These sentences are not fully accessible in the public domain, and are not issued as published decisions, searchable on CanLII.ca in a visible, easy-to-aggregate way. Instead, the vast majority of judicial sentencing occurs through oral reasoning, rendered in dispersed provincial courtrooms. These decisions are public in theory, but in practice are obscured by localized record-keeping. It is impractical and expensive to gather and analyze individual case transcripts. Each of these three factors is examined in greater detail below.

LACK OF LEGAL REPRESENTATION

Lack of legal representation is an obvious theme in Jacquie's experiences. As chapter 6 presents, the one-sidedness of Canadian law's operations towards Indigenous persons is long-standing. She was not empowered to challenge the status quo through access to adequate legal counsel for her appeal. She was represented by a Legal Aid lawyer for her initial sentencing. In my interpretation of the audio transcript, the lawyer was half-hearted in his request for Jacquie to be sentenced to house arrest rather than custody.

• FACTORS THAT BUFFER THE LEGAL SYSTEM FROM CHANGE •

The expectation of all involved in the process appeared to be that her pregnancy would be inconsequential to her sentencing, and so it was. This was consistent with the cynical view of some criminal defence lawyers I have spoken with as well, who do not view pregnancy as a consequential consideration in sentencing. Legal Aid lawyers represent so many defendants that their services cannot reasonably be expected to be very personalized or to radically challenge the existing system. Jacquie even recounted to me that her lawyer appeared to have forgotten that she was pregnant until he was reminded of this fact some time in advance of the hearing. This was despite the fact she remembered telling him early on in her pregnancy. Legal Aid lawyers in this process are providing a basic level of legal representation, and they are not funded to be able to do more. Legal Aid facilitates the usual workings of legal process; it is not a Court Challenges program that tests and shapes the law.[2]

Once Legal Aid decided not to represent Jacquie on appeal, for reasons that were not shared with either Jacquie or myself, she was left to the nightmare of self-representation from jail. Jacquie had no legal training. She had no access to the internet (nor do any prisoners in Canada).[3] Telephone calls through the Texas-based "Telemate" system were expensive, and sending and receiving faxes was difficult and erratic.

As recounted in the Introduction, the local Elizabeth Fry Society lobbies corrections agencies on particular issues but does not provide sentencing appeal representation. Neither does CLASSIC, a legal clinic in Saskatoon. Pro bono volunteers are not a reliable source of access to justice. Motions for Court-Appointed Counsel remain one possible source of funding for a lawyer. However, such a motion would be difficult to initiate unassisted from prison, especially if one was unaware of this process. Furthermore, Motions for Court-Appointed Counsel appear to be governed by a murky standard of whether it is in "the interests of

justice" for such counsel to be granted.[4] Jacquie recounted that during the motion hearing the Crown stated that "the sentencing was fair," suggesting that this motion can operate as a superficial review of sentencing.

Overall, it is clear that after her initial sentence, Jacquie was without legal representation, and she and Yuri were rendered objects of the system's process. The fact that I, a law professor, became involved was highly unusual and is the exception which proves the rule. Those affected by automatic newborn-mother separation thus lack access to legal representation which would challenge this legal system feedback loop, either by an effective appeal or by judicial review of the separation and/or the newborn's apprehension; this lack of access to legal representation is a critical factor that contributes to the feedback loop's perpetuation. Without representation these persons are not actually participating in the legal system and are not empowered to bring forward law and arguments relative to their rights and personhood, in order that such arguments may be then potentially accepted into judge-made law, or into the practice of administrative bodies.

DEMOGRAPHIC UNIFORMITY AMONG JUDGES AND OTHER KEY LAW-MAKERS

A particular demographic is overrepresented as regards those who are judges in Saskatchewan, and in the rest of Canada: that of persons who are white, middle-aged, and male.[5] Data reported in 2016 shows male judges outnumbering female judges by more than two to one in Saskatchewan, and female judges are outnumbered by male judges in every Canadian jurisdiction.[6]

Homogeneity in judicial background contributes to a certain level of specificity in life experience and perspective among judges. Importantly,

FACTORS THAT BUFFER THE LEGAL SYSTEM FROM CHANGE

this perspective is not only over-represented in judicial practice but also in other positions of power in the legal system, including key positions such as Premier or Canadian Ministers of Justice (see Appendix). Commonality in perspectives and socialization biases among actors within the legislative and executive branches thus also impacts the prospects for legal system change on those fronts. Mid-2019 saw zero women Premiers in office.[7] To a certain extent, subjective views of life inescapably frame reasoning and assessments of fact.[8] There are rules in place to address judicial bias, but these have a high threshold and would not be triggered by most judicial reasoning.[9]

Demographic uniformity among those who participate in Canadian law influences its assumed content and meaning. Harold R. Johnson describes a mechanism by which this occurs: "If the people who write the law and the people who interpret the law and the people who teach the law are all from the same culture and share the same values, as they were when I went to law school, they do not have to fully explain their reasoning or ever question it. The decisions I studied in law school were written primarily by white male judges, and in writing their decisions they relied upon their own sense of propriety. Judges explain the rationale behind their decisions but often leave a great deal unsaid. The problem is that only people who share their particular cultural beliefs can fill in the blanks."[10]

If the majority of judges (and key elected lawmakers) have never given birth and have never provided primary care for a newborn, their understanding of pregnancy, childbirth, and early childcare will be necessarily limited. They will have little personal appreciation for the impact that automatic separation of newborn from mother will have on the health of either the newborn or the mother. This collective lack of experience and understanding, of a significant part of human experience, gives grounds

for knowledge flaws in legal thinking that involves pregnancy, childbirth, and early childcare. This lack of child bearers' input and perspective in crafting law and performing judicial practice contributes to a sustained data bias[11] in law.

Yet as a counterpoint to this, there has been a clear cultural shift in recent decades such that it is now much more common than not for fathers to attend their children's births.[12] Many judges are fathers and likely have at least observed labour, childbirth, and early childcare. The same is true for fathers in key political positions, with executive and legislative importance (such as Ministers of Justice). The potential insight of such men into the position of pregnant persons, and into the needs of children as young infants, should thus not be hastily dismissed.

In my view, persons in judicial and legislative power are not actively seeking to subjugate pregnant persons by forcing them to endure labour in shackles, nor to violate children's rights by denying them access to bonding; rather, persons in power are being egregiously slow to take initiative to change old, problematic laws and practices to make them more appropriate for people who give birth, as well as for children. Silence is acceptance of these problematic norms, and too many people who actually have the insight needed to understand that there is a problem are still silent about it and are allowing the status quo system to continue. Those with this insight must put change on their radar and assist with breaking down old expectations and bringing new values into the system, as was achieved recently in Minnesota with the passage of the "Healthy Start Act."[13]

Homogeneity in gender, race, and overall demographic representation and perspective contributes towards inertia in system expectations, but this factor should not be overstated, since anyone from any background or gender can bring anti-racist and/or anti-androcentrist expectations

FACTORS THAT BUFFER THE LEGAL SYSTEM FROM CHANGE

into the system. The converse is also true. Indeed, a person of any gender has the capacity to express and perpetuate androcentric expectations.

As overwhelmingly non-Indigenous persons, many judges and elected politicians will likely have little personal experience with the Canadian state's interference with Indigenous family relations. This will also affect their perception. They may not see forcing an Indigenous mother to abandon her newborn child as a problematic extension of the approach to Indigenous family bonds discussed in chapter 8. They may not see it as an extension of the mindset that underpinned forcibly removing at least 150,000 young children from their families to live in residential school institutions,[14] or removing more than 20,000 Indigenous children from their families to place them for adoption around the world in the Sixties Scoop.[15] They may not connect it to the apprehension practices today, termed the Millennium Scoop, which are placing more Indigenous children in care now than were placed in residential schools at their height.[16] They may not have the life experience to see that recklessly separating an Indigenous mother and her newborn is actually not acceptable or fair, despite the fact that it has been the modus operandi of the Canadian state as regards Indigenous families for many decades. They may not see this as inflicting intergenerational trauma on literally another generation.

Just as is the case with the misleading male vs. female binary of ideological expectations discussed above, non-Indigenous judges ought by now to have the capacity to reject colonial lens norms. Non-Indigenous judges ought to know better by now than to be passive in the face of colonial values. It is simply too late for an educated non-Indigenous individual to claim ignorance of Canada's violation of Indigenous human rights through Canadian law. Residential schools are now a household term in Canada. School children across Canada wear orange on September 30 out of respect for residential school survivors as well

as to honour the children who never returned home from these institutions. Non-Indigenous judges and politicians ought to have open eyes by now to Canada's problematic past and ought to take action towards a new approach that breaks the cycle.[17]

I do not know for certain the sentencing judge's demographic situation. He has been described to me by several people with firsthand knowledge as a white man in his sixties. This is also the demographic of the SKCA Justice who denied Jacquie's motion for Court-Appointed Counsel. Considering that Saskatchewan, in 2016, had only two Indigenous judges, it is not surprising that the sentencing Judge was apparently not Indigenous.[18] He also said, "In her culture, is it a bad thing to be raised by a grandparent?" suggesting that he does not himself identify as Indigenous, as he did not say "our" culture.

Law as a cyclical system of self-reference validates the choice of incarceration in sentencing as judges reference previous acts of incarceration as validation of their decision to incarcerate. This is the choice even when a child will lose his mother as a result of this judicial determination. One has to ask: Where is the change in attitude going to come from? The fresh perspective of new judges, and hopefully more Indigenous judges, is one way for a change in expectations away from the cycle of over-incarceration and away from the cycle of automatic separation of mothers and their newborns. Or perhaps current judges will recognize their role in the system and see the embedded colonial and androcentric norms they are in fact enacting, and choose instead to drop these lenses and apply Canadian law that values universal legal personhood and due process. Current judges may also shift their reasoning to the extent that counsel increasingly puts legal arguments before courts, such as those outlined in chapter 12, which do not perpetuate colonial lens and androcentric lens norms.

• FACTORS THAT BUFFER THE LEGAL SYSTEM FROM CHANGE •

ORAL REASONING AND LACK OF TRANSPARENCY

Another factor that fosters the feedback loop is the lack of collective public attention on this loop in operation. The vast majority of the judicial sentencing decisions that send pregnant persons to jail (to automatically have their newborns taken) are unwritten, unreported decisions that are enacted in highly localized courtroom environments. As noted in chapter 1, I have calculated that in the 2014–15 year only about 4 percent of adult admissions to sentenced custody in Saskatchewan had written reasons.[19] The Saskatchewan courts do not keep any sort of cumulative records with respect to sentencing or hearings. Unless a written decision is posted on CanLII, there is no written record of the sentencing beyond what is in the court case file. One can ask to pull files at the courthouse if the file number is known and can request transcripts or an audio recording for a fee; but there is no way a member of the public could, for instance, search and retrieve amalgamated records of all the sentencing of pregnant women for a given year. A cursory examination suggests that other provinces are the same in this regard.

In law school, aspiring lawyers read countless cases and arrive at the erroneous belief that legal proceedings are predominately recorded in written format. In contrast, it is by the spoken word in widely separated courtroom settings across the country that judges render their sentences upon women's newborns, communicating embedded norms through spatialized categories. These judgments are omitted from the collective, accessible record. When the openness of the court exists only on a very narrow level, local expectations are isolated from disruption by outside commentary.

PART V
SOLUTIONS

The ILLEGALITY of SHACKLING a PREGNANT PERSON in LABOUR

NOW TURN TO THE LAW THAT APPLIES TO JACQUIE AND YURI'S experiences once the colonial lens and androcentric lens norms are rejected. The eight spatially embedded norms in operation I have identified in this work are below.

Having restated the norms in operation, the current chapter addresses the illegality of shackling a person in labour, while chapter 12 examines automatic newborn-mother separation. Considering that the exercise here is applying the law without the colonial lens and androcentric lens norms, I will first methodically reject each such norm that appears at risk of being applied by legal system actors in the context of shackling during labour.

Table 11.1. Colonial Lens Norms

Spatialized Category	Embedded Norm	Application in Jacquie & Yuri's Case
Indigenous woman	1. Indigenous women are presumed unfit mothers and poor housekeepers according to long-standing colonial myth. *Note: When brought before a court of law and marked as being due for custody, this bad mother label is intensified and a woman is deemed a non-mother with no rights over her maternity.*	Jacquie was viewed in the court as a mother with no value; sentencing effect on ability to mother was not considered; pregnancy was presented as neutral factor; vague reference to "culture."
Indigenous person before apparatus of Canadian criminal law (court)	2. "Savages" who transgress civilized law require containment and imprisonment since they are threats to Canada. 3. Canada is never uncivilized, and abuse of Indigenous persons by Canada is without legal weight.	The only sentence considered by the Judge was custody. Despite colonial trauma in background, including family members having attended residential schools, Jacquie was regarded as being without trauma inflicted by Canada. There was thus no *Gladue* mitigation of culpability or judicial requirement to consider alternatives to custody; Jacquie was constructed as being without trauma because she had taken college classes and/or because Canada has been absolved from any trauma inflicted on her by presumably providing resources for her education.

Indigenous person in prison	4. Indigenous persons sent to jail are "dying Indians" and "savages"; jail can also be defined generally as a place for society's trash and constant security threats such that unbounded suffering is a given.	Pain and injustice of separation on mother and son is rationalized as part of the unbounded pain of prison; denial of medical care and labour in shackles is part of the "acceptable" pain and neglect of prison. *Note: Contrary expectations present in prison administration and Ministry of Justice that considered and valued newborn health prevented separation practice in Yuri's case.*
Indigenous child	5. It is in the best interests of the Indigenous child for Canada to take the child away from their "savage" and/or "dying" family and attempt to civilize them. *Note: By this norm it is unremarkable that an Indigenous child when born goes to Social Services, without even an individualized review of the circumstances, because he or she is not allowed to remain with his or her mother.*	Yuri was poised to be separated from his mother, as indicated on her maternal hospital chart. This was due to a blanket prison level policy in a province where 85 percent of women in prison are Indigenous. *Note: Contrary expectations present in corrections and the Ministry of Justice averted this norm's application when Yuri was born.*

Table 11.2. Androcentric Lens Norms

Spatialized Category	Embedded Norm	Application in Jacquie & Yuri's Case
Incarcerated person in the public sphere of prison	6. Treatment as anything but a male prisoner is "special treatment." *Note: Accommodation of pregnancy and post-natal care with a newborn is excessive accommodation (for persons presumed to get pregnant on purpose).*	All provinces and territories in Canada except BC and NWT lack formal accommodation for women after birth with their newborns. The federal program is geographically limited and discretionary. Prison is expected to be inhumane, so lack of accommodation is excused. Shackles are used on women in labour as if they were male prisoners, who never experience such an exceptional state as labour.
Person accused in the public sphere of court	7. Sentencing someone as anything other than male is "special treatment." *Note: The Crown's seeking to avoid "special treatment" makes it purportedly in the state's interest to punish a newborn child by removal from his or her mother; the androcentric lens has no accommodation for childbearing and frames the child as being forever the same person as his or her mother.*	Alternatives to custody not considered despite knowledge that child would be separated from mother; comparator sentencing cases did not include pregnant women. It is seen as fair to punish a newborn child by denying him his mother because the child is seen as forever the same person as his mother and he or she must bear the weight of punishment too.

Mother outside of the private sphere of domesticity, in court and in prison	8. Women belong in the private sphere as mothers who are good and pure or as wives who are obedient and dutiful; a deviant woman in the public sphere who transgresses such norms is neither pure nor obedient and is a bad mother without rights to her maternity.	Women sentenced to custody are deemed unfit mothers; mothers in prison do not remain with their babies after birth because mothers are deemed unfit by prejudice in sentencing courts and elsewhere; it is presumed that separation is no hardship for babies; there is no need for mother-baby programs in Canada, nor need for consideration of motherhood in sentencing, because criminals are deemed bad mothers without value to their children's well-being. *Note: Stigma against Indigenous mothers is the particular norm in effect in Jacquie's case.*

Beginning with the colonial lens norms, we need to reject any assumption that an Indigenous woman in labour deserves pain because she is understood inherently as a "savage" who requires domination or as a "dying" person it is pointless to help in their pain. Also refused is the proposition that a courtroom understandably sentences persons to boundless suffering, since they require containment and punishment. I maintain that prison is not a wasteland where any pain is expected and excusable. In addition, I refuse to render invisible the risks of shackling on the mother's coming child, who is a legal person at birth and not a mere afterthought. Regarding the androcentric lens, I reject that an incarcerated person is inherently assumed to fit a male standard, in such a way that makes the pain of labour incomprehensive and ignorable.

A pregnant woman in labour is understood here as being free from all of these communicated biases. She is a person, experiencing a state of exceptional pain and deep medical risk, and to whom the placement of leg shackles or handcuffs is profoundly inhumane and unconstitutional treatment by the state. I analyze the legal issues in three parts. I first describe the practice from a medical and psychological perspective. Second, I outline applicable international human rights law, which clearly condemns this practice. Third, I describe how Canadian law prohibits the state, at a constitutional level, from restraining a woman who is in labour since this constitutes cruel and unusual punishment, as well as a violation of sections 7 and 15 of the Charter.

LABOUR IN SHACKLES

Guards placed leg restraints on Jacquie for many hours during her labour, including while she was experiencing significant medical distress due

to a ruptured placenta. She was shackled during ambulance transport as well as while a patient at the Victoria Hospital in Prince Albert, as recorded on her hospital chart. Other pregnant women report being shackled by guards in Canada as well, including during their labour. In doctoral research completed in 2018, a formerly incarcerated woman interviewed reported her experience of being restrained to her hospital bed during her labour in Ottawa.[1] This practice must stop if Canada is to comply with its international law obligations, and if public authorities are to act in a constitutionally sound manner towards pregnant individuals. Incarcerated persons are not temporary outcasts from Canada's system of rights and democracy.[2] The practice can be rooted out in each jurisdiction, through crystal clear directions to staff indicating that placing restraints on a woman in labour violates her constitutional rights under the Canadian Charter of Rights and Freedoms, as well as those of her child.

There are serious medical risks posed to mother and child by the shackling of women during labour, and indeed to pregnant persons who are not presently in labour. Dignam and Adashi, legal and medical scholars respectively, outline the extensive risks identified in medical literature:

> The antepartum application of leg irons to mothers-to-be may cause imbalance while walking and thus increase proneness to falls. In that context, concurrent handcuffing may prevent a woman from breaking a fall and avoiding injury. Intrapartum shackling poses additional challenges. Preventing walking during the first stage of labor may deny the woman the benefits of labor acceleration and discomfort alleviation. Preventing walking during the postpartum phase may enhance the risk of deep vein thrombosis and its life-threatening

embolic complications. In addition, restricting maternal repositioning precludes relief from aortocaval compression in the face of fetal distress or maternal hypotension. Maternal immobilization in the supine position also compromises the administration of epidural anesthesia. Perhaps most importantly, constrained maternal positioning undermines delivery in cases of cephalopelvic disproportion (CPD) or shoulder dystocia. Shackling throughout the four stages of labor may also impede the rapid transition to an emergency cesarean section if required.[3]

The above medical considerations are in addition to the affront to human dignity, worsened pain due to restriction of movement, and psychological trauma to the mother presented by the practice of shackling during labour.[4] Inability to adjust position as needed when faced with each painful wave of a contraction would present grave physical and psychological suffering.

The American College of Obstetricians and Gynecologists, in a 2011 Committee Opinion, denounced the use of shackles during pregnancy and labour, and wrote that restraints on pregnant women should never include those that interfere with leg movement, due to fall risk.[5] The Committee's opinion was that "physical restraints interfere with the ability of health care providers to safely practice medicine by reducing their ability to assess and evaluate the mother and the fetus and making labor and delivery more difficult."[6] Listing many of the risks identified by Dignam and Adashi above, the American College of Obstetricians and Gynecologists Committee also opined that:

Women should never be shackled during evaluation for labor or labor and delivery....

Prompt and uninhibited assessment for vaginal bleeding during pregnancy is important. Shackling can delay diagnosis, which may pose a threat to the health of the woman or the fetus....

Shackling interferes with normal labor and delivery: The ability to ambulate during labor increased the likelihood for adequate pain management, successful cervical dilation, and a successful vaginal delivery.... Women need to be able to move or be moved in preparation for emergencies of labor and delivery, including shoulder dystocia, hemorrhage, or abnormalities of the fetal heart rate requiring intervention, including urgent cesarean delivery....

After delivery, a healthy baby should remain with the mother to facilitate mother-child bonding. Shackles may prevent or inhibit this bonding and interfere with the mother's safe handling of her infant.[7]

In addition to this opinion by the American College of Obstetricians and Gynecologists, the American Medical Association in 2010 passed a resolution denouncing restraints during labour save for in exceptional listed circumstances.[8] United States courts have repeatedly found shackling during labour to be a violation of the Eighth Amendment of the Constitution of the United States prohibition against the unnecessary and wanton infliction of pain.[9] In recent years more than seventeen states in the United States have now passed legislation banning or severely restricting the practice, as a result of advocacy efforts.[10]

INTERNATIONAL LAW CONSIDERATIONS

International treaty and customary law, referenced in UN Committee and Rapporteur interpretations[11] as well as UN Statements[12] and UN

General Assembly Resolutions, outlines that the shackling of pregnant women during labour violates recognized rules of international human rights. Shackling during labour represents violation of the right to be free from violence, the right to be free from torture and other ill-treatment, the right to non-discrimination, and the right to health.[13]

Canada's relevant treaty obligations include those under the Convention against Torture (CAT), namely the prohibition of torture at article 2 and of cruel, inhuman or degrading treatment or punishment at article 16.[14] Canada is also a party to the International Covenant on Civil and Political Rights (ICCPR) and as such is bound by articles 7 ("No one shall be subjected to torture or to cruel, inhuman or degrading treatment or punishment") and 10 ("All persons deprived of their liberty shall be treated with humanity and with respect for the inherent dignity of the human person").[15] Canada is also bound under article 12 of the Convention on the Elimination of All Forms of Discrimination against Women that holds that state parties "shall ensure to women appropriate services in connection with pregnancy, confinement and the postnatal period."[16] Furthermore, the International Covenant on Economic, Social and Cultural Rights at article 12 provides that state parties such as Canada will "recognize the right of everyone to the enjoyment of the highest attainable standard of physical and mental health," including those rights necessary for the "reduction of the stillbirth-rate and of infant mortality and for the healthy development of the child."[17]

UN Treaty interpretations specific to pregnant women advise that shackling during labour is contrary to key human rights treaties. In 2006, the UN Human Rights Committee, which is the expert monitoring body for the ICCPR, specifically admonished the United States in relation to ICCPR articles 7 and 10 concerning reports of shackling of detained women during childbirth, writing that the Committee "recommends

• THE ILLEGALITY OF SHACKLING A PREGNANT PERSON IN LABOUR •

the State party to prohibit the shackling of detained women during childbirth."[18]

The Committee against Torture, the monitoring body for the CAT, in 2006 specifically referenced article 16 (regarding "cruel, inhuman or degrading treatment or punishment") in the context of its review of the period report of the United States, commenting: "The Committee is concerned at the treatment of detained women in the State party, including gender-based humiliation and incidents of shackling of women detainees during childbirth (art. 16). The State party should adopt all appropriate measures to ensure that women in detention are treated in conformity with international standards."[19] The Committee repeated its admonition with regard to the practice in 2014, stating that the Committee was "concerned at reports that, in certain cases, incarcerated women are still shackled or otherwise restrained throughout pregnancy and during labour, delivery and post-partum recovery (arts. 2, 11, 12, 13, 14 and 16)."[20]

The relevant international standards referenced by the Committee against Torture include Rule 48(2) of the United Nations Standard Minimum Rules for the Treatment of Prisoners (the "Nelson Mandela Rules"), as well as Rule 24 of the United Nations Rules for the Treatment of Women Prisoners and Non-Custodial Measures for Women Offenders (the "Bangkok Rules"). These resolutions unanimously adopted by the UN General Assembly both expressly provide that instruments of restraint "shall never be used on women during labour, during childbirth and immediately after childbirth."[21]

In 2019 the Ontario Court of Appeal (ONCA) recognized that "the Mandela Rules are an authoritative interpretation of international rules including the Convention against Torture and Other Cruel, Inhuman or Degrading Treatment or Punishment."[22] The ONCA's rationale flows

from the recognition that "the Mandela Rules represent an international consensus of proper principles and practices in the management of prisons and the treatment of those confined."[23] The ONCA further noted the history of such a consensus being reached on a number of other issues with regard to the treatment of prisoners, citing Pentelechuk J. (as she then was) in *R v. Prystay*: "Societal views on what is acceptable treatment or punishment evolve over time. Forced sterilization, residential schools, lobotomies to treat mental disorders, corporal punishment in schools and the death penalty are all examples of treatment once considered acceptable."[24]

In sum, Canada's international law obligations, particularly under the CAT and the ICCPR, bind Canada under international law to prevent the shackling of women during labour. Under the CAT, Canada is obliged by article 16 to "undertake to prevent acts of cruel, inhuman or degrading treatment or punishment," and the aforementioned Mandela Rules, Bangkok Rules, and the Committee against Torture's views are persuasive regarding the interpretation of this provision. In the light of this guidance, article 16 of the CAT is understood as obliging states to undertake to prevent shackling during labour and delivery, since it constitutes cruel, inhumane, or degrading treatment or punishment. Regarding the ICCPR, obligations on Canada from this treaty have similar wording as seen in the CAT and include that of ensuring that "no one shall be subjected to torture or to cruel, inhuman or degrading treatment or punishment" (article 7). This article should be understood in the light of the aforementioned Human Rights Committee opinion that this obligation is breached when a state permits shackling of women in labour, an opinion that also referenced article 10 of the treaty ("All persons deprived of their liberty shall be treated with humanity and with respect for the inherent dignity of the human person").[25]

Canada's obligation under international law to prevent shackling of pregnant women during labour affects domestic Canadian law via two mechanisms. First, Canada's international law obligations inform the scope of the Charter, as a minimum standard of protection as per the SCC in *Slaight Communications*.[26] Second, Canada's international law obligations shape the interpretation of Canadian law via the statutory presumption of compliance, which holds that Parliament and provincial legislatures intend to create laws in a manner consistent with Canada's international law commitments.[27] By these rationales, the Charter and relevant legislation should be understood as disallowing shackling in labour under domestic law, in order to fulfill Canada's international law treaty obligations to prevent the human rights violation of shackling during labour.

SHACKLING OF PERSONS IN LABOUR AS A CHARTER VIOLATION

As emphasized in the medical and international law discussions above, shackling a pregnant woman's legs when she is experiencing labour, as Jacquie experienced, grossly violates her human rights and dignity. It is only rationalized from a perspective that either entirely ignores or obviously minimizes what she is experiencing. I reject here any conception of a woman in labour as being inherently deserving of violence or pain (i.e., such as by being defined as a "savage" or as someone marked indelibly as a security threat) or as a subject that is by definition not experiencing this level of pain (i.e., as a default—male—prisoner who cannot experience labour, as seen through the androcentric lens).

In my experience, labour is extremely challenging. A woman in this state can furthermore be compromised from advocating for herself due to the pain she is experiencing. Moreover, what can be surreal and

unnerving about the experience, aside from the incredible pain, is the fact that all around the person in labour, everyone else is experiencing normalcy; the pregnant person alone is in an alternate experience of almost indescribable intensity. Labour and childbirth is furthermore often superficially represented in popular media and film,[28] contributing to a lack of understanding on the part of bystanders who may also lack personal experience. Childbirth is often either presented with full theatrical hysteria, or with saccharine sentimentality devoid of effort or agency on the part of the mother. It is also not common to discuss labour and childbirth with much candour in public discourse; childbirth is still a largely private and taboo topic.

The problem with leaving labour and childbirth in the shadows of popular and even policy discussion is that it is prone to being misrepresented. Any representation that a heavily pregnant person, especially during labour, presents the same calculus of restraint use as an incarcerated person who is not pregnant or in labour is wholly misguided and inaccurate. And yet, on the face of our country's enacted laws, presented below, there is nothing distinguishing the restraints treatment of persons who are in labour from those who are not. This is inexcusable from a Charter perspective, since such laws, in order to comply with the Charter, must be understood to mean that when a woman is in labour she is not to be physically restrained by metal leg shackles, or handcuffs, because she is in an extreme experience of physical pain and psychological stress, along with the fact that these pose profound medical risk to herself and her child. Shackling a woman in this situation is cruel and unusual punishment (section 12), it violates her liberty and security of the person (section 7), and it is discrimination against her on the basis of sex (section 15).

CRUEL AND UNUSUAL PUNISHMENT

For punishment to be cruel and unusual it must "outrage standards of decency," as the SCC held in *R. v. Smith*.[29] Revisiting section 12 in detail in 2022, the SCC clarified that "Section 12 protects, first, against the imposition of a punishment that is so excessive as to be incompatible with human dignity and, second, against the imposition of a punishment that is intrinsically incompatible with human dignity."[30]

Societal expectations of decency change over time and, like the lash and other now-rejected forms of corporal punishment,[31] applying metal restraints on a pregnant woman during labour and childbirth is punishment that must be now understood as intrinsically incompatible with human dignity. Recall from the preceding sections how shackling during labour presents objectionable medical risks as well as psychological and physical trauma. Recall also that shackling during labour has been unequivocally denounced at the international level, in the Mandela Rules and Bangkok Rules, as well as in expert committee interpretations of state obligations under the CAT and the ICCPR. Furthermore, not only is this a section 12 violation as regards the mother, but considering the impact that restraints have as regards the safe delivery of the child, this presents cruel and unusual treatment of the child independently of the mother, who becomes a person at birth, in a manner parallel to that discussed by the Federal Court in *Canadian Doctors for Refugee Care v. Canada (Attorney general)*.[32] It is also doubtful that shackling during labour is conduct that can be saved under section 1 of the Charter, since it is not a minimally impairing approach to proportionately meeting a state objective that can be justified in a free and democratic society.[33]

VIOLATION OF THE RIGHT TO LIFE, LIBERTY, AND SECURITY OF THE PERSON

Under Charter section 7, "Everyone has the right to life, liberty and security of the person and the right not to be deprived thereof except in accordance with the principles of fundamental justice." This is a powerful provision that requires detailed analysis. It must be identified whether the state action (of shackling during labour) interferes with life, liberty, or security of the person and, if so, whether that interference is inconsistent with the principles of fundamental justice. Shackling is an interference with a woman's liberty (as a physical restraint)[34] and her security of the person (as an interference with her physical and psychological integrity).[35] The impact on a woman's liberty and security of the person in this context is also serious enough to constitute a deprivation.[36]

Determining whether this deprivation is not in accordance with principles of fundamental justice, such as because it is overbroad or grossly disproportionate, will depend in part on an assessment of the purpose of the state action. While legislative language varies among jurisdictions, the purpose of allowing wide discretion to use restraints on persons who are incarcerated is generally to promote order and control, with some specific mention of avoiding escape or injury.[37]

Depending on how broadly the state's legitimate objective is cast, using restraints on a person in labour is an example of either overbreadth or gross disproportionateness. Regarding the former, as the SCC held in *Bedford*, "Overbreadth deals with a law that is so broad in scope that it includes *some* conduct that bears no relation to its purpose. In this sense, the law is arbitrary *in part*. At its core, overbreadth addresses the situation where there is no rational connection between the purposes of the law and *some*, but not all, of its impacts."[38] If the state's objective

is cast as deterring escape or assaults, then there is a rational connection between shackling some prisoners and deterring escape (it prevents some who would run from doing so), so the law is not arbitrary. However, it is arbitrary in some of its applications, meaning it is overbroad: it catches "some conduct that bears no relation to its purpose."[39] There is no real risk a person in labour will escape (one can scarcely walk while in labour), so shackling the person to prevent escape is not rationally supported. Moreover, if the objective is to deter assaults against guards, again, given the physical exertion of labour, it seems doubtful that a labouring woman could reasonably present such a physical risk to those around them that restraints are required. The measure is overbroad: some prisoners may assault and need to be shackled; but not all prisoners (e.g., labouring prisoners) will assault and need to be shackled.

If the state objective is permitted to be broadly cast, such as relating generally to order and control in correctional facilities, the act of shackling women in labour is an example of state action that is "disproportionate to any legitimate government interest."[40] The harmful effects to women (and their infants) which flow from shackling during labour, in the form of elevated medical risks, physical and psychological suffering, as well as affront to human dignity, are grossly disproportionate to the state objectives of order and control.

Violations of section 7 are not always regarded as being entitled to potential justification under section 1, but in the event that such analysis was required it is likely that this state action would not be saved under section 1. This is a situation in which a more tailored policy (e.g., excluding women in labour from shackles, or using alternative security measures) would deal with the problems posed by overbreadth or gross disproportionateness. There is no enforcement impossibility or other consideration that prevents the development of a narrower policy.[41]

A blanket policy lacking exemptions for women in labour is not the least rights-impairing way to achieve the goals of maintaining order and control or deterring escape or assaults.[42]

EQUALITY RIGHTS UNDER SECTION 15

Shackling during labour also violates the Charter's guarantee of equality, namely as regards its adverse effects on a members of a protected group.[43] The SCC has long regarded discrimination on the basis of pregnancy as constituting discrimination on the basis of sex.[44] Equally applicable rules, namely those concerning the use of restraints on all incarcerated persons, are being applied in a way that has an adverse impact on pregnant persons. The disproportionate impact at issue here takes the form of elevated medical risks, violation of human dignity, and physical and psychological pain being placed on pregnant persons due to the use of restraints on them during labour.[45] Indeed, the medical risks posed to parent and child if leg restraints or handcuffs are used on a pregnant person even when they are not presently in labour also raises section 15 concerns.

In addition to showing the disproportionate impact of a seemingly neutral law on a protected group, to establish a section 15(1) violation due to adverse effects it must be shown that the impact has the effect of reinforcing, perpetuating, or exacerbating disadvantage.[46] Here the ill-treatment of women during labour and childbirth perpetuates a long-standing source of disadvantage to women, namely their subjection to physical and psychological violence and control, as well as an inability for their status as childbearing persons to be appropriately accommodated in public policy. The over-representation of Indigenous women within the broader population of incarcerated women is also relevant to this section 15 analysis.[47] As is the case with the section 1 analysis

undertaken as regards section 7, above, it is doubtful that this discrimination is demonstratively justifiable in a free and democratic society given that the application of shackles on a person in labour is not a minimally impairing approach to pursuing the relevant state objective.

CURRENT LEGISLATIVE FRAMEWORK

Having established how the act of shackling a person during labour violates her Charter rights and Canada's international law obligations, it is useful to reflect on the current treatment of restraints use in provincial, territorial, and federal laws. There is no direct treatment of pregnant women and restraint use in corrections legislation or regulations themselves in Canada, save for in Ontario, where legislation has been passed but not yet enacted (as of January 2024) that prohibits the use of restraints on women in labour.[48]

For five jurisdictions, namely BC, Alberta, Saskatchewan, New Brunswick, and within the Federal system, I was able to access policy directives that appear to discourage the use of restraints on women in labour, and for some on pregnant persons generally.[49] I had sought documentation from all jurisdictions, and administrators in Prince Edward Island, Nova Scotia, and Manitoba responded to my query by stating that while they had no formal policy on the matter, they would never place restraints on a person in labour. This leaves six jurisdictions, Ontario, Quebec, Newfoundland and Labrador, Northwest Territories, Yukon, and Nunavut, for which I could identify no formal or informal assurances, policy directives, or legislation presently in effect denouncing the practice. It also bears stating that policy directives, such as operations manuals, that proscribe the practice, while encouraging, should not be overstated in their weight. Administrative actors cannot fetter their own discretion, and

these policy documents do not create legal obligations in themselves.[50]

What then is the legal scope and status of corrections laws concerning the use of restraints on women in labour? Where there is ambiguity in their interpretation, statutes can be interpreted in a Charter-complaint manner, namely one in which women in labour are excluded from a default staff empowerment to shackle.[51] They can also be interpreted according to the presumption of intended compliance with Canada's international law obligations, recalling that shackling during labour is understood to violate the ICCPR and the CAT.[52] Most corrections laws do not create pure discretion on the part of prison administrators in shackling decisions, such that the legal analysis remains focused on the enabling statute itself, and not on the individual administrative decisions relevant to shackling.[53] If challenged in Charter litigation, such corrections statutes can be remedied by being read down as including a prohibition on placing restraints on persons in labour, in order to ensure that legislation does not violate the Charter rights outlined above.

Legislation relevant to shackling women in labour is thus unconstitutional to the extent that it appears to allow guards to place restraints on persons who are in labour. It is advisable therefore that relevant ministries issue clear interpretive documents to personnel directing them to not shackle women in labour, in order to ensure that a Charter-compliant understanding of the statute is the version being acted upon. Aside from statutory validity considerations, an incarcerated person who experiences labour in shackles would also be entitled to claim for damages under section 24 of the Charter for this egregious violation of their constitutional rights.

HOW the LAW PROTECTS a NEWBORN from AUTOMATIC SEPARATION from THEIR MOTHER

A CENTRAL QUESTION REMAINS: IF COLONIAL LENS AND ANDrocentric lens expectations are rejected in legal system communications, is automatic newborn-mother separation actually legal in Canadian and provincial law? A review of how Canadian law views denying a newborn their mother's care without an individualized review of the circumstances by public authorities reveals that this practice is clearly inconsistent with the Charter rights of the infant and violates Canada's international treaty obligations.

The practice assessed here is as follows: A child is born and is taken from his or her mother's care, *without any state decision-maker actively reflecting*

on this act of separation. Usually, the newborn is apprehended by child protection authorities and placed in foster care. This can include group home care with shifting caregivers. Once the mother is released, she can apply to have her baby back, but time will have passed and the child's attachments to his or her foster caregivers may militate against return to his or her mother. Furthermore, this will likely occur after a key window of bonding and development has passed, to the detriment of the newborn's health.

This mechanism of separation and apprehension is strikingly thoughtless. It is as if no one in the legal system has yet considered what this practice of haphazard denial of a birthing parent's care might bring to the newborns affected. It is time to include reflection concerning the newborn affected in the legal system's process, especially to include in the legal system a consideration of the health impacts of this separation on the newborn.

Medical experts agree that infant-mother separation is a highly consequential act from the newborn's perspective, including with respect to how bonding disruption relates to risk of psychiatric ill-effects.[1] Internationally renowned child psychologist Penelope Leach outlines the contemporary scientific consensus regarding newborn attachment and brain development:

> Although we have known for several decades that attachment relationships are of the utmost importance for infants' physical and psychological well-being, recent neurological research has demonstrated that the quality of the caregiver-infant bond directly influences the development of brain structures that are responsible for social and emotional functioning throughout our lives....
>
> Much more human brain development occurs *outside* of the womb (compared to all other species). Human children undergo

an unusually long period of complete dependency, necessitating intense and long-lived social bonds between caregivers and offspring. And the quality of brain development in the early months and years of life is shaped to a significant degree by the nature of these intense social bonds. Although at birth the baby's brain has all of the neurons (brain cells) that she will ever need, she now needs the loving human attention that will stimulate her brain cells to make rich and "intelligent" connections with and between different regions of the brain....

For optimal growth and development, the human brain requires a balance between different biochemicals. Positive, enjoyable interactions with parents—especially with mother—encourage that balance. Early positive experiences produce increased glucose metabolism, which in turn stimulates the development of neuronal connections. A chemical called norepinephrine plays an important role in our ability to concentrate and maintain sustained effort. Infants who have experienced neglect or separation from their mothers tend to have low levels of norepinephrine.

The capacity for pleasure and optimism depends on the number of dopamine and opiate receptors that develop in the baby's brain, especially in the prefrontal cortex. A baby who has lots of warm, rewarding contact with mother will form more dopamine synapses.... A baby who is deprived of affectionate early contact with his mother, and therefore lives with high levels of stress, will have a permanent scarcity of dopaminergic neurons because stress hormones, such as cortisol, effectively "turn them off."[2]

The state-sanctioned act of removing a newborn from his or her birthing parent's care, without an accountable determination as to what

this means for the newborn, must be understood as an act of serious deprivation, given current medical knowledge of child development.

Automatic newborn-mother separation raises two main topics in law: process obligations and substance obligations. On process, obligations held by Canada are being breached by both judges and corrections authorities when a child is separated from his or her mother without consideration of the child's interests as a primary consideration, and without basic due process. Both international law and the Charter place a process requirement on state actors when they act to affect a person's rights.

Substance obligations refer to the content of the child's legal rights and best interests that the state actor must consider during its fulfillment of process obligations. I consider process and substance obligations below, first in the context of correctional authorities' conduct and then as regards the sentencing courts.

CORRECTIONAL AUTHORITIES

On process obligations, the law is clearly supportive of the newborn's right to not be arbitrarily denied their mother's care, both under international human rights law and according to Canada's obligations under the Charter. Denying a newborn the opportunity for sustained bonding with a primary nurturer is an action that poses significant physiological and psychological ill-effects, which are both immediate and lifelong, and process obligations attach to this action.[3] This action implicates the newborn's basic human rights, namely the child's rights to health and to family, each protected under the UNCRC, which Canada has ratified.[4]

When this separation occurs, without review by the state of the child's circumstances, this is a violation of Canada's obligations under article 3 of the UNCRC to consider the best interests of the child as a primary

consideration in state decisions that affect the child.[5] Canada's UNCRC obligations affect Canadian law through the interpretive presumption of statutory compliance as well as the role that international law obligations have in informing minimum standards of Charter protections, discussed in the preceding section.[6] For instance, according to the statutory presumption of compliance, domestic statutes governing the conduct of correctional authorities should be interpreted as obliging personnel to consider the best interests of a child who will be affected by a corrections decision; this would include a decision whether or not to allow the newborn child to remain under the care of his or her mother.

A newborn's removal from his or her mother, without any review by the state of the child's individualized circumstances, is also a violation of the child's constitutionally protected right to security of the person under section 7 of the Charter.[7] The physical and psychological integrity of the newborn is clearly affected by a decision that denies a mother's care, constituting an interference with the child's security of the person.[8] This interference is not in accordance with principles of fundamental justice because it is a decision made without fair process.[9] The content of fair process obligations under the Charter is contextually determined, including the level of importance of the decision to the individual affected.[10] Here there is in fact *no* process of decision-making, since the separation is automatic, presenting an unequivocal breach of the fair process obligations that apply in state decisions affecting a person's section 7 interests.

To summarize, if corrections ministries automatically separate newborns from their mothers without considering the best interests of the child as a primary consideration, this is a prima facie breach of UNCRC article 3 and places Canada in violation of its international law obligations. The statutory presumption of compliance requires that legislation

relevant to corrections' actions be interpreted as requiring corrections to act in a manner compliant with the UNCRC, meaning that the child's best interests should be considered as a primary consideration.[11] Aside from the UNCRC, Charter protection of a person's right to due process (under section 7) is also violated by newborn-mother separation as automatically completed by corrections agencies.

Since correctional authorities are required to consider a child's interests as a primary consideration before separation, the possibility of a child and mother staying together must actually exist, since otherwise the consideration process is disingenuous and incompatible with the object and purpose of the UNCRC and the Charter's protection in relation to due process. Since the UNCRC and the Charter require consideration of a child's interests and rights before separation can occur, this rationally requires the possibility of non-separation as a possible outcome of good faith decision-making that provides due process.

In other words, compliance with the UNCRC and the Charter requires that correction procedures provide a real possibility of accommodating young infants with their mothers as part of the good faith process of considering the interests of children in a non-arbitrary fashion. This requires that policies are put in place to accommodate infants as the need arises. Indeed in 2018 a UN Special Rapporteur specifically called on Canada to institute better accommodation for mothers and infants in correctional facilities.[12]

I now consider the substantive content that state actors such as those in corrections ministries must consider in the course of meeting their process obligations. This includes an assessment of the child's best interests, such that these can be considered as a primary consideration by the state decision-maker. The child's relevant human rights and his or her Charter rights require consideration as well. Concerning the latter,

the denial to the newborn of his or her mother and the opportunity for bonding is such a significant act, particularly from a health perspective,[13] that it engages an infant's section 7 (security of the person) and section 15 (equality) rights, as the BC Supreme Court identified in *Inglis*, after extensive expert evidence.[14]

Security of the person includes emotional and psychological security, and denying a child the building blocks for mental health throughout his or her life is an interference with the child's security of the person.[15] Analysis in this area requires identifying the purpose of the government measure that offends the security interest.[16] In *Inglis*, one government purpose at issue was an attempted guarantee of infants' safety by barring them from residing with their mothers in custody.[17] A similar characterization might be made by a ministry that was seeking to continue automatically separating all newborns from their mothers, although the court in *Inglis* found a full guarantee of safety to be an inappropriate and unacceptable government standard.[18] Separating a newborn from their mother, when she is willing and able to care for the child, considering the health impacts of disrupted bonding, would in the vast majority of cases appear to be an arbitrary, overbroad, and/or grossly disproportionate violation of the child's section 7 right to security of the person.[19]

The decision to permit a child to remain in his or her mother's care must furthermore be informed by the human rights treaties that Canada is bound to under international law, including those guaranteeing the aforementioned child's right to health,[20] right to a family[21] (particularly considering that the family is a fundamental unit of society),[22] and the obligation not to discriminate against women and to make special provisions for pregnancy and post-natal care.[23] In addition, the United Nations Declaration on the Rights of Indigenous Peoples is directly

relevant and should be brought to bear in deliberations considering an Indigenous newborn's right to bond with his or her mother.[24]

On a practical level, it bears note that newborn children themselves often require very little in the way of special equipment. If nursing is established (although the lack thereof should not devalue the merit of a mother in providing care and bonding for her child),[25] then very little is needed initially beyond a car seat, diapers, sleepers, and a playpen or bassinet. Experiences suggest that a baby is in fact a positive addition to the custodial environment and provides a calming and purpose-bringing presence.[26]

The converse of allowing newborns to stay with their incarcerated mothers, namely the practice of automatic separation, is dire in terms of the environmental situation created. This policy causes women to face severe risk of depression, due to the shock and trauma of having one's baby removed from one's care without regard to the biological and emotional drive to care for that child.[27] In addition, the rehabilitation purpose of corrections agencies is entirely frustrated if it involves the infliction of the additional trauma on the mother of forcing her to abandon her newborn. But the most problematic result of automatic separation is its serious infringement on the rights of the newborn, including the child's right to health, family, and security of the person (including fair process), especially since the disruption of infant bonding has immediate and lifelong negative effects on the child's health and development.[28]

The logistics of avoiding automatic newborn-mother separation, by accommodating newborns as needed, are thus not unduly complex or onerous, and indeed present the benefits of reducing trauma and mental health risks within the population of incarcerated persons. The widely endorsed expert Guidelines for Mother-Child Units in Correctional

Facilities can guide the policy shift towards ending the rights-violating practice of automatic newborn-mother separation.[29] The decades-long accommodation practice in BC, albeit if reportedly underutilized in recent years, and facility-level accommodation in the NWT, along with extensive international practice, particularly in Europe,[30] show practical examples of newborn accommodation.

In order to bring corrections agencies across Canada into compliance with Canada's international law obligations, particularly with regard to the child's right to health, as well as for corrections authorities to ensure respect for a child's Charter rights to security of the person and equality, the practice that requires all incarcerated mothers to leave their newborns at the hospital and return to jail to recover from childbirth alone must be jettisoned by those Canadian provinces and territories that still lack infant accommodation policies. Instead, a simple choice can be made to allocate space in the system for the newborn such that he or she can be cared for by his or her birthing parent. This can be an act made in contemplation of the newborn's best prospects for healthy development. That being said, non-carceral sentencing options are often even better positioned to serve the child's best interests than are custodial sentences, as discussed below.

SENTENCING COURTS

Having considered the corrections context, I turn now to courts as state actors. A judge faced with sentencing (or gaoling) a pregnant woman, or indeed a mother with a young dependant child or children, has a clear legal duty to consider the interests of the child affected, indeed as a primary consideration. The judge has a procedural obligation to fulfil and substantive rights of the child to consider.

Similar to the corrections context, the judge's procedural obligation here comes from UNCRC article 3 and the Charter, in particular section 7. A failure to consider the impact of sentencing on the child, including the impact of automatic newborn-mother separation, is a breach of UNCRC article 3 (as the Committee on the Rights of the Child has repeatedly stated),[31] and of Canadian law, since according to the interpretive presumption of compliance the law governing judicial determinations is meant to be read in a manner consistent with the UNCRC as a treaty ratified by Canada.[32] Similarly to the corrections discussion above, it is also a breach of the child's Charter rights, and especially as regards protection of a person's due process rights under section 7.[33]

In the case of a pregnant woman, it is no bar to the judge's consideration of the child's future interests that the child is not yet a legal person, since the interests at issue are not the rights of the fetus but concern the *future* rights of the unborn child, similar to the situation in law when a baby is able to sue third parties in negligence for conduct experienced in the womb.[34] The judge does not have to base a decision on the present rights of the child, but can seek and secure assurances of fair process and possible newborn accommodation in order to address what would otherwise be a highly likely future rights infringement, since sentencing to automatic separation will leave no space in the system for due process. Similarly, the future rights of the child can guide the judge to consider available non-custodial options, just as the current rights of children that a mother is a caregiver to may require consideration, including potential selection of non-custodial sentencing options. Moreover, in the context of automatic separation, a child's interests are largely aligned with his or her mother's since she, too, faces a risk to health (especially of postpartum depression) from the practice of automatic separation. That said, the threat to health faced by the newborn is more severe.

Concepts like collateral effects,[35] caregiving obligations,[36] and sentences appropriate to Indigenous persons are relevant to sentencing law and practice in their own right and have clear potential relevance to the sentencing of a pregnant woman or a mother of a young child or children. However, these concepts are no substitute for distinctly considering the rights of the child as per the state obligation found in the UNCRC. Where separation is imminent if custody is ordered, consideration of these concepts is also not a substitute for direct judicial consideration of this impending separation in the manner needed to fulfill due process requirements under Charter section 7. (Separation from his or her mother upon birth impinges upon the child's security of the person and this ought not to occur without fair process.) The child's interests and rights thus merit their own transparent analysis and should not be collapsed in with the sentencing considerations of the mother.

The child and the mother are not the same person, yet both of their positions must be equally addressed by the state. The unique context of this undertaking is the reason why the Italian Ministry of Justice has a memorandum of understanding in place (renewed in 2016) with the National Ombudsperson for Children and Adolescents, which asks judges to consider the rights of dependant children as may be affected in judicial sentencing and pre-trial determinations.[37] As a further example of addressing this distinct legal situation, South Africa's Constitutional Court has upheld the notion that a mother's sentencing should take into account its effects on her children.[38] Distinction between the sentencing of the mother and the interests of the child must be made in the court, for clarity of analysis, for fairness to the child, and for the completeness of consideration of the child's best interests as a required primary consideration of the state decision-maker.

Fairness and clarity of analysis also requires that any suggestion, by the prosecutor or any court actor, that the woman is pregnant "on purpose" in order to affect sentencing, should be wholly rejected by the court. The reasons for this necessary rejection are twofold. First, this suggestion is highly prejudicial to the woman and impugns her values and commitment to her child. It is a suggestion that she is an unfit mother and that the court should sentence her to separation from her child, through the implicit pre-judgment that is presently common and that was initially experienced by Jacquie. Second, this is an obvious application of the androcentric lens which regards all accused persons as properly having to fit a male mould, and which sees pregnancy and motherhood to infants as an abnormal and unnatural state that should not be accepted as a natural experience. As mentioned, 85 percent of women in fact give birth at some point.[39] Pregnancy and childbirth is a normal part of human existence, and it is unacceptable to denigrate women for being pregnant and to deny them and their children appropriate treatment in law.

A child is not the same person as its mother once it is born; the state should have no interest in punishing a child for what a mother has done, and in fact it would be an abuse of the child's rights to do so. A woman's sentence must necessarily consider a balancing of sentencing objectives with a child's interests and rights. An androcentric lens which obscures the distinct legal personality of mother and child must be discarded. It is wrong in law to collapse a child's existence (and rights) into an assessment of a mother's offence. A court must transparently consider both lines of analysis (i.e., offence sentencing on the one hand as compared with a child's rights and interests on the other) in a distinct fashion before making an ultimate sentencing decision. The Bangkok Rules, unanimously adopted by the UN General Assembly in 2010, give

sensible direction to courts on how to achieve this: "Non-custodial sentences for pregnant women and women with dependent children shall be preferred where possible and appropriate, with custodial sentences being considered when the offence is serious or violent or the woman represents a continuing danger, and after taking into account the best interests of the child or children, while ensuring that appropriate provision has been made for the care of such children."[40]

Therefore, the way for judges to proceed in a manner that is consistent with the UNCRC is to outline the best interests of the child, taking into account the child's age and important characteristics such as health and developmental needs, and to consider how the child's interests would be affected by the variety of sentencing options available to the court. As the Committee on the Rights of the Child put it, the UNCRC requires that state courts take "full consideration of the likely impacts of different sentences on the best interests of the affected child or children."[41] The court should be cognizant of punitive but non-custodial options such as house arrest and/or electronic monitoring.

Substantively speaking, then, when considering the likely imposition of newborn separation from a mother, the child's security of the person (including a right to health and psychological security) and right to equality are rights which require review by the court.[42] Particularly when dealing with a newborn, for whom bonding is a vital health requirement, these rights require due consideration.

In sum, with respect to the issue of separating a mother from her young child or children, both correctional actors and courts have clear process obligations, namely under the UNCRC and the Charter. On the substantive side, correctional agencies and courts must also give weight to a child's interests as well as the rights of the child or children affected. Separation triggers the child's rights under international human rights

law (including the right to health and to family), under human rights legislation (e.g., Human Rights Codes relating to discrimination), and under the Charter (particularly as regards the child's right to security of the person and right to equality under sections 7 and 15).

CONCLUSION

Whether directly expressed or not, arguments concerning what the law is or how it should operate will have as their basis a particular theoretical understanding of law, or a combination of such theories. Theories of law, or about law, are manifold, stemming from schools of thought in politics, philosophy, and social science, among many others. For example, from an Anglo-European cultural and scholarly standpoint, an argument that characterizes adherence to law as being the price one pays for living in civilization evokes conservative political theory, such as the writings of Edmund Burke and Thomas Hobbes. An argument that idealizes law's protection of individual liberty is likely relying on liberalism for its orientation, for instance the reasoning of Thomas Locke. Calls for the operation of law to be consistent with higher moral norms are often aligned with the natural law tradition in legal philosophy. As a further example, when persons denounce how the letter of the law is being broken in a particular instance, they are likely relying on a positivist understanding of law, which regards the appropriate enactment of the law to be the source of its legitimacy.

What I contend in this book is that the rights to due process of mothers and babies are being grossly violated by the Canadian state. At root,

this resembles a liberal argument; I am regarding law's purpose and justification as being the safeguarding of liberty among people in society. If as a child you are arbitrarily removed from your mother by the state, this is a tyrannical act that exceeds the measured power that liberalism grants to the state. My argument is further that this state behaviour is indeed illegal according to our own country's doctrinal law, especially constitutionally protected due process rights. I am thus employing a positivist approach in my argument as well. The preceding chapter has outlined the relevant legal analysis.

But liberalism and positivism alone do not explain *why* the Canadian state is violating the rights of mothers and children. For an explanation of why the legal system operates in the way that it does, I have turned to scholarship from fields including the sociology of law, critical race theory, and critical Indigenous legal scholarship. Regarding the sociology of law, I employ Niklas Luhmann's systems theory of law; Luhmann theorized law to be an essentially amoral social system comprised of matching communications regarding what is expected to be "legal" vs. "illegal." I have charted the legal system communications at play in automatic newborn-mother separation.

Concerning critical race scholarship, I have relied on Sherene Razack's analysis in which she historicizes Canadian legal processes as well as identifies how particular spaces ("spatial categories") are coded in communications as to whether or not universal justice norms are in effect with regard to such spaces. Concerning scholarship that critiques Canadian law from Indigenous perspectives, I have turned to the writings of Patricia Monture, and others, who detail the Canadian legal system's pursuit of colonial objectives over the rights and humanity of Indigenous peoples.

I have used systems theory to argue that the Canadian state is violating the rights of certain mothers and children because legal system

• CONCLUSION •

actors are following prejudicial norms that *direct* such acts of rights violation. What is insidious about this directive within the legal system is that it is not spelled out in its entirety. It is communicated by the implied and overlapping meanings of spatial constructs. Put simply, it is not that there is a clear directive that all newborns born to incarcerated persons are disentitled from basic bonding with their birthing parent, for expressly declared reasons. Instead, the directive is contained in the implied meanings of spatial categories that are communicated regarding: the Indigenous woman, the court, the prison, and the Indigenous child.

All of these spatial categories together (and individually) have constructed weight that communicates the message that it is acceptable—indeed required—for the legal system to act in the way that it does. On top of the spatial categories that communicate colonial ideological assumptions, the spatial categories that share reinforcing messages based in patriarchal ideology are also communicated to direct this practice, namely: the accused in sentencing (constructed as conforming to a cis male model), the prisoner in jail (also male), and the good mother (who is "pure" and who belongs in the private sphere of home).

Luhmann's theory gives a guide as to how the prejudicial norms at issue may be disrupted and rendered impotent within the system. Since the theory postulates that the legal system is made up of matching communicated expectations as to what is "legal" vs. "illegal," all that needs to happen is that in individual communications amongst relevant actors in the legal system (e.g., judges, counsel, corrections personnel), the expected norms communicated must be changed to reflect those that are consistent with the due process rights of mother and child. For instance, in the sentencing process, rather than communicating the norm that a pregnant Indigenous woman will be worthless as

a mother to the health of her coming child, such that separation automatically at birth is acceptable, the norm that can be communicated is that a pregnant Indigenous woman will be potentially of great value as a mother to the health of her coming child, such that separation at birth would only be acceptable if done for a compelling reason following due process. Once the implied worth of an Indigenous woman as a mother is changed in the expected communications in the courtroom, towards her being defined as potentially having great value to her coming child, then the rest of the legal system communications will change accordingly, and space can be made in the system to consider her child's interests.

Much of this book has thus been concerned with making express the problematic and prejudicial norms that are employed implicitly and explicitly in those quarters of the legal system that are enacting the automatic separation of mother and newborn; they are also evident in other examples of the legal system's operation, including the Stanley acquittal. These norms are identified here so that in practice they can be acknowledged and rejected as having no place in a fair legal system. I analyze Jacquie's experience under Canadian legal process and have identified instances in which norms based on colonial racism that devalue Jacquie and her son Yuri were inserted into legal communications by reference to spatial categories. I have called these norms colonial lens norms because they are based in a colonial ideology of Anglo-European entitlement and white racial superiority.

In addition to colonial lens norms, patriarchal male-centric ideology is the root of several other assumptions that I identify and refer to as androcentric lens norms. These are available as an overlay to the colonial lens norms, and the two sets of norms can be referenced simultaneously or independently in legal system communications,

• CONCLUSION •

unless they are identified as invalid and are rejected in legal system communications.

When the belief structures that underlie settler colonialism and heteropatriarchy are examined in close detail, it becomes evident that these are perhaps not distinct ideologies at all, but are in fact just different places of emphasis within one common and overarching ideology. The colonial lens and the androcentric lens have different norms associated with their respective biased ways of seeing, but each such lens is just telling a different part of a unifiable and dehumanizing story: that of endeavoured domination and dispossession through heteropatriarchal, colonial assumptions.[1]

The colonial and androcentric lenses do not need to be part of the legal system in Canada. The system can value women, infants, and parenthood in a way that creates a more positive future for all involved. When Nelson Mandela came to power in South Africa, one of his first actions was to release all the women sentenced for non-violent offences with children under the age of twelve years from jail, to facilitate children's care.[2] He knew that this was an important step in moving the society forward and healing it from apartheid.

For reconciliation to happen in Canada, the beliefs which have underpinned and legitimized inhumane practices of Canada and its legal system and institutions have to change sufficiently for new expectations and practices to emerge. Indigenous parenting must become valued by Canada. Indigenous women must become valued by Canada. Canada indeed must face and accept its responsibility for causing the over-incarceration of Indigenous persons, allowing this practice to end.

Jacquie's experience shows that court process and correctional policy in Canada still need to realize a considerable value shift towards more respectful treatment of Indigenous people by the legal system

and towards ending the assumptions that have underpinned Canada's imposition of residential schools and other policies towards Indigenous children. It is evident that the inherent value of an Indigenous woman as a mother, even to her newborn, merited no consideration by a judge in sentencing.

Canada, as a society, has actively and deliberately dehumanized Indigenous peoples for many years to justify colonization of this land, and there is inertia against now duly extending the rule of law to Indigenous children and their families. The tropes of the "dying" and the "savage" are still present in wide swaths of the legal system as it interacts with Indigenous persons. This shadow of colonial oppression by law will retreat as the norms that perpetuate it are rejected by actors and actions in the legal system.

Every day, people around the world judge each other, often unfairly, over trivial things. We stigmatize each other according to any number of biased criteria, and our societies stumble on with human thoughts and actions influenced by racism, ageism, and sexism, among other prejudices. It is one thing, however, for bias to take the form of silent personal judgment without overt action. It is another thing entirely for bias that is animated within the legal system to drive public policy and court decisions as they relate to newborn children, affecting the entire trajectory of these children's lives.

Remedying this requires changes in administrative policies within corrections ministries. If incarceration is judged necessary, there must be somewhere for a woman to go, with her child, after she gives birth and is released from hospital. There are already facilities within corrections ministries that accommodate women with children, and many more could do so. Corrections civil servants, if their ministries are serious about reconciliation, need to adopt the policies needed to ensure that

CONCLUSION

pregnant persons can be moved to suitable facilities, be they halfway houses, family treatment centres, or healing lodges.

Pivotal to this required policy shift is a need for communications in courts, corrections, and elsewhere to show a rejection of androcentric lens norms, especially those that misconstrue the ability to care for an infant as an optional privilege, and instead consider the situation from the infant's point of view. This is a shift that will happen if a critical mass of people publicly reject the still prominent conception that infant care is not "real" work. To the contrary, it is deeply demanding work that contributes to society. Here the goal is to accommodate the child and to permit the mother to fulfill her abilities, not automatically enjoin her from doing so. Instead of arbitrarily assuming that a mother is worthless at her job, those with power in the situation can take the time to reflect on the value she actually has, especially to her infant.

While providing for mothers and infants together in correctional facilities would stop the obvious injustice of removal from occurring, it is actually a stop-gap measure. The real solution is for all involved in the criminal sentencing process, especially the lawyers and judges, to end the façade of androcentrism and stop the pretense that sentencing a pregnant person is the same as sentencing a cis man. Even though the child is not yet born, a just sentence cannot be delivered if it is based on wilful blindness to the profound effects it will have on a child. All need to stop pretending that they are not passing judgment on the woman's value as a mother when ignoring her pregnancy in sentencing. When a pregnant woman with three months remaining in her pregnancy is sentenced to thirteen months in jail, and it is put openly to the court that the child is not permitted in jail and the baby will be removed from the mother, the obvious cannot be ignored: the newborn is being sentenced, as well as the mother, to automatic separation. It should no longer be

acceptable in Canadian law to punish a child for something they did not do. This extends to a need for greater acknowledgement in Canadian law of the damaging impacts of caregiver sentencing on children who are indeed already born.

What has to change are the communicated expectations of those operating in the legal system, including instances of silent acquiescence. About twenty years ago, a decades-old Saskatoon police practice of abandoning Indigenous persons away from urban centres to freeze in the cold was eventually broadly denounced, once it was publicized and rejected. Similarly, every lawyer, judge, or civil servant faced with a mother about to be unfairly devalued, or a child whose rights to due process and to health are about to be unjustly violated, has the power to act to reject the norms underpinning this practice. Automatic separation is not a valid part of the legal system—it breaches the United Nations Convention on the Rights of the Child and the Canadian Charter. Just like the break from past practice occurred for Yuri, thanks to the willingness of corrections and Ministry of Justice personnel to reflect on a child's best interests, when prompted to do so, this practice can be ended by those with proximity to it. It can be ended by those in the courtroom rejecting the fallacy that it is acceptable to punish children. Access to information requests show that automatic separation is happening to dozens of children every year in Canada, and this inexcusable practice can and should be halted immediately.

The legal system exists only as we make it. Legal principles are present in Canadian law to support rejection of automatic newborn-mother separation, namely the constitutional right to fair process and the state's obligation to consider a child's best interests. As soon as the colonial and androcentric lenses are stripped away, these principles of law appear and guide the legal system away from automatic newborn-mother separation.

CONCLUSION

This book thus does not propose radical changes. I am reasoning within existing doctrine and simply propose that we, within the legal system, treat newborn children born to incarcerated mothers as persons entitled to the rule of law.

ACKNOWLEDGEMENTS

This book could not have been written without the extreme generosity of legal scholars at the College of Law, University of Saskatchewan, and elsewhere, along with that of several practicing and retired lawyers. Thank you to everyone who read drafts, explained novel areas of the law to me, and who encouraged this work, even as it was still revealing itself to me. I am unable to list everyone who was vital to the project but would like to acknowledge particular debts of gratitude to Sarah Burningham, Mark Carter, Felix Hoehn, Harold R. Johnston, Jaime Lavallee, Ken Norman, Michael Plaxton, Jamesy Patrick, Tim Quigley, Ben Ralston, Lucinda Vandervort, and Barbara von Tigerstrom. All errors remain my own. Thank you also to my many research assistants who were invaluable in this project. I also thank the peer reviewers, and persons at the University of Regina Press, for guiding me with clarity towards improvements.

 I thank C., M., and L. for their brilliance and courageousness. I thank my husband and my children for keeping me grounded and bringing me joy. I thank my dad, stepmom, and brothers for their love, support, and joie de vivre. I am grateful to my extended family and my friends for all their support. My ruthless but jolly volunteer editor (and mother) also

deserves special mention: Thanks for the amelioration! I finally thank Jacquie for believing in this project and for always reminding me with her notes and pictures how important it is to seek to choose positivity and growth in one's actions and thoughts.

APPENDIX
CANADIAN FEDERAL/ PROVINCIAL/TERRITORIAL MINISTERS of JUSTICE (2023)

Jurisdiction	Justice Minister	Gender	Link (as of June 26, 2023)
Alberta	Mickey Amery	Male	https://www.alberta.ca/justice-and-solicitor-general.aspx
British Columbia	Niki Sharma	Female	https://news.gov.bc.ca/ministries/attorney-general/biography
Manitoba	Kelvin Goertzen	Male	https://www.gov.mb.ca/minister/min_justice.html
New Brunswick	Hugh J.A. (Ted) Flemming	Male	https://legnb.ca/en/members/current/40/flemming-hugh-ja-ted
Newfoundland and Labrador	John Hogan	Male	https://www.justice.gov.nl.ca/just/department/minister.html
Northwest Territories	R.J. Simpson	Male	https://www.ntassembly.ca/meet-members/mla/rj-simpson

Nova Scotia	Brad (B.J.) Johns	Male	https://nslegislature.ca/members/cabinet/attorney-general-and-minister-justice
Nunavut	David Akeeagok	Male	https://www.assembly.nu.ca/node/6492
Ontario	Doug Downey	Male	https://www.ontario.ca/page/meet-premiers-team
Prince Edward Island	Bloyce Thompson	Male	https://www.princeedwardisland.ca/en/employee/thompson-bloyce-2
Quebec	Simon Jolin-Barrette	Male	https://www.assnat.qc.ca/fr/deputes/jolin-barrette-simon-15359/index.html
Saskatchewan	Bronwyn Eyre	Female	https://www.saskatchewan.ca/government/government-structure/ministries/justice
Yukon	Tracy-Anne McPhee	Female	https://yukonassembly.ca/member/tracy-anne-mcphee
Canada	David Lametti	Male	https://www.justice.gc.ca/eng/abt-apd/min.html

BIBLIOGRAPHY

Abbott, Laura Jane. "The Incarcerated Pregnancy: An Ethnographic Study of Perinatal Women in English Prisons." DHRes thesis, University of Hertfordshire, February 2018. https://pdfs.semanticscholar.org/f333/763630484431e574ff07b09490b654f51c40.pdf.

Acker, Joan. "Jobs, Bodies: A Theory of Gendered Organizations." *Gender and Society* 4, no. 2 (1990): 139–58.

Acoose, Janice. *Iskwewak—Kah' Ki Yaw Ni Wahkomakanak: Neither Indian Princesses nor Easy Squaws*. Vancouver: Women's Press, 1995.

Alexander, Michelle. *The New Jim Crow: Mass Incarceration in the Age of Colorblindness*. New York: New Press, 2011.

Alphonso, Caroline, and Marjan Farahbaksh. "Canadian Law Only Changed 26 Years Ago." *Globe and Mail*. April 1, 2009. https://www.theglobeandmail.com/news/world/canadian-law-only-changed-26-years-ago/article1150644.

American Congress of Obstetricians and Gynecologists. *Health Care for Pregnant and Postpartum Incarcerated Women and Adolescent Females*. 2011. Accessed July 1, 2020. http://www.acog.org/Resources_And_Publications/Committee_Opinions/Committee_on_Health_Care_for_Underserved_Women/Health_Care_for_Pregnant_and_Postpartum_Incarcerated_Women_and_Adolescent_Females.

American Medical Association. *Shackling of Pregnant Women in Labor*. Resolution 203. 2010.

Annamma, Subini Ancy, Darrell D. Jackson, and Deb Morrison. "Conceptualizing Color-Evasiveness: Using Dis/Ability Critical Race Theory to Expand a Color-Blind Racial Ideology in Education and Society." *Race Ethnicity and Education* 20, no. 2 (2017): 147–62.

Anwar, Shamena, Patrick Bayer, and Randi Hjalmarsson. "The Impact of Jury Race in Criminal Trials." *Quarterly Journal of Economics* 127, no. 2 (2012): 1017–55.

Arendt, Hannah. *Eichmann in Jerusalem: A Report on the Banality of Evil*. New York: Viking Press, 1963.

Arneil, Barbara. "Women as Wives, Servants and Slaves: Rethinking the Public/Private Divide." *Canadian Journal of Political Science* 34, no. 1 (2001): 29–54.

Arvin, Maile, Eve Tuck, and Angie Morrill. "Decolonizing Feminism: Challenging Connections between Settler Colonialism and Heteropatriarchy." *Feminist Formations* 25, no. 1 (Spring 2013): 8–34.

Aston, Megan, Sheri Price, Martha Paynter, Meaghan Sim, Joelle Monaghan, Keisha Jefferies, and Rachel Ollivier. "Mothers' Experiences with Child Protection Services: Using Qualitative Feminist Poststructuralism." *Nursing Reports* 11 (2021): 913–28.

Attorney General of Saskatchewan. "Practice Memorandum 'Gladue Principles.'" https://publications.saskatchewan.ca/#/products/103743.

Bacchi, Carol. "Do Women Need Equal Treatment or Different Treatment?" *Australian Journal of Law and Society* 8, no. 80 (1992): 80–94.

Backhouse, Constance. "Nineteenth-Century Canadian Prostitution Law: Reflection of a Discriminatory Society." *Social History/Histoire sociale* 18, no. 36 (1985): 387–423.

Balfour, Gillian. "Falling Between the Cracks of Retributive and Restorative Justice: The Victimization and Punishment of Aboriginal Women," *Feminist Criminology* 3, no. 2 (April 2008): 101–20.

Barker, Jayne, Adrienne Daniels, Kymberly O'Neal, and Sharon L. Van Sell. "Maternal-Newborn Bonding Concept Analysis." *International Journal of Nursing & Clinical Practices* 4 (2017): 229.

Baron-Cohen, Simon. *The Science of Evil: On Empathy and the Origins of Cruelty*. New York: Basic Books, 2010.

BIBLIOGRAPHY

Barrera, Jorge. "Ottawa Says It's Not Liable for Cultural Damage Caused by Kamloops Residential School: Court Documents." *CBC News*. June 2, 2021. https://www.cbc.ca/news/indigenous/reparations-residential-school-1.6050501.

Bauman, Zygmunt. *Modernity and the Holocaust*. Ithaca: Cornell University Press, 2000.

Bauman, Zygmunt. *Wasted Lives: Modernity and Its Outcasts*. Malden: Polity Press, 2004.

Baxter, Hugh. "Niklas Luhmann's Theory of Autopoietic Legal Systems." *Annual Review of Law and Social Science* 9 (2013): 167–84.

Behavioural Research Ethics Board. University of Saskatchewan (November 5, 2018).

Bellamy, Sherry, and Cindy Hardy. *Post-Traumatic Stress Disorder in Aboriginal People in Canada: Review of Risk Factors, Current Knowledge and Directions for Further Research*. Prince George, BC: National Collaborating Centre for Aboriginal Health, 2015.

Bell, Colleen, and Kendra Schreiner. "The International Relations of Police Power in Settler Colonialism: The 'Civilizing' Mission of Canada's Mounties." *International Journal* 73, no. 1 (2018): 111–26.

Bem, Sandra Lipsitz. *The Lenses of Gender: Transforming the Debate on Sexual Inequality*. New Haven: Yale University Press, 1993.

Bendo, Daniella, Taryn Hepburn, Dale C. Spencer, and Raven Sinclair. "Advertising 'Happy' Children: The Settler Family, Happiness and the Indigenous Child Removal System." *Children & Society* 1 (2019): 399–413.

Benería, Lourdes. "Reproduction, Production and the Sexual Division of Labour." *Cambridge Journal of Economics* 3, no. 3 (1979): 203–25.

Bergen, Heather, and Salina Abji. "Facilitating the Carceral Pipeline: Social Work's Role in Funneling Newcomer Children from the Child Protection System to Jail and Deportation." *Affilia: Journal of Women and Social Work* 35, no. 1 (2020): 34–48.

Bergen, Rachel. "3 First Nations Women, 1 unidentified Woman Were Victims of Alleged Serial Killer: Winnipeg Police." *CBC News*. December 1, 2022.

Blackstock, Cindy. "The Complainant: The Canadian Human Rights Tribunal on First Nations Child Welfare." *McGill Law Journal* 62, no. 3 (2016): 285–328.

Blackstock, Cindy. "For Indigenous Kids' Welfare, Our Government Knows Better; It Just Needs to Do Better." *Globe and Mail*, January 16, 2019. https://www.theglobeandmail.com/opinion/article-for-indigenous-kids-welfare-our-government-knows-better-they-just/.

Bonilla-Silva, E. *Racism without Racists: Color-blind Racism and the Persistence of Racial Inequality in America*. 4th ed. Lanham, MD: Rowman & Littlefield, 2014.

Borrows, John. "The Durability of *Terra Nullius*: *Tsilhqot'in Nation v. British Columbia*." *UBC Law Review* 48 (2015): 701–742.

Borrows, John. "Sovereignty's Alchemy: An Analysis of *Delgamuukw v. British Columbia*." *Osgoode Hall Law Journal* 37, no. 3 (1999): 537–96.

Bourgeois, Jennifer Wyatt, Jasmine Drake, and Howard Henderson. "The Forgotten: The Impact of Parental and Familial Incarceration on Fragile Communities." In *Children of Incarcerated Parents: From Understanding to Impact*, edited by Judy Krysik and Nancy Rodriguez, 65–87. New York: Springer, 2022.

Bourgeois, Robin. "Colonial Exploitation: The Canadian State and the Trafficking of Indigenous Women and Girls in Canada." *UCLA Law Review* 62 (2015): 1426–63.

Bowlby, John. "The Nature of the Child's tie to his Mother." *International Journal of Psycho-Analysis* 39, (1958): 350–73.

Boyce, Margaret. "Carceral Recognition and the Colonial Present at the Okimaw Ohci Healing Lodge." *Sites: A Journal of Social Anthropology & Cultural Studies* 14, no. 1 (2017): 13–34.

Boyd, Susan B., ed. *Challenging the Public/Private Divide: Feminism, Law, and Public Policy*. Toronto: University of Toronto Press, 1997.

Boyd, Susan C. *From Witches to Crack Moms: Women Drug Law, and Policy*. 2nd ed. Durham: Carolina Academic Press, 2015.

Boyer, Yvonne. "First Nations Women's Contributions to Culture and Community through Canadian Law." In *Restoring the Balance: First Nations Women, Community, and Culture*, edited by Gail Guthrie Valaskakis,

Madeleine Dion Stout, and Éric Guimond, 69–96. Winnipeg: University of Manitoba Press, 2009.

Boyer, Yvonne, and Judith Bartlett. *External Review: Tubal Ligation in the Saskatoon Health Region: The Lived Experience of Aboriginal Women.* Saskatoon: Saskatoon Health Region, 2017.

Bradford, Lori E.A., Udoka Okpalauwaekwe, Cheryl L. Waldner, and Lalita A. Bharadwaj. "Drinking Water Quality in Indigenous Communities in Canada and Health Outcomes: A Scoping Review." *International Journal of Circumpolar Health* 75, (2016): 1–17.

Bremer, Laurie J. "Pregnancy Discrimination in Mexico's Maquiladora System: Mexico's Violation of Its Obligations under NAFTA and the NAALC." *Law and Business Review of the Americas* 5 (1999): 567–88.

Brennan, Sarah. "Canada's Mother-Child Program: Examining Its Emergence, Usage and Current State." *Canadian Graduate Journal of Sociology and Criminology* 3, no. 1 (2014): 11–33.

Bresnahan, Mary, Jie Zhuang, Joanne Goldbort, Elizabeth Bogdan-Lovis, Sun-Young Park, and Rose Hitt. "Made to Feel Like Less of a Woman: The Experience of Stigma for Mothers Who Do Not Breastfeed." *Breastfeeding Medicine* 15, no. 1 (2020): 35–40.

Brester, Fanny. *Archetypal Grief: Slavery's Legacy of Intergenerational Child Loss.* London: Routledge, 2018.

Brett, Rachel. "Best Interests of the Child when Sentencing a Parent: Some Reflections on International and Regional Standards and Practice." Families Outside (UK). 2018. https://www.familiesoutside.org.uk/content/uploads/2018/05/Best-Interests-of-the-Child-when-Sentencing-a-Parent-UPDATD.pdf.

Bromwich, Rebecca M. "Theorizing the Official Record of Inmate Ashley Smith: Necropolitics, Exclusions, and Multiple Agencies." *Manitoba Law Journal* 40, no. 3 (2017): 194–224.

Brown, DeNeen L. "Left for Dead in a Saskatchewan Winter." *Washington Post.* November 22, 2003.

Buckel, Sonja. *Subjectivation and Cohesion: Towards the Reconstruction of a Materialist Theory of Law.* Brill: Leiden, 2020.

Bultitude, Karen, Paola Rodari, and Emma Weitkamp. "Bridging the Gap Between Science and Policy: The Importance of Mutual Respect, Trust and the Role of Mediators." *Online Journal of Science Communication* 11, no. 3 (2012): 1–4, https://jcom.sissa.it/archive/11/03/Jcom1103(2012)C01/.

Byrne, Mary W., Lorie Goshin, and Barbara Blanchard-Lewis. "Maternal Separations during the Reentry Years for 100 Infants Raised in a Prison Nursery." *Family Court Review* 50, no. 1 (2012): 77–90.

Canadian Friends Service Committee (Quakers). *Considering the Best Interests of the Child when Sentencing Parents in Canada*. December 2018. https://quakerservice.ca/wp-content/uploads/2018/12/Considering-the-Best-Interests-of-the-Child-when-Sentencing-Parents-in-Canada.pdf.

Canadian Heritage. "Government of Canada Reinstates the Modernized Court Challenges Program to Better Defend the Rights and Freedoms of Canadians." Government of Canada. February 7, 2017. https://www.canada.ca/en/canadian-heritage/news/2017/02/government_of_canadareinstatesthemodernizedcourtchallengesprogra0.html.

Cardinal, Harold. *The Unjust Society*. Madeira Park: Douglas and McIntyre, 1999.

Carlson, Kathryn Blaze. "Taken Without Mother's Consent: Woman Calls for Inquiry into P.E.I. 'Systematic Removal of Children.'" *National Post*. March 11, 2012. https://nationalpost.com/news/canada/p-e-i-woman-calls-for-inquiry-into-adoption-practices-that-led-to-systematic-removal-of-children.

Carreiro, Donna. "Indigenous Children for Sale: The Money Behind the Sixties Scoop." *CBC News*. September 28, 2016. https://www.cbc.ca/news/canada/manitoba/sixties-scoop-americans-paid-thousands-indigenous-children-1.3781622.

Carter, Sarah. "Categories and Terrains of Exclusion: Constructing the 'Indian Woman' in the Early Settlement Era in Western Canada." *Great Plains Quarterly* 13, no. 3 (1993): 147–61.

Carter, Sarah. *Lost Harvests: Prairie Indian Reserve Farmers and Government Policy*. Montreal and Kingston: McGill-Queen's University Press, 1990.

Cassidy, Julie. "The Stolen Generations—Canada and Australia: the Legacy of Assimilation." *Griffith Law Review* 15, no. 1 (2006): 111–52.

Chambers, Angelina N. "Impact of Forced Separation Policy on Incarcerated Postpartum Mothers." *Policy, Politics, & Nursing Practice* 10, no. 3 (2009): 204–11.

Chartrand, Vicki. "Unsettled Times: Indigenous Incarceration and the Links Between Colonialism and the Penitentiary in Canada." *Canadian Journal of Criminology and Criminal Justice* 61, no. 3 (2019): 67–89.

Civilian Review and Complaints Commission for the Royal Canadian Mounted Police. *Commission's Final Report: Chairperson-Initiated Complaint and Public Interest Investigation into the RCMP's Investigation of the Death of Colten Boushie and the Events that Followed.* Last modified March 22, 2021. https://www.crcc-ccetp.gc.ca/pdf/boushie-rep-en.pdf.

Clarke, Jennifer G., and Rachel E. Simon. "Shackling and Separation: Motherhood in Prison." *AMA Journal of Ethics, Policy Forum, Virtual Mentor* 15, no. 9 (2013): 779–85.

Coase, Ronald. "The Problem of Social Cost." *Journal of Law & Economics* 3 (October 1960): 1–44.

Cohen, Sidney. "Mother-Baby Unit at B.C. Jail In-Use for the First Time in Eight Years." *Metro News*. February 1, 2016.

Collaborating Centre for Prison Health and Education (CCPHE), University of British Columbia. *Guidelines for Mother–Child Units in Correctional Facilities.* 2015. https://www.cfpc.ca/uploadedFiles/Directories/Committees_List/MCU-Guidelines.pdf.

Collins, Patricia Hill. *Black Feminist Thought: Knowledge, Consciousness, and the Politics of Empowerment.* New York: Routledge, 2000.

Comack, Elizabeth, ed. *Locating Law.* 2nd ed. Black Point, NS: Fernwood, 2006.

Commission of Inquiry into Certain Events at the Prison for Women in Kingston / The Honourable Louise Arbour Commissioner. Ottawa: Solicitor General Canada, 1996. https://publications.gc.ca/collections/collection_2017/bcp-pco/JS42-73-1996-eng.pdf.

Common, David, and Chelsea Gomez. "RCMP 'Sloppy' and 'Negligent' in Investigating Colten Boushie's Death, Say Independent Experts." *CBC News*. March 12, 2018.

Cooke, Alex. "Nova Scotia Ends Controversial Practice of Birth Alerts, One of Last Provinces to Do So." November 30, 2021. https://globalnews.ca/news/8413275/nova-scotia-ends-birth-alerts/.

Correctional Service of Canada. *Creating Choices: The Report of the Task Force on Federally Sentences Women*. Ottawa: Correctional Service of Canada, 1990.

Corrections Canada. Commissioner's Directive Number 567-3. In effect February 26, 2018. https://www.csc-scc.gc.ca/politiques-et-lois/567-3-cd-eng.shtml#s2a.

Courts of Saskatchewan. "Judges." *Court of Appeal*. https://sasklawcourts.ca/court-of-appeal/judges/.

Craig, Meaghan. "Gerald Stanley Pleads Guilty to Gun Charge." *Global News*. April 16, 2018.

Crenshaw, Kimberlé Williams. "Mapping the Margins: Intersectionality, Identity Politics, and Violence against Women of Color." *Stanford Law Review* 43, no. 6 (1991): 1241–99.

Cunliffe, Emma. "Ambiguities: Law, Morality, and Legal Subjectivity in H.L.A. Hart's the Concept of Law." In *Feminist Encounters with Legal Philosophy*, edited by Maria Drakopoulou, 185–204. Abingdon: Routledge-Cavendish, 2013.

Cunliffe, Emma. "The Magic Gun: Settler Legality, Forensic Science, and the Stanley Trial." *Canadian Bar Review* 98, no. 2 (2020): 270–314.

Cuthand, Doug. "Cuthand: First Nations Traditions Tested At Stanley Trial." *Saskatoon StarPhoenix*. February 3, 2018.

Cyr, Kevin. "Police Use of Force: Assessing Necessity and Proportionality." *Alberta Law Review* 53, no. 3 (2016): 553–79.

Dafnos, Democratia. "Negotiating Colonial Encounters: (Un)mapping the Policing of Indigenous Peoples' Protests in Canada." PhD dissertation. York University, 2014.

Daschuk, James. *Clearing the Plains: Disease, Politics of Starvation, and the Loss of Indigenous Life*. New edition. Regina: University of Regina Press, 2019.

Daschuk, James. "When Canada Used Hunger to Clear the West." *Globe and Mail*. July 19, 2013.

Davida, Shai. "How Do People Make Sense of Wealth and Poverty?" *Current Opinion in Psychology* 43 (2022): 42–47.

Davies, William H. *Alone and Cold: Davies Commission—Inquiry into the Death of Frank Paul—Interim Report*. 2008. https://www2.gov.bc.ca/assets/gov/law-crime-and-justice/about-bc-justice-system/inquiries/daviescommission-interimreport.pdf.

Dayan, Colin. *The Law Is a White Dog: How Legal Rituals Make and Unmake Persons*. Princeton: Princeton University Press, 2011.

Demers, Jason. *Warehousing Prisoners in Saskatchewan: A Public Health Approach*. Regina: Canadian Centre for Policy Alternatives, 2014.

Dempsey, Hugh A. *The Great Blackfoot Treaties*. Vancouver: Heritage House Publishing Company, 2015.

Denov, Myriam S., and Kathryn M. Campbell. "Criminal Injustice: Understanding the Causes, Effects, and Responses to Wrongful Conviction in Canada." *Journal of Contemporary Criminal Justice* 21, no. 3 (August 2005): 224–49.

Department of Justice Canada. *The Path to Justice: Preventing Wrongful Convictions*. Ottawa: Federal/Provincial/Territorial Heads of Prosecutions, Subcommittee on the Prevention of Wrongful Convictions. 2011. https://publications.gc.ca/collections/collection_2015/jus/J2-419-2011-eng.pdf.

Department of Justice Canada. *Report on the Prevention of Miscarriages of Justice*. Department of Justice Canada, 2004. CanLIIDocs 424. https://canlii.ca/t/t1px.

Dignam, Brett, and Eli Y. Adashi. "Health Rights in the Balance: The Case Against Perinatal Shackling of Women Behind Bars." *Health and Human Rights Journal* 16, no. 2 (2014).

Dorries, Heather, Robert Henry, David Hugill, Tyler McCreary, and Julie Tomiak, eds. *Settler City Limits*. Winnipeg: University of Manitoba Press, 2019.

Downe, Pamela. "'Bad Mothers' in the HIV/AIDS Epidemic in Canada." In *"Bad Mothers": Representations, Regulations, and Resistance*, edited by Michelle

Hughes Miller, Tamar Hager, and Rebecca Bromwich, 103–12. Toronto: Demeter, 2017.

Dunn, P. "John Braxton Hicks (1823–97) and Painless Uterine Contractions." *Archives of Disease in Childhood. Fetal and Neonatal Edition* 81, no. 2 (1999): F157.

Earick, Mary E. "We Are Not Social Justice Equals: The Need for White Scholars to Understand Their Whiteness." *International Journal of Qualitative Studies in Education* 31, no.8 (2018): 800–20.

Edwards, Kyle. "When You Have to Give Birth in Secret." *Today's Parent*. September 10, 2018. https://www.todaysparent.com/family/parenting/when-you-have-to-give-birth-in-secret/.

Edwards, Peter. *One Dead Indian: The Premier, the Police, and the Ipperwash Crisis*. Toronto: McClelland & Stewart, 2001.

Embrick, David G., and Wendy Leo Moore. "White Space(s) and the Reproduction of White Supremacy." *American Behavioral Scientist* 64, no. 14 (2020): 1935–45.

England, Paula. "Emerging Theories of Care Work." *Annual Review of Sociology* 32 (2005): 381–99.

Ermine, Willie. "The Ethical Space of Engagement." *Indigenous Law Journal* 6, no. 1 (2017): 193–203.

"External Escorts." *Adult Custody Services Policy Manual, Security 507*. Custody, Supervision and Rehabilitation Services. February 25, 2019. https://publications.saskatchewan.ca/#/products/102083.

Fair, Helen, and Roy Walmsley. "World Prison Population List." *World Prison Brief*. Institute for Crime & Justice Policy Research, University of London. Birkbeck: 2021. https://www.prisonstudies.org/sites/default/files/resources/downloads/world_prison_population_list_13th_edition.pdf.

"Family Devastated after Colten Boushie Shot and Killed on Farm near Biggar, Sask." *CBC News*, August 11, 2016. https://www.cbc.ca/news/canada/saskatchewan/homicide-victim-family-devastated-loved-one-shot-biggar-sask-1.3717268.

Feagin, Joe R. *The White Racial Frame: Centuries of Racial Framing and Counter-Framing*. New York: Routledge, 2013.

• BIBLIOGRAPHY •

Feldman, Ruth, A. Weller, J.F. Leckman, J. Kuint, and A.I. Eidelman. "The Nature of the Mother's Tie to Her Infant: Maternal Bonding under Conditions of Proximity, Separation, and Potential Loss." *Journal of Child Psychology and Psychiatry* 40, no. 6 (1999): 936–37.

"Fetal Alcohol Spectrum Disorder and the Criminal Justice System: A Poor Fit." *Factsheet Issue 26*. John Howard Society of Ontario, 2010. http://www.johnhoward.on.ca/wp-content/uploads/2014/09/facts-26-fasd-and-the-criminal-justice-system-december-2010.pdf.

Fidan, Caroline, Tyler Doenmez, Jaime Cidro, Stephanie Sinclair, Ashley Hayward, Larissa Wodtke, and Alexandra Nychuk. "Heart Work: Indigenous Doulas Responding to Challenges of Western Systems and Revitalizing Indigenous Birthing Care in Canada." *BMC Pregnancy and Childbirth* 22, no. 41 (2022): 1–14.

Fine, Sean. "Jury Trials at Risk as Judge Strikes Down Federal Ban on Peremptory Challenges Enacted after Boushie Case." *Globe and Mail*. November 6, 2019.

Fine, Sean. "Ontario Police Officer's Conviction in Death of Indigenous Woman Puts Focus on Drug-Abuse Stereotypes." *Globe and Mail*. November 3, 2019.

Finer, Lawrence B., and Stanley K. Henshaw. "Disparities in Rates of Unintended Pregnancy in the United States, 1994 and 2001." *Perspectives on Sexual and Reproductive Health* 38, no. 2 (2006): 90–96. https://www.guttmacher.org/journals/psrh/2006/disparities-rates-unintended-pregnancy-united-states-1994-and-2001.

"First Nations Children Still Taken from Parents." *CBC News*. August 2, 2011. http://www.cbc.ca/news/politics/first-nations-children-still-taken-from-parents-1.1065255.

Flanders-Stepans, Mary Beth. "Alarming Racial Differences in Maternal Mortality." *Journal of Perinatal Education* 9, no. 2 (2000): 50–51.

Fletcher, Robson. "Women Spend 50% More Time Doing Unpaid Work than Men: Statistics Canada." *CBC News*. June 1, 2017. https://www.cbc.ca/news/canada/calgary/men-women-housework-unpaid-statistics-canada-1.4141367.

Flood, Colleen M., and Lorne Sossin. *Administrative Law in Context*. 3rd ed. Toronto: Emond Montgomery, 2018.

Flynn, Alexandrea, and Estair Van Wagner. "A Colonial Castle: Defence of Property in *R v. Stanley*." *Canadian Bar Review* 98, no. 2 (2020): 358–87.

Forester, Brett, and Fraser Needham. "Canada, First Nations Reveal Details of $40B Draft Deals to Settle Child Welfare Claims." *APTN News*. January 4, 2022. https://www.aptnnews.ca/national-news/canada-first-nations-reveal-details-of-40b-draft-deals-to-settle-child-welfare-claims/.

Francis, Daniel. *The Imaginary Indian*. Vancouver: Arsenal Pulp Press, 1992.

Franco, Christine, Erika Mowers, and Deborah Landis Lewis. "Equitable Care for Pregnant Incarcerated Women: Infant Contact after Birth—A Human Right." *International Perspectives on Sexual and Reproductive Health* 52, no. 4 (2020): 211–15.

Freeman, Andrea. "Unmothering Black Women: Formula Feeding as an Incident of Slavery." *Hastings Law Journal* 69 (2018): 1545–1606.

Friedman, Susan Hatters, Aimee Kaempf, and Sarah Kauffman. "The Realities of Pregnancy and Mothering while Incarcerated." *Journal of the American Academy of Psychiatry and the Law*, 48 (2020): 365–75.

Friesen, Joe. "Thousands Rally Across Canada after Gerald Stanley Acquitted in Killing of Colten Boushie." *Globe and Mail*. February 10, 2018.

Galbraith, John Kenneth. *The Anatomy of Power*. Boston: Houghton Mifflin, 1983.

Gallagher, Charles A. "Color-Blind Privilege: The Social and Political Functions of Erasing the Color Line in Post Race America." *Race, Gender & Class* 10, no. 4 (2003): 22–37.

García-Del Moral, Paulina. "The Murders of Indigenous Women in Canada as Feminicides: Toward a Decolonial Intersectional Reconceptualization of Femicide." *Signs* 43, no. 4 (Summer 2018): 929–54.

Garland, Eric L., Carrie Pettus-Davis, and Matthew O. Howard. "Self-Medication among Traumatized Youth: Structural Equation Modeling of Pathways between Trauma History, Substance Misuse, and Psychological Distress." *Journal of Behavioral Medicine* 36, no. 175 (2013): 175–85. https://doi.org/10.1007/s10865-012-9413-5.

Gau, Jacinta M. "A Jury of Whose Peers? The Impact of Selection Procedures on Racial Composition and the Prevalence of Majority-White Juries." *Journal of Crime and Justice* 39, no. 1 (2016): 75–87.

Gavigan, Shelley A.M. *Hunger, Horses and Government Men*. Vancouver: UBC Press, 2014.

Gebhard, Amanda, Sheelah McLean, and Verna St. Denis, eds. *White Benevolence: Racism and Colonial Violence in the Helping Professions*. Blackpoint, NS: Fernwood, 2022.

Gilbert, Jérémie. *Indigenous Peoples' Land Rights under International Law: From Victims to Actors*. 2nd ed. Leiden: Brill Nijhoff, 2016.

Gillis, Megan. "New Details on Jail Birth in Nurse's Discipline Decision." *Ottawa Citizen*. June 12, 2016. https://ottawacitizen.com/news/local-news/new-details-on-jail-birth-in-nurses-discipline-decision.

Gillis, Wendy, and Jennifer Pagliaro. "Board Tells Toronto Police to Review If It Can Investigate Individuals Behind 'Systemic' Discrimination." June 22, 2022. https://www.thestar.com/news/gta/2022/06/22/board-tells-toronto-police-to-review-if-it-can-investigate-individuals-behind-systemic-discrimination.html.

Givetash, Linda. "Jail Program Gives Moms a New Start, Helps Babies Develop, Advocates Say." *CTV News*. July 17, 2016.

Givetash, Linda. "Mother-Child Prison Program Giving Babies, Mothers 'A Better Chance.'" *Toronto Star*. July 17, 2016.

Godfrey, Erin B., and Sharon Wolf. "Developing Critical Consciousness or Justifying the System? A Qualitative Analysis of Attributions for Poverty and Wealth among Low-Income Racial/Ethnic Minority and Immigrant Women." *Cultural Diversity & Ethnic Minority Psychology* 22, no. 1 (2015) 93–103.

Gordon, Ilanit, Orna Zagoory-Sharon, James F. Leckman, and Ruth Feldman. "Oxytocin and the Development of Parenting in Humans." *Biological Psychiatry* 68, no. 4 (2010): 377–82.

Goshin, Lorie S., Mary W. Byrne, and Barbara Blanchard-Lewis. "Preschool Outcomes of Children Who Lived as Infants in a Prison Nursery." *Prison Journal* 94, no. 2 (2014): 139–58.

Government of Saskatchewan. "Ministry of Justice and Attorney General." Accessed June 20, 2017. https://www.saskatchewan.ca/government/government-structure/ministries/justice.

Government of Saskatchewan. "Provincial Court Judge Appointed in Saskatoon." March 23, 2018. https://www.saskatchewan.ca/government/news-and-media/2018/march/23/judge-appointed-in-saskatoon.

Graeber, David. "The Bully's Pulpit: On the Elementary Structure of Domination." *The Baffler* 28 (July 2015): 30–38.

Grant, Meghan. "Blood Tribe Wins Massive Land Claim Battle in Federal Court." *CBC News*. June 12, 2019.

Grant, Tavia. "Who is Minding the Gap?" *Globe and Mail*. March 6, 2017. https://www.theglobeandmail.com/news/national/gender-pay-gap-a-persistent-issue-in-canada/article34210790.

Graveland, Bill, and Stephanie Taylor. "No Women at the Table as Canada's Premiers Gather in Saskatoon." *Globe and Mail*. July 10, 2019. https://www.theglobeandmail.com/canada/article-no-women-at-the-table-as-canadas-premiers-gather-in-saskatoon/.

Graveland, Bill. "Not Guilty Verdict in Shooting Death of Colten Boushie 'Absolutely Perverse.'" Canadian Press. February 10, 2018. https://www.thestar.com/news/canada/2018/02/10/outrage-follows-not-guilty-verdict-for-gerald-stanley-in-shooting-death-of-colten-boushie.html.

Green, Rayna. "The Pocahontas Perplex: The Image of Indian Women in American Culture." In *Unequal Sisters: A Multicultural Reader in U.S. Women's History*, edited by Ellen Carol DuBois and Vicki L. Ruis, 15–21. New York: Routledge, 1990.

Griffith, Andrew. "Diversity among Federal and Provincial Judges." *Policy Options*. May 4, 2016. http://policyoptions.irpp.org/2016/05/04/diversity-among-federal-provincial-judges/.

Gualtieri, Giacomo, Fabio Ferretti, Alessandra Masti, Andrea Pozza, and Anna Coluccia. "Post-Traumatic Stress Disorder in Prisoners' Offspring: A Systematic Review and Meta-Analysis." *Clinical Practice & Epidemiology in Mental Health* 36 (2020): 36–45.

Hagen, Brad, Ruth Grant Kalishuk, Cheryl Currie, Jason Solowoniuk, and Gary Nixon. "A Big Hole with the Wind Blowing through It: Aboriginal Women's Experiences of Trauma and Problem Gambling." *International Gambling Studies* 13, no. 3 (2013): 356–70.

Hahn, Monica, Neal Sheran, Shannon Weber, Deborah Cohan, and Juno Obedin-Maliver. "Providing Patient-Centered Perinatal Care for Transgender Men and Gender-Diverse Individuals." *Obstetrics & Gynecology* 134, no. 5 (2019): 959–63.

Hannah-Moffat, Kelly. "Sacrosanct or Flawed: Risk, Accountability and Gender-Responsive Penal Politics." *Current Issues in Criminal Justice* 22, no. 2 (2016): 193–215.

Hanson, Cindy. "Gender, Justice, and the Indian Residential School Claims Process." *International Indigenous Policy Journal* 7, no. 1 (2016): https://ojs.lib.uwo.ca/index.php/iipj/article/view/7482/6126.

Hargreaves, Alison. *Violence against Indigenous Women*. Waterloo: Wilfrid Laurier University Press, 2017.

Harvey, Alan Burnside. *Tremear's Annotated Criminal Code, Canada, 1944*. 5th ed. Calgary: Burroughs & Company, 1944.

Hathaway, Oona H. "Path Dependence in the Law: The Course and Pattern of Legal Change in a Common Law System." *Iowa Law Review* 86 (2000): 601–65.

Hazan, Cindy, and Mary I. Campa. *Human Bonding: The Science of Affectional Ties*. New York: Guilford, 2013.

Henderson, James (Sakej) Youngblood. "Interpreting *Sui Generis* Treaties." *Alberta Law Review* 36, no. 1 (1997): 46–96.

Henry, Frances, and Carol Tator. *Discourses of Domination: Racial Bias in the Canadian English-Language Press*. Toronto: University of Toronto Press, 2002.

Higgins, Ethan M., Justin Smith, and Kristin Swartz. "'We Keep the Nightmares in Their Cages': Correctional Culture, Identity, and the Warped Badge of Honor." *Criminology* (2022): 1–26.

Hildebrandt, Walter. *Views from Fort Battleford: Constructed Visions of an Anglo-Canadian West*. Edmonton: Athabasca University Press: 2008.

Hinge, Gail. *Indian Acts and Amendments, 1868–1975.* Vol. 2 of *Consolidation of Indian Legislation.* Ottawa: Indian and Northern Affairs Canada, 1978.

Hoehn, Felix. "Back to the Future: Reconciliation and Indigenous Sovereignty After *Tsilhqot'in.*" *University of New Brunswick Law Review* 67 (2016): 109–145.

Hoekzema, Elseline, Erika Barba-Müller, Cristina Pozzobon, Marisol Picado, Florencio Lucco, David García-García, Juan Carlos Soliva et al. "Pregnancy Leads to Long-Lasting Changes in Human Brain Structure." *Nature Neuroscience* 20 (2017): 287–96.

Hogg, Keith. "Seeing Justice Done: Increasing Indigenous Representation on Canadian Juries." *Appeal: Review of Current Law and Law Reform* 26 (2021): 51–70.

Holliday, Wyatt. "The Answer to Criminal Aggression is Retaliation: Stand-Your-Ground Laws and the Liberalization of Self-Defense." *University of Toledo Law Review* 43 (2012): 407–36.

Hopper, Tristin. "Gerald Stanley's 'Magical Gun': The Extremely Unlikely Defence that Secured His Acquittal." *National Post.* February 14, 2018.

Houle, Robert, and Dallas Hunt. "Murdered by 'Bad Luck': Indigenous Life and Death in Canada." Yellowhead Institute Policy Brief no. 104 (July 29, 2021). https://yellowheadinstitute.org/wp-content/uploads/2021/07/Houle-and-Hunt-Murdered-Bad-Luck-07-29-21.pdf.

Hubbard, Tasha. *Two Worlds Colliding.* 49 minutes. Saskatoon: National Filmboard of Canada, 2004. https://www.nfb.ca/film/two_worlds_colliding.

Hugill, David. "Comparative Settler Colonial Urbanisms." In Dorries et al., *Settler City Limits,* 81–103.

Hugill, David. *Missing Women, Missing News: Covering Crisis in Vancouver's Downtown Eastside.* Black Point, NS: Fernwood, 2010.

Human Rights Watch. *Mexico's Maquiladoras: Abuses against Women Workers.* August 17, 1996. https://www.hrw.org/news/1996/08/17/mexicos-maquiladoras-abuses-against-women-workers.

Human Rights Watch. *Those Who Take Us Away: Abusive Policing and Failures in Protection of Indigenous Women and Girls in Northern British Columbia, Canada.* 2013. https://www.hrw.org/report/2013/02/13/those-who-take-us-away/abusive-policing-and-failures-protection-indigenous-women.

Huncar, Andrea. "Indigenous Women Nearly 10 Times More Likely to be Street Checked by Edmonton Police, New Data Shows." CBC News. June 27, 2017.

Hunter, Rosemary. "More than Just a Different Face? Judicial Diversity and Decision-Making." *Current Legal Problems* 68, no. 1 (2015): 119–41.

Hutchins, Peter W. "Cede, Release and Surrender: Treaty-Making, the Aboriginal Perspective and the Great Judicial Oxymoron or Let's Face It— It Didn't Happen." In *Aboriginal Law Since Delgamuukw*, edited by Maria Morellato, 431–64. Aurora, ON: Canadian Law Book, 2009.

Hylton, John. "Locking Up Indians in Saskatchewan: Some Recent Findings." In *Deviant Designations: Crime, Law and Deviance in Canada*, edited by T. Fleming and L.A. Visano, 61–68. Toronto: Butterworths, 1983.

Independent Review of Ontario Corrections. *Segregation in Ontario*. Queen's Printer for Ontario, 2017. https://hsjcc.on.ca/wp-content/uploads/IROC-Segregation-Report-2017-03.pdf.

Indigenous Law Centre. *Gladue Awareness Project: Final Report*. Saskatoon: University of Saskatchewan, 2019.

Indigenous Services Canada. "Reducing the Number of Indigenous Children in Care." 2021. https://www.sac-isc.gc.ca/eng/1541187352297/1541187392851.

Ingraham, Christopher. "The World's Richest Countries Guarantee Mothers More than a Year of Paid Maternity Leave. The U.S. Guarantees Them Nothing." *Washington Post*. February 5, 2018. https://www.washingtonpost.com/news/wonk/wp/2018/02/05/the-worlds-richest-countries-guarantee-mothers-more-than-a-year-of-paid-maternity-leave-the-u-s-guarantees-them-nothing/?noredirect=on&utm_term=.172cda8e8827.

International Centre for Prison Studies. *International Profile of Women's Prisons*. London, King's College, April 2008. https://www.prisonstudies.org/sites/default/files/resources/downloads/20080501_womens_prisons_int_review_final_report_v_2.pdf.

Jackson, Michael. "Locking Up Natives in Canada." *University of British Columbia Law Review* 23, no. 2 (1989): 215–300.

Jacobs, Madelaine Christine. "Assimilation through Incarceration: The Geographic Imposition of Canadian Law over Indigenous Peoples." PhD thesis. Queen's University, 2012.

Jai, Julie. "Bargains Made in Bad Times: How Principles from Modern Treaties Can Invigorate Historic Treaties." In *The Right Relationship: Reimagining the Implementation of Historical Treaties*, edited by John Borrows and Michael Coyle, 105–48. Toronto: University of Toronto Press, 2017.

Jaimes-Guerrero, Marianette. "Savage Erotica Exotica: Media Imagery of Native Women in North America." *Hypatia* 18, no. 2 (2003): 58–69.

Jefferson, Christie. *Conquest by Law*. Report to Solicitor General of Canada. Ottawa, 1994. https://www.publicsafety.gc.ca/cnt/rsrcs/pblctns/cnqst-lw/cnqst-lw-eng.pdf.

Johnson, Harold R. *Firewater: How Alcohol Is Killing My People (and Yours)*. Regina: University of Regina Press, 2016.

Johnson, Harold R. "Look Twice before Judging an Indigenous Person." *Globe and Mail*. May 19, 2017.

Johnson, Harold R. *Peace and Good Order*. Toronto: McClelland & Stewart, 2019.

Johnson, Kayla. "Maternal Infant Bonding: A Review of Literature." *International Journal of Childbirth Education* 28, no. 3 (2013): 17–22.

Johnston, Janice. "Explosive Allegations against Male Prison Guards Contained in Lawsuit." *CBC News*. March 12, 2018. https://www.cbc.ca/news/canada/edmonton/prison-guards-correctional-service-of-canada-waterboarding.

Johnston, Janice. "'I'm the Victim and I'm in Shackles': Edmonton Woman Jailed While Testifying against Her Attacker; Alberta Justice Minister Apologizes for 'Appalling' Treatment of Sexual Assault Victim." *CBC News*. June 5, 2017.

Jokic, Dallas. "Cultivating the Soil of White Nationalism: Settler Violence and Whiteness as Territory." *Journal of Critical Race Inquiry* 7, no. 2 (2020): 1–21.

Kaiser-Derrick, Elspeth. *Implicating the System*. Winnipeg: University of Manitoba Press, 2017.

Kamel, Géhane. *Investigation Report Concerning the Death of Joyce Echaquan*. Quebec: Bureau de coroner de Quebec, 2020. https://www.coroner.gouv

.qc.ca/fileadmin/Enquetes_publiques/2020-06375-40_002__1__sans_logo_anglais.pdf.

Kamir, Orit. *Framed: Women in Law and Film*. Durham: Duke University Press, 2006.

Kaye, Frances W. "Little Squatter on the Osage Diminished Reserve: Reading Laura Ingalls Wilder's Kansas Indians." *Great Plains Quarterly* 20, no. 2 (2000): 123–40.

Kaye, Julie. "Reconciliation in the Context of Settler-Colonial Gender Violence: 'How Do We Reconcile with an Abuser?'" *Canadian Review of Sociology* 53, no. 4 (2016): 461–67.

Kaye, Julie. *Responding to Human Trafficking: Dispossession, Colonial Violence, and Resistance among Indigenous and Racialized Women*. Toronto: University of Toronto Press, 2017.

Keller, James. "Alberta Introduces Law to Protect Rural Landowners Who Use Force to Defend Their Property." *Globe and Mail*. November 6, 2019. https://www.theglobeandmail.com/canada/alberta/article-alberta-introduces-law-to-protect-rural-landowners-who-use-force-to/.

Kelly, Erin, and Frank Dobbin. "Civil Rights Law at Work: Sex Discrimination and the Rise of Maternity Leave Policies." *American Journal of Sociology* 105, no. 2 (1999) 455–92.

Kendi, Ibram X. *How to Be an Anti-Racist*. New York: Random House, 2019.

Kennedy, Mark. "Harper Sparks Controversy by Linking Guns and Personal Security." *Ottawa Citizen*. March 16, 2015.

Kerr, Lisa. "Sentencing Ashley Smith: How Prison Conditions Relate to the Aims of Punishment." *Canadian Journal of Law and Society* 32, no. 2 (2017): 187–207.

Khosla, Rajat, Christine Zamplas, Joshua P. Vogel, Meghan A. Bohren, Mindy Roseman, and Joanna N. Erdman. "International Human Rights and the Mistreatment of Women During Childbirth." *Health and Human Rights Journal* 18, no. 2 (2016): 131–43.

Kiiwetinepinesiik Stark, Heidi. "Criminal Empire: The Making of the Savage in a Lawless Land." *Theory & Event* 19, no. 4 (2016).

King, Laura. "Hiding in the Pub to Cutting the Cord? Men's Presence at Childbirth in Britain c. 1940s–2000s." *Social History of Medicine* 30, no. 2 (April 2016): 1–19.

King, Thomas. *The Inconvenient Indian*. Minneapolis: University of Minnesota Press, 2013.

Kline, Marlee. "Complicating the Ideology of Motherhood: Child Welfare Law and First Nation Women." *Queen's Law Journal* 18, no. 2 (1993): 306–42.

Kolahdooz, Fariba, Katherine Launier, Forouz Nader, Kyoung June Yi, Philip Baker, Tara-Leigh McHugh, Helen Vallianatos, and Sangita Sharma. "Canadian Indigenous Women's Perspectives of Maternal Health and Health Care Services: A Systematic Review." *Diversity and Equality in Health and Care* 13, no. 5 (2016): 334–48.

Krasowski, Sheldon. *No Surrender: The Land Remains Indigenous*. Regina: University of Regina Press, 2019.

Krasowski, Sheldon. "To Understand Why the Land Remains Indigenous, Look to History." *Globe and Mail*. April 19, 2019. https://www.theglobeandmail.com/opinion/article-to-understand-why-the-land-remains-indigenous-look-to-history/.

LaFrance, Adrienne. "What Happens to a Woman's Brain When She Becomes a Mother." *The Atlantic*. January 8, 2015. https://www.theatlantic.com/health/archive/2015/01/what-happens-to-a-womans-brain-when-she-becomes-a-mother/384179/.

Landertinger, Laura. "Child Welfare and the Imperial Management of Childhood in Settler Colonial Canada, 1880s–2000s." PhD thesis. University of Toronto, 2017. https://tspace.library.utoronto.ca/bitstream/1807/80850/3/Landertinger_Laura_C_201711_PhD_thesis.pdf.

Landes, Joan B. "Further Thoughts on the Public/Private Distinction." *Journal of Women's History* 15, no. 2 (2003): 29–38.

Lappi-Seppälä, Tapio. "Penal Policy in Scandinavia." *Crime and Justice* 36, no. 1 (2007): 217–95.

Lawrence, Bonita. "Gender, Race, and the Regulation of Native Identity in Canada and the United States: An Overview." *Hypatia* 18, no. 2 (2003): 3–31.

Lawrence, Sonia. "Cultural (in)Sensitivity: The Dangers of a Simplistic Approach to Culture in the Courtroom." *Canadian Journal of Women and the Law* 13, no. 1 (2001): 107–36.

Lawrence, Sonia, and Debra Parkes. "*R v. Turtle*: Substantive Equality Touches Down in Treaty 5 Territory." (2021) 66 Criminal Reports (7th) 430–47.

Leach, Penelope. "Starting off Right." In *Child Honouring: How to Turn This World Around*, edited by Raffi Cavoukian and Sharna Olfman, 17–28. Praeger, Westport, Connecticut, and London: 2006.

LeBeuf, Marcel-Eugène. *The Role of the Royal Canadian Mounted Police during the Indian Residential School System*. Ottawa: RCMP, 2011.

Ledding, Andrea. "Solemn Anniversary of 1885 Battleford Hangings Marked at Wanuskewin." *Eagle Feather News*. November 30, 2018.

Leo, Geoff. "60-Hour Delay before Regina Police Called in Laundry Chute Death." *CBC News*. May 16, 2016.

Levinson, Justin D. "Forgotten Racial Equality: Implicit Bias, Decisionmaking, and Misremembering." *Duke Law Journal* 57 (2008): 345–424.

Leyens, Jacques-Philippe. "Retrospective and Prospective Thoughts about Infrahumanization." *Group Processes & Intergroup Relations* 12, no. 6 (2009): 807–17.

Liauw, Jessica, et al. "The Unmet Contraceptive Need of Incarcerated Women in Ontario." *Journal of Obstetrics and Gynaecology Canada* 38, no. 9 (September 2016): 820–26.

Library of Congress. *Laws on Children Residing with Parents in Prison*. Report. August 2014. https://www.loc.gov/law/help/children-residing-with-parents-in-prison/children-residing-with-parents-in-prison.pdf.

Light, Caroline. *Stand Your Ground: A History of America's Love Affair with Lethal Self-Defense*. Boston: Beacon Press, 2017.

Lindberg, Darcy. "The Myth of the Wheat King and the Killing of Colten Boushie." *The Conversation*. March 1, 2018. https://theconversation.com/the-myth-of-the-wheat-king-and-the-killing-of-colten-boushie-92398.

Lindberg, Tracey. "Critical Indigenous Legal Theory Part 1: The Dialogue Within." *Canadian Journal of Women and the Law* 27, no. 2 (2015): 224–47.

Ling, Justin. "Houses of Hate: How Canada's Prison System Is Broken." *Macleans Magazine*. February 28, 2021. https://www.macleans.ca/news/canada/houses-of-hate-how-canadas-prison-system-is-broken/.

Lipsitz, George. *How Racism Takes Place*. Philadelphia: Temple University Press, 2011.

Liu, Jianghong, Patrick Leung, and Amy Yang. "Breastfeeding and Active Bonding Protects against Children's Internalizing Behavior Problems." *Nutrients* 6, no. 1 (2014): 76–89.

Loeffler, Charles E., and Daniel S. Nagin. "The Impact of Incarceration on Recidivism." *Annual Review of Criminology* 5 (January 2022): 133–52.

Lozinski, Peter. "Passages: July 27, 1960—Indigenous People of Saskatchewan Get Full Liquor Privileges." *Daily Herald*. November 9, 2017. https://paherald.sk.ca/2017/11/09/passages-july-27-1960-indigenous-people-saskatchewan-get-full-liquor-privileges/.

Luce, Ann, Marilyn Cash, Vanora Hundley, Helen Cheyne, Edwin van Teijlingen, and Catherine Angell. "'Is It Realistic?' The Portrayal of Pregnancy and Childbirth in the Media." *BMC Pregnancy and Childbirth* 16, no. 40 (2016): 1–10.

Lugones, María. "Toward a Decolonial Feminism." *Hypatia* 25, no. 4 (2010): 742–59.

Luhmann, Niklas. *Law as a Social System*. Translated by Klaus A Ziegert, edited by Fatima Kastner, Richard Nobles, David Schiff, and Rosamund Ziegert. Oxford: Oxford University Press, 2004.

Luhmann, Niklas. *A Sociological Theory of Law*. 2nd ed. New York: Routledge, 2014.

MacDonald, David B. "Canada's History Wars: Indigenous Genocide and Public Memory in the United States, Australia and Canada." *Journal of Genocide Research (Special Issue on Canada and Colonial Genocide)* 17, no. 4 (2015): 411–31.

MacDonald, David B. "Settler Silencing and the Killing of Colten Boushie: Naturalizing Colonialism in the Trial of Gerald Stanley." *Settler Colonial Studies* 11, no. 1 (2021): 1–20.

Macdonald, Nancy. "Saskatchewan: A Special Report on Race and Power." Special Report. *Macleans Magazine*. July 29, 2016. https://www.macleans.ca/news/canada/saskatchewan-a-special-report-on-race-and-power/.

MacDonald, Noni E., Richard Stanwick, and Andrew Lynk. "Canada's Shameful History of Nutrition Research on Residential School Children: The Need for Strong Medical Ethics in Aboriginal Health Research." *Paediatrics & Child Health* 19, no. 2 (2014): 64.

MacFarlane, Bruce A. "Convicting the Innocent: A Triple Failure of the Justice System." *Manitoba Law Journal* 31, no. 3 (2006): 403–85.

MacFarlane, Bruce A. "Wrongful Convictions: The Effect of Tunnel Vision and Predisposing Circumstances in the Criminal Justice System." Prepared for the Inquiry into Pediatric Forensic Pathology in Ontario, The Honourable Stephen T. Goudge, Commissioner. 2008.

MacPherson, Alex. "'It's Not Going to End There. I'm Going to Keep Fighting': Lafond Family Upset with Coroner's Inquest Determination of Accidental Death." *Saskatoon Starphoenix*, June 29, 2018.

Malakieh, Jamil. "Adult and Youth Correctional Statistics in Canada, 2016/2017." Ottawa: Statistics Canada, June 19, 2018. https://www150.statcan.gc.ca/n1/pub/85-002-x/2018001/article/54972-eng.htm.

"Malaysia: Babies for Sale." *Al Jazeera*. November 24, 2016. https://www.aljazeera.com/programmes/101east/2016/11/malaysia-babies-sale-161124133921861.html.

Malone, Kelly. "'They Have a Lot to Teach Us': Inmates Call for Canadian Justice Reform in Journal." *CBC News*. December 2, 2017.

Manuel, Arthur. *The Reconciliation Manifesto*. Toronto: James Lorimer, 2017.

Marelj, Bayleigh, and Tessa Vikander. "Several Canadian Provinces Still Issue Birth Alerts, Deemed 'Unconstitutional and Illegal' in B.C." *IndigiNews*. January 15, 2021. https://indiginews.com/vancouver-island/status-of-birth-alerts-across-canada.

Marken, Ron. "'There Is Nothing but White between the Lines': Parallel Colonial Experiences of the Irish and Aboriginal Canadians." In *Native North America*, edited by Renée Hulan, 156–73. Toronto: ECW Press, 1999.

Maynard, Robyn. *Policing Black Lives State Violence in Canada from Slavery to the Present*. Halifax: Fernwood, 2017.

Mbembé, Achille. *Necropolitics*. Durham: Duke University Press, 2019.

McAdam (Saysewahum), Sylvia. *Nationhood Interrupted: Revitalizing Nêhiyaw Legal Systems*. Saskatoon: Purich, 2015.

McCallum, Mary Jane, and Adele Perry. *Structures of Indifference*. Winnipeg: University of Manitoba Press, 2018.

McDougall, Robert L. "Duncan Campbell Scott." *Canadian Encyclopedia*. August 11, 2008. https://www.thecanadianencyclopedia.ca/en/article/duncan-campbell-scott.

McGillivray, Kate. "Vast Majority of Staff at Toronto Jail Afraid to Go to Work, Report Says." CBC *News*. December 14, 2018.

McGuire, Michaela M., and Danielle J. Murdoch. "(In)-justice: An Exploration of the Dehumanization, Victimization, Criminalization, and Over-Incarceration of Indigenous Women in Canada." *Punishment & Society* (2021): 1–22.

McKay, Marlene Elizabeth. "A Feminist Poststructural Analysis of Aboriginal Women's Positioning in a Colonial Context: Nehinaw Iskwewak E-Pikiskwecik." PhD thesis. University of Regina, 2015.

McKendy, Laura. "The Pains of Jail Imprisonment: Experiences at the Ottawa-Carleton Detention Centre." PhD thesis. Carleton University, 2018.

McLean, Sheelah. "'We Built a Life from Nothing': White Settler Colonialism and the Myth of Meritocracy." *Our Schools/Our Selves* 32 (Fall/Winter 2018): 32–33.

McMillan Cottom, Tressie. *Thick and other Essays*. New York: New Press, 2019.

McNeil, Kent. "Sovereignty and the Aboriginal Nations of Rupert's Land." *Manitoba History* 37 (1999): 2–8.

McNinch, James. "'I Thought Pocahontas Was a Movie': Using Critical Discourse Analysis to Understand Race and Sex as Social Constructs." In *"I Thought Pocahontas Was a Movie": Perspectives on Race/Culture Binaries in Education and Service Professions*, edited by James McNinch and Carol Schick, 151–76. Regina: University of Regina Press, 2009.

Michaels, Samantha. "Getting Your Period in Prison Is Hell. These Numbers Prove It." *Mother Jones*. May 3, 2019. https://www.motherjones.com/crime-justice/2019/05/getting-your-period-in-prison-is-hell-these-numbers-prove-it.

Millar, Hayli, and Yvon Dandurand. "The Impact of Sentencing and Other Judicial Decisions on the Children of Parents in Conflict with the Law: Implications for Sentencing Reform." *School of Criminology and Criminal Justice University of the Fraser Valley and International Centre for Criminal Law Reform and Criminal Justice Policy*. 2017. https://icclr.org/wp-content/uploads/2019/06/Millar-and-Dandurand-_2017_Impact-of-Sentencing-on-Children-on-Parents_07_02_2017.pdf.

Miller, Robert J., Jacinta Ruru, Larissa Benhrendt, and Tracey Lindberg. *Discovering Indigenous Lands*. Oxford: Oxford University Press, 2010.

Milloy, John. *Indian Act Colonialism: A Century of Dishonour, 1869–1969*. Ottawa: National Centre for First Nations Governance, 2008. https://fngovernance.org/wp-content/uploads/2020/09/milloy.pdf.

Ministry of Social Services. *Children's Services Manual*. Regina: Ministry of Social Services, 2016.

Minnesota Department of Corrections. "Healthy Start Act SF 1315/HF 1403." 2021. https://www.senate.mn/committees/2021-2022/3099_Committee_on_Judiciary_and_Public_Safety_Finance_and_Policy/Healthy%20Start%20Act%20Fact%20Sheet%20-%20SF%201315.pdf.

Minson, Shona. *Maternal Sentencing and the Rights of the Child*. Cham, Switzerland: Palgrave MacMillan, 2020.

Monchalin, Lisa. *The Colonial Problem*. Toronto: University of Toronto Press, 2017.

Monkman, Lenard. "Debunking the Myth that All First Nations People Receive Free Post-Secondary Education." *CBC News*. January 29, 2016. www.cbc.ca/news/indigenous/debunking-the-myth-that-all-first-nations-people-receive-free-post-secondary-education-1.3414183.

Monture-Angus, Patricia. "Standing against Canadian Law: Naming Omissions of Race, Culture and Gender." In Comack, *Locating Law*, [INSERT 73-93].

Monture-Angus, Patricia. *Journeying Forward*. Halifax: Fernwood, 1999.

Monture-Angus, Patricia. *Thunder in My Soul: A Mohawk Woman Speaks*. Halifax: Fernwood, 1995.

Moore, Dawn, and Kelly Hannah-Moffat. "The Liberal Veil: Revisiting Canadian Penalty." In *The New Punitiveness*, edited by John Pratt, David Brown, Mark Brown, Simon Hallsworth, and Wayne Morrison, 85–100. London: Willan, 2005.

Morgan-Mullane, Anna. "Trauma Focused Cognitive Behavioral Therapy with Children of Incarcerated Parents." *Clinical Social Work Journal* 46, no. 3 (2018): 200–09.

Morrow, Adrian, and Patrick White. "Treatment of Adam Capay 'Disturbing,' Wynne Admits." *Globe and Mail*. October 31, 2016. https://www.theglobeandmail.com/news/national/treatment-of-adam-capay-disturbing-wynne-admits/article32609857/.

Morse, Bradford W. "A Unique Court: S. 107 *Indian Act* Justices of the Peace." *Canadian Legal Aid Bulletin* 5, no. 2–3 (1982): 131–50.

Mosby, Ian. "Administering Colonial Science: Nutrition Research and Human Biomedical Experimentation in Aboriginal Communities and Residential Schools, 1942–1952." *Histoire sociale/Social History* 46, no. 91 (2013): 145–72.

Moseson, Heidi, et al. "The Imperative for Transgender and Gender Nonbinary Inclusion." *Obstetrics & Gynecology* 135, no. 5 (May 2020): 1059–68.

Moss, Wendy, and Elaine Gardner-O'Toole. "Aboriginal People: History of Discriminatory Laws." Ottawa: Library of Parliament, 1987. http://publications.gc.ca/collections/collection_2008/lop-bdp/bp/bp175-e.pdf.

Müller-Mall, Sabine. *Legal Spaces: Towards a Topological Thinking of Law*. Berlin/Heidelberg: Springer-Verlag, 2013.

Multilateral Treaties Deposited with the Secretary-General. United Nations, New York (ST/LEG/SER.E). Accessed June 10, 2022. https://treaties.un.org/Pages/ParticipationStatus.aspx.

Murdocca, Carmela. "Ethics of Accountability: Gladue, Race, and the Limits of Reparative Justice." *Canadian Journal of Women & the Law* 30, no. 3 (2018): 522–42.

Murray, Jamie, Thomas E. Webb, and Steven Wheatley, eds. "Encountering Law's Complexity." In *Complexity Theory and Law: Mapping an Emergent Jurisprudence*, 3–22. Abingdon: Routledge, 2019.

Nadal, Kevin, Kristin Davidoff, and Whitney Fujii-Doe. "Transgender Women and the Sex Work Industry: Roots in Systemic, Institutional, and Interpersonal Discrimination." *World Journal of Trauma Dissociation* 15, no. 2 (2014): 169–93.

Naffine, Ngaire. "Sexing the Subject (of Law)." In *Public and Private: Feminist Legal Debates*, edited by Margaret Thornton, 18–39. Melbourne: Oxford University Press, 1995.

National Inquiry into Missing and Murdered Indigenous Women and Girls. *A Legal Analysis of Genocide: Supplementary Report of the National Inquiry into Missing and Murdered Indigenous Women and Girls*. n.d. https://www.mmiwg-ffada.ca/wp-content/uploads/2019/06/Supplementary-Report_Genocide.pdf.

National Inquiry into Missing and Murdered Indigenous Women and Girls. *Our Women and Girls Are Sacred: Interim Report of the National Inquiry into Missing and Murdered Indigenous Women and Girls*. 2017. https://www.mmiwg-ffada.ca/wp-content/uploads/2018/03/ni-mmiwg-interim-report.pdf.

National Inquiry into Missing and Murdered Indigenous Women and Girls. *Reclaiming Power and Place: The Final Report of the National Inquiry into Missing and Murdered Indigenous Women and Girls*. 2 vols. Ottawa: 2019.

Office of the Correctional Investigator. *OCI Annual Report 2021–2022*. June 30, 2022. https://oci-bec.gc.ca/en/content/office-correctional-investigator-annual-report-2021-2022#s9.

Office of the Correctional Investigator. "Proportion of Indigenous Women in Federal Custody Nears 50%: Correctional Investigator Issues Statement." December 17, 2021. https://www.oci-bec.gc.ca/cnt/comm/press/press20211217-eng.aspx.

Owusu-Bempah, Akwasi, Maria Jung, Firdaous Sbaï1, Andrew S. Wilton, and Fiona Kouyoumdjian. "Race and Incarceration: The Representation and

Characteristics of Black People in Provincial Correctional Facilities in Ontario, Canada." *Race and Justice* 13, no. 4 (2021): 532–40. https://doi.org/10.1177/21533687211006461.

Palmater, Pamela. "Shining Light on the Dark Places: Addressing Police Racism and Sexualized Violence against Indigenous Women and Girls in the National Inquiry." *Canadian Journal of Women and the Law* 28 (2016): 253–84.

Pargas, Damian Alan. "Disposing of Human Property: American Slave Families and Forced Separation in Comparative Perspective." *Journal of Family History* 34, no. 3 (2009): 251–74.

Parkes, Debra, and Kim Pate. "Time for Accountability: Effective Oversight of Women's Prisons." *Canadian Journal of Criminology and Criminal Justice* 48, no. 2 (April 2006): 251–86.

Parkes, Debra. "Women in Prison: Liberty, Equality, and Thinking Outside the Bars." *Journal of Law & Equality* 12 (2016): 126–56.

Parliamentary Assembly of the Council of Europe. *Mothers and Babies in Prison*. Report. Social, Health and Family Affairs Committee. Doc. 8762. June 9, 2000. http://assembly.coe.int/nw/xml/XRef/X2H-Xref-ViewHTML.asp?FileID=8953&lang=EN.

Paterson, John, and Gunther Teubner. "Changing Maps: Empirical Legal Autopoiesis." *Social and Legal Studies* 7 (1998): 451–86.

Paynter, Martha, Ruth Martin-Misener, Adelina Iftene, Gail Murphy Tomblin. "The Correctional Services Canada Institutional Mother Child Program: A Look at the Numbers." *The Prison Journal* 102, no. 2: 610–25.

Perez, Caroline Criado. *Invisible Women: Exposing Data Bias in a World Designed for Men*. New York: Abrams Press, 2019.

Perry, Adele. "'Fair Ones of a Purer Caste': White Women and Colonialism in Nineteenth-Century British Columbia." *Feminist Studies* 23, no. 3 (1998): 501–24.

Phillips, Doret, and Gordon Pon. "Anti-Black Racism, Bio-Power, and Governmentality: Deconstructing the Suffering of Black Families Involved with Child Welfare." *Journal of Law and Social Policy* 28 (2018): 81–100.

BIBLIOGRAPHY

Picard, André. "Babies Need Their Mothers, Even When Mom's in Jail." *Globe and Mail*. February 23, 2016.

Piper, Leanne K., Zoe Stewart, and Helen R. Murphy. "Gestational Diabetes." *Obstetrics, Gynaecology and Reproductive Medicine* 27, no. 6 (2017): 171–76.

"Policy: G-46, Obstetrical Care." *Adult Institutional Policy*. New Brunswick Public Safety Corrections. August 2010.

Press Office of the Holy See. *Joint Statement of the Dicasteries for Culture and Education and for Promoting Integral Human Development on the "Doctrine of Discovery."* February 30, 2023. https://press.vatican.va/content/salastampa/en/bollettino/pubblico/2023/03/30/230330b.html.

Provencher, Claudine, Anne Milan, Stacey Hallman, and Carol D'Aoust. "Report on the Demographic Situation in Canada: Fertility: Overview, 2012 to 2016." *Statistics Canada*, June 5, 2018. https://www150.statcan.gc.ca/n1/pub/91-209-x/2018001/article/54956-eng.htm.

Prudent, Jana G. "'This Can Happen to You': David Milgaard Works to Help Free Other Innocent People—Even Though It Opens the Wounds of His Past." *Globe and Mail*. August 3, 2019.

Public Safety Canada. *2020 Corrections and Conditional Release Statistical Overview*. March 22, 2022. https://www.publicsafety.gc.ca/cnt/rsrcs/pblctns/ccrso-2020/index-en.aspx#sc4.

Public Safety Canada. *2021 Corrections and Conditional Release Statistical Overview*. March 2023. https://www.publicsafety.gc.ca/cnt/rsrcs/pblctns/ccrso-2021/ccrso-2021-en.pdf.

Pulkingham, Jane, and Tanya van der Gaag. "Maternity/Parental Leave Provisions in Canada: We've Come a Long Way. But There's Further to Go." *Canadian Woman Studies* 23, no. 3–4 (2004): 116–25.

Quan, Douglas. "Canadian Prisons Embracing Babies." *National Post*. January 23, 2017.

Quenneville, Guy. "Coming Trial 'Is Not a Referendum on Racism,' Says Lawyer for Man Accused of Killing Colten Boushie." *CBC News*. January 26, 2018. https://www.cbc.ca/news/canada/saskatoon/coming-trial-referendum-racism-lawyer-killing-colten-boushie-1.4506553.

Quenneville, Guy. "Police Watchdog's Investigative File, Recommendations on Colten Boushie Case Now in Hands of RCMP." *CBC News*. February 27, 2020.

Quigley, Tim. "Some Issues in Sentencing of Aboriginal Offenders." In *Continuing Poundmaker and Riel's Quest*, edited by Richard Gosse, James Youngblood Henderson, and Roger Carter, 269–300. Saskatoon: Purich Publishing, 1994.

Rachlinski, Jeffrey J., Sheri Lynn Johnson, Andrew J. Wistrich, and Chris Guthrie. "Does Unconscious Racial Bias Affect Trial Judges?" *Notre Dame Law Review* 84 (2008) 1195–1246.

Rancière, Jacques. *Dis-Agreement: Politics and Philosophy*. Minneapolis: University of Minnesota Press, 1999.

Ray, Victor. "A Theory of Racialized Organizations." *American Sociological Review* 84, no. 1 (2019): 26–53.

Razack, Sherene H. *Dying from Improvement: Inquests and Inquiries into Indigenous Deaths in Custody*. Toronto: University of Toronto Press, 2015.

Razack, Sherene H. "Gendered Racial Violence and Spatialized Justice: The Murder of Pamela George." *Canadian Journal of Law and Society* 15, no. 2 (2000): 91–130.

Razack, Sherene H. "'It Happened More than Once': Freezing Deaths in Saskatchewan." *Canadian Journal of Women and the Law* 26, no. 1 (2014): 51–80.

Razack, Sherene. *Looking White People in the Eye: Gender, Race, and Culture in Courtrooms and Classrooms*. University of Toronto Press: Toronto, 1998.

Razack, Sherene H., ed. *Race, Space and the Law: Unmapping a White Settler Society*. Toronto: Between the Lines, 2002.

Razack, Sherene. "Speaking for Ourselves: Feminist Jurisprudence and Minority Women." *Canadian Journal of Women and the Law* 4 (1990–91): 440–58.

"RCMP Facebook Group Claims Colten Boushie 'Got What He Deserved.'" *APTN*. February 15, 2018. https://aptnnews.ca/2018/02/15/rcmp-facebook-group-claims-colten-boushie-got-deserved/.

"Reasonable Doubt." Panel discussion. February 13, 2020. University of Saskatchewan, College of Law. Saskatoon, SK, Canada.

Regan, Paulette. *Unsettling the Settler Within.* Vancouver: UBC Press, 2010.

Report of the Aboriginal Justice Inquiry of Manitoba. 5 vols. Winnipeg: 1992.

Ricciardelli, Rosemary, and Michael Adorjan. "Lifting the Liberal Veil: Examining the Link between Role Orientation and Attitudes toward Prisoners for Provincial Correctional Officers." In *Imprisonment: Identity, Experience and Practice,* edited by Rose Ricciardelli and Katharina Maier, 81–103. Leiden: Brill, 2015.

Rioux, Charlie, Scott Weedon, Kira London-Nadeau, Ash Paré, Robert Paul Juster, Leslie E. Roos, Makayla Freeman, Lianne Tomfohr-Madsen. "Gender-Inclusive Writing for Epidemiological Research on Pregnancy." *Journal of Epidemiology and Community Health* (28 June 2022). doi: 10.1136/jech-2022-219172.

Roach, Kent. *Canadian Justice, Indigenous Injustice.* Montreal and Kingston: McGill-Queen's University Press, 2019.

Roach, Kent. "Juries, Miscarriages of Justice and the Bill C-75 Reforms." *Canadian Bar Review* 98, no. 2 (2020): 315–57.

Robert, Tammy. "No, Rural Prairie Dwellers, You Can't Shoot to Protect Your Property." *Macleans Magazine.* February 8, 2018.

Roberts, Dorothy. *Torn Apart.* New York: Basic Books, 2022.

Robinson, Paul, Taylor Small, Anna Chen, and Mark Irving. "Over-Representation of Indigenous Persons in Adult Provincial Custody, 2019/2020 and 2020/2021." *Juristat.* Statistics Canada. July 12, 2023. https://www150.statcan.gc.ca/n1/pub/85-002-x/2023001/article/00004-eng.pdf.

Ross, Lynda R. *Interrogating Motherhood.* Athabasca, AB: Athabasca University Press, 2017. https://read.aupress.ca/read/interrogating-motherhood/section/00fa7ed0-ab32-450c-bfd2-588baf46d8bc.

Rottleuthner, Hubert. "A Purified Sociology of Law: Niklas Luhmann on the Autonomy of the Legal System." *Law and Society Review* 23, no. 5 (1989): 779–98.

Royal Commission on Aboriginal Peoples. *Looking Forward, Looking Back*. Vol. 1 of *Report of the Royal Commission on Aboriginal Peoples*. 1996. https://www.bac-lac.gc.ca/eng/discover/aboriginal-heritage/royal-commission-aboriginal-peoples/Pages/final-report.aspx.

Ruether, Rosemary Radford. "Misogynism and Virginal Feminism in the Fathers of the Church." In *Religion and Sexism*, edited by Rosemary Radford Ruether, 150–83. New York: Simon and Schuster, 1974.

Sacks, Karen. "Appendix Three: Engels Revisited: Women, the Organization of Production, and Private Property." In *Woman, Culture, and Society*, edited by Michelle Zimbalist Rosaldo and Louise Lamphere, 207–23. Stanford, CA: Stanford University Press, 1974.

Saskatchewan, "Provincial Court Judge Appointed in La Ronge." https://www.saskatchewan.ca/government/news-and-media/2018/march/23/judge-appointment-in-la-ronge.

Saskatchewan, "Provincial Court Judge Appointed in Saskatoon." https://www.saskatchewan.ca/government/news-and-media/2018/march/23/judge-appointed-in-saskatoon.

"Saskatchewan Premier Tells 115 Inmates Refusing to Eat How to Avoid Prison Food—Don't Go to Jail." *National Post*. January 7, 2016. https://nationalpost.com/news/canada/saskatchewan-premier-tells-115-inmates-refusing-to-eat-how-to-avoid-prison-food-dont-go-to-jail.

Sayers, Naomi. "#MMIW: A Critique of Sherene Razack's Piece Exploring the Trial of Pamela George's Murder." *kwetoday*. December 26, 2014, https://kwetoday.com/2014/12/26/mmiw-a-critique-of-sherene-razacks-exploration-of-the-trial-of-the-murder-of-pamela-george/.

Schmunk, Rhianna, "'You Are Not a Bad Mother': Husband Pens Letter to Moms with Postpartum Depression after Losing Wife." *CBC News*. January 17, 2017.

Schneider, Bethany. "A Modest Proposal: Laura Ingalls Wilder Ate Zitkala-Ša." *GLQ: A Journal of Gay and Lesbian Studies* 21, no. 1 (2015): 65–93.

Schuengel, Carlo, Mirjam Oosterman, and Paula S. Sterkenburg. "Children with Disrupted Attachment Histories: Interventions and Psychophysiological

Indices of Effects." *Child and Adolescent Psychiatry and Mental Health* 3, no. 26 (2009): https://www.ncbi.nlm.nih.gov/pmc/articles/PMC2749813/.

Schwartz, Daniel. "Truth and Reconciliation Commission: By the Numbers." CBC *News*. June 2, 2015. https://www.cbc.ca/news/indigenous/truth-and-reconciliation-commission-by-the-numbers-1.3096185.

Scott, James T.D. "Reforming Saskatchewan's Biased Sentencing Regime." *Criminal Law Quarterly: A Canadian Journal* 65 (2017): 91–139.

Sevunts, Levon. "Indigenous Parents Forced to Give Up Children for Better Access to Healthcare: Opposition MP." CBC *News*. October 26, 2017. https://www.rcinet.ca/en/2017/10/26/indigenous-parents-forced-to-give-up-children-for-better-access-to-healthcare-opposition-mp/.

Shaheen-Hussain, Samir. *Fighting for a Hand to Hold: Confronting Medical Colonialism Against Indigenous Children in Canada*. Montreal and Kingston: McGill-Queen's University Press, 2020.

Sheppard, Colleen. *Inclusive Equality: The Relational Dimensions of Systemic Discrimination in Canada*. Montreal and Kingston: McGill-Queen's University Press, 2010.

Shingler, Benjamin. "No Charges in Val-d'Or Abuse Scandal Will Breed Further Mistrust, Indigenous Leaders Say." CBC *News*. November 16, 2016.

Šimonović, Dubravka. "End of Mission Statement by Dubravka Šimonović, United Nations Special Rapporteur on Violence against Women, Its Causes and Consequences—Official Visit to Canada." Statements. United Nations Human Rights Office of the High Commissioner. April 23, 2018. https://www.ohchr.org/en/statements/2018/04/end-mission-statement-dubravka-simonovic-united-nations-special-rapporteur.

Simpson, Audra. "Sovereignty, Sympathy and Indigeneity." In *Ethnographies of U.S. Empire*, edited by Carole Anne McGranaghan and John Collins, 72–89. Durham: Duke University Press, 2018.

Simpson, Leanne Betasamosake. *As We Have Always Done*. Minneapolis: University of Minnesota Press, 2017.

Sinclair (Ótiskewápíwskew), Raven. "Identity or Racism? Aboriginal Transracial Adoption." In *Wicihitowin: Aboriginal Social Work in Canada*,

edited by Raven Sinclair, Michael Anthony Hart, and Gord Bruyere, 89–100. Halifax and Winnipeg: Fernwood, 2009.

Sinclair, Raven. "The Indigenous Child Removal System in Canada: An Examination of legal Decision-Making and Racial Bias." *First Peoples Child & Family Review* 11, no. 2 (2016): 8–18.

Sinha, Vandna, Stephen Ellenbogen, and Nico Trocmé. "Substantiating Neglect of First Nations and Non-Aboriginal Children." *Children & Youth Services Review* 35 (2013): 2080–90.

Skinner, Shirley, Otto Driedger, and Brian Grainger. *Corrections: A Historical Perspective on the Saskatchewan Experience*. Regina: Canadian Plains Research Center, University of Regina, 1981.

Slotkin, Richard. *Gunfighter Nation: The Myth of the Frontier in Twentieth-Century America*. Norman: University of Oklahoma Press, 1998.

Smith, Andrea. *Conquest: Sexual Violence and American Indian Genocide*. Durham: Duke University Press, 2015.

Smith, Bryand. "Legal Personality." *Yale Law Journal* 37, no. 3 (1928): 283–99.

Smith, David Livingstone. "Paradoxes of Dehumanization." *Social Theory and Practice* 42, no. 2 (April 2016): 416–43.

Smits, David D. "The 'Squaw Drudge': A Prime Index of Savagism." *Ethnohistory* 29, no. 5 (1982): 281–306.

Sölle, Dorothee. "Mary Is a Sympathizer." In *Wise Women*, edited by Susan Cahill, 322–29. New York: Norton, 1996.

Spratt, Eve G., Courtney Marsh, Amy E. Wahlquist, Carrie E. Papa, Paul J. Nietert, Kathleen T. Brady, Teri Lynn Herbert, and Carol Wagner. "Biologic Effects of Stress and Bonding in Mother-Infant Pairs." *International Journal of Psychiatry in Medicine* 51, no. 3 (2016): 246–57.

Starblanket, Gina, and Dallas Hunt. "How the Death of Colten Boushie Became Recast as the Story of a Knight Protecting His Castle." *Globe and Mail*. February 13, 2018.

Statistics Canada. "Adult and Youth Correctional Statistics, 2020/2021." Ottawa: Statistics Canada, April 20, 2022. https://www150.statcan.gc.ca/n1/daily-quotidien/220420/dq220420c-eng.htm.

Statistics Canada. "After an Unprecedented Decline Early in the Pandemic, the Number of Adults in Custody Rose Steadily over the Summer and Fell Again in December 2020." *The Daily*. July 8, 2021. https://www150.statcan.gc.ca/n1/daily-quotidien/210708/dq210708a-eng.htm.

Statistics Canada. *Quality of Employment in Canada: Pay Gap, 1998 to 2021*. Statistics Canada Catalogue no. 14280001. May 30, 2022. https://www150.statcan.gc.ca/n1/pub/14-28-0001/2020001/article/00003-eng.htm.

Statistics Canada. *Table 4 Admissions to Adult Correctional Services, by Type of Supervision and Jurisdiction, 2014/2015*. Ottawa: Statistics Canada, 2016. https://www150.statcan.gc.ca/n1/pub/85-002-x/2016001/article/14318-eng.htm.

Statistics Canada. *Table 6 Admissions to Adult Custody, by Aboriginal Identity, Sex and Jurisdiction, 2006/2007 and 2016/2017*. Ottawa: Statistics Canada, 2018. https://www150.statcan.gc.ca/n1/pub/85-002-x/2018001/article/54972/tbl/tbl06-eng.htm.

Statistics Canada. *Total Population by Aboriginal Identity and Registered or Treaty Indian Status, Saskatchewan, 2016 Census*. Ottawa: Statistics Canada, 2019. https://www12.statcan.gc.ca/census-recensement/2016/as-sa/fogs-spg/Facts-PR-Eng.cfm?TOPIC=9&LANG=Eng&GK=PR&GC=47.

Stefanovich, Olivia. "Chief Poundmaker, Wrongly Convicted of Treason-Felony in 1885, to Be Exonerated by Trudeau." CBC *News*. May 7, 2019.

Sterritt, Angela. "Indigenous Grandfather and 12-Year-Old Handcuffed in Front of Vancouver Bank after Trying to Open an Account." CBC *News*. January 9, 2020.

Stevenson, Allyson D. *Intimate Integration: A History of the Sixties Scoop and the Colonization of Indigenous Kinship*. Toronto: University of Toronto Press, 2021.

Stevenson, Winona. "Colonialism and First Nations Women in Canada." In *Racism, Colonialism and Indigeneity and Canada*, edited by Martin J. Cannon and Lina Sunseri, 44–56. Toronto: Oxford University Press, 2011.

Stewart, Michelle, and Corey Laberge. "Care-to-Prison Pipeline." In Dorries et al., *Settler City Limits*, 196–221.

Stirrett, Natasha. "Re-Visiting the Sixties Scoop: Relationality, Kinship and Honouring Indigenous Stories." MA thesis, Queens University, 2015.

Storey, Kenton. "The Pass System in Practice: Restricting Indigenous Mobility in the Canadian Northwest, 1885–1915." *Ethnohistory* 69, no. 2 (2022): 137–61.

Stote, Karen. *An Act of Genocide: Colonialism and the Sterilization of Aboriginal Women*. Black Point, NS: Fernwood, 2015.

Sufrin, Carolyn, Lauren Beal, Jennifer Clarke, Rachel Jones, and William D. Mosher. "Pregnancy Outcomes in U.S. Prisons, 2016–2017." *American Journal of Public Health* 109, no. 5 (2019): 779–805.

Sylvestre, Marie-Eve. "The (Re)Discovery of the Proportionality Principle in Sentencing in Ipeelee: Constitutionalization and the Emergence of Collective Responsibility." *Supreme Court Law Review* 63, no. 2 (2013): 461–81.

Sylvestre, Marie-Eve, and Marie-Andrée Denis-Boileau. "Ipeelee and the Duty to Resist." *University of British Columbia Law Review* 51, no. 2 (2018): 548–611.

Symanski, Mary Ellen. "Maternal-Infant Bonding: Practice Issues for the 1990s." *Journal of Nurse-Midwifery* 37, no. 2 (1992): S67–S73.

Tadiar, Neferti X.M. "Life-Times in Fate Playing." *South Atlantic Quarterly* 111, no. 4 (2012): 783–802.

Tait, Carrie. "Saskatchewan's Racial Divide." *Globe and Mail*. August 19, 2016.

Talaga, Tanya. *Seven Fallen Feathers*. Toronto: House of Anansi Press, 2017.

Tasker, John Paul. "Jane Philpott Unveils 6-point Plan to Improve 'Perverse' First Nations Child Welfare System." *CBC News*. January 25, 2018. http://www.cbc.ca/news/politics/jane-philpott-six-point-plan-first-nations-child-welfare-1.4503264.

Tasker, John Paul. "Ottawa to Hand Over Child Welfare Services to Indigenous Governments." *CBC News*. November 30, 2018. https://www.cbc.ca/news/politics/tasker-ottawa-child-welfare-services-indigenous-1.4927104.

Taylor, Stephanie. "Saskatchewan to Continue Using 'Birth Alerts' to Track Indigenous Babies Despite MMIW Inquiry's Call to Stop." *Globe and Mail*. June 19, 2019. https://www.theglobeandmail.com/canada/article-saskatchewan-to-continue-using-birth-alerts-to-track-indigenous/.

• BIBLIOGRAPHY •

Teelucksingh, Cheryl. *Claiming Space: Racialization in Canadian Cities.* Waterloo: Wilfrid Laurier University Press, 2006.

Thielen-Wilson, Leslie. "Feeling Property: Settler Violence in the Time of Reconciliation." *Canadian Journal of Women and the Law* 30, no. 3 (2018): 494–521.

Thomson, Aly, and Blair Rhodes. "RCMP Deleted Documents in Wrongful Conviction Case, Federal Report Finds." *CBC News.* July 12, 2019.

Tilly, Charles. *Durable Inequality.* Berkeley: University of California Press, 1998.

"Tina Fontaine: Murdered Schoolgirl 'Was Repeatedly Failed.'" *BBC News.* March 12, 2019. https://www.bbc.com/news/world-us-canada-47544095.

"U.S. Child Migrants: 2,000 Separated from Families in Six Weeks." *BBC News.* June 15, 2018.

Toronto Police Service. *Race & Identity Based Data Collection Strategy Understanding: Use of Force & Strip Searches in 2020.* Toronto: Toronto Police Service, 2022. https://embed.documentcloud.org/documents/22060566-98ccfdad-fe36-4ea5-a54c-d610a1c5a5a1/?embed=1.

Troian, Martha. "Decades Old MMIWG Cases Not Being Researched by Inquiry." *APTN National News.* November 23, 2017.

Truth and Reconciliation Commission of Canada. *Canada's Residential Schools: The Final Report of the Truth and Reconciliation Commission of Canada.* 6 vols. Montreal and Kingston: McGill-Queen's University Press, 2015.

Truth and Reconciliation Commission of Canada, *Honouring the Truth, Reconciling for the Future: Summary of the Final Report of the Truth and Reconciliation Commission of Canada.* 2015. https://publications.gc.ca/collections/collection_2015/trc/IR4-7-2015-eng.pdf.

Tully, Kristin P., Alison M. Stuebe, and Sarah B. Verbiest. "The Fourth Trimester: A Critical Transition Period with Unmet Maternal Health Needs." *American Journal of Obstetrics & Gynecology* 217, no. 1 (2017): 37–41.

Tunney, Catharine. "RCMP Watchdog's Review into Colten Boushie Case Delayed." *CBC News.* March 4, 2019.

"Two Worlds Colliding Screen Ten Years after Release." *CBC News.* November 20, 2014.

United Nations [hereafter UN] Committee against Torture. Concluding Observations on the Combined Third to Fifth Periodic Reports of the United States of America. UN Doc. CAT/C/USA/CO/3-5 (December 19, 2014). https://documents-dds-ny.un.org/doc/UNDOC/GEN/G14/247/23/PDF/G1424723.pdf?OpenElement.

UN Committee Against Torture. *Conclusions and Recommendations of the Committee against Torture.* UN Doc. CAT/C/USA/CO/2 (July 25, 2006). https://undocs.org/CAT/C/USA/CO/2.

UN Committee on the Rights of the Child. General Comment No. 14 on the Right of the Child to Have His or Her Best Interests Taken as a Primary Consideration. UN Doc. CRC/C/GC/14 (May 29, 2013). http://www2.ohchr.org/English/bodies/crc/docs/GC/CRC_C_GC_14_ENG.pdf.

UN General Assembly. Convention against Torture and Other Cruel, Inhuman or Degrading Treatment or Punishment. December 10, 1984 (ratified by Canada on June 24, 1987). 1465 UNTS 85.

UN General Assembly. Convention on the Elimination of All Forms of Discrimination against Women. December 18, 1979 (ratified on December 10, 1981). 1249 UNTS 13.

UN General Assembly. Convention on the Prevention and Punishment of the Crime of Genocide. December 9, 1948 (entered into force January 12, 1951, ratified by Canada September 3, 1952). 78 UNTS 277.

UN General Assembly. Convention on the Rights of the Child. November 20, 1989 (ratification by Canada on December 13, 1991). 1577 UNTS 3.

UN General Assembly. Guidelines for the Alternative Care of Children Without Parental Care. UN Doc. A/RES/64/142 (December 18, 2009).

UN General Assembly. A Human Rights–Based Approach to Mistreatment and Violence Against Women in Reproductive Health Services with a Focus on Childbirth and Obstetric Violence. Report of the Special Rapporteur on Violence against Women, Its Causes and Consequences. UN Doc. A/74/137 (July 11, 2019).

UN General Assembly. International Convention on the Elimination of All Forms of Racial Discrimination. December 21, 1965. UNTS 660 195.

UN General Assembly. International Covenant on Civil and Political Rights. December 19, 1966 (accession by Canada May 19, 1976). 999 UNTS 171.

UN General Assembly. International Covenant on Economic, Social and Cultural Rights. December 16, 1966 (accession by Canada May 19, 1976). CAN TS 1976 No 46.

UN General Assembly. Report of the Inquiry Concerning Canada of the Committee on the Elimination of Discrimination against Women under Article 8 of the Optional Protocol to the Convention on the Elimination of All Forms of Discrimination against Women. UN Doc. CEDAW/C/OP.8/CAN/1 (2015).

UN General Assembly. United Nations Declaration on the Rights of Indigenous Peoples. UN Doc. A/RES/61/295 (October 2, 2007). https://www.un.org/esa/socdev/unpfii/documents/DRIPS_en.pdf.

UN General Assembly. United Nations Rules for the Treatment of Women Prisoners and Non-Custodial Measures for Women Offenders (the Bangkok Rules). UN Doc. A/RES/65/229 (March 16, 2011).

UN General Assembly. United Nations Standard Minimum Rules for the Treatment of Prisoners (the Nelson Mandela Rules). UN Doc. A/RES/70/175 (2016).

UN General Assembly. Vienna Convention on the Law of Treaties. Entered into force January 27, 1980. 1155 UNTS 331.

UN Human Rights Committee. Concluding Observations of the Human Rights Committee, United States of America. UN Doc. CCPR/C/USA/CO/3/Rev.1 (December 18, 2006).

Valdes, Francisco. "Unpacking Hetero-Patriarchy: Tracing the Conflation of Sex, Gender & Sexual Orientation to Its Origins." *Yale Journal of Law & the Humanities* 8, no. 1 (1996): 161–211.

van Ert, Gib. "The Reception of International Law in Canada: Three Ways We Might Go Wrong." *Centre for International Governance Innovation*, 150 and Beyond Paper No. 2. 2018. https://www.cigionline.org/publications/reception-international-law-canada-three-ways-we-might-go-wrong.

Vandervort, Lucinda. "Flaming Misogyny or Blindly Zealous Enforcement? The Bizarre Case of *R v. George*." *Manitoba Law Journal* 42, no. 3 (2019): 1–38.

Vasiljevic, Milica, and G. Tendayi Viki. "Dehumanization, Moral Disengagement, and Public Attitudes to Crime and Punishment." In *Humanness and Dehumanization*, edited by Paul G. Bain, Jeroen Vaes, and Jacques Philippe Leyens, 129–46. New York: Psychology Press, 2013.

Wakefield, Jonny. "Former Alberta Inmate Carried Stillborn Baby for Weeks after Seeking Help From Sstaff." *Edmonton Journal*. March 26, 2018. https://edmontonjournal.com/news/local-news/former-alberta-inmate-carried-stillborn-baby-for-weeks-after-seeking-help-from-staff.

Walby, Sylvia. "Theorising Patriarchy." *Sociology* 23, no. 2 (May 1989): 213–34.

Waring, Marilyn. *If Women Counted*. New York: Harper & Row, 1988.

Warner, Jennifer. "Infants in Orange: An International Model-Based Approach Prison Nurseries." *Hastings Women's Law Journal* 26 (2015): 65.

Watt, Jaime. "Toronto Police Culture Still Harms LGBTQ Community." *Toronto Star*. February 11, 2018.

"'We Do Not Accept Your Apology,' Activist Tells Toronto's Police Chief after Race-Based Data Released." *CBC News*. June 15, 2022. https://www.cbc.ca/news/canada/toronto/toronto-police-race-based-data-use-force-strip-searches-1.6489151.

White, Patrick. "'Shocking and Shameful': For the First Time, Indigenous Women Make Up Half the Female Population in Canada's Federal Prisons." *Globe and Mail*. May 5, 2022.

Wilder, Laura Ingalls. *Little House on the Prairie*. New York: Harper & Row, 1971.

Williams, Natara. "Pre-Hire Pregnancy Screening in Mexico's Maquiladoras: Is It Discrimination?" *Duke Journal of Gender Law & Policy* 12 (2005): 131–50.

Williams, Robert B. "Wealth Privilege and the Racial Wealth Gap: A Case Study in Economic Stratification." *Review of Black Political Economy* 44 (2017): 303–25.

Windsong, Elena Ariel. "Incorporating Intersectionality into Research Design: An Example Using Qualitative Interviews." *International Journal of Social Research Methodology* 21, no. 2 (2016): 135–47.

• BIBLIOGRAPHY •

Winston, Robert, and Rebecca Chicot. "The Importance of Early Bonding on the Long-Term Mental Health and Resilience of Children." *London Journal of Primary Care* 8, no. 1 (2016): 12–14.

Wolfe, Patrick. "Nation and MiscegeNation: Discursive Continuity in the Post-Mabo Era." *Social Analysis: The International Journal of Anthropology*, no. 36 (October 1994): 93–152.

Wolfson, Lindsay, Nancy Poole, Melody Morton Ninomiya, Deborah Rutman, Sherry Letendre, Toni Winterhoff, Catherine Finney et al. "Collaborative Action on Fetal Alcohol Spectrum Disorder Prevention: Principles for Enacting the Truth and Reconciliation Commission Call to Action #33." *International Journal of Environmental Research and Public Health* 16, no. 9 (2019): 1589–1602. https://doi:10.3390/ijerph16091589.

World Health Organization. *The Prevention and Elimination of Disrespect and Abuse During Facility-Based Childbirth: WHO Statement*. 2014. https://apps.who.int/iris/bitstream/handle/10665/134588/WHO_RHR_14.23_eng.pdf.

Wright, David H. *Report of the Commission of Inquiry into Matters Relating to the Death of Neil Stonechild*. Saskatoon: Saskatchewan Ministry of Justice, 2004.

Wright, Melissa W. "The Dialectics of Still Life: Murder, Women, and Maquiladoras." *Public Culture* 11, no. 3 (1999): 453–74.

Young, Rachel. "The Importance of Bonding." *International Journal of Childbirth Education* 28, no. 3 (2013): 11–16.

NOTES

INTRODUCTION

1. This work has been subject to ethics review, and names are chosen pseudonyms. Behavioural Research Ethics Board, University of Saskatchewan, November 5, 2018.
2. Government of Saskatchewan, "Ministry of Justice and Attorney General."
3. This is in contrast to apprehensions ordered by judges, or when an administrative actor identifies a threat of serious harm to the child. "All of these factors point to serious harm or risk of serious harm as an appropriate threshold for apprehension without prior judicial authorization." *Winnipeg Child and Family Services v. KLW*, [2000] 2 SCR 519 at 577 (quotation is from the majority decision).
4. *Dobson (Litigation Guardian of) v. Dobson*, [1999] 2 SCR 753. Children become legal persons at birth.
5. Reference re Secession of Quebec, 1998 CanLII 793 (SCC), [1998] 2 SCR 217 at paras 49, 54; see also *Toronto (City) v. Ontario (Attorney General)*, 2021 SCC 34 (CanLII) (on the role of unwritten principles in interpreting the Charter).
6. Reference re Secession of Quebec at paras 70–71.
7. Roncarelli v. Duplessis, [1959] SCR 121; Reference Re Manitoba Language Rights, [1985] 1 SCR 721.
8. *Singh v. Minister of Employment and Immigration*, [1985] 1 SCR 177 (on fairness and fundamental justice); *Curr v. The Queen*, [1972] SCR 88 (on due process); *Baker v. Canada (Minister of Citizenship and Immigration)*, [1999] 2 SCR 817 (on administrative fairness).
9. UN General Assembly, Convention on the Rights of the Child, 1577 UNTS 3.
10. UN General Assembly, Convention on the Rights of the Child (emphasis added).
11. As of June 10, 2022, the Convention on the Rights of the Child was ratified by 196 parties. Multilateral Treaties Deposited with the Secretary-General, chapter IV, subchapter 11.

12 Jacquie as was granted credit for remand time served, namely for the one month of incarceration which was directly following her arrest.
13 Paul Robinson et al., "Over-Representation of Indigenous Persons." Statistics Canada reports that "Indigenous adults accounted for about one-third of all adult admissions to provincial and territorial (31%) and federal (33%) custody, while representing approximately 5% of the Canadian adult population in 2020." Statistics Canada, Adult and Youth Correctional Statistics, 2020/2021. Malakieh reports that "in 2016/2017, Aboriginal adults accounted for 28% of admissions to provincial/territorial correctional services and 27% for federal correctional services, while representing 4.1% of the Canadian adult population." Malakieh, *Adult and Youth Correctional Statistics in Canada, 2016/2017*. See also Public Safety Canada, 2021 Corrections and Conditional Release Statistical Overview.
14 Luhmann, *Law as a Social System*; Razack, "Gendered Racial Violence," 117; Monture, "Standing against Canadian Law," 77; Tracey Lindberg, "Critical Indigenous Legal Theory Part 1," 224.
15 Miller et al., *Discovering Indigenous Lands*, 131.
16 E.g., Razack, "Gendered Racial Violence."
17 Razack, "Gendered Racial Violence."
18 Dehumanization can involve seeing someone as simultaneously human and subhuman. David Livingstone Smith, "Paradoxes of Dehumanization," 416–43. Note also relevant concept of infrahumanization. Leyens, "Retrospective and Prospective Thoughts about Infrahumanization," 807–17.
19 Crenshaw, "Mapping the Margins," 1241–99.
20 Regarding discrimination and over-policing in Canada, see, e.g., the 2022 Toronto Police Service examination of 7,114 strip searches and 949 incidents involving use of force. Black residents were overrepresented in the "enforcement actions" taken against them by a factor of 2.2 times. For use of force by police, Black, Latino, East/Southeast Asian and Middle Eastern people were overrepresented by factors of 1.6 times, 1.5 times, 1.2 times, and 1.2 times, respectively. See, e.g., Toronto Police Service, *Race & Identity Based Data Collection Strategy Understanding*. "'We Do Not Accept Your Apology.'" For 2010 data showing incarceration of Black men and women in Ontario at five and three times the rate of white men and women, respectively, see Owusu-Bempah et al., "Race and Incarceration." On gender identity discrimination, see, e.g., Moseson et al., "The Imperative for Transgender and Gender Nonbinary Inclusion," 1059–68.
21 For instance, while ideologies of white entitlement to control are connected to both anti-Indigenous and anti-Black racism, the histories and images and/or narratives employed to dehumanize are distinct. Phillips and Pon describe distinct histories in the context of racism in Canadian child welfare policy. Phillips and Pon, "Anti-Black Racism, Bio-Power, and Governmentality," 81–100. See also Brester, *Archetypal Grief*. In analysis published initially in 1990, sociologist Patricia Hill Collins examines the "controlling images" employed to oppress Black women, including the "mammy," "matriarch," "welfare mother" and "jezebel." Collins, *Black Feminist Thought*, 65–96. See also Roberts, *Torn Apart*.

NOTES

22. Rioux et al., "Gender-Inclusive Writing"; Hahn et al., "Providing Patient-Centered Perinatal Care," 959–63.
23. Luhmann, *A Sociological Theory of Law*, 284–85.
24. The impacts on children have been described as "collateral consequences" as well as "collateral damage." Minson, *Maternal Sentencing and the Rights of the Child*, 36.
25. *Dobson (Litigation Guardian of) v. Dobson*, [1999] 2 SCR 753 at 761.
26. The word "prejudice" means "pre-judge" in Latin. *Report of the Aboriginal Justice Inquiry of Manitoba*, vol. 1, *The Justice System and Aboriginal People*, chapter 4. "Prejudice" has origins "from Old French, from Latin praejudicium, from prae 'in advance' + judicium 'judgment.'" *Oxford Dictionary of English*, 3rd ed. (2015), s.v. "prejudice."
27. See Tully, Stuebe, and Verbiest, "The Fourth Trimester," 37.
28. See for example Gordon et al., "Oxytocin and the Development of Parenting in Humans," 377; Hazan and Campa, *Human Bonding*; Kayla Johnson, "Maternal Infant Bonding," 17; Liu, Leung, and Yang, "Breastfeeding and Active Bonding," 76; Young, "Importance of Bonding," 11; Symanski, "Maternal-Infant Bonding," S67.
29. See Schuengel, Oosterman, and Sterkenburg, "Children with Disrupted Attachment Histories."
30. "[T]he parent-infant bond provides a foundation for future adaptation, relationships, and mental health for children and adults." Spratt et al., "Biologic Effects of Stress and Bonding," 246. "[T]he connection made after birth directly affects both the mother and newborn physiologically, psychologically and emotionally. A strong bond formed between a mother and infant leads to positive outcomes and impacts the maternal child relationship through the lifespan." Barker et al., "Maternal-Newborn Bonding."
31. Bultitude, Rodari, and Weitkamp, "Bridging the Gap between Science and Policy," 1.
32. Bauman, *Modernity and the Holocaust*. All are doing their job in seeming disregard to the violence they are committing, which raises an example of Hannah Arendt's observations on the banality of evil. Arendt, *Eichmann in Jerusalem*.
33. Prince, as cited in *Report of the Aboriginal Justice Inquiry of Manitoba*, vol. 1, *The Justice System and Aboriginal People*, chapter 4.
34. Razack, *Looking White People in the Eye*, 10. See also Murdocca, "Ethics of Accountability," 522.
35. This is what I understand Lisa Monchalin to call the "colonial problem." Monchalin, *The Colonial Problem*.
36. On the problem with Western universalizing see Ermine, "The Ethical Space of Engagement," 198. On reflection on one's own positionality see, e.g., Earick, "We Are Not Social Justice Equals," 800–20.
37. Krasowski, *No Surrender*, 266, 272. On differing conceptions of treaty-making, see Kiiwetinepinesiik Stark, "Criminal Empire." See also Cardinal, *The Unjust Society*, 33.
38. Krasowski, *No Surrender*, 267.
39. Perry, "'Fair Ones of a Purer Caste,'" 501.
40. Wolfe, "Nation and MiscegeNation," 96.

I. SENTENCING THE NEWBORN

1. In the 2014–15 fiscal year only about 4 percent (178 out of 4,401) of Saskatchewan admissions to sentenced custody had written reasons. Specifically, Statistics Canada reported 4,401 admissions to sentenced adult custody in Saskatchewan in the 2014–15 fiscal year. Saskatchewan Courts confirmed to me that all written decisions are released to CanLII. In CanLII, the total number of court decisions at all levels in Saskatchewan containing the word "sentence" or "sentencing" was 178 for this time period. (The total number of written criminal decisions—not even just the sentencing ones—was 435.) Statistics Canada, *Table 4 Admissions to Adult Correctional Services*. Jury trials and plea bargains do not have published written reasons.
2. Sonia Lawrence, "Cultural (in)Sensitivity," 107–36.
3. This raised obvious issues concerning a person's right to notice as part of a decision-maker's duty of fairness. Flood and Sossin, *Administrative Law in Context*, 224–26; *Supermarchés Jean Labrecque Inc. v. Flamand*, [1987] 2 SCR 219.
4. Piper, Stewart, and Murphy, "Gestational Diabetes," 171; see also Kolahdooz et al., "Canadian Indigenous Women's Perspectives," 334–48.
5. Braxton Hicks contractions are false or practice labour contractions that occur for some women during pregnancy. Dunn, "John Braxton Hicks," F157.
6. During the time of Jacquie's experience in 2016 there was no restraints policy in Saskatchewan specific to women in labour, but this was changed in 2017 and it is now prohibited to place restraints on women in labour. See "External Escorts" in *Adult Custody Services Policy Manual*, February 25, 2019, s. 7.3 (p. 6). The December 28, 2016, version of this manual (on file with author) did not disallow shackles during labour; the August 1, 2017 version (on file with author) included for the first time a prohibition on restraints during labour and delivery.
7. UN Committee on the Rights of the Child, General Comment No. 14, at paras 28, 69.
8. *Baker v. Canada (Minister of Citizenship and Immigration)*, [1999] 2 SCR 817.
9. "In August 2013, Sue Delanoy, Executive Director of the Saskatchewan branch of the Elizabeth Fry Society suggested that only five of the approximately 140 inmates at Pine Grove Correctional were non-Aboriginal." Canadian Centre for Policy Alternatives, *Warehousing Prisoners in Saskatchewan*, 27–35. Statistics Canada reported that for 2016–17 an average of 85 percent of women admitted to Saskatchewan Provincial Corrections were Aboriginal. Statistics Canada, *Table 6 Admissions to Adult Custody*. Note that Indigenous persons comprised 16.3 percent of Saskatchewan's population in 2016. Statistics Canada, *Total Population by Aboriginal Identity*.
10. Monkman, "Debunking the Myth."
11. Royal Commission on Aboriginal Peoples, *Looking Forward, Looking Back*; Truth and Reconciliation Commission of Canada, *Honouring the Truth, Reconciling for the Future*.
12. Garland, Pettus-Davis, and Howard, "Self-Medication among Traumatized Youth," 175–185; Hagen et al., "A Big Hole with the Wind Blowing through It," 356; Bellamy and Hardy, *Post-Traumatic Stress Disorder*.
13. Wolfson et al., "Collaborative Action on Fetal Alcohol Spectrum Disorder Prevention," 1589.

NOTES

14 Monture-Angus, *Journeying Forward*, 24.
15 "The figures are stark and reflect what may fairly be termed a crisis in the Canadian criminal justice system. The drastic overrepresentation of aboriginal peoples within both the Canadian prison population and the criminal justice system reveals a sad and pressing social problem." *R v. Gladue*, [1999] 1 SCR 688, 722.

2. AUTOMATIC SEPARATION IN CANADA

1 *Inglis v. British Columbia (Minister of Public Safety)*, 2013 BCSC 2309 at para. 15.
2 *Inglis v. British Columbia (Minister of Public Safety)*, 2013 BCSC 2309 at para. 2. The mother-baby program had been in place since 1973.
3 *Inglis v. British Columbia (Minister of Public Safety)*, 2013 BCSC 2309 at para. 345.
4 "I find that the interest of mothers and infants to remain together is one aspect of the security of the person of each that falls within the scope of s. 7. The decision to cancel the Mother Baby Program removed one important option, the one presumed at law to be favourable, from the process of determining the best interests of the child. As a result, infants have been and will be separated from their mothers during the critical formative period of their life, interfering with their attachment to their mother, and depriving them of the physical and psychological benefits associated with breastfeeding. The mothers have already and will continue to suffer the adverse consequences of separation from their infants. The decision to cancel the Mother Baby Program was state action that constituted an infringement of the s. 7 rights to security of the person of both mothers and babies." *Inglis v. British Columbia (Minister of Public Safety)*, 2013 BCSC 2309 at para. 412.
5 *Inglis v. British Columbia (Minister of Public Safety)*, 2013 BCSC 2309 at para. 569.
6 *Inglis v. British Columbia (Minister of Public Safety)*, 2013 BCSC 2309 at para. 570.
7 *Inglis v. British Columbia (Minister of Public Safety)*, 2013 BCSC 2309 at para. 612.
8 Winston and Chicot, "The Importance of Early Bonding," 12–14; Tully, Stuebe, and Verbiest, "The Fourth Trimester," 37.
9 LaFrance, "What Happens to a Woman's Brain When She Becomes a Mother."
10 Hoekzema et al., "Pregnancy Leads to Long-Lasting Changes," 287.
11 Clarke and Simon, "Shackling and Separation," 779–85; Warner, "Infants in Orange," 65; Friedman, Kaempf, and Kauffman, "The Realities of Pregnancy and Mothering While Incarcerated," 365–75.
12 A Bill for an Act Relating to Corrections; Authorizing the Placement of Pregnant and Postpartum Female Inmates in Community-Based Programs, Senate, State of Minnesota, 92nd Session, SF No. 1315; Minnesota Department of Corrections, "Healthy Start Act SF 1315/HF 1403."
13 Local Procedural Directive for the Pine Grove Correctional Centre. On file with author.
14 Ministry of Social Services, *Children's Services Manual*, 200 (on maintenance rates), 217 (on the maximum number of foster children). For north of the 54th parallel, the rate for children 0–5 is $714/month.

15 Child and Family Services Act, ss 1989–90, c. C-7.2, ss 4, 35–39.
16 Community Safety Division, Manitoba Justice, letter to author, July 12, 2016 (reference no. 2016–62).
17 Liauw et al., "The Unmet Contraceptive Need of Incarcerated Women in Ontario," 820–26.
18 Givetash, "Jail Program Gives Moms a New Start."
19 Ministry of Community Safety and Correctional Services, Ontario, letter to author, July 20, 2016, no. CSCS-A-2016-02771. (This numbering is the internal filing identifier from the organization providing the information.)
20 Justice Sector Freedom of Information and Privacy Office (FOIP), Ontario, letter to author, (October 1, 2020, no. SOLGEN-A-2020-01919.
21 Justice and Solicitor General FOIP Office, Alberta, letter to author, November 2, 2016, no. 2016-G-0230.
22 Alberta Health Services, Alberta, letter to author, June 10, 2022, no. 2020-G-080; Community Services & Safety Sector, Justice and Solicitor General FOIP Office, Alberta, letter to author, August 27, 2020, no. 2020-G-0419.
23 Community Safety Division, Manitoba Justice, letter to author, July 12, 2016, no. 2016-62.
24 Community Safety Division, Manitoba Justice, letter to author, May 27, 2020, no. 2020-067.
25 Ministry of Justice, Saskatchewan, letter to author, May 11, 2016, no. CP00916G; Ministry of Justice, Saskatchewan, letter to author, July 22, 2016, no. CP04116G (clarifying timeframe for records).
26 "Prenatals in Pine Grove January 1, 2016 to December 31, 2019," Ministry of Justice, Saskatchewan, enclosure to letter to author, June 10, 2020, no. CP 015-20G.
27 Department of Justice, Nova Scotia, letter to author, July 19, 2016, no. 2016-00865-JUS.
28 Service Nova Scotia and Internal Services, Nova Scotia, letter to author, June 16, 2020, no. 2020-00735-JUS.
29 Department of Public Safety, New Brunswick, letter to author, July 11, 2016, unnumbered.
30 Department of Public Safety, New Brunswick, letter to author, May 26, 2020, unnumbered.
31 Access and Privacy Services Office, PEI, letter to author, July 20, 2016, no. 2016-106-JPS.
32 Access and Privacy Services Office, PEI, telephone conversation, March 2020.
33 Department of Justice and Public Safety, Newfoundland and Labrador, letter to author, July 12, 2016, no. JPS/078/2016.
34 Department of Justice and Public Safety, Newfoundland and Labrador, letter to author, April 30, 2020, no. JPS/069/2020.
35 Government of the Northwest Territories, letters to author, July 22, 2016 and August 19, 2016, unnumbered.
36 Government of the Northwest Territories, letter to author, May 14, 2020, unnumbered.
37 Highways and Public Works, Yukon, letter to author, October 19, 2016, no. A-6448.
38 Deputy Minister, Justice, Yukon, letter to author, May 5, 2020, no. A-8284.
39 Department of Justice, Nunavut, letter to author, July 5, 2016, no. 1029-20-JUS0434.

• NOTES •

40 Department of Justice, Nunavut, letter to author, May 15, 2020, no. 1029-20-JUS0106.
41 Ministère de la Sécurité publique, Quebec, letter to author, July 15, 2016, no. 118018.
42 Ministère de la Sécurité publique, Quebec, letter to author, October 21, 2016, no. 119223.
43 In BC at that time, one was not permitted to make an information request in the form of a question. One was required to request specific records, but no one would tell me what precise type of records I was supposed to request. After two attempts, I gave up.
44 Cohen, "Mother-Baby Unit at BC Jail."
45 Givetash, "Mother-Child Prison Program."
46 Ministry of Citizens' Services, British Columbia, letter to author May 21, 2020, no. PSS-2020-2614.
47 Correctional Service Canada, letter to author, August 11, 2016, no. A-2016-00165.
48 Quan, "Canadian Prisons Embracing Babies."
49 Correctional Service Canada, letter to author, July 14, 2020, no. A-2020-00020.
50 Picard, "Babies Need Their Mothers."
51 Public Safety Canada, *2020 Corrections and Conditional Release Statistical Overview,* "Table C3. Number of Admissions to CSC Facilities."
52 Sufrin et al. report a pregnancy rate of 3.8 percent among incarcerated women in the U.S. Sufrin et al, "Pregnancy Outcomes in U.S. Prisons, 2016–2017," 799; see also Bryne et al. citing multiple studies and reporting an estimated 4–10 percent pregnancy rate among women entering custody. Byrne, Goshin, and Blanchard-Lewis, "Maternal Separations During the Reentry Years," 77–90.
53 Liauw et al., "The Unmet Contraceptive Need of Incarcerated Women in Ontario."
54 Office of the Correctional Investigator, *OCI Annual Report 2021–2022.*
55 Paynter et al., "The Correctional Service Canada Institutional Mother Child Program," 9.
56 Paynter et al., 8.

3. A SYSTEMS VIEW OF THE LEGAL SYSTEM

1 Luhmann, *Sociological Theory,* 26, 284. See also Buckel, *Subjectivation and Cohesion,* 8–37; Baxter, "Niklas Luhmann's Theory of Autopoietic Legal Systems," 167–84.
2 Luhmann, *Law as a Social System,* 284.
3 Luhmann, 284.
4 Luhmann, 111.
5 Luhmann, 282–83.
6 Luhmann, 357.
7 Luhmann, 368.
8 The political sovereign influences law but not entirely directly. "The paradoxes of the political system culminate in the formula of the sovereign...[but] an adequate theory of the legal system cannot be constructed if its factual operations are defined as the implementation of political programmes, no matter how much legal decision may be guided by politically desirable consequences." Luhmann, 364.

9 Murray, Webb, and Wheatley, eds., "Encountering Law's Complexity," 6; Rottleuthner, "A Purified Sociology of Law," 779.
10 Paterson and Teubner, "Changing Maps: Empirical Legal Autopoiesis," 456.
11 Razack, "Gendered Racial Violence," 117. Razack, "Introduction: When Place Becomes Race," in Razack, ed., *Race, Space and the Law*, 1; Razack, *Dying from Improvement*. For application of theory to human trafficking of Indigenous women, see Robin Bourgeois, "Colonial Exploitation," 1426. On trafficking and dispossession, see Julie Kaye, *Responding to Human Trafficking*.
12 Razack, "Gendered Racial Violence," 95 (emphasis in original). I also see parallels between Razack's spatialized justice definitional categories and the "racial schemas" identified within racialized organizations theory, building on theories of racialized social systems. As Ray explains with reference to DiMaggio and Sewell, "Schemas are generalizable, often unconscious, cognitive 'default assumptions' acting as situationally applicable templates for social action. Put simply, schemas can be thought of as a kind of unwritten rulebook explaining how to write rules. For our purposes, racial schemas provide a set of 'fundamental tools of thought' for the accumulation and distribution of organizational resources." Ray, "A Theory of Racialized Organizations," 26 at 31. On how social spaces become embedded with white privilege and domination see also Embrick and Moore, "White Spaces(s) and the Reproduction of White Supremacy," 1935–45, 1937.
13 Describing Foucaultian discourse analysis in socio-legal scholarship, see Cunliffe, "Ambiguities," 185 at 199; see also Henry and Tator, *Discourses of Domination*.
14 McNinch, "'I Thought Pocahontas Was a Movie,'" cited in McNinch and Schick, eds., "*I Thought Pocahontas was a Movie*," 151.
15 On social analysis of space and race, see Teelucksingh, *Claiming Space*. For theorization on spatiality and global law, see Müller-Mall, *Legal Spaces*.
16 Razack, "Gendered Racial Violence," 97.
17 Razack, 97.
18 Razack, 102.
19 Razack, 96.
20 Razack, 123 (emphasis added). Razack cites Denise Ferriera da Silva, "Interrogating the Socio-Logos of Justice: Considerations of Race Beyond the Logic of Exclusion," Law and Society Association Summer Institute, University of Buffalo, SUNY (8 July 2000): 2, cited in Razack "Gendered Racial Violence," 116. Indigenous lawyer Naomi Sayers critiques Razack's article for Razack's construction of sex work as innately violent. Sayers, "#MMIW: A Critique of Sherene Razack's Piece." With regard to Razack's reference to the defence as the source of this argument it is notable that counsel for one of persons convicted for Pamela George's murder went on to be appointed to the bench. Some of his judgments have been subject to critique for showing misogyny. *R v. Kummerfield*, 1997 CanLII 11511 (SK KB); Vandervort, "Flaming Misogyny or Blindly Zealous Enforcement?" 1–38.
21 Razack, *Dying from Improvement*, 86–87, citing Slotkin, *Gunfighter Nation*.
22 Razack, *Dying from Improvement*, 59. For another discussion of Razack's work and the idea of Indigenous persons being "on the brink of death," see McCallum and Perry's

NOTES

scholarship concerning Brian Sinclair's death. Mr. Sinclair died in the waiting room of a Winnipeg hospital, unattended to for thirty-four hours. McCallum and Perry, *Structures of Indifference*, 5–7.

23 Stewart and Laberge, "Care-to-Prison Pipeline," 208. Stewart and Laberge also identify the work of Tadiar and Melissa W. Wright concerning persons constructed as being waste and/or disposable. Tadiar, "Life-Times in Fate Playing," 783–802; Melissa W. Wright, "The Dialectics of Still Life" 453–74.
24 Davies, *Alone and Cold: Davies Commission*, 13.
25 Razack, *Dying from Improvement*, 59.
26 Razack, "'It Happened More than Once.'" 51.
27 Razack, *Dying from Improvement*, 59.
28 Thomas King, *The Inconvenient Indian*, 34. Regarding the popular record of the creation of Canada, Starblanket and Hunt also identify key myths, which bear similarity to the categories identified by Thomas King and Razack, among others. Starblanket and Hunt, *Storying Violence*, 31. See also Francis, *The Imaginary Indian*.
29 Wilder, *Little House on the Prairie*; Schneider, "A Modest Proposal," 65–93; Frances W. Kaye, "Little Squatter on the Osage Diminished Reserve," 123.
30 "Their faces were bold and fierce and terrible. Their black eyes glittered. High on their foreheads and above their ears where hair grows, these wild men had no hair." Wilder, 140.
31 "It was a proud, still face. No matter what happened, it would always be like that... Pa and Ma and Mary and Laura slowly turned and looked at that Indian's proud straight back." Wilder, 305.
32 Wilder, 310–11.
33 Wilder, 308–09.
34 "For over a century, the central goals of Canada's Aboriginal policy were to eliminate Aboriginal governments; ignore Aboriginal rights; terminate the Treaties; and, through a process of assimilation, cause Aboriginal peoples to cease to exist as distinct legal, social, cultural, religious, and racial entities in Canada. The establishment and operation of residential schools were a central element of this policy, which can best be described as 'cultural genocide.'" Truth and Reconciliation Commission of Canada, *Honouring the Truth, Reconciling for the Future*, 1.
35 Miller et al., *Discovering Indigenous Lands*, 131.
36 Luhmann, *Sociological Theory*, 26, 284.
37 Monture, "Standing against Canadian Law," 77.
38 Monture, 89.
39 Luhmann, *Law as a Social System*, 378–79.
40 Establishing status and non-status Indians, prohibiting Indian land ownership, see Gradual Enfranchisement Act, 1869 SC, c. 6, s. 1. Establishing that an Indian found intoxicated would be arrested and jailed for a period of up to one month, see An Act to amend certain laws respecting Indians, SC 1874, c. 21, s. 4. Defining a "person" as an individual who was not an Indian, see The *Indian Act*, 1976 SC, c. 18, s. 12.
41 Daschuk, "When Canada Used Hunger to Clear the West"; see also Gavigan, *Hunger, Horses and Government Men*, 124–25. Gavigan also highlights sources which link these

starvation policies to the highest levels of government, particularly to Prime Minister and Superintendent General of Indian Affairs John A. Macdonald, and to Deputy Superintendent General of Indian Affairs Lawrence Vankoughnet.

42 Daschuk, *Clearing the Plains*, 114.
43 *Indian Act*, 1876, SC 1876, c. 18.
44 On the scandal in Parliament following news reports of North-West Mounted Police and Indian Agents on the prairie-owning indigenous women, see Carter, "Categories and Terrains of Exclusion."
45 *Report of the Aboriginal Justice Inquiry of Manitoba*, vol. 1, *The Justice System and Aboriginal People*, chapter 4 (emphasis added).
46 *Indian Act*, 1876, s. 13.
47 Storey, "The Pass System in Practice," 137–61.
48 Storey, 137–61.
49 Razack, *Dying from Improvement*, 86–87. The 2016 death of Jordan Bruce Lafond, following a police chase and violent arrest, was controversially determined by inquest to be accidental. MacPherson, "'It's Not Going to End There'"; Fine, "Ontario Police Officer's Conviction."
50 Daschuk, *Clearing the Plains*, 185
51 Daschuk, 185 (emphasis added).
52 Bradford et al., "Drinking Water Quality," 1.
53 See, e.g., McNeil, "Sovereignty and the Aboriginal Nations of Rupert's Land," 2–8. On the Hudson's Bay Company, see also Gavigan, *Hunger, Horses, and Government Men*, 25–27.
54 See, e.g., Cardinal, *Unjust Society*, 24–42; Meghan Grant, "Blood Tribe Wins Massive Land Claim Battle." Regarding treatment of Métis persons, see *Manitoba Metis Federation Inc. v. Canada* (Attorney General), [2013] 1 SCR 623. Note also the issue of rights to Aboriginal title in unceded territory, discussed in *Tsilhqot'in Nation v. British Columbia*, [2014] 2 SCR 257. Regarding Canada's failure to implement treaty promises regarding land and agriculture, see McAdam (Saysewahum), *Nationhood Interrupted*, 67–79.
55 Describing the trajectory of interpretive approaches, see Henderson, "Interpreting *Sui Generis* Treaties," 46.
56 Several scholars have traced the enduring presence of *terra nullius* and the doctrine of discovery in Canadian law concerning sovereignty and title to land. Borrows, "The Durability of *Terra Nullius*," 701; Hoehn, "Back to the Future," 106 at 118–20, 138; Borrows, "Sovereignty's Alchemy," 537–96. Modern treaties raise additional considerations. On modern treaties see, e.g., Jai, "Bargains Made in Bad Times," 105–48.
57 Krasowski acknowledges that the spirit of the treaties may nonetheless provide a positive force for reconciliation: "Even though my research uncovered duplicitous dealings by the Canadian government during the negotiations, the treaty relationship still endures. It is my hope that discussions of treaty lands do not create more divisions between settlers and Indigenous peoples. The guiding principles of mutual respect and sharing can help guide our understanding of treaty-making. The treaties were meant to benefit both settlers and Indigenous peoples equally, and reimagining

• NOTES •

our relationships to the lands and resources can lead to reconciliation, rather than polarization." Krasowski, "To Understand Why the Land Remains Indigenous"; see also Hutchins, "Cede, Release and Surrender,": 431–64.

58 UN General Assembly, Vienna Convention on the Law of Treaties, 1155 UNTS 331 at articles 44, 49 (fraud renders treaty voidable or allows severability of provisions).

59 Gilbert discusses similar fraud and translation issues as regards British colonial treaty practice in Africa, New Zealand, and North America. Gilbert, *Indigenous Peoples' Land Rights*, 68–69.

60 Regarding on-reserve schooling, see Cardinal, *Unjust Society*, 24–42; Meghan Grant, "Blood Tribe"; *Manitoba Metis Federation Inc. v. Canada (Attorney General)*, [2013] 1 SCR 257; *Tsilhqot'in Nation v. British Columbia*, [2014] 2 SCR 257; McAdam (Saysewahum), *Nationhood Interrupted*, 67–69; Krasowski, *No Surrender*, 215.

61 "The infamous penal laws of eighteenth-century Ireland, statutes based on race, language, and religion, were designed to subjugate an entire people under an odious form of apartheid. The Irish were forbidden appropriate education; denied the vote; barred from public office; prohibited from owning land, weapons, or even a horse worth five pounds." Marken, "'There is Nothing but White between the Lines,'" 164.

62 Dayan, *The Law Is a White Dog*, 40–45. On the connection between enslavement and contemporary criminal law process see Alexander, *The New Jim Crow*. See also Mbembé, *Necropolitics*.

4. THE COLONIAL LENS: SEEING THE "SAVAGE" AND THE "DYING"

1 Kiiwetinepinesiik Stark, "Criminal Empire," 1; Razack, "Gendered Racial Violence," 117.
2 Razack, "Gendered Racial Violence," 117.
3 McDougall, "Duncan Campbell Scott." This statement was made in relation to the residential schools.
4 Gavigan, *Hunger, Horses and Government Men*, 185 (footnotes excluded).
5 *Report of the Aboriginal Justice Inquiry of Manitoba*, vol. 2, The Death of Helen Betty Osborne; National Inquiry into Missing and Murdered Indigenous Women and Girls, *Reclaiming Power and Place*.
6 Troian, "Decades Old MMIWG Cases." On the failure of news agencies to cover murders related to Vancouver's Downtown Eastside, see, e.g., Hugill, *Missing Women, Missing News*.
7 Sterritt, "Indigenous Grandfather and 12-Year-Old Handcuffed."
8 Luhmann, *Law as a Social System*, 490.
9 Legal personhood (also called legal personality) is understood as the capacity for rights and obligations within a legal system; see Bryand Smith, "Legal Personality."
10 Leo, "60-Hour Delay before Regina Police Called."
11 Johnston, "'I'm the Victim and I'm in Shackles'"; *R v. Blanchard*, 2016 ABQB 706 (CanLII), paras 229–34.
12 *R v. Blanchard*, paras 221, 234.

13 Julie Kaye, "Reconciliation in the Context of Settler-Colonial Gender Violence," 461.
14 *R v. Barton*, 2019 SCC 33; *R v. Barton*, 2021 ABQB 603.
15 Hargreaves, *Violence Against Indigenous Women*, 34–35. On police investigations regarding missing Indigenous students in Thunder Bay, see Talaga, *Seven Fallen Feathers*.
16 Rachel Bergen, "3 First Nations Women."
17 There are evident parallels between the colonial lens and "carceral logics" discussed in various literatures. Heather Bergen and Abji describe the latter in the following way: "By carceral logics, we refer to presuppositions that frame marginalized communities as threats to the social order rather than adopting a systemic analysis of the structural barriers experienced by such communities. The purpose of such criminalizing frames is to then position punitive state responses as the solution to such threats: 'solutions' that amount to increased policing, mass incarceration, and mass deportation in the prison industrial complex." Heather Bergen and Abji, "Facilitating the Carceral Pipeline," 34–48. There are also parallels to the white racial frame and to the lenses of gender. See Feagin, *The White Racial Frame*; Bem, *The Lenses of Gender*. Despite these above similarities, the colonial lens presented here is specific to the settler colonial racial and gender dynamic and especially how it is imprinted into *ways of seeing* persons and spaces. On ways of seeing, Hugill's comments on settler perception and Lipsitz's "white spatial imaginary" are of note. Hugill, "Comparative Settler Colonial Urbanisms," 87. Lipsitz writes of the context of racism in the United States: "[A] white spatial imaginary based on exclusivity and augmented exchange value forms the foundational logic behind prevailing spatial and social policies in cities and suburbs today. This imaginary does not emerge simply or directly from the embodied identities of people who are white. It is inscribed in the physical contours of the places where we live, work, and play, and it is bolstered by financial rewards for whiteness. Not all whites endorse the white spatial imaginary, and some Blacks embrace it and profit from it. Yet every white person benefits from the association of white places with privilege, from the neighborhood race effects that create unequal and unjust geographies of opportunity." Lipsitz, *How Racism Takes Place*, 28.
18 Harold R. Johnson, "Look Twice Before Judging."
19 Sheppard, *Inclusive Equality*, 22–23.
20 Shaheen-Hussain, *Fighting for a Hand to Hold*, 71.
21 Shaheen-Hussain, 71.
22 Sheppard, *Inclusive Equality*, 22.
23 Brown, "Left for Dead in a Saskatchewan Winter."
24 On the duration of the initial investigation, see David H. Wright, *Report of the Commission of Inquiry into Matters Relating to the Death of Neil Stonechild*, 198. On the seatbelt check and chance exchange, see Hubbard, *Two Worlds Colliding*.
25 *R v. Munson*, 2003 SKCA 28; [2004] 2 WWR 107.
26 National Inquiry into Missing and Murdered Indigenous Women and Girls, *Reclaiming Power and Place*, 355.
27 Kline, "Complicating the Ideology of Motherhood," 306–42.

5. CASE STUDY: THE STANLEY ACQUITTAL

1. The firearms charges that Mr. Stanley pleaded guilty to did not include any conviction in relation to the handgun that killed Mr. Boushie. Craig, "Gerald Stanley Pleads Guilty to Gun Charge."
2. Mr. Stanley was questioned during his testimony: "Instead of reaching into that cabin with a—with a gun in your hand, why wouldn't you have let it go before you reached in there?" He answered, "I guess I could have threw it out on the road." *R v. Stanley*, Trial Vol. 4, T743.
3. See, e.g., Roach, "Juries, Miscarriages of Justice and the Bill C-75 Reforms," 315–57; Cunliffe, "The Magic Gun," 270–314; David B. MacDonald, "Settler Silencing and the Killing of Colten Boushie," 1–20; Jokic, "Cultivating the Soil of White Nationalism," 1–21; Thielen-Wilson, "Feeling Property," 494–521 (applying Razack's spatiality of racialized violence to the shooting).
4. Starblanket and Hunt, *Storying Violence*, 31.
5. Starblanket and Hunt, 84–87. Cree legal scholar Darcy Lindberg writes: "We must let the 'castle' imagery die. When invoked, it calls upon a history of racist policy that has dispossessed, imprisoned and sanctioned violence against Indigenous peoples. It also calls to an unwritten canon of prairie law, one traditionally decided around kitchen tables but seeping further into the light of social media, where Indigenous peoples are often suspected as criminals without evidence and adjudicated without process." Darcy Lindberg, "The Myth of the Wheat King"; Flynn and Van Wagner, "A Colonial Castle," 358–87.
6. Roach, *Canadian Justice, Indigenous Injustice*, 50–52. Roach notes then Prime Minister Stephen Harper's comments on the campaign trail in Saskatchewan to the effect that guns were needed for security in rural areas. Kennedy cites the president of the National Firearm Association as saying, "If you've got someone breaking into your house and life and limb are clearly at threat, I think there is a need to understand the most basic tenets of English common law—which is a person's home is their castle." Kennedy, "Harper Sparks Controversy"; see Robert, "No, Rural Prairie Dwellers" (including illustrative quotations of rural landowners); see Starblanket and Hunt's analysis specific to the castle imagery in the Stanley trial in Starblanket and Hunt, *Storying Violence*, 86–88.
7. *R v. Stanley*, Trial Vol. 5, January 29, 30, 31, 2018, and February 1, 2, 5, 6, 8, and 9, 2018, Battleford, Saskatchewan, at T843–T844. See also Stanley's counsel's opening statement: "That's what this case comes down to is when you're in a... situation where you have intruders, and you don't have the luxury of being able to wait for police assistance that's not reasonably going to get there to deal with that situation, this case comes down to what's reasonable in that circumstance." *R v. Stanley*, Trial Vol. 4, January 29, 30, and 31, 2018, and February 1, 2, 5, 6, 8, and 9, 2018, Battleford, Saskatchewan, at T607. Stanley's counsel used the term "luxury" in this way repeatedly during the trial and used it four times in his address to the jury alone. The Judge also reiterated the term "luxury" in his instructions to the jury, in the context of

recapitulating the defence's theory of the case. Use of the term "luxury" is meant to suggest that normal rules on self-defence and defence of property only apply where the police are close at hand, not in the country. In rural areas, the thinking goes, those rules are "luxuries" because the landowner is on the "frontier" of civilized justice and has to have a fully free hand to defend it. *R v. Stanley*, Trial Vol. 5, at T843, T900.
8 See, e.g., Cyr, "Police Use of Force," 663.
9 In a version of events that bore little resemblance to those presented later in the courtroom, Sheldon Stanley told the RCMP call-taker that "three men and two women had come onto their property and tried to steal vehicles from the yard, had almost run someone over, and one of the three men had been shot," and furthermore that "The remaining two men had fled the scene on foot to the west and were armed with a gun." Civilian Review and Complaints Commission for the Royal Canadian Mounted Police, *Commission's Final Report*, 6.
10 *R v. Stanley*, Trial Vol. 2, January 29, 30, and 31, 2018, and February 1, 2, 5, 6, 8, and 9, 2018, Battleford, Saskatchewan, at T352; see also T358; on age, see T345.
11 See, e.g., Roach, *Canadian Justice, Indigenous Justice*, 75.
12 For C.C.'s description of the sound of the bullet close to his right ear, see *R v. Stanley*, Trial Vol. 2, T355; for E.M.'s testimony that the shots were not warning shots, see *R v. Stanley*, Trial Vol. 2, T306; on the starting of the quad, see testimony of Gerald Stanley, *R v. Stanley*, Trial Vol. 4, T680.
13 *R v. Stanley*, Trial Vol. 4, T742. This is revealed in the cross-examination of Stanley:
 Q. Okay. Then what are you—what are you suggesting, then?
 A. I don't know what the—I was doing with the right hand.
 Q. Pardon me?
 A. I don't know what the right hand was doing.
 Q. Well, it's your right hand.
 A. Yeah, well, I wasn't looking at it.
 Q. With a gun in it?
 A. Right.
14 *R v. Stanley*, Trial Vol. 4, T700. See Roach, *Canadian Justice*, 3–5.
15 Common and Gomez, "RCMP 'Sloppy' and 'Negligent'"; see also Roach, *Canadian Justice*, 70. On the RCMP's treatment of evidence, the release of the vehicle within a week of the shooting, and the observation that the bullet was never found, see *R v. Stanley*, Trial Vol. 4, T741–T745.
16 Civilian Review and Complaints Commission for the Royal Canadian Mounted Police, *Commission's Final Report*, 21–22.
17 Tait, "Saskatchewan's Racial Divide."
18 "RCMP Facebook Group."
19 Roach, *Canadian Justice*, 85. Roach cites preliminary hearing transcripts at page 308.
20 Roach, *Canadian Justice*, 77. Roach reproduces the Facebook statement of August 14, 2016.
21 *Citizen's Arrest and Self-defence Act*, 2012 SC, c. 9.
22 "Reasonable Doubt" (comments of Tim Quigley).

23 Roach, *Canadian Justice, Indigenous Justice*, 173.
24 Trial transcripts at T519, cited in Roach, *Canadian Justice*, 131. The expert for the defence testified that "It is my experience that hang fires are extremely rare and usually occur within seconds of the initial strike of the primer." Transcripts at T579, cited in Roach, *Canadian Justice*, 136.
25 Roach, 139.
26 Roach, 190.
27 Roach, 85.
28 *R v. Stanley*, Trial Vol. 5, T856. The Crown's decision to not rely on B.J.'s testimony can also be understood in relation to Stanley's counsel's treatment of her in cross-examination. The Court directed Stanley's counsel near the end of his cross-examination of B.J.: "I was just going [to] raise a relatively small point, and that is, Mr. Spencer, when questioning the witnesses, you have on occasion injected your opinion into things such as 'I don't believe you're telling the truth' and 'from my perspective, I can't believe how this can be true.' Generally speaking, I don't think that's an appropriate thing to do in front of the jury. You can submit to them. You can do all sorts of things. But injecting your own personal views into it is generally considered to be inappropriate. Not horribly wrong, but I'd ask you to try to rephrase in different ways, if you would." *R v. Stanley*, Trial Vol. 3, January 29, 30, and 31, 2018, and February 1, 2, 5, 6, 8, and 9, 2018, Battleford, Saskatchewan, at T450. As a further example, Stanley's counsel said "I don't believe you're telling the truth" when B.J. did not wish to re-enact the way that Stanley was holding the gun at the point that her friend was shot. *R v. Stanley*, Trial Vol. 3, at T432. This attack on her credibility was highly inappropriate given the cultural sensitivities at play: "[B.J.] was asked to demonstrate how the man who shot the deceased held the gun. She refused, stating that she didn't feel comfortable doing that. The reason was obvious to Cree people watching the trial. She would be mimicking the last moments of her friend's death, and that was wrong." Cuthand, "Cuthand: First Nations Traditions." Cuthand also remarks that witnesses were shown pictures which showed their friend's body during their testimonies, causing them significant distress considering that presenting and viewing such photos is a cultural taboo.
29 Roach, *Canadian Justice, Indigenous Justice*, 157. On the lawyers' and the trial judge's emphasis on the witnesses' criminality and drinking, see Roach, 160. The Crown described E.M. in the closing address to the Jury: "I never thought [E.M.] would be much of an important witness in this case because he didn't see what happened...[E.M.], whatever you think of his credibility, had no reason to lie about what he saw of a woman on a lawn mower. It's—it's just an observation that he made." *R v. Stanley*, Trial Vol. 5, T863–T864.
30 Roach, *Canadian Justice, Indigenous Justice*, 84–85, 190.
31 Roach, 143.
32 In his opening statement, Mr. Stanley's lawyer provides this narrative: "Ultimately, ultimately, this case comes down to a freak accident that occurred in the course of an unimaginably scary situation one afternoon.... How did he get shot? It's a freak accident." *R v. Stanley*, Trial Vol. 4, T607–T608. See Hopper, "Gerald Stanley's 'Magical

Gun.'" On the parallels between this argument and that seen in a more recent shooting case, see Houle and Hunt, "Murdered by 'Bad Luck.'"

33 Transcripts, T898, cited in Roach, *Canadian Justice, Indigenous Justice*, 174. Starblanket and Hunt continue, "To be clear, 'the circumstances' described by the defense involve a context wherein the hard-working Stanleys are said to have faced 'intruders' (i.e. Indigenous youth) whose presence and behaviours are said to have incited 'pure terror' in Gerald Stanley [here the authors cite *R v. Stanley* 2018, 848]. Yet no one pointed out the ways in which he and Sheldon Stanley's antagonistic response to the youth *as they were attempting to drive off the property* contributed to an 'escalating situation.' Ultimately, these circumstances, which Stanley contributed to, would be used by the defense to argue that Stanley should be found not guilty of manslaughter by committing the unlawful act of careless use of a firearm." Starblanket and Hunt, *Storying Violence*, 111–12 (emphasis in original).

34 *R v. Stanley*, Trial Vol. 5, T843–T844. Stanley even sought to have this context transform the gun into a mere piece of metal, stating: "When it's empty, it's just a piece of metal, you know." *R v. Stanley*, Trial Vol. 4, T741.

35 *R v. Stanley*, Trial Vol. 4, T606 (emphasis added).

36 *R v. Stanley*, Trial Vol. 4, T606–T607.

37 Transcripts, T898, cited in Roach, *Canadian Justice, Indigenous Justice*, 175; see also Trial transcripts, T893, T898, cited in Roach, 67. Roach observes that the RCMP did not charge Stanley in relation to the first two shots fired, despite E.M.'s testimony at the preliminary inquiry that he believed that the shots were at him, suggesting that the RCMP viewed these shots as justified. Roach, 81–82. On the concession by the Crown regarding the first two shots, see *R v. Stanley*, Trial Vol. 5, T812.

38 Roach, *Canadian Justice, Indigenous Justice*, 175–77.

39 Roach, 165–78.

40 *R v. Stanley*, Trial Vol. 4, T606.

41 Starblanket and Hunt, "How the Death of Colten Boushie Became Recast."

42 Kendi, *How to Be an Anti-Racist*, 10.

43 Coase, "The Problem of Social Cost," 1–44.

44 Shaheen-Hussain, *Fighting for a Hand to Hold*, 104; Bonilla-Silva, *Racism without Racists*; Gallagher, "Color-Blind Privilege," 22–37; Annamma, Jackson, and Morrison, "Conceptualizing Color-Evasiveness," 147–62.

45 Robert B. Williams, "Wealth Privilege and the Racial Wealth Gap," 304; Godfrey and Wolf, "Developing Critical Consciousness or Justifying the System?" 93–103; Davida, "How Do People Make Sense of Wealth and Poverty?" 44; McLean, "'We Built a Life from Nothing,'" 32.

46 I am not including counsel for the Boushie family in this listing. Roach, *Canadian Justice, Indigenous Justice*, 3, 71, 81, 113–15.

47 Quenneville, "Coming Trial 'Is Not a Referendum on Racism.'"

48 On the jury selection, see Roach, *Canadian Justice, Indigenous Justice*, 3.

49 Gau, "A Jury of Whose Peers?" 86; Hogg, "Seeing Justice Done," 53; Anwar, Bayer, and Hjalmarsson, "The Impact of Jury Race in Criminal Trials," 1050.

50 Civilian Review and Complaints Commission for the Royal Canadian Mounted Police, *Commission's Final Report*, 21.
51 Roach, *Canadian Justice, Indigenous Justice*, 158. Roach cites transcripts at 321–22, in which during cross examination E.M. queries, "Aren't we here today for Mr. Stanley?"
52 On the firearms charges, see Craig, "Gerald Stanley Pleads Guilty."
53 Quenneville, "Police Watchdog's Investigative File." On policy responses related to the castle doctrine, see Keller, "Alberta Introduces Law to Protect Rural Landowners" (regarding Bill 27, Trespass Statutes [Protecting Law-abiding Property Owners] Amendment Act, 2019, in force December 5, 2019). The verdict sparked protests in cities across Canada; see Friesen, "Thousands Rally across Canada." Also illustrative of the controversial character of the case is Red Pheasant First Nation Chief Clint Wuttunee's description of the verdict as "absolutely perverse" and his observation that "Colten Boushie was shot in the back of the head at point blank range. Nevertheless, an all-white jury formed the twisted view of that obvious truth and found Stanley not guilty." Graveland, "Not Guilty Verdict In Shooting Death"; Fine, "Jury Trials at Risk."

6. THE INSTRUMENTALIZED STEREOTYPE OF THE UNFIT INDIGENOUS MOTHER

1 National Inquiry into Missing and Murdered Indigenous Women and Girls, *Our Women and Girls are Sacred*, 3.
2 Jaimes-Guerrero, "Savage Erotica Exotica," 191.
3 Carter, "Categories and Terrains of Exclusion," 147 (emphasis added).
4 Winona Stevenson, "Colonialism and First Nations Women," 47; and Acoose, *Iskwewak—Kah' Ki Yaw Ni Wahkomakanak*.
5 Green, "The Pocahontas Perplex," 15–21, quoted in Carter, "Categories and Terrains of Exclusion," 147.
6 Winona Stevenson, "Colonialism and First Nations Women," 46. Monchalin writes, "There is also the ideal of Euro-American portrayals of motherhood; the sacrificing and even martyred pioneer woman prototype appears in many films." Monchalin, *The Colonial Problem*, 178–83.
7 Jaimes-Guerrero, "Savage Erotica Exotica," 192.
8 McKay, "A Feminist Poststructural Analysis," 72–73.
9 See Cardinal, *Unjust Society*, 24–42; Meghan Grant, "Blood Tribe"; *Manitoba Metis Federation Inc v. Canada (Attorney General)*, 1 SCR 257; *Tsilhqot'in Nation v. British Columbia*, [2014] 2 SCR 257; McAdam (Saysewahum), *Nationhood Interrupted*, 67–69.
10 Carter, "Categories and Terrains of Exclusion," 151. See also Daschuk, *Clearing the Plains*, 185. Note contemporary reports of sexual assault of Indigenous women by police. Human Rights Watch, *Those Who Take Us Away*. Shingler, "No Charges in Val-d'Or Abuse Scandal." Note also differential laws on prostitution discussed in the following chapter; these made it easier to charge Indigenous women with prostitution than non-Indigenous women.

11 Stote, *An Act of Genocide*; Boyer and Bartlett, *External Review*. Regarding access to health care and to social assistance, see Downe, "'Bad Mothers' in the HIV/AIDS Epidemic in Canada," 103–20.
12 Balfour, "Falling Between the Cracks," 115.
13 Graeber, "The Bully's Pulpit," 37–38.
14 Graeber, 37–38.
15 Graeber, 37–38.
16 Galbraith, *The Anatomy of Power*, 51.
17 Graeber, "The Bully's Pulpit," 37–38.
18 Baron-Cohen, *The Science of Evil*.
19 *R v. Ewanchuk*, 1998 ABCA 52.
20 Provincially, aside from Saskatchewan's above-mentioned change in policy in 2017, it appears that only New Brunswick expressly disallows leg irons on women in their second or third trimester, holding that "pregnant offenders are not restrained during labour and delivery." "Policy: G-46, Obstetrical Care," Adult Institutional Policy, New Brunswick Public Safety Corrections, effective August 2010, 1–2. At the federal level (Corrections Canada), a 2018 Commissioner's Directive disallows use of restraints on women in labour. Corrections Canada, Commissioner's Directive Number 567-3. There are reports, spanning multiple jurisdictions, of the use of leg shackles on pregnant women and on women during labour. Malone, "'They Have a Lot to Teach Us'"; McKendy, "The Pains of Jail Imprisonment," 160 (a prisoner named Karen was shackled to a bed in an Ottawa hospital during labour).
21 On racism in health care and the 2020 death in hospital of Atikamekw woman Joyce Echaquan, see Kamel, *Investigation Report Concerning the Death of Joyce Echaquan*.

7. COURTS AS THE GATEWAY TO INDIGENOUS OVER-INCARCERATION

1 The Aboriginal Justice Inquiry of Manitoba report discusses policing bias, lack of legal representation, recourse to pre-trial detention, and problematic aspects of hearing processes and sentencing, concluding with respect to the latter that "the number of charges and the seriousness of charges do not adequately account for Aboriginal rates of incarceration." *Report of the Aboriginal Justice Inquiry of Manitoba*, vol. 1, *The Justice System and Aboriginal People*, chapter 4.
2 Legal scholar Oona Hathaway describes how path dependency works in judicial reasoning: "The doctrine of *stare decisis* that is central to our common law system creates an explicitly path-dependent process. The past forms the point of departure for the present. The present, in turn, forms the point of departure for the future. Therefore, the historical path leading to each new outcome or decision directly shapes that outcome in specific and systematic ways." Hathaway, "Path Dependence in the Law," 663.
3 For a discussion of the Canadian myth of benevolence see Regan, *Unsettling the Settler Within*, 235.

• NOTES •

4 *Report of the Aboriginal Justice Inquiry of Manitoba*, vol. 1, *The Justice System and Aboriginal People*, chapter 4.
5 For empirical demonstration of sentencing bias in written reasons in Saskatchewan, see Scott, "Reforming Saskatchewan's Biased Sentencing Regime," 91. Scott reviewed written Saskatchewan sentencing decisions published on CanLII from 1996 to 2014. For example, Scott calculates that non-Aboriginal persons sentenced for hazardous driving, including dangerous and impaired driving and driving which causes death and injury, received an average of 9.8 months, custody per person while Aboriginal persons sentenced in this category of offences received an average 30.3 months, custody per person.
6 See, e.g., Huncar, "Indigenous Women Nearly 10 Times More Likely to Be Street Checked"; Wendy Gillis and Pagliaro, "Board Tells Toronto Police."
7 Skinner, Driedger, and Grainger, *Corrections: A Historical Perspective*. Hylton, reporting on 1977–78 data, writes: "In comparison to male non-natives, male treaty Indians were 25 times more likely to be admitted to a provincial correctional centre while non-status Indians or Metis were 8 times more likely to be admitted... For women the figures are even more extreme: a treaty Indian woman was 131 times more likely to be admitted and a non-status or Metis woman 28 times more likely than a non-native." Hylton, "Locking Up Indians in Saskatchewan," 61, quoted in Jackson, "Locking up Natives in Canada," 215; see also Jefferson, *Conquest by Law*; and Chartrand, "Unsettled Times," 67–89.
8 Malakieh, "Adult and Youth Correctional Statistics in Canada, 2016/2017."
9 Statistics Canada, "Adult and Youth Correctional Statistics, 2020/2021."
10 Statistics Canada, "Adult and Youth Correctional Statistics, 2020/2021."
11 Robinson et al., "Over-Representation of Indigenous Persons."
12 White, "'Shocking and Shameful.'"
13 C-41, An Act to Amend the Criminal Code (Sentencing) and Other Acts in Consequence Thereof, Statute of Canada 1995, c. 22, House Government Bill, 35th Parliament, 1st Session, January 17, 1994–February 2, 1996.
14 Truth and Reconciliation Commission of Canada, *Honouring the Truth, Reconciling for the Future*, 1.
15 "The children of the Battleford Industrial School and all surrounding reserves were forced to watch the public hanging alongside curious settlers from the surrounding area... The entire reserves were denied rations, their five dollars a year, and all things made of metal were taken away... People would scatter to the States, Alberta, and surrounding reserves to hide over this time, if they did not starve to death first, decimating the population. Mosquito's reserve lost 50 children in one-year, Grizzly Bear and Lean man lost 80, to starvation." Ledding, "Solemn Anniversary of 1885 Battleford Hangings." See also Daschuk, *Clearing the Plains*, 156–57.
16 Stefanovich "Chief Poundmaker, Wrongly Convicted."
17 Note the use of court injunctions as a means of quelling protest through arrests. Manuel, *The Reconciliation Manifesto*, 215. On criminalization of Indigenous protest, see, e.g., Dafnos, "Negotiating Colonial Encounters." Note also the killing of Dudley George; see Peter Edwards, *One Dead Indian*.

18 Jacobs, "Assimilation through Incarceration," ii.
19 Bell and Schreiner, "The International Relations of Police Power," 111; see Hildebrandt, *Views from Fort Battleford*.
20 An Act to Amend "The *Indian Act*, 1880," 1881 SC 1881, c. 17, s. 12.
21 This is detailed in the section entitled "History of the *Indian Act* Courts" in *Report of the Aboriginal Justice Inquiry of Manitoba*, vol. 1, *The Justice System and Aboriginal People*, chapter 7; see also Morse, "A Unique Court," 139.
22 Jacobs, "Assimilation through Incarceration," 146.
23 *Report of the Aboriginal Justice Inquiry of Manitoba*, vol. 1, *The Justice System and Aboriginal People*, chapter 7.
24 *Report of the Aboriginal Justice Inquiry of Manitoba*, vol. 1, *The Justice System and Aboriginal People* (emphasis added).
25 Hinge, *Indian Acts and Amendments*. This comprises more than four hundred pages of legislation.
26 See, e.g., Bonita Lawrence, "Gender, Race, and the Regulation of Native Identity," 3; Milloy, *Indian Act Colonialism*; Monchalin, *The Colonial Problem*, 110–18.
27 *Drybones* struck down the 1952 version of the *Indian Act* which set the maximum penalty for possessing alcohol, making alcohol, or being intoxicated as an Indian off a reserve at a maximum of three months' imprisonment. *The Queen v. Drybones*, 1970 SCR 282. Moss and Gardner-O'Toole summarize that "in 1874, for an Indian to be found in a state of intoxication became an offence punishable by imprisonment of no more than one month; an additional period not exceeding 14 days was imposed if the Indian did not give the name of his supplier." Furthermore, they note that "in 1887, being an Indian in a state of intoxication was made punishable by either a fine or imprisonment or both. In addition, the police were empowered to arrest an intoxicated Indian without a warrant and to confine him until sober, at which point, he was to be brought to trial ... By 1936, the *Indian Act* made it a criminal offence to be in possession of any intoxicant in the home of an Indian, whether on or off a reserve" (notes excluded). Moss and Gardner-O'Toole, "Aboriginal People: History of Discriminatory Laws," paras 1–3 of section "A. Liquor Offences." Moss and Gardner-O'Toole cite the following: An Act to Amend Certain Laws Respecting Indians, SC 1874, c. 21, s. 1; An Act to Amend "The *Indian Act*," SC 1887, c. 33, s. 10; *Indian Act*, RSC 1927, c. 98, s. 126; An Act to Amend the *Indian Act*, SC 1936, c. 20, ss 6–12.
28 Storey, "The Pass System in Practice," 137.
29 Section 3 of the 1884 Act further to Amend "The *Indian Act*, 1880" held that "any Indian or other person who engages in or assists in celebrating the Indian festival known as the 'Potlach' or the Indian dance known as the 'Tamanawas' is guilty of a misdemeanor, and shall be liable to imprisonment for a term of not more than six nor less than two months in any gaol or other place of confinement." This punishment also extended to anyone who directly or indirectly encouraged such practices. An Act further to amend "The *Indian Act*, 1880," S. Dom. C. 1884, c. 27. This same amending statute at s. 1 established a two-year penalty for inciting three or more Indians to make demands on an Indian Agent in a disorderly manner.

• NOTES •

30 "Any parent, guardian or person with whom an Indian child is residing who fails to cause such child, being between the ages aforesaid, to attend school as required by this section after having received three days' notice so to do by a truant officer shall, on the complaint of the truant officer, be liable on summary conviction before a justice of the peace or Indian agent to a fine of not more than two dollars and costs, or imprisonment for a period not exceeding ten days or both, and such child may be arrested without a warrant and conveyed to school by the truant officer." An Act to Amend the *Indian Act*, SC 1920 (10–11 George V) c. 50, s. 10(3), 307–12; see also LeBeuf, *The Role of the Royal Canadian Mounted Police*.

31 "Every person who, without the consent of the Superintendent General expressed in writing, receives, obtains, solicits or requests from any Indian any payment or contribution or promise of any payment or contribution for the purpose of raising a fund or providing money for the prosecution of any claim which the tribe or band of Indians to which such Indian belongs, or of which he is a member, has or is represented to have for the recovery of any claim or money for the benefit of the said tribe or band, shall be guilty of an offence and liable upon summary conviction for each such offence to a penalty not exceeding two hundred dollars and not less than fifty dollars or to imprisonment for any term not exceeding two months." The *Indian Act*, RS 1927, c. 81 (s. 141).

32 Carter, "Categories and Terrains of Exclusion," 159. Backhouse notes: "In 1880 the federal government enacted the first of a series of laws specifically designed to prevent the prostitution of Indian women... The statute prohibited the keeper of any house from allowing Indian women prostitutes on the premises. The customary phrase 'common bawdy house' had not been used, so it would no longer be necessary for the Crown to prove the character of the institution—any house would suffice... In an effort to encourage the number of charges against native Indians under the legislation, the Indian Act was amended in 1884 so that keepers of 'tents and wigwams' as well as houses fell specifically within the statute... When the Criminal Code was first enacted in 1892, Parliament removed all of these provisions from the Indian Act and inserted them into the Code with one alteration. The provision against Indians keeping, frequenting, or being found in disorderly houses was reintroduced, but restricted to unenfranchised Indian women only." Backhouse, "Nineteenth-Century Canadian Prostitution Law," 420–21. See also legislation identified by Backhouse: An Act to amend and consolidate the laws respecting Indians, SC 1880 (43 Vict) c. 28, ss 95–96; An Act further to amend "The *Indian Act*, 1880," S. Dom. C. 1884, c. 27, s. 14; The Criminal Code, SC 1892 (55 & 56 Vict.) c. 29, s. 190(c). The Criminal Code provision outlined a penalty of six months imprisonment for an "unfranchised Indian woman, who keeps, frequents or is found in a disorderly house, tent or wigwam used for any such purpose," creating a lower threshold for criminality than for enfranchised Indian women, who had to actually engage in prostitution in order to meet the criminality threshold. This provision itself shows the law constructing the expectation that Indigenous women are by their nature deviant, presumed prostitutes, and subject to incarceration. This offence was included in the 1927 version of the Criminal

Code but does not appear after the next major rewriting that preceded the 1953–54 version. Criminal Code, RSC 1927, c. 36, s. 220; see also Boyer, "First Nations Women's Contributions," 69.
33 Harold R. Johnson, *Firewater*.
34 Harvey, *Tremear's Annotated Criminal Code*, 212.
35 Huncar, "Indigenous Women Nearly 10 Times More Likely."
36 Quigley, "Some Issues in Sentencing of Aboriginal Offenders," 273 (emphasis added). Quigley's chapter is cited in *R. v. Gladue*, [1999] 1 SCR 722.
37 Skinner, Driedger, and Grainger, *Corrections*, 150.
38 Skinner, Driedger, and Grainger, 153.
39 Skinner, Driedger, and Grainger, 155.
40 Razack, "Gendered Racial Violence," 100–03.
41 Jacobs, *Assimilation through Incarceration*, 256 (emphasis added).
42 *The Queen v. Drybones*, 1970 SCR 282.
43 Lozinski, "Passages: July 27, 1960"; "Douglas Asks Patience in Dealing with Indians."
44 Royal Commission on Aboriginal Peoples, *Looking Forward, Looking Back*, 550.
45 Thomson and Rhodes, "RCMP Deleted Documents"; Denov and Campbell, "Criminal Injustice," 226. Tunnel vision has been extensively examined in reports and scholarship on wrongful convictions. Department of Justice Canada, *Report on the Prevention of Miscarriages of Justice*; Department of Justice Canada, *The Path to Justice*, 43–54; MacFarlane, "Wrongful Convictions"; MacFarlane, "Convicting the Innocent," 403–85.
46 Speaking at a public event in Saskatoon, lawyer Nicholas Blenkinsop "outlined how Aboriginal people are still more vulnerable to arrest for public intoxication. He said that some police appear to be unaware that such arrests are only legal if the person is a danger to him or herself or to other people, or are a nuisance. 'I have seen a number of situations where the police use drunk in public as an avenue to interact with individuals and trench upon their rights in a way that they shouldn't be doing so[.]'" "Two Worlds Colliding Screen."
47 "The common idea of claiming 'color blindness' is akin to the notion of being 'not racist'—as with the 'not racist,' the color-blind individual, by ostensibly failing to see race, *fails to see racism and falls into racist passivity*.... The good news is that racist and antiracist are not fixed identities. We can be a racist one minute and an antiracist the next. What we say about race, what we do about race, in each moment, determines what—not who—we are." Kendi, *How to Be an Anti-Racist*, 10 (emphasis added).
48 Skinner, Driedger, and Grainger, *Corrections*, 153.
49 Skinner, Driedger, and Grainger, 150 (emphasis added).
50 Skinner, Driedger, and Grainger, 159.
51 Quigley, "Some Issues in Sentencing Aboriginal Offenders," 274 (emphasis added).
52 Razack, *Dying from Improvement*, 59.
53 Tunney, "RCMP Watchdog's Review."
54 Tait, "Saskatchewan's Racial Divide."
55 *Indian Act*, 1876, ss 3, 86–89.

NOTES

56 Boyce, "Carceral Recognition and the Colonial Present," 13.
57 Kaiser-Derrick, *Implicating the System*, 295.
58 Kiiwetinepinesiik Stark, "Criminal Empire," 1.
59 Kiiwetinepinesiik Stark, 1.
60 "Women were not allowed to participate at any level of local government until 1951 revisions to the Indian Act." Winona Stevenson, "Colonialism and First Nations Women," 51.
61 *R v. Gladue*, [1999] 1 SCR at 722.
62 C-41, An Act to Amend the Criminal Code (Sentencing) and Other Acts in Consequence Thereof, Statute of Canada 1995, c. 22, House Government Bill, 35th Parliament, 1st Session, January 17, 1994–February 2, 1996.
63 *R v. Ipeelee*, [2012] 1 SCR 433, 468 at para. 59.
64 *R v. Gladue*, [1999] 1 SCR at 724–5.
65 Malakieh, "Adult and Youth Correctional Statistics in Canada, 2016/2017."
66 *R v. Ipeelee*, [2012] 1 SCR at 468 (emphasis added).
67 *R v. Chanalquay*, 2015 SKCA 141 at para. 42 (emphasis added).
68 *R v. Chanalquay*, 2015 SKCA 141 at para. 43 (emphasis added). For a critique of the SKCA's messaging on *Gladue*, see Scott, "Reforming Saskatchewan's Biased Sentencing Regime," 91. For an extensive review of Canadian cases and on judicial reticence to shift sentencing practice, see Sylvestre and Denis-Boileau, "Ipeelee and the Duty to Resist," 548. It is also worthy of note that Saskatchewan courts have ruled that only if a Probation Officer's Pre-sentence Report contains insufficient *Gladue* information will a court order a separate Gladue Report. The policy of Crown prosecutions is also to not support separate Gladue Reports except in rare circumstances. This effectively means that there is at present practically no public funding for stand-alone Gladue Reports in Saskatchewan. This is in contrast to neighbouring Alberta, which has reportedly dozens of Gladue Report writers providing publicly funded reports upon counsel request. For cases describing the funding situation, see *R v. Gamble*, 2019 SKQB 327; *R v. Desjarlais*, 2019 SKQB 6; *R v. Peepeetch*, 2019 SKQB 132; and *R v. Sand*, 2019 SKQB 18. The Attorney General of Saskatchewan's "Practice Memorandum 'Gladue Principles'" states: "Prosecutors should take the position that Courts should presume the PSR is adequate unless and until the PSR is seen to be otherwise." Attorney General of Saskatchewan, "Practice Memorandum 'Gladue Principles,'" 6. On the differences between Gladue Reports and Pre-sentence Reports, see Indigenous Law Centre, *Gladue Awareness Project*, 75–82.
69 *R v. Ipeelee*, [2012] 1 SCR 477–78 (emphasis added).
70 *R v. Ipeelee*, [2012] 1 SCR 468.
71 *R v. Slippery*, 2015 SKCA 149 at para. 47 (citing *R v. Chanalquay*, 2015 SKCA 141 at para. 40).
72 See Kaiser-Derrick, *Implicating the System*, 295.
73 Sylvestre, "The (Re)Discovery of the Proportionality Principle," 475.
74 Cases that show sympathy and flexibility towards Indigenous people who stand accused are not tantamount to being cases that acknowledge and denounce the

violence committed by Canada towards Indigenous peoples. A recent case that shows an encouraging willingness of the court to move beyond questions of individual culpability towards the societal level effects of colonialism is *R v. Turtle*, 2020 ONCJ 429. See Sonia Lawrence and Parkes, "*R v. Turtle*: Substantive Equality Touches Down in Treaty 5 Territory," 430.

75 Hanson, "Gender, Justice, and the Indian Residential School Claims Process." The article observes biases in the compensation model employed. For a summary of civil litigation related to residential schools, see Cassidy, "The Stolen Generations," 111.

76 *Canada (Attorney General) v. First Nation Child and Family Caring Society of Canada*, 2019 FC 1529.

77 Audra Simpson, "Sovereignty, Sympathy and Indigeneity," 80.

78 Simpson, 87 (emphasis in original).

79 National Inquiry into Missing and Murdered Indigenous Women and Girls, *A Legal Analysis of Genocide*.

80 Loeffler and Nagin, "The Impact of Incarceration on Recidivism," 133–52.

81 *First Nations Child and Family Caring Society of Canada et al. v. Attorney General of Canada (for the Minister of Indian and Northern Affairs Canada)*, 2016 CHRT 2; Forester and Needham, "Canada, First Nations Reveal Details."

82 *First Nations Child and Family Caring Society of Canada et al. v. Attorney General of Canada (for the Minister of Indian and Northern Affairs Canada)*, 2016 CHRT 2, para. 2 (emphasis added).

83 *First Nations Child and Family Caring Society of Canada et al. v. Attorney General of Canada (for the Minister of Indian and Northern Affairs Canada)*, 2016 CHRT 2, para. 412 (emphasis added). Litigation is also ongoing with regard to a class action claim for reparations for loss of culture. Barrera, "Ottawa Says It's Not Liable."

84 Murdocca, "Ethics of Accountability."

85 United Nations Declaration on the Rights of Indigenous Peoples Act, SC 2021, c. 14, https://laws-lois.justice.gc.ca/eng/acts/U-2.2/. Also of unclear effect is the Vatican's denouncement of the Doctrine of Discovery. Press Office of the Holy See, *Joint Statement of the Dicasteries for Culture and Education*.

86 Statistics Canada, *Table 6 Admissions to Adult Custody*.

87 Her sentence was indeed five months longer than that received by the two police officers who abandoned Darrel Night outside of Saskatoon at 5:00 a.m. in January at twenty-two degrees below zero in a jean jacket. *R v. Munson*, 2003 SKCA 28.

8. PRISON WASTELANDS AND THE REMOVAL OF CHILDREN

1 McGuire and Murdoch, "(In)-justice: An Exploration," 1–22.

2 Dayan, *The Law Is a White Dog*.

3 Parkes and Pate, "Time for Accountability," 251–86; Johnston, "Explosive Allegations against Male Prison Guards"; *Commission of Inquiry into Certain Events at the Prison for Women in Kingston*, 195. The Arbour report notes the problematic breakdown of the rule

• NOTES •

of law in prison; it denounces unexplained gaps in the video recordings and violent strip searching of women by male guards and makes disturbing references to baton use. See, e.g., *Commission of Inquiry into Certain Events*, 71, 75, 85.

4 Fair and Walmsley, "World Prison Population List."
5 On Canada, see Moore and Hannah-Moffat, "The Liberal Veil," 85–100. On Scandinavian policies, see Lappi-Seppälä, "Penal Policy in Scandinavia," 217–95.
6 Ricciardelli and Adorjan, "Lifting the Liberal Veil," 81–103.
7 Higgins, Smith, and Swartz, "'We Keep the Nightmares in Their Cages,'" 1–26.
8 Bauman, *Wasted Lives*.
9 Bromwich completes discourse analysis regarding Ashley Smith's incarceration and death and identifies the notion of the *homo sacer* (or outcast) as being in operation in her case and in inmate deaths more generally. "Raced and gendered governmental systems of power and knowledge that allow people to be categorized as neither alive nor dead were actively involved in Ashley Smith's death both before and after her transfer to CSC custody. What is horrifying is not that any person in particular, or any group, planned to kill her. They almost certainly did not. Rather, systems of power in place brought about her death, have eluded accountability for it, and remain in place, making similar deaths in custody predictably likely to recur." Bromwich, "Theorizing the Official Record," 196.
10 See, e.g., Kerr, "Sentencing Ashley Smith," 189.
11 Razack, "Gendered Racial Violence," 102.
12 Razack, *Dying from Improvement*, 59.
13 Razack, 5, 31.
14 Razack, 5.
15 Vasiljevic and Viki, "Dehumanization, Moral Disengagement, and Public Attitudes," 129–46.
16 McGillivray, "Vast Majority of Staff at Toronto Jail."
17 Independent Review of Ontario Corrections, *Segregation in Ontario*.
18 Morrow and White, "Treatment of Adam Capay 'Disturbing,' Wynne Admits"; *R v. Capay*, 2019 ONSC 535.
19 "Saskatchewan Premier Tells 115 Inmates."
20 Landertinger, "Child Welfare and the Imperial Management of Childhood."
21 An Act to Amend the *Indian Act*, 1920 SC c. 50.
22 Schwartz, "Truth and Reconciliation Commission: By the Numbers."
23 UN General Assembly, Convention on the Prevention and Punishment of the Crime of Genocide, 78 UNTS 277, article 2(e).
24 Carreiro, "Indigenous Children for Sale." On June 22, 2022, the Federal Court of Canada certified a class action claim for off-reserve children and their families who were taken in the "Millennium Scoop," between 1992 and 2019. *Stonechild v. Canada*, 2022 FC 913 (CanLII), https://canlii.ca/t/jpvkn.
25 See, e.g., Bendo et al., "Advertising 'Happy' Children," 3. *Brown v. Canada (Attorney General)*, 2017 ONSC 251, para. 14 (sixteen thousand children were taken from Ontario alone). Note the federal enactment of legislation that is topical but underapplied

within Saskatchewan courts at present. An Act Respecting First Nations, Inuit and Metis Children, Youth and Families, SC 2019, c. 24.

26 "As the Truth and Reconciliation Commission noted in its 2015 report, First Nations children are placed in child-welfare care at 12 times the rate of other children." Blackstock, "For Indigenous Kids' Welfare"; Truth and Reconciliation Commission of Canada, *Canada's Residential Schools*, vol. 5, The Legacy [hereafter cited as *Canada's Residential Schools*, vol. 5], 21–31 (on funding incentives, apprehensions statistics, and international criticism). See also Sinclair (Ótiskewápíwskew), "Identity or Racism?" 92–94 (on the evolution of the Sixties Scoop to the Millennium Scoop).

27 Indigenous Services Canada, "Reducing the Number of Indigenous Children in Care."

28 Sinclair (Ótiskewápíwskew), "The Indigenous Child Removal System," 14 (emphasis added); see also Sinha, Ellenbogen, and Trocmé, "Substantiating Neglect of First Nations and Non-Aboriginal Children," 2080–90 (on disproportion in substantiation of neglect).

29 Taylor, "Saskatchewan to Continue Using 'Birth Alerts.'" "Many such cases begin with a 'birth alert,' when a CFS agency informs a hospital of an expecting mother in its system (underage mothers automatically trigger alerts). In Winnipeg, when that baby arrives, an agency called the Child and Family All Nations Coordinated Response Network (ANCR) is called to assess the new mother." Kyle Edwards, "When You Have to Give Birth in Secret." Summarizing newborn apprehension statistics for Manitoba: "Provincewide in 2017, 354 newborns were taken into care before they were 31 days old, and 86 per cent were Indigenous. At the end of year, 259 of those infants remained in care." Kyle Edwards. See also Fidan et al., "Heart Work"; Aston et al., "Mothers' Experiences with Child Protection Services."

30 Marelj and Vikander, "Several Canadian Provinces"; Cooke, "Nova Scotia Ends Controversial Practice."

31 Gebhard, McLean, and St. Denis, eds., *White Benevolence*.

32 Daschuk, *Clearing the Plains*, 98.

33 Monchalin, *The Colonial Problem*, 105.

34 Daschuk, *Clearing the Plains*, 149.

35 Carter, "Categories and Terrains of Exclusion," 159. See also Carter, *Lost Harvests*.

36 Palmater, "Shining Light on the Dark Places," 253; "Tina Fontaine: Murdered Schoolgirl 'Was Repeatedly Failed.'"

37 Mosby, "Administering Colonial Science," 145; Noni E. MacDonald, Stanwick, and Lynk, "Canada's Shameful History," 64.

38 *Canada's Residential Schools*, vol. 5, 35, 234.

39 Truth and Reconciliation Commission of Canada, *Canada's Residential Schools*, vol. 6, Reconciliation [hereafter cited as *Canada's Residential Schools*, vol. 6], 48.

40 *Canada's Residential Schools*, vol. 5, 29.

41 Sevunts, "Indigenous Parents Forced to Give Up Children"; Blackstock, "The Complainant," 285; *First Nations Child and Family Caring Society of Canada*, 2019 FC 1529.

42 The Child and Family Services Act, SS 1989–90, c. C-7.2, ss 4, 35–39.

NOTES

9. LAW THROUGH THE ANDROCENTRIC LENS

1. Walby, "Theorising Patriarchy."
2. Valdes, "Unpacking Hetero-Patriarchy."
3. Susan B. Boyd, ed., *Challenging the Public/Private Divide*.
4. Razack, "Speaking for Ourselves," 441–42 (emphasis in original).
5. Bem, *The Lenses of Gender*; Acker, "Jobs, Bodies: A Theory of Gendered Organizations," 139–58.
6. García-Del Moral, "The Murders of Indigenous Women in Canada as Feminicides," 393; Lugones, "Toward a Decolonial Feminism."
7. Ross, *Interrogating Motherhood*, 103.
8. Alphonso and Farahbaksh, "Canadian Law Only Changed 26 Years Ago,"; An Act to amend the Criminal Code in relation to sexual offences and other offences against the person and to amend certain other Acts in relation thereto or in consequence thereof, 1980-81-82-83 SC, c. 125, s. 19. Earlier wording described offences as occurring when a woman was "not his wife": "A male person commits rape when he has sexual intercourse with a female person who is not his wife." *Criminal Code*, 1970 RSC, c. C-34, s. 143.
9. *Henrietta Muir Edwards and others v. The Attorney General of Canada*, AC 124, 1929 UKPC 86.
10. Ruether, "Misogynism and Virginal Feminism," 164.
11. Kamir, *Framed: Women in Law and Film*, 77.
12. Winona Stevenson, "Colonialism and First Nations Women," 46–47.
13. Stigma against single motherhood can be traced to the patriarchal legal construction of support and inheritance rights being dependant on whether a child was born in or out of wedlock; wedlock rules permitted philandering lords and gentry to sire children with servants with relative impunity, leaving women and children with little rights to the male's assets. Pregnant women who were not married faced shame from their families and churches; men were the safe keepers of their "honour" and could choose not to marry such women. Legitimacy Act 1926, 1926 C. 60; An Act to amend the law relating to children born out of wedlock [15th December 1926], UK Public General Acts 1926, C. 60, http://www.legislation.gov.uk/ukpga/Geo5/16-17/60/enacted.
14. "Malaysia: Babies for Sale." On removal of children from unwed mothers from the 1950s to the 1970s, see Carlson, "Taken Without Mother's Consent."
15. Susan C. Boyd, *From Witches to Crack Moms*, 20, citing E. N. Glenn, "Social Constructions of Mothering: A Thematic Overview" in E. N. Glenn, G. Chang, & L. N. Forcey, Eds. *Mothering: Ideology, Experience, and Agency* (New York: Routledge, 1994), 1.
16. Fletcher, "Women Spend 50% More Time."
17. Waring, *If Women Counted*.
18. "Recent annual data show that, in yearly earnings, women working full time in Canada still earned 74.2 cents for every dollar that full-time male workers made. Another measure that controls for the fact that men typically work more hours than women—the hourly wage rate—shows women earned 87.9 cents on the dollar as of last year." Tavia Grant, "Who Is Minding the Gap?". "In 2021, female employees earned 11.1% less per hour than male employees." Statistics Canada, *Quality of Employment in Canada*.

19 Christopher Ingraham, "The World's Richest Countries guarantee mothers more than a year of paid maternity leave. The U.S. guarantees them nothing," *Washington Post*, February 5, 2018, https://www.washingtonpost.com/news/wonk/wp/2018/02/05/the-worlds-richest-countries-guarantee-mothers-more-than-a-year-of-paid-maternity-leave-the-u-s-guarantees-them-nothing/?noredirect=on&utm_term=.172cda8e8827
20 Natara Williams, "Pre-Hire Pregnancy Screening," 131; Bremer, "Pregnancy Discrimination in Mexico's Maquiladora System," 567; Human Rights Watch, *Mexico's Maquiladoras*.
21 Pulkingham and Van der Gaag, "Maternity/Parental Leave Provisions in Canada," 117; Bacchi, "Do Women Need Equal Treatment or Different Treatment?" 86; Kelly and Dobbin, "Civil Rights Law at Work," 468.
22 "The pregnant woman is an irregularity of the patriarchal prison system, meaning that the suffering she experiences is exceptional to any other 'pain of imprisonment.'" Abbott, "The Incarcerated Pregnancy," 174.
23 "In Maine, Republican state Rep. Richard Pickett last month argued against a state bill that would guarantee unrestricted access to pads and tampons in prisons there. He said incarcerated women already had adequate access. 'Quite frankly, and I don't mean this in any disrespect, the jail system and the correctional system was never meant to be a country club,' he added." Michaels, "Getting Your Period in Prison Is Hell."
24 Waring, *If Women Counted*; England, "Emerging Theories of Care Work," 381–99.
25 Provencher et al., "Report on the Demographic Situation in Canada." ("The percentage of women aged 50 and older who have never given birth to a child was 14.1% in 1990, compared with 15.3% in 2011.")
26 Finer and Henshaw, "Disparities in Rates of Unintended Pregnancy," 90. In 2001, 49 percent of U.S. pregnancies were unexpected and "contraceptives were used during the month of conception for 48% of the unintended pregnancies that ended in 2001."
27 "Correctional officers reportedly told the rookie nurse that Julie Bilotta was probably 'faking it.' One asked if her breech baby's emerging foot was smuggled drugs." Megan Gillis, "New Details on Jail Birth."
28 Wakefield, "Former Alberta Inmate Carried Stillborn Baby."
29 The idea that women are mere "afterthoughts" in corrections has been discussed for decades. Correctional Service of Canada, *Creating Choices*, 28; Parkes, "Women in Prison," 127–56; Hannah-Moffat, "Sacrosanct or Flawed," 193.
30 Monture-Angus, *Thunder in My Soul*, 219.
31 International Centre for Prison Studies, *International Profile of Women's Prisons*, 5 (mothers and children), 35 (Denmark), 42 (Germany), 53 (New Zealand), and 55 (Spain); Parliamentary Assembly of the Council of Europe, *Mothers and Babies in Prison*, paras 16–24 (summarizing state practices); Library of Congress, *Laws on Children Residing with Parents in Prison*.
32 Graveland and Taylor, "No Women at the Table." As of June 2023, of the fourteen territorial, provincial, and federal Justice Ministers, three are female and ten are male. Similarly to the judicial context, males outnumber females as Justice Ministers by more than two to one. See Appendix. On the gender of judges, see Griffith, "Diversity among Federal and Provincial Judges."

NOTES

33 Gender analysis and the public-private divide is widely discussed in multiple fields including history, law, politics, and economics. See, e.g., Landes, "Further Thoughts on the Public/Private Distinction," 34; Naffine, "Sexing the Subject (of Law)"; Arneil, "Women as Wives, Servants and Slaves," 42; Sacks, "Appendix Three: Engels Revisited," 221–22; Benería, "Reproduction, Production and the Sexual Division of Labour," 204.

34 See, e.g., Tully, Stuebe, and Verbiest, "The Fourth Trimester," 37; Barker et al., "Maternal-Newborn Bonding"; Spratt et al., "Biologic Effects of Stress and Bonding," 246; Gordon et al., "Oxytocin and the Development of Parenting in Humans," 377; Hazan and Campa, *Human Bonding*; Kayla Johnson, "Maternal Infant Bonding," 17; Liu, Leung, and Yang, "Breastfeeding and Active Bonding," 76; Young, "Importance of Bonding," 11; Symanski, "Maternal-Infant Bonding," S67; Schuengel, Oosterman, and Sterkenburg, "Children with Disrupted Attachment Histories."

35 Dignam and Adashi, "Health Rights in the Balance."

36 Tully, Stuebe, and Verbiest, "The Fourth Trimester," 37; Barker et al., "Maternal-Newborn Bonding"; Spratt et al., "Biologic Effects of Stress and Bonding," 246; Gordon et al., "Oxytocin and the Development of Parenting in Humans," 377; Hazan and Campa, *Human Bonding*; Kayla Johnson, "Maternal Infant Bonding," 17; Liu, Leung, and Yang, "Breastfeeding and Active Bonding," 76; Young, "Importance of Bonding," 11; Symanski, "Maternal-Infant Bonding," S67; Schuengel, Oosterman, and Sterkenburg, "Children with Disrupted Attachment Histories."

37 See, e.g., Canadian Friends Service Committee (Quakers), *Considering the Best Interests of the Child*, 4 (on Canadian law lagging behind other states in this regard); see also Millar and Dandurand, "Impact of Sentencing."

38 Sölle, "Mary Is a Sympathizer," 325. According to this binary, women are also maligned if they choose not to become mothers, since this is construed as selfishness and incomplete or improper womanhood.

39 Windsong, "Incorporating Intersectionality into Research Design," 136.

40 "Laws and policies that impede Black mothers' ability to breastfeed their children began in slavery and persist as an incident of that institution today. They originated in the practice of removing enslaved new mothers from their infants to work or to serve as wet nurses for slave owners' children. *The stereotype of the bad Black mother justified this separation*." Freeman, "Unmothering Black Women," 1545 (emphasis added); Flanders-Stepans, "Alarming Racial Differences in Maternal Mortality," 50. See also sociologist Tressie McMillan Cottom's account of being read as "incompetent" as a Black woman in labour in a hospital setting. McMillan Cottom, *Thick and Other Essays*, 86. On anti-Black racism in Canada, see Maynard, *Policing Black Lives*. Note also cis-centrism and discrimination. Nadal, Davidoff, and Fujii-Doe, "Transgender Women and the Sex Work Industry," 169.

41 Pargas, "Disposing of Human Property," 251; "U.S. Child Migrants."

42 Carter, "Categories and Terrains of Exclusion," 147.

10. FACTORS THAT BUFFER THE LEGAL SYSTEM FROM CHANGE

1. Coase, "The Problem of Social Cost," 1–44.
2. Canadian Heritage, "Government of Canada Reinstates the Modernized Court Challenges Program."
3. Ling, "Houses of Hate."
4. Criminal Code, 1985 RSC, c. C-46, s. 684. It is notable that according to Saskatchewan Court Services, "in fiscal year 2016/17, in the Court of Appeal, there were 18 applications for court appointed counsel and 5 orders were granted." Email from Saskatchewan Court Services, June 13, 2017.
5. Griffith, "Diversity among Federal and Provincial Judges." Macdonald notes: "In perhaps the most glaring omission of minority voices, just two of the 101 judges in the province—where 81 per cent of those sentenced to provincial custody are Indigenous, higher than in any other province—is either First Nations or Metis." Macdonald, "Saskatchewan: A Special Report." Since 2016 at least two Metis jurists have been appointed as judges; see Government of Saskatchewan, "Provincial Court Judge Appointed in Saskatoon"; Government of Saskatchewan, "Provincial Court Judge Appointed in La Ronge."
6. Griffith, "Diversity among Federal and Provincial Judges"; see figure 3, showing about 26 percent for female judges who are federally appointed and less than 30 percent for female judges who are provincially appointed. Hunter, "More than Just a Different Face?" 119–41.
7. Graveland and Taylor, "No Women at the Table." See Appendix.
8. Rachlinski et al., "Does Unconscious Racial Bias Affect Trial Judges?" 1195; Levinson, "Forgotten Racial Equality," 345.
9. *R v. S (RD)*, [1997] 3 SCR 484; *R v. Hamilton* (2004), 72 OR (3d) 1 (ONCA).
10. Harold R. Johnson, *Peace and Good Order*, 21.
11. Perez, *Invisible Women*.
12. Laura King, "Hiding in the Pub to Cutting the Cord?" 1–19.
13. A Bill for an Act Relating to Corrections; Authorizing the Placement of Pregnant and Postpartum Female Inmates in Community-Based Programs, Senate, State of Minnesota, Ninety-second Session, S.F. No. 1315; Minnesota Department of Corrections, "Healthy Start Act SF 1315/HF 1403."
14. Schwartz, "By the Numbers."
15. Bendo et al., "Advertising 'Happy' Children," 3; Allyson D. Stevenson, *Intimate Integration*.
16. *Canada's Residential Schools*, vol. 6. On the term Millennium Scoop, see "First Nations Children Still Taken from Parents." On perverse funding incentives, see Tasker, "Jane Philpott Unveils 6-Point Plan."
17. Indeed, the National Judicial Institute provides training for all judges on *Gladue* sentencing and Indigenous oral history, suggesting that resources are available to ensure judges are up-to-date in their views. That said, provincial judges in Saskatchewan at least are not obliged to engage in such training as of 2022. There is no continuing education requirement in the relevant legislation or regulation governing

provincial judges. This means that the majority of interactions between Indigenous persons and courts of law are occurring in contexts whereby judges have no obligation to update their knowledge.
18 Macdonald, "Saskatchewan: A Special Report."
19 Statistics Canada, *Table 4 Admissions to Adult Correctional Services*.

11. THE ILLEGALITY OF SHACKLING A PREGNANT PERSON IN LABOUR

1 McKendy, "The Pains of Jail Imprisonment," 160.
2 *Sauvé v. Canada (Chief Electoral Officer)*, 2002 SCC 68 at para. 40.
3 Dignam and Adashi, "Health Rights in the Balance," at 18.
4 Dignam and Adashi.
5 American Congress of Obstetricians and Gynecologists, *Health Care*, 3.
6 American Congress of Obstetricians and Gynecologists, *Health Care*, 3.
7 American Congress of Obstetricians and Gynecologists, Committee Opinion Number 511 at 3.
8 American Medical Association, *Shackling of Pregnant Women in Labor*, 2010.
9 See, e.g., *Villegas v. Metropolitan Government of Davidson County*, 789 F Supp 2d 895, 919 (MD TN 2011); *Nelson v. Corr Med Services*, 583 F3d at 534 (8th Cir 2009); and *Brawley v. Washington*, 712 F Supp 1208 (WD Wash 2010).
10 Dignam and Adashi, "Health Rights in the Balance." See, e.g., Public Act 91-253, Illinois General Assembly, Illinois Compiled Statutes, Counties, 55 Ill. Comp. Stat. 5/3-15003.6, 2000, http://www.ilga.gov/legislation/legisnet91/hbgroups/hb/910HB0392LV.html. See also Second Chance Act of 2007: Community Safety through Recidivism Prevention, Public Law 110-199, Section 232, April 9, 2008, http://www.gpo.gov/fdsys/pkg/PLAW-110publ199/pdf/PLAW-110publ199.pdf.
11 UN General Assembly, A Human Rights–Based Approach.
12 World Health Organization, *The Prevention and Elimination of Disrespect and Abuse*.
13 Khosla et al., "International Human Rights," 139.
14 UN General Assembly, Convention against Torture, 1465 UNTS 85.
15 UN General Assembly, International Covenant on Civil and Political Rights, 999 UNTS 171.
16 UN General Assembly, Convention on the Elimination of All Forms of Discrimination against Women, 1249 UNTS 13.
17 UN General Assembly, International Covenant on Economic, Social and Cultural Rights, CAN TS 1976 No 46 at article 12.
18 UN Human Rights Committee, Concluding Observations of the Human Rights Committee, at para. 33.
19 UN Committee against Torture, Conclusions and Recommendations of the Committee Against Torture, at 8.
20 UN Committee against Torture, Concluding Observations on the Combined Third to Fifth Periodic Reports, at 11.

21 UN General Assembly, United Nations Standard Minimum Rules for the Treatment of Prisoners (the Nelson Mandela Rules), at rule 48; UN General Assembly, United Nations Rules for the Treatment of Women Prisoners (the Bangkok Rules), at rule 24.
22 *Canadian Civil Liberties Ass'n v. Canada (Attorney General)*, 2019 ONCA 243 at para. 23.
23 *Canadian Civil Liberties Ass'n v. Canada (Attorney General)*, 2019 ONCA 243 at para. 23.
24 *Canadian Civil Liberties Ass'n v. Canada (Attorney General)*, 2019 ONCA 243 at para. 29, citing *R. v. Prystay*, 2019 ABQB 8 at para. 128.
25 UN Human Rights Committee, Concluding Observations of the Human Rights Committee, United States of America, at para. 33.
26 *Slaight Communications Inc. v. Davidson*, [1989] 1 SCR 1038 at 1056; see also *Health Services and Support –Facilities Subsector Bargaining Ass'n v. British Columbia*, 2007 SCC 27 at para. 70.
27 *Baker v. Canada (Minister of Citizenship and Immigration)*, [1999] 2 SCR 817; see also *R. v. Hape*, 2007 SCC 26, paras 53–54; see also Van Ert, *The Reception of International Law in Canada*.
28 Luce et al., "'Is It Realistic?'"
29 *R. v. Smith (Edward Dewey)*, [1987] 1 SCR 1045 at 86.
30 *R. v. Bissonnette*, 2022 SCC 23 at para. 60.
31 *R. v. Bissonnette*, 2022 SCC 23 at paras 65–66.
32 "I am also satisfied that this treatment is 'cruel and unusual,' particularly, but not exclusively, as it affects children who have been brought to this country by their parents. The cuts to health insurance coverage effected through the 2012 modifications to the IFHP potentially jeopardize the health, and indeed the very lives, of these innocent and vulnerable children in a manner that shocks the conscience and outrages our standards of decency. They violate section 12 of the Charter." *Canadian Doctors for Refugee Care v. Canada (Attorney General)*, 2014 FC 651.
33 *R. v. Bissonnette*, 2022 SCC 23 at para. 120. If the stated objective is avoiding escape, there are other available approaches to transporting a woman who is very advanced in her pregnancy, such as by using an additional escort, aside from the use of metal leg restraints or handcuffs.
34 *Blencoe v. British Columbia (Human Rights Commission)*, 2000 SCC 44 at para. 49.
35 *Blencoe v. British Columbia (Human Rights Commission)*, 2000 SCC 44; *Carter v. Canada (Attorney General)* 2015 SCC 5; *Ewert v. Canada* 2018 SCC 30.
36 *Canada (Attorney General) v. Bedford*, 2013 SCC 72.
37 For example, Manitoba's Correctional Services Regulation reads in part: "The following equipment may be used to maintain order in, and control the inmates of, a custodial facility:... (e) devices designed to restrain one or more limbs or the whole body of a person[.]" Correctional Services Regulation, 1999, Man Reg 128/99, s. 73(1), https://canlii.ca/t/52bgn. See also, e.g., Corrections Act, 2009, SY 2009, c. 3, s. 19, https://canlii.ca/t/54bxq (on preventing escape).
38 *Canada (Attorney General) v. Bedford*, 2013 SCC 72 at para. 112 (emphasis in original).
39 *Canada (Attorney General) v. Bedford*, 2013 SCC 72 at para. 112.
40 *Canada (Attorney General) v. PHS Community Services Society*, 2011 SCC 44 at para. 133; see

• NOTES •

also *Canada (Attorney General) v. Bedford*, 2013 SCC 72, at para. 136.
41 *Carter v. Canada (Attorney General)*, 2015 SCC 5 at para. 102.
42 *Carter v. Canada (Attorney General)*, 2015 SCC 5 at paras 114–5.
43 *Fraser v. Canada (Attorney General)*, 2020 SCC 28; *Eldridge v. British Columbia (Attorney General)*, [1997] 3 SCR 624 at para. 64.
44 *Brooks v. Canada Safeway Ltd.*, [1989] 1 SCR 1219.
45 *Fraser v. Canada (Attorney General)*, 2020 SCC 28 at para. 61.
46 *Fraser v. Canada (Attorney General)*, 2020 SCC 28 at paras 78–81.
47 *Inglis v. British Columbia (Minister of Public Safety)*, 2013 BCSC 2309 at para. 612.
48 Correctional Services and Reintegration Act, 2018, SO 2018, c. 6, Sch. 2, s. 96, https://canlii.ca/t/5353v (this is not yet in force as of January 2024). The Ontario legislation that is presently in force does not address pregnancy in the context of restraints. Ministry of Correctional Services Act, RRO 1990, Regulation 78, General, RRO 1990, Reg 778, https://canlii.ca/t/5556k. For a further sample of the legislative treatment of restraints and related discretion see, e.g., Alberta: Corrections Regulation, 2001, Alta Reg 205/2001, s. 50, https://canlii.ca/t/54wqb; Quebec: Act Respecting the Québec Correctional System, 2002, CQLR c. S-40.1, s. 193, https://canlii.ca/t/55g2q; Yukon: Corrections Act, 2009, SY 2009, c. 3, s. 19, https://canlii.ca/t/54bxq; NWT: Corrections Regulations, R-073-2021, in force October 29, 2021, SI-027-2021, s. 21, https://www.justice.gov.nt.ca/en/files/legislation/corrections/corrections.r3.pdf; Nunavut: Corrections Act, 2019, ASN c. 13, s. 24, https://www.nunavutlegislation.ca/en/media/1588; Manitoba: Correctional Services Regulation, 1999, Man Reg 128/99, s. 73, https://canlii.ca/t/52bgn.
49 "1.7.26. Supervision of Pregnant Inmates," Adult Custody Policy, Adult Custody Division, Corrections Branch, Ministry of Justice, BC, issued April 2005, http://docs.openinfo.gov.bc.ca/d26445513a_response_package_jag-2013-00337.pdf; "Policy 6–6.3 Use of Restraint Chair," Adult Centre Operations Branch, Policies and Procedures, Alberta Corrections, revised February 21, 2020 (chair not to be used on pregnant persons); "Whenever transfer of a pregnant female inmate is necessary, every effort shall be made to ensure that a secure, safe and comfortable means of transportation is utilized," "Policy 4–4.2 Admission, Transfers, Discharge and Release," Adult Centre Operations Branch, Policies and Procedures, Alberta Corrections, released April 9, 2018; "External Escorts," Adult Custody Services Policy Manual, Security 507, Custody, Supervision and Rehabilitation Services, Saskatchewan, latest revisions effective February 25, 2019, s. 7.3 (page 6), https://publications.saskatchewan.ca/#/products/102083. "Policy: G-46, Obstetrical Care," Adult Institutional Policy, New Brunswick Public Safety Corrections, effective August 2010; Corrections Canada, Commissioner's Directive Number 567-3.
50 *Canada (Citizenship and Immigration) v. Thamotharem*, 2007 FCA 198.
51 *Bell ExpressVu Limited Partnership v. Rex*, 2002 SCC 42; *Slaight Communications Inc. v. Davidson*, [1989] 1 SCR 1038 at 1078.
52 *Baker v. Canada (Minister of Citizenship and Immigration)*, [1999] 2 SCR 817.
53 *Singh (Parminder) v. Canada (Minister of Citizenship and Immigration)*, 2016 FCA 96.

12. HOW THE LAW PROTECTS A NEWBORN FROM AUTOMATIC SEPARATION FROM THEIR MOTHER

1. Schuengel, Oosterman, and Sterkenburg, "Children with Disrupted Attachment Histories."
2. Leach, "Starting Off Right," 23–24.
3. Gordon et al., "Oxytocin and the Development of Parenting in Humans," 377; Hazan and Campa, *Human Bonding*; Kayla Johnson, "Maternal Infant Bonding," 17; Liu, Leung, and Yang, "Breastfeeding and Active Bonding," 76; Young, "Importance of Bonding," 11; Symanski, "Maternal-Infant Bonding," S67.
4. UN General Assembly, Convention on the Rights of the Child, 1577 UNTS 3; see articles 24 (health) and 9 (family).
5. UN General Assembly, Convention on the Rights of the Child, at article 3.
6. *Baker v. Canada (Minister of Citizenship and Immigration)*, [1999] 2 SCR 817; *Slaight Communications Inc. v. Davidson*, [1989] 1 SCR 1038.
7. *Winnipeg Child and Family Services v. KLW*, [2000] 2 SCR 519. Child apprehension affects the right to security of the person and must only be done in accordance with the principles of fundamental justice.
8. *New Brunswick v. G(J)*, [1999] 3 SCR 46 (finding an interference with a mother's s. 7 right in the context of child apprehension and outlining fair procedure requirements).
9. On the procedural content of fundamental justice, see *Singh v. Minister of Employment and Immigration*, [1985] 1 SCR 177.
10. *Suresh v. Canada (Minster of Citizenship and Immigration)*, 2002 SCC 1 at para. 115; *R v. Lyons*, [1987] 2 SCR 309 at 361.
11. *Baker v. Canada (Minister of Citizenship and Immigration)*, [1999] 2 SCR 817; see *Blencoe v. British Columbia (Human Rights Commission)*, [2000] 2 SCR 307.
12. For example, Šimonović reports: "During the visits I conducted to correctional facilities, I was deeply concerned about their overcrowding. In addition, both of the facilities visited have not currently in place any child and mother program." Šimonović, "End of Mission Statement by Dubravka Šimonović."
13. Gordon et al., "Oxytocin and the Development of Parenting in Humans," 377; Hazan and Campa, *Human Bonding*; Kayla Johnson, "Maternal Infant Bonding," 17; Liu, Leung, and Yang, "Breastfeeding and Active Bonding," 76; Young, "Importance of Bonding," 11; Symanski, "Maternal-Infant Bonding," S67.
14. *Inglis v. British Columbia (Minister of Public Safety)*, 2013 BCSC 2309.
15. On the interference with psychological integrity as engaging section 7 protection, see, e.g., *New Brunswick (Minister of Health and Community Services) v. G(J)*, [1999] 3 SCR 46 at paras 63–64; *Winnipeg Child and Family Services v. KLW*, 2 SCR at 568–570.
16. *Canada (Attorney General) v. Bedford*, 2013 SCC 72 at paras 111–17.
17. *Inglis v. British Columbia (Minister of Public Safety)*, 2013 BCSC 2309 at para. 455.
18. *Inglis v. British Columbia (Minister of Public Safety)*, 2013 BCSC 2309 at para. 455.
19. *Inglis v. British Columbia (Minister of Public Safety)*, 2013 BCSC 2309 at para. 455; *Canada (Attorney General) v. Bedford*, 2013 SCC 72; *Doré v. Barreau du Québec*, 2012 SCC 12, [2012]

NOTES

1 SCR 395 (on Charter application to administrative state actions under discretionary authority). The best interests of the child itself was not found to be a guiding section 7 principle of fundamental justice, but this does not discount the requirement of fair process, nor the principles of arbitrariness, overbreadth, and gross disproportionality. *Canadian Foundation for Children, Youth and the Law v. Canada (AG)*, [2004] 1 SCR 76.

20 UN General Assembly, Convention on the Rights of the Child, 1577 UNTS 3 at article 24. The right to health is also guaranteed in other treaties to which Canada is a party. This includes UN General Assembly, International Covenant on Economic, Social and Cultural Rights, CAN TS 1976 No 46, article 12; UN General Assembly, Convention on the Elimination of All Forms of Discrimination against Women, 1249 UNTS 13, article 12; and UN General Assembly, International Convention on the Elimination of All Forms of Racial Discrimination, 660 UNTS 195, article 5.

21 UN General Assembly, Convention on the Rights of the Child, 1577 UNTS 3 at article 7.

22 UN General Assembly, International Covenant on Civil and Political Rights, 999 UNTS 171 at article 23; UN General Assembly, International Covenant on Economic, Social and Cultural Rights, CAN TS 1976 No 46 at article 10.

23 UN General Assembly, Convention on the Elimination of All Forms of Discrimination against Women, 1249 UNTS 13 at article 12.

24 "States shall take measures, in conjunction with indigenous peoples, to ensure that indigenous women and children enjoy the full protection and guarantees against all forms of violence and discrimination." UN General Assembly, United Nations Declaration on the Rights of Indigenous Peoples, at article 22(2). Canada is internationally recognized as needing to improve in this area: "It was also reported that aboriginal women are less likely to be sentenced to alternative measures to incarceration." UN General Assembly, Report of the Inquiry Concerning Canada, at para. 174.

25 Bresnahan et al., "Made to Feel Like Less of a Woman," 39; Schmunk, "'You Are Not a Bad Mother.'"

26 *Inglis v. British Columbia (Minister of Public Safety)*, 2013 BCSC 2309 at para. 82.

27 Feldman et al., "The Nature of the Mother's Tie to Her Infant," 936–37; Chambers, "Impact of Forced Separation Policy," 205; Franco, Mowers, and Lewis, "Equitable Care for Pregnant Incarcerated Women," 213.

28 Bowlby, "The Nature of the Child's Tie to His Mother," 350–73; on separation effects on children, see also Gualtieri et al., "Post-Traumatic Stress Disorder in Prisoners' Offspring," 43; Morgan-Mullane, "Trauma Focused Cognitive Behavioral Therapy," 202; Jennifer Wyatt Bourgeois, Drake, and Henderson, "The Forgotten," 65–87. "Children who spent time with their mothers in a prison nursery had significantly lower mean anxious/depressed and withdrawn behavior scores than children who were separated from their mothers in infancy or toddlerhood because of incarceration." Goshin, Byrne, and Blanchard-Lewis, "Preschool Outcomes of Children Who Lived as Infants in a Prison Nursery," 147.

29 Collaborating Centre for Prison Health and Education (CCPHE), *Guidelines for Mother-Child Units in Correctional Facilities*.

30 International Centre for Prison Studies, *International Profile of Women's Prisons*.
31 "Since 2005, the Committee has increasingly addressed the situation of children of incarcerated and administratively detained parents as part of its concluding observations... [the Committee's] now more than 50 concluding observations, 40 of which were made in 2010 or after, have instructed domestic courts to consider the best interests of the child principle when remanding or sentencing a parent to custody, emphasizing the use of alternative sanctions where possible and appropriate." Millar and Dandurand, "Impact of Sentencing," 10.
32 *Baker v. Canada (Minister of Citizenship and Immigration)*, [1999] 2 SCR 817.
33 On the interference with psychological integrity as engaging section 7 protection, see, e.g., *New Brunswick (Minister of Health and Community Services) v. G(J)*, [1999] 3 SCR 46 at paras 63–64; *Winnipeg Child and Family Services v. KLW*, 2 SCR at 568–70.
34 *Dobson (Litigation Guardian of) v. Dobson*, [1999] 2 SCR 753.
35 *R v. Pham*, [2013] 1 SCR 739.
36 Canadian Friends Service Committee (Quakers), *Considering the Best Interests of the Child*, 11. The Canadian Friends Service Committee cites cases on the importance of considering caregiving, including: *R v. Hamilton*, 2003 CanLII 2862 at para. 197 (Ont. SC); *Regina v. Scott*, [1996] OJ No. 3419 (CA); *Regina v. Wellington*, [1999] OJ No. 569 (CA); *Regina v. Hadida*, [2001] OJ No. 843 (CA) at para. 2; *The Queen v. Bunn* (2000), 140 CCC (3d) 505 (SCC) at 517; and *Regina v. Holub and Kufrin* (2002), 163 CCC (3d) 166 (Ont. CA).
37 "First signed in 2014 and renewed in 2016, there is a Memorandum of Understanding between the Ministry of Justice, the National Ombudsman for Childhood and Adolescence and Bambinisenasbarre (an NGO), which includes (Article 1) asking judicial authorities to take into account the rights and requirements of minor children when deciding on pretrial measures and in sentencing persons who have parental responsibility, giving priority to measures alternative to pretrial detention in prison, including choosing sentencing measures which take into consideration the child's best interests. Italy also has specific laws relating to women offenders who have children, designed to avoid pre-trial custody or imprisonment as much as possible." Brett, "Best Interests of the Child," 10.
38 *S v. M*, [2007] ZACC 18 (26 September 2007), CCT 53/06, http://www.saflii.org/za/cases/zacc/2007/18.html.
39 Provencher et al., "Report on the Demographic Situation in Canada."
40 "When the child's sole or main carer may be the subject of deprivation of liberty as a result of preventive detention or sentencing decisions, non-custodial remand measures and sentences should be taken in appropriate cases wherever possible, the best interests of the child being given due consideration. States should take into account the best interests of the child when deciding whether to remove children born in prison and children living in prison with a parent. The removal of such children should be treated in the same way as other instances where separation is considered." UN General Assembly, United Nations Rules for the Treatment of Women Prisoners [...] (the Bangkok Rules), at para. 64. Further guidance is available

• NOTES •

from UN General Assembly, Guidelines for the Alternative Care of Children Without Parental Care, at para. 48.
41 UN Committee on the Rights of the Child, General Comment No. 14, at paras 28, 69.
42 *Inglis v. British Columbia (Minister of Public Safety)*, 2013 BCSC 2309.

CONCLUSION

1 Arvin, Tuck, and Morrill, "Decolonizing Feminism," 8–34. Michi Saagiig Nishnaabeg scholar Leanne Betasamosake Simpson locates heteropatriarchy as a foundational dispossession force. Leanne Betasamosake Simpson, *As We Have Always Done*, 51.
2 *President of the Republic of South Africa v. Hugo*, 1997 (6) BCLR 708 (CC) (citing Presidential Act No. 17).

INDEX

Aboriginal Justice Inquiry of Manitoba, 100
Adashi, Eli Y., 181–82
alcohol
 effects of abuse of, 118
 rules on possession, use, 101–2, 104–6, 108
Alouette Correctional Centre (Maple Ridge), 19
Alphonse, Paul, 39
American College of Obstetricians and Gynecologists, 182–83
American Medical Association, 183
androcentric lens/norms
 contributing to child-mother separation, 153–55, 157–59, 161, 195, 215
 presence in the legal/prison system, xix, 19, 50, 150, 163
 reflecting heteropatriarchal male-centricity, xviii, 147, 149, 180, 206, 212–13
 relegating women's issues to private sphere, 148, 152
 spatial categories within, 178
assimilation, forced, 52–53, 87, 98–99, 137, 144
autopoiesis. *See* systems theory

"bad/unfit mother" stereotype. *See* motherhood
Barton, Bradley, 55
Bauman, Zygmunt, 133
Beal, Lauren, 31
bonding
 critical for newborn health, development, xxi, 12–13, 88, 196, 201, 207
 denied with automatic separation, 154, 161
 negative lifelong effects when denied, 20–21, 159, 198

Boushie, Colten, xviii, 61, 63–64, 66–69, 71, 73–75, 79, 108
Boyd, Susan C., 152
Brass, Alvina, 53
Buffalo Woman, 55

Cameron, Malcolm D., 45
Canada
 as controlling/dehumanizing Indigenous peoples, 98, 101, 214
 incarceration rate in, 31, 132
 international treaty obligations of, 184, 186, 194, 199, 201
 needing to value Indigenous motherhood, 213
 obliged to cease shackling labouring prisoners, 187, 198
 perpetually innocent towards Indigenous peoples, 60, 96, 110–12, 123, 126
 presumed entitled to take Indigenous children, 137, 140–41, 177
 violating Indigenous human rights through legal system, 128, 169
 See also legal system, Canadian
Canada (Attorney General) v. Bedford, 190
Canadian Charter of Rights and Freedoms
 constitutional rights in, xiii, 20, 198–200, 208
 disallowing shackling of labouring prisoners, 181, 187
 forbidding automatic newborn-mother separation, 203–5, 216
 protecting best interests of child, 207
Canadian Doctors for Refugee Care v. Canada, 189

Canadian Human Rights Tribunal, 124, 127–28
Capay, Adam, 134
Carter, Sarah, 84, 102
castle doctrine
 defence of property, self, 64–66, 69, 72, 74–76, 78–79
 justifying use of force, 65, 72
 prairie version of, 73–74
child, best interests of
 denied in legal system judgments, xv, 35, 94
 needs to be primary consideration, xiii, 20, 22, 24, 143–44, 199–200, 203–5, 207, 212, 216
 required by treaty obligations, 15, 62, 198
child welfare system, 139, 142–43
 See also foster care
Clarke, Jennifer, 31
Clearing the Plains, 47
Coase, Ronald, 77
colonialism, settler
 anti-Indigenous racism in, xvii–xviii, 50, 77
 belief structures similar to heteropatriarchy, 86, 213
 Canada's accountability in, 38, 96, 123
 impact of Christianity on, 86–87
 injustices of supported by criminal law, 98, 111
 See also colonial lens/norms
colonial lens/norms
 as dehumanizing Indigenous women, 83–84, 88, 93, 143, 149, 180, 213
 embedded in legal/prison system, xix, 13, 114, 122, 129, 131, 133, 136, 163, 169, 195
 leading to Indigenous over-incarceration, 75, 108, 130
 in legal system's attitude towards Indigenous persons, 46, 49–51, 53–59, 96, 98–99, 105, 109–10, 123, 140–41, 154
 reflected in Stanley case, 73, 76
 spatial categories within, 60–61, 63, 90, 137, 175–76, 212
Committee on the Rights of the Child, 204, 207
Community Legal Assistance Services for Saskatoon Inner City (CLASSIC) clinic, xiv, 7, 165

Contois, Rebecca, 55
Convention against Torture and Other Cruel, Inhuman or Degrading Treatment or Punishment, 184–86, 189
Convention on the Elimination of All Forms of Discrimination against Women, 184
Convention on the Prevention and Punishment of the Crime of Genocide, 138
courts
 existing in public sphere, 148–49
 lacking respect for Indigenous persons, 92, 111, 118, 130, 213
 lack of transparency in, 170–71
 needing to shed colonial, androcentric norms, 55, 108, 110, 114, 120, 122–24, 137, 153, 161, 170, 215
 obliged to recognize rights of child and reject separation practice, 158, 201, 203, 206–7, 211, 214, 216
 as pathway to Indigenous incarceration, 60, 95–96, 99–100, 129
 treatment of pregnancy, childbirth and newborn by, 150, 154
 See also judges
Criminal Code/criminal law
 amendments to sentencing in, 98, 113, 118–19, 126
 human misery inherent in, 143
 operating with colonial lens, 96, 99, 126
 regarding prostitution charges, 102, 105
 used to control/contain Indigenous persons, 11, 48, 52–53, 98–99, 103–4, 110, 112–13, 124
 used to secure state domination, 17, 98, 140
 See also legal system, Canadian

Daschuk, James, 44, 47
Dayan, Colin, 49
Department of Indian Affairs, 44, 47
Dignam, Brett, 181–82
Disinhibited Attachment Disorder, xxi
Douglas, Tommy, 105
Driedger, Otto, 104, 107
Drybones, 105
"dying"/"drunken Indian" stereotype
 as dehumanizing Indigenous persons, 141
 as devaluing Indigenous women, 54, 83, 88, 94, 137, 180

• INDEX •

embedded in Canadian policy, 47
present in legal/prison system, 50, 60, 110, 133–36, 177, 214
spatial category within colonial lens, xvi, 39–41, 46

Ehalt, Sergeant Bruce, 58
Elizabeth Fry Society, xiv, 165

Federal Mother-Child Program, 23–24, 31–32
Fetal Alcohol Spectrum Disorder (FASD), 16
Fighting for a Hand to Hold, 57
Firewater, 102
foster care
believed preferable in some cases, 13–14, 46, 93, 144
Indigenous children overrepresented in, 138, 141–42
infant's attachment to caregiver, 196
placement in after sentencing, xxii, 22, 28

Gavigan, Shelley, 53
genocide, 41, 126, 138
George, Pamela, 37–38, 52
Gladue, Cindy, 55
Graeber, David, 88–89, 91
Grainger, Brian, 104, 107
Guidelines for Mother-Child Units in Correctional Facilities, 202

Hansen, Robin
background of, xxiii–xxiv, 20
experience with Jacquie and Yuri, xi–xv, 3, 6–8, 12
Hargreaves, Alison, 55
Harper, Prime Minister Stephen, 127
Harris, Morgan Beatrice, 55
Healthy Start Act (Minnesota), 21, 168
heteropatriarchal male-centricity
as androcentrism, xvii–xviii, 147, 212
defining public and private spheres, 156, 159
influencing criminal sentencing, 147, 211
justifying newborn-mother separation, 149
sharing beliefs of colonialism, 213
supported by Judeo-Christian beliefs, 150, 153
Hunt, Dallas, 64–65

Iftene, Adelina, 31
Implicating the System, 123
Indian Act, 43, 48–49, 53, 99–100, 109, 112
Indian Agents, 46, 53, 100–101, 103–4, 140
Indian Residential Schools
forced attendance at, 15, 55, 102, 124, 137, 169
as a *Gladue* background factor, 117, 119, 122, 124–25, 128
intergenerational trauma from, 3, 16, 93, 116, 118, 122, 127, 139, 176
loss of parenting skills through, 16
negative legacy of, 17, 111, 124
settlement agreement, 124, 141
state culpability, apology for, 127–29, 186, 214
vehicle of forced assimilation, 54, 87, 99
See also assimilation, forced
Indigenous children
apprehension of as form of violence, 59, 139, 142, 166
dislocated from families, 15, 54, 138
taking of, as justified, 41, 88, 137–38, 140–41
Indigenous legal scholarship, xvi, xviii, 37, 210
Indigenous over-incarceration
addressing need to reduce, 113–15, 124, 127–29, 142, 213
attempt to contain, erase Indigenous peoples, 97–98
colonial norms contributing to, 60, 73, 75, 96, 130
driven by Indigenous criminality stereotypes, 105
indicative of state oppression, xv, 17, 103, 112
reflecting diminished role of Indian Agents, 104
Indigenous peoples
colonial biases and racism towards, xxv, 15, 41, 57
as criminal hostile invader, 52, 66, 68, 74, 78
dehumanization of, 39–40, 46, 214
denied right to rule of law, xv, 45, 48
dispossessed of land, 37–38, 40, 42, 53, 87, 213
manufactured criminality of, 38, 69, 102–5, 109, 111, 123–24, 126, 128
moral culpability reduced by background factors, 113–15, 125

Indigenous peoples *(continued)*
 over-policing of, 96, 103, 124
 spatial containment/starvation of, 37, 40, 43–45, 53, 58
Indigenous women
 deemed to be prostitutes, 102
 dehumanization of, 54–55, 60, 83–85
 forced sterilization of, 54, 87, 141, 186
 need to become valued by Canada, 213
 overrepresented in prison, 20, 192
 viewed as unfit mothers, 87, 130, 162, 176
 See also motherhood
Inglis v. British Columbia, 19–21, 201
International Covenant on Civil and Political Rights (ICCPR), 184, 186, 189
International Covenant on Economic, Social and Cultural Rights, 184

Jacobs, Madelaine, 99, 104
Jacquie
 childbirth experience of, 7–11, 92, 94, 157, 181
 intergenerational survivor of residential schools, 17, 121
Jacquie's sentencing
 affected by androcentric lens in legal system, 159
 denied consideration of *Gladue* factors, 116–22, 128–29
 displaying dehumanizing treatment, 135–36
 norms based on colonial racism, 212
 reflecting over-incarceration practice, 130
Johnson, Harold R., 56, 102, 167
Jones, Rachel, 31
judges
 lack of diverse perspectives, 164, 166–69
 needing to consider interest of child, 203–4, 214
 slow to take up change to practice, 168–70
 See also courts
justice, spatialized
 influencing Stanley trial, 76, 78
 operating in legal/prison system, xvi–xviii, 35–36, 49–50, 154
 supporting racial hierarchy and stereotypes, 37–40, 94
 viewed through colonial lens, 46, 56, 87

Kaiser-Derrick, Elspeth, 123
Kamir, Orit, 151
Keeseekoose First Nation (SK), 53
Kiiwetinepinesiik Stark, Heidi, 51, 111
King, Thomas, 40

Laberge, Corey, 39
law, criminal. *See* Criminal Code/criminal law
law, international human rights, xix, 180–81, 184, 186, 198, 207
law, rule of, xii, 40, 45, 47–49, 52, 131, 134, 217
The Law is a White Dog, 49
lawmakers, role in amending sentencing practices, 164, 167–68
Leach, Penelope, 196
legal system, Canadian
 colonial racism embedded in, 17, 42, 53, 63, 69, 136
 constraints against change, 106, 163
 creating criminality label for Indigenous persons, 109, 111
 criminal justice system, 16, 43, 113
 discriminating against Indigenous persons, xvi, xviii, 45, 49, 56–58, 128, 211
 embedded with androcentric norms, 147, 150, 159, 161
 legal representation as absent or limited, xi, xiv, 5, 164–66
 See also Criminal Code/criminal law
Luhmann, Niklas, xvi–xvii, xix, 35–36, 42–43, 53, 89, 126, 157, 210–11

Machiskinic, Nadine, 54
Mandela, Nelson, 213
Manitoba Indian Brotherhood, xxii, 45
Martin-Misener, Ruth, 31
McClung, Justice John, 91
McKay, Marlene, 86
Millennium Scoop, 54, 137–38, 169
Monture, Patricia, xvi, 42–43, 156, 210
Morris, Alexander, 45
Mosher, William D., 31
motherhood
 "bad/unfit" mother stereotype, 87–88, 90–91, 93, 130, 149, 159, 161, 176, 179
 lack of consideration for in sentencing, 179
 occurring in private sphere, unnatural in public sphere, 148, 152, 154, 160, 206

INDEX

shameful when unwed, 151, 153
unacceptable for deviant of law, 14, 88, 160–61
See also pregnancy/childbirth
Myran, Marcedes, 55

Naistus, Rodney, 58
National Inquiry into Murdered and Missing Indigenous Women and Girls (MMIWG), xv, 59, 83, 126, 139
newborn-mother separation, automatic
in absence of mother-child programs, 21–24, 30–32
as act of violence, oppression, 59, 90, 161
assumed during sentencing, xviii, xxi
due to lack of legal representation, 166
enabled by colonial/androcentric norms, xvi–xvii, 61, 93, 130, 148–49, 154, 159, 164
enabled by racist stereotypes, 15
impact of experience on lifelong health, 157–58
legal support needed to reject practice, 212, 215–16
owing to spatialized justice norms, 50
posing threats to health of mother, newborn, xxii, 196, 202, 204
practice contrary to Canadian law, 60, 195, 210
violating Canada's international treaty obligations, 195
violating Charter rights, xv, 169, 195, 200, 202, 209
newborns
benefits of breastfeeding, 20, 148
dehumanized and dislocated by separation, 143
entitled to healthy treatment, 136
maltreatment through separation, 88, 158
maternal attachment critical to health, 14, 20, 196–97
numbers born in custody, by province, 25–29
right to fair process, 23
right to security of the person, 60, 199–201, 204, 207, 217
sentencing of, xx, 14, 92, 154, 215
See also bonding; child, best interests of; newborn-mother separation, automatic

Night, Darrel, 58–59
North-West Mounted Police, 46, 100

Office of the Correctional Investigator Annual Report 2021–2022, 31
Ontario Court of Appeal (ONCA), 185–86
oppression
due to adherence to colonial norms, vii, xx, 102, 214
of Indigenous peoples by the state, xv, 56, 111
newborn removal as form of, 88
as victim-blaming, 89–91
of women in androcentrism and Christian patriarchy, 149, 160
Osborne, Helen Betty, 53

Pass System, 46, 100, 104
Paul, Frank, inquiry, 40
Paynter, Martha, 31
Pentelechuk, Madam Justice Dawn, 186
Pine Grove Correctional Centre (Prince Albert), xi–xii, 7–8, 11–12
post-traumatic stress disorder (PTSD), 16
Poundmaker, Chief, 98
pregnancy/childbirth
accommodation of in prisons, 154–57, 178
mitigating or aggravating factor in sentencing, 5
occurring in private sphere, 160, 168, 188, 206
See also shackling, during labour/delivery
Prince, Rufus, xxii, 45
prisoners/incarcerated persons
dehumanization of, 131–32
forced to conform to male standard, 159, 178, 180, 188
mental, physical stress on, 132, 202
restraints, directives for pregnant persons, 192, 194, 211
state mistreatment of, 134, 181
prisons/correctional facilities
dehumanization in, 131–33
as male environment, by default, 153–54, 158–59, 178, 187
need to accommodate mothers and newborns, 202–3, 214–15
as unfit for children, 134, 143, 156
vehicle for civilizing Indigenous persons, 109

Pro Bono Law Saskatchewan, Criminal Appeals Panel Program, xiv, 7

Quigley, Tim, 103, 107

racism
 basis of settler society, 37
 devaluing Indigenous persons, 212
 embedded in legal system, xxv, 50, 57, 63, 78, 128, 162
 embedded in residential schools, 138
 factor in Stanley trial, 69
 as gendered anti-Indigenous, xvii–xviii
 as stigmatizing, 214
Razack, Sherene, 104, 133, 148
 spatialized justice theory, xvi–xvii, xxii, 35–40, 42, 46, 52, 65, 94, 210
Reactive Attachment Disorder, xxi
Reference re Secession of Quebec, xii
Riel, Louis, 98
Roach, Ken, 71, 75
Roncarelli v. Duplessis, xii
Royal Canadian Mounted Police (RCMP), 55, 100, 108
 response during Boushie case, 65, 68, 70–72, 78–79
Royal Commission on Aboriginal Peoples (RCAP), xv, 15, 125
Ruether, Rosemary Radford, 150
R v. Chanalquay, 121
R v. Gladue
 connection between policing and incarceration, 103
 decision on sentencing analysis, 113–14, 122–23
 factors mitigating Indigenous culpability, 124, 126, 128
R v. Ipeelee, 113, 121
R v. Prystay, 186
R v. Slippery, 119, 121
R v. Smith, 189
R v. Stanley, 67

Saskatchewan
 attitude toward prisoner well-being, 134, 193
 automatic newborn removals in, xii, 22, 24, 139
 demographics of judges, 166, 170
 Indigenous incarceration in, 15, 103–4, 107–8, 129
 lack of transparency in court decisions, 171
 Legal Aid, xiv
 Ministry of Justice, xi
 Ministry of Social Services, 22
 number of infants born to incarcerated persons, 26, 30
Saskatchewan Court of Appeal (SKCA), 5, 115, 119, 121, 170
"savage" Indigenous stereotype
 dehumanizing Indigenous persons, 40, 46, 51, 83, 96, 99
 devaluing Indigenous women, 54–55, 87–88, 94, 117, 130, 135, 151, 180, 187
 operating in Stanley case, 63, 65–66
 present in legal/prison system, 60, 103, 108–12, 123, 133, 176–77, 214
 spatial category of colonial lens, xvi, 38–39, 41, 137, 141
Scott, Duncan Campbell, 52
sentencing
 alternatives to custodial sentences, 17, 116, 129, 178, 203–4, 207, 211
 causing boundless suffering, 180
 decision not subject to societal scrutiny, 164, 171
 default practice as androcentric, xx, 153, 158, 178, 215
 Gladue factors for consideration, 113–26, 128
 impact on parent and child, 15, 23, 62, 205–6, 214
 stereotypes influencing, 88
shackling, during labour/delivery
 deemed acceptable for prisoners, 154, 157, 177
 health risks and harms from, 92, 157, 181–83, 192
 as illegal/unconstitutional, xix, 158, 175, 180, 183
 as inhumane and degrading punishment, 168, 186, 188–89
 provincial legislation on, 193
 violation of Charter, international law/treaties, 184–88, 190–92
Shaheen-Hussain, Dr. Samir, 57
Sheppard, Colleen, 57
Simpson, Audra, 125

INDEX

Sinclair, Justice Murray, 141
Sinclair, Phoenix, 39
Sinclair, Raven, 138
Sixties Scoop, 54, 137
Skinner, Shirley, 104, 107
Slaight Communications, 187
Slotkin, Richard, 39
Smith, Ashley, 132
Sölle, Dorothee, 160
Stanley, Gerald
 exhibiting anti-Indigenous bias, xviii
 family members of, 67–68, 78
 hang-fire defence of, 70–72
 manslaughter charge against, 64, 69, 72–73
 trial and acquittal of, 61, 63–64, 66, 69–71, 73–76, 78–79, 212
 as vulnerable settler, 65, 78
Starblanket, Gina, 64–65
Stevenson, Winona, 84
Stewart, Michelle, 39
Stonechild, Neil, 58
Storying Violence, 64
Sufrin, Carolyn, 31
Supreme Court of Canada (SCC)
 protecting individual from arbitrary state action, xii, 187, 189–90
 recognizing injustices toward Indigenous persons, 17
 regarding Cindy Gladue murder, 55, 122
 sentencing factors for Indigenous persons, 114, 118, 126, 129
systems theory
 influencing Stanley trial, 76
 operating in legal/prison system, xvi–xix, 35–36, 49, 66, 157, 210

terra nullius construct, xvi, xxv, 42, 128
Tomblin, Gail Murphy, 31
trauma
 caused by newborn-mother separation, 92, 134, 154, 202
 due to shackling during labour, 93, 182, 189
 intergenerational, due to colonialism, 16, 93, 117, 122, 124, 127, 129, 139, 169, 176

treaties/treaty-making, 45, 48, 52, 87, 112, 140
Treaty 6, 44, 98, 102
Treaty 6 First Nation, xi
Treaty 7, xxiii
Truth and Reconciliation Commission (TRC), xv, 15–16, 125
 Calls to Action, 141–42

United Nations Convention on the Rights of the Child (UNCRC), xiii, xv, 62, 198–200, 204–5, 207, 216
United Nations Declaration on the Rights of Indigenous Peoples (UNDRIP), 201
United Nations Declaration on the Rights of Indigenous Peoples (UNDRIP) Act, 128
United Nations Human Rights Committee, 184, 186
United Nations Rules for the Treatment of Women Prisoners and Non-Custodial Measures for Women Offenders (Bangkok Rules), 185–86, 189, 206
United Nations Standard Minimum Rules for the Treatment of Prisons (Mandela Rules), 185–86, 189

Victoria Hospital (Prince Albert), 12, 157, 180

Wall, Premier Brad, 68
Wegner, Lawrence Kim, 58
Wilder, Laura Ingalls, 41
Windsong, Elena, 161
Wolfe, Patrick, xxv
women
 archetypes of in Judaeo-Christian tradition, 151, 159–60
 belonging to private sphere, 179
 European ideal of womanhood, 84–85
 Madonna-Whore dichotomy, 84, 91, 151, 160
 sentenced to custody deemed unfit mothers, 179
 unfair treatment in public sphere, 150, 152–53
 See also Indigenous women; motherhood

Robin Hansen teaches law at the University of Saskatchewan. She lives in Saskatoon.